THE ART OF
DreamWorks
ANIMATION

THE ART OF
DREAMWORKS
ANIMATION

BY **RAMIN ZAHED**
FOREWORD BY **JEFFREY KATZENBERG**
INTRODUCTION BY **BILL DAMASCHKE**

Abrams, New York

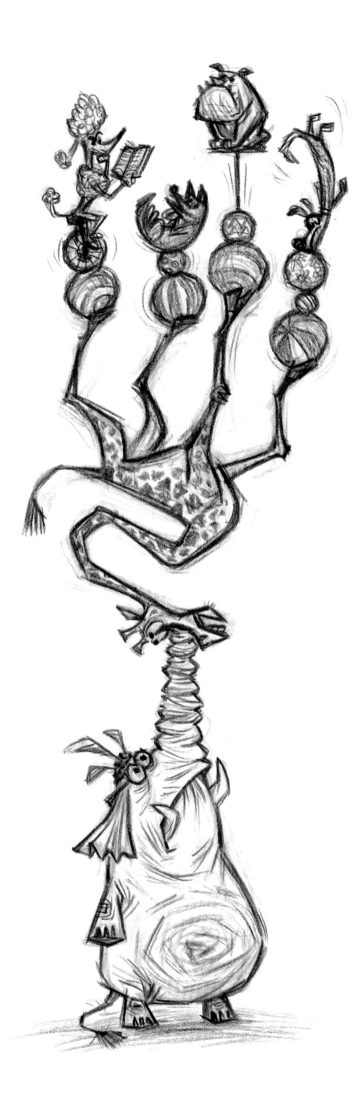

CONTENTS

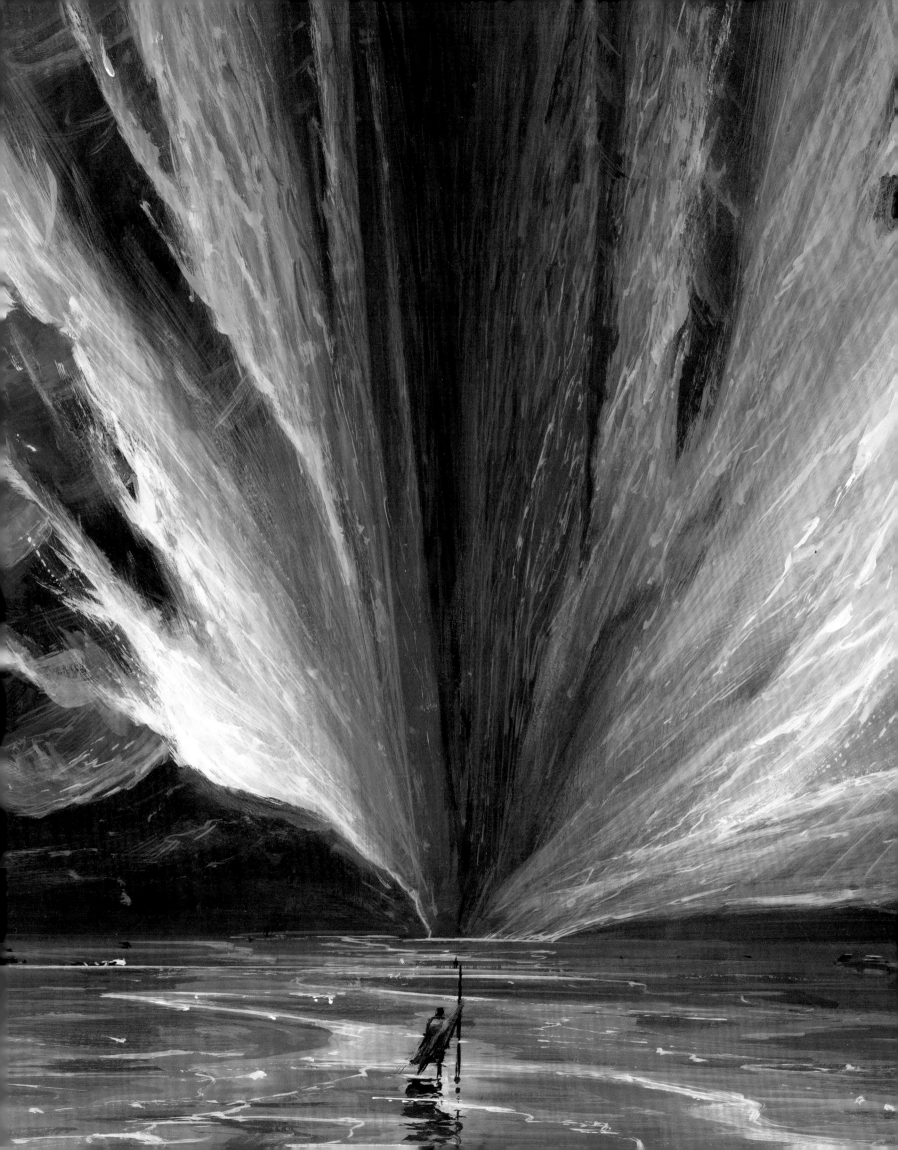

FOREWORD

Every time I drive through the gates of our studio, I'm reminded of what it feels like to work in a place that is built on and driven by passion. This word goes to the essence of DreamWorks Animation and, I believe, it is something that is shared by each and every one of us at our company.

You see, people who work in animation are among the most passionate I've ever met. They have to be. It takes more than four years to create the 130,000 intricate frames that make up a single ninety-minute film. This Herculean effort only comes together because everyone involved cares so passionately about this extraordinary art form.

For me—a guy who started in live-action film production—I discovered my love for animation in an unusual way. Back in 1984, I was named chairman of The Walt Disney Studios. On my first day on the job, Disney's CEO, Michael Eisner, called me into his office and pointed out the window to a building across the lot. He asked, "Do you know what they do over there?" I answered, "I've no idea." He said, "That's where they make the animated movies . . . and you're now in charge."

Later that day, I headed over to that building to see what I was getting into, and there I found a supremely talented and highly passionate group of people who had a contagious enthusiasm for their work. I had an awful lot to get done in my new job, but I just didn't want to leave. I didn't realize it at the time, but that day my life was forever changed. And so began the renaissance of Disney animation that included *The Little Mermaid*, *Who Framed Roger Rabbit*, *Beauty and the Beast*, *Aladdin*, and *The Lion King*.

A decade later, when I joined with Steven Spielberg and David Geffen to build a studio of our own, there was no question what I wanted to do. I was thrilled to find that so many passionate, creative, and driven people wanted to join me in creating DreamWorks Animation. And in turn, these individuals introduced us to other exceptionally talented people. And so, the DreamWorks family grew. And it is only together that we have been able to become such an indispensable part of families' lives.

We have taken our audiences to ancient Egypt, to mystic China, to modern-day Madagascar, to a mythical land of Vikings and dragons, to a prehistoric world of cavemen, and to the fairy-tale kingdom of Far Far Away. I have viewed our films in just about every one of the forty-five languages in which they play, and I am continually amazed how, regardless of the country or the culture, the theaters are filled with the universal language of laughter. It's what keeps me coming to work every day.

You see, the passion for animation isn't just found among the filmmakers; it's also found among the filmgoers. Around the world, people love animation. And if you're holding this book in your hands, I suspect you're one of those people.

I hope you will enjoy the pages that follow. They celebrate two decades of incredible artists and creativity at DreamWorks Animation. Here's to the future, as we continue to explore the passionate possibilities of this limitless medium.

Jeffrey Katzenberg

Jeffrey Katzenberg is the chief executive officer and a co-founder and director of DreamWorks Animation SKG. In 1994, along with Steven Spielberg and David Geffen, he co-founded DreamWorks SKG, which has produced a number of celebrated films including three Best Picture Academy Award® winners—*American Beauty*, *Gladiator*, and *A Beautiful Mind*. In 2004, DreamWorks Animation became a publicly traded company with Katzenberg at the helm. Prior to his time with DreamWorks, Katzenberg served as chairman of The Walt Disney Studios.

Under Katzenberg's leadership, DreamWorks Animation has become the largest animation studio in the world and, as of 2014, will have released thirty animated feature films, which have enjoyed both critical and commercial successes, earning nine Academy Award nominations and two wins for Best Animated Feature.

In 2013, Katzenberg was awarded the prestigious Jean Hersholt Humanitarian Award by the Academy of Motion Picture Arts and Sciences for his outstanding contributions to humanitarian causes. Together with his wife, Marilyn, Katzenberg provides support and leads fund-raising efforts on behalf of dozens of local, national, and international organizations focused on health care, education, the arts, Jewish causes, children, civic improvement, and the environment.

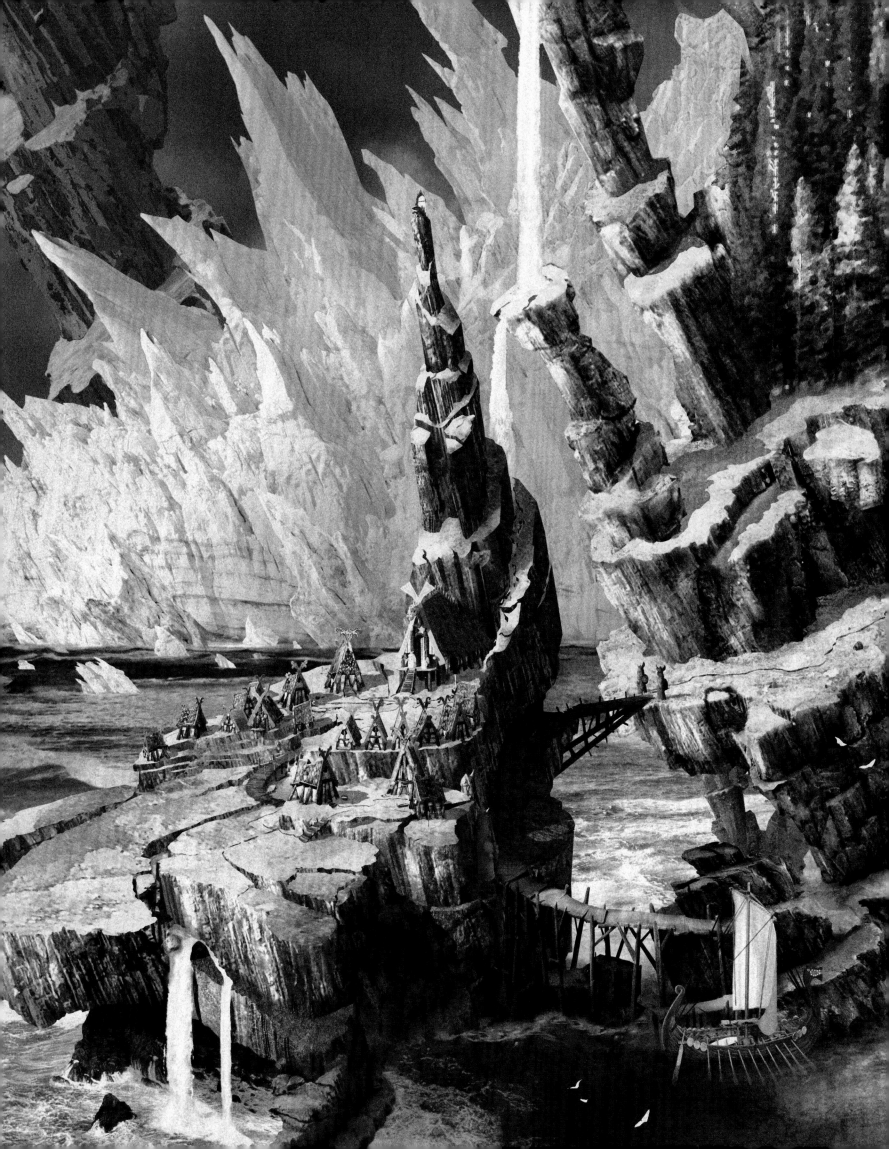

We're used to telling stories with pictures in the animation world, and the story told by the following pictures is one very close to my heart. I was a production assistant on *The Prince of Egypt*, one of DreamWorks' first animated films, and the primary reason I was excited to join the company was that it seemed like a place where you could try to do things differently. Where you could make different kinds of movies without having to conform to a predetermined set of visual rules. And, nearly twenty years later, I think it's still that quest for something newer, smarter, and better that inspires and invigorates our artists today.

From an emotional perspective, the art in each film is a direct extension of that individual filmmaker's sensibilities and the unique story he or she wants to tell. We rely heavily on our filmmakers to push the visuals in a new direction. Our animators are encouraged to come up with something original—to find something specific that inspires them. The culture at DreamWorks is one of embracing collaboration, valuing outside opinions, and learning from different backgrounds, and that environment brings about a creative electricity at the company that is evidenced in the art we create.

There is no "DreamWorks way" to draw a girl, or a dog, or a rock, for that matter. From the classic traditional references of *The Prince of Egypt* to the cartoony world of *Madagascar* and the fantastic realm of *How to Train Your Dragon*, each of the DreamWorks films has a stark contrast in look, feel, style, and sensibility. Whether it's a curmudgeonly ogre who finally finds love in a world of fractured fairy tales, a wild stallion traveling across the frontiers of the Old West, or a dumpling-loving panda who masters the art of kung fu in ancient China, it is only through the collective work of all the artists that the final experience becomes complete. And each of these experiences has the power to elicit completely different emotions from an audience.

Over the past two decades, the tools that our artists have used to elicit those emotions have gotten better and better. Technology has opened new doors for them. They can now create things—flowing hair, sparkling fire, splashing water—that were thought impossible just five or six years ago. The stunning world of *The Croods* is an excellent example of how new tools can inspire our filmmakers to create an adventure without limits. Regardless of where future innovations will take the animation industry or how and where audiences will enjoy the movies of tomorrow, the artists' imagination will always play a pivotal role in a DreamWorks film.

It's that limitless imagination, coupled with exceptional artistry, that defines animation as a medium. The following pages are wonderful excerpts of DreamWorks' contribution to that art form. They are a compendium of all that DreamWorks has been and all that it will be: characters and worlds that surprise, delight, and entertain in a way that always keeps audiences coming back for more.

Bill Damaschke

As chief creative officer for DreamWorks Animation, **Bill Damaschke** is responsible for leading the creative and artistic direction of the studio. His responsibilities include overseeing the creative production and development processes for all of the studio's feature projects, including shaping the creative teams behind each film and growing the studio's creative talent pool. Damaschke is also integrally involved in the studio's future release slate, which puts him at the helm of a wide range of feature films in various stages of production. After joining DreamWorks in 1995, Damaschke served as a producer and executive producer on a number of the studio's feature films before being named head of creative production in 1999, head of creative production and development in 2005, and co-president of production for feature animation and president of live theatricals in 2007, then taking his current position of chief creative officer. A native of Chicago, Damaschke graduated from Wesleyan University with a BFA in music and theater. He began his career in animation working on the hit feature film, *Pocahontas*.

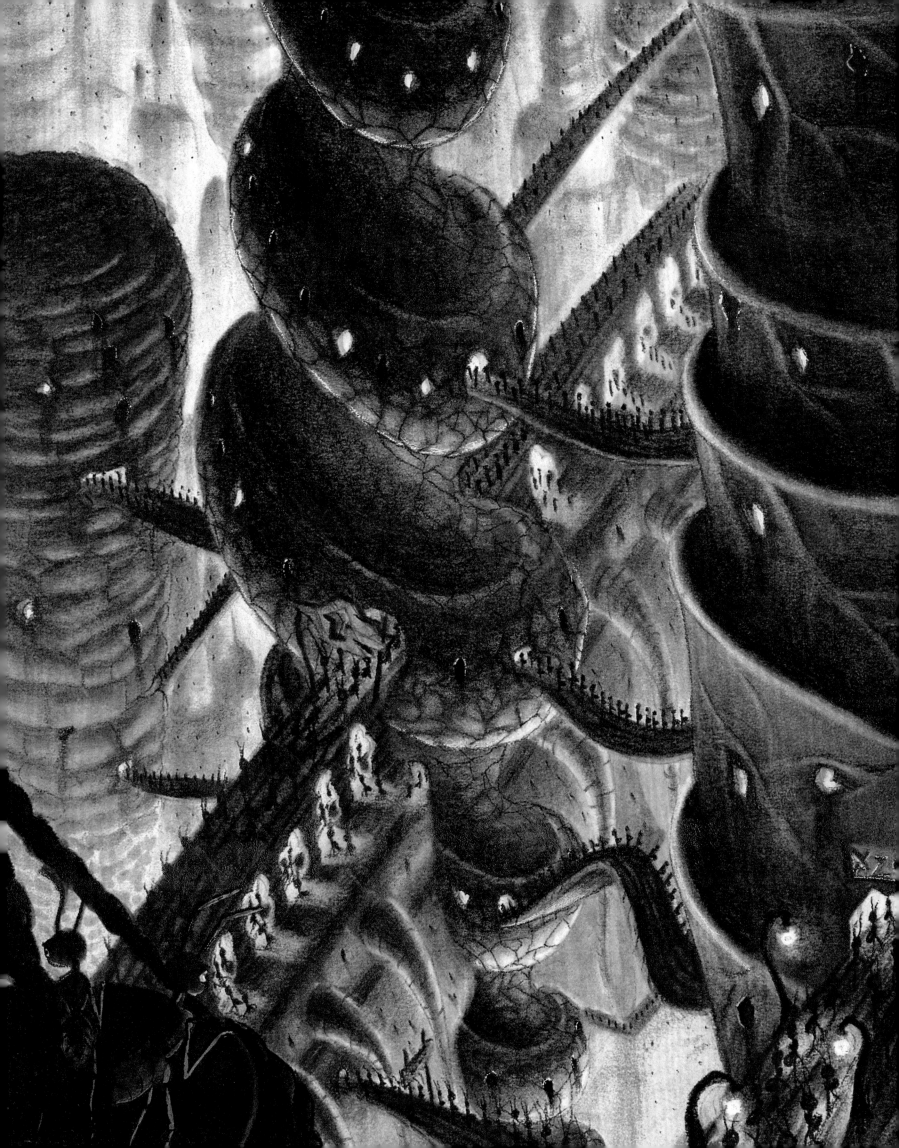

ANTZ

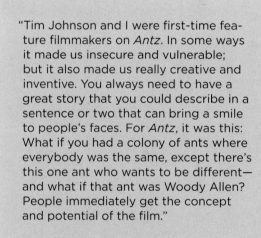

"Tim Johnson and I were first-time feature filmmakers on *Antz*. In some ways it made us insecure and vulnerable; but it also made us really creative and inventive. You always need to have a great story that you could describe in a sentence or two that can bring a smile to people's faces. For *Antz*, it was this: What if you had a colony of ants where everybody was the same, except there's this one ant who wants to be different—and what if that ant was Woody Allen? People immediately get the concept and potential of the film."

Eric Darnell, Director

BiBo

Directors	**Eric Darnell, Tim Johnson**
Producers	**Brad Lewis, Aron Warner, Patty Wooton**
Executive Producers	**Penney Finkelman Cox, Sandra Rabins, Carl Rosendahl**
Production Designer	**John Bell**
Art Director	**Kendal Cronkhite**
Visual Effects Supervisor	**Ken Bielenberg**

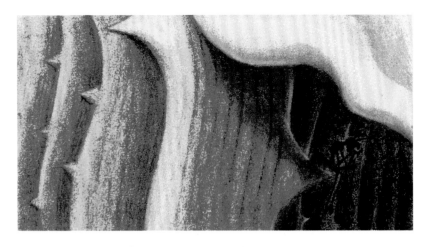

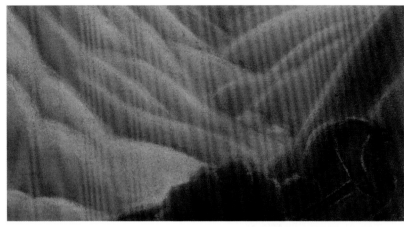

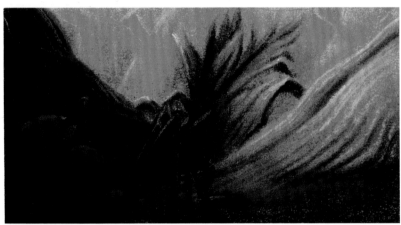

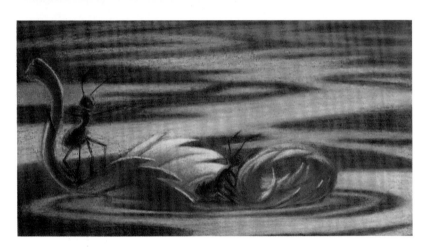

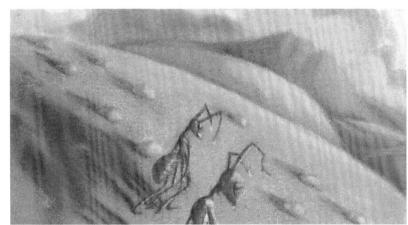

"The human world above ground was about representing how small these ants were in relationship to us. We got down on the ground, at ant eye level, and documented our world from that perspective. We also studied microscopic photography and incorporated that into the design and story of the film, as you can see when our ants get trapped in a water drop."

Kendal Cronkhite, Art Director

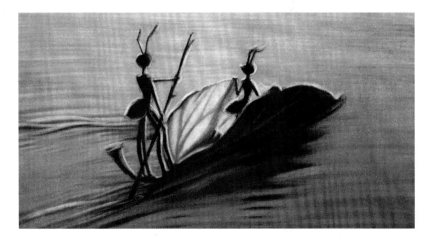

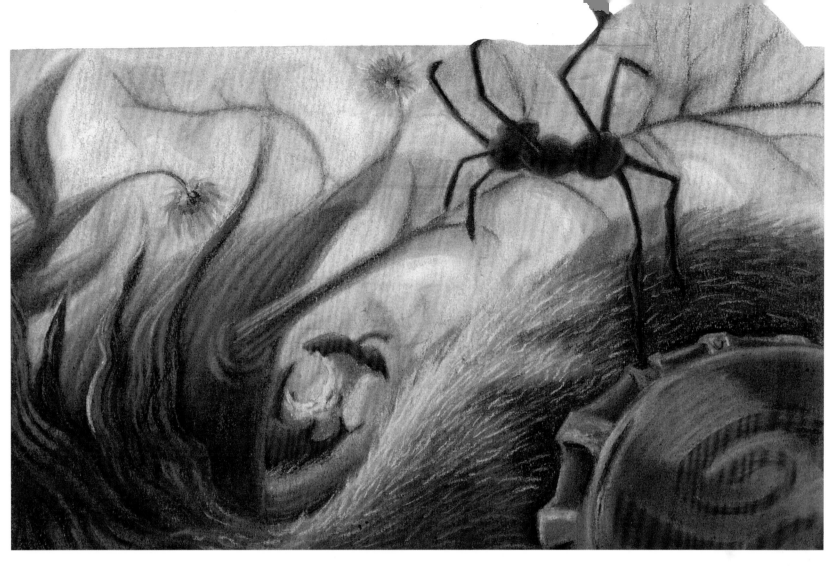

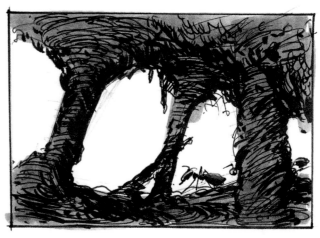

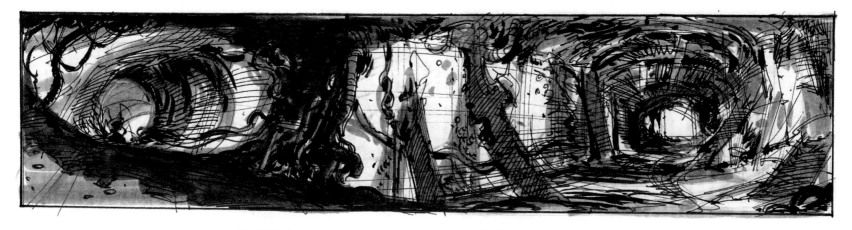
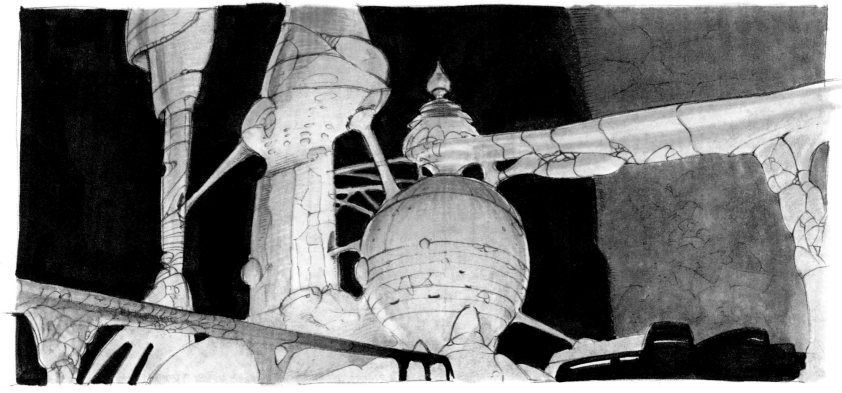

"DreamWorks had produced some amazing hand-drawn animated features, and now we had this CG ability in our tool kit. When you look back at what we were doing on *Antz,* we couldn't do fabric or hair. Now we are working on *Home,* which features a young girl with really curly hair, who goes through many new hairstyles, lots of different clothing changes. We have so much fabric and hair in this movie, and it's really interesting to compare it with our first CG-animated movie that came out sixteen years ago. It's true what they say that our only limits in this medium are the filmmakers' imagination."

Tim Johnson, Director

"During *Antz,* we really had a front-row seat to the CG animation revolution. It was the second fully animated, computer-generated feature film of all time, following *Toy Story.* We felt that we were experimenting with a brand-new medium and that our horizon was limitless."

Tim Johnson, Director

"The challenge in designing the subterranean world for *Antz* was to combine the conformist-like attributes of a gigantic ant society with an organic Ant Hill environment. The works of the artist Andy Goldsworthy and photographer Karl Blossfeldt were the artistic inspiration for *Antz.* Their works represent the architectural structure in the natural world and how the natural world can be organized into architectural sculpture. Fritz Lang's *Metropolis* helped us to visualize the scope of this Ant Hill, teeming with life."

Kendal Cronkhite, Art Director

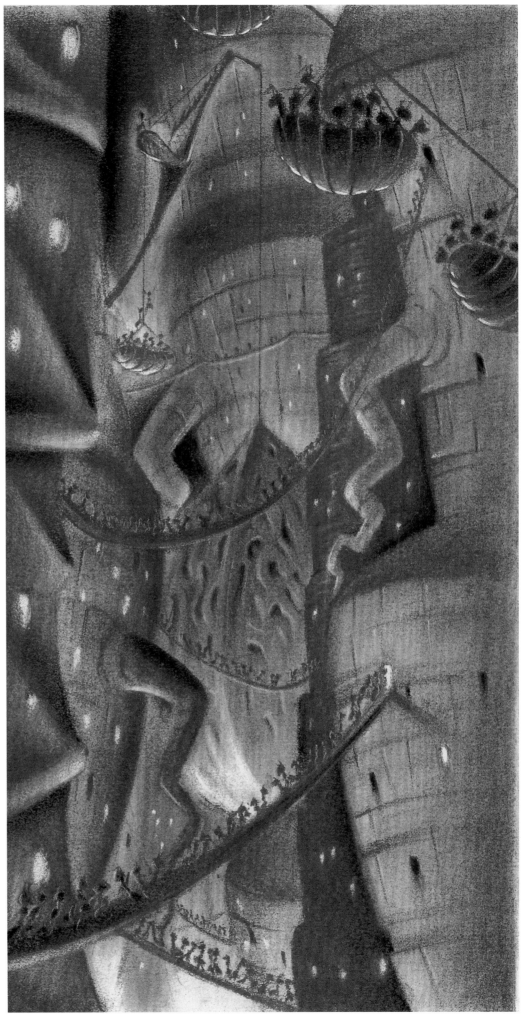

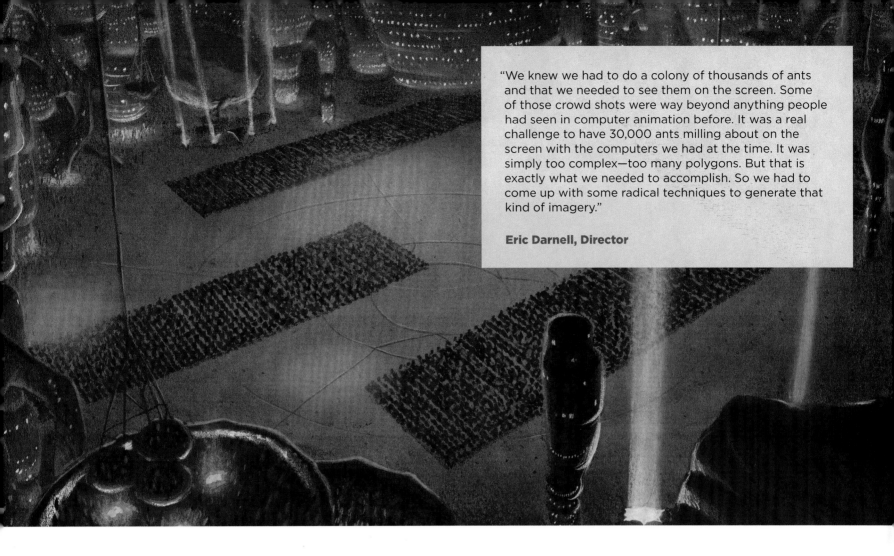

"We knew we had to do a colony of thousands of ants and that we needed to see them on the screen. Some of those crowd shots were way beyond anything people had seen in computer animation before. It was a real challenge to have 30,000 ants milling about on the screen with the computers we had at the time. It was simply too complex—too many polygons. But that is exactly what we needed to accomplish. So we had to come up with some radical techniques to generate that kind of imagery."

Eric Darnell, Director

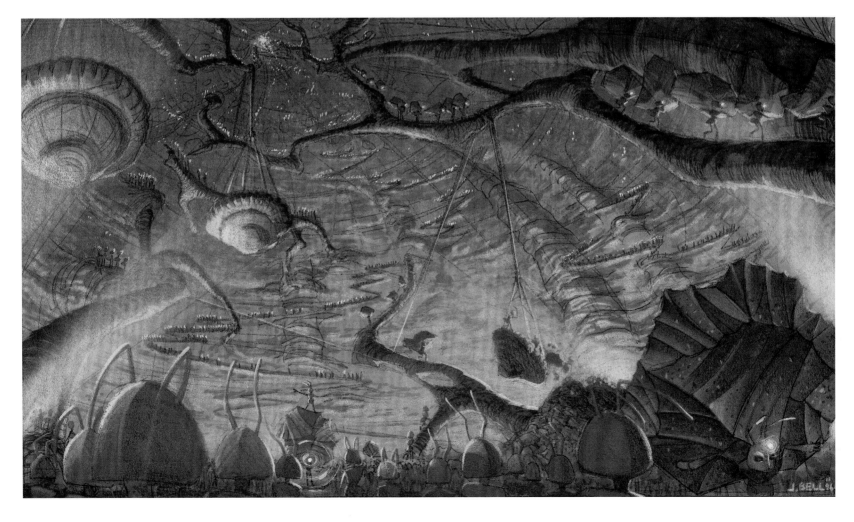

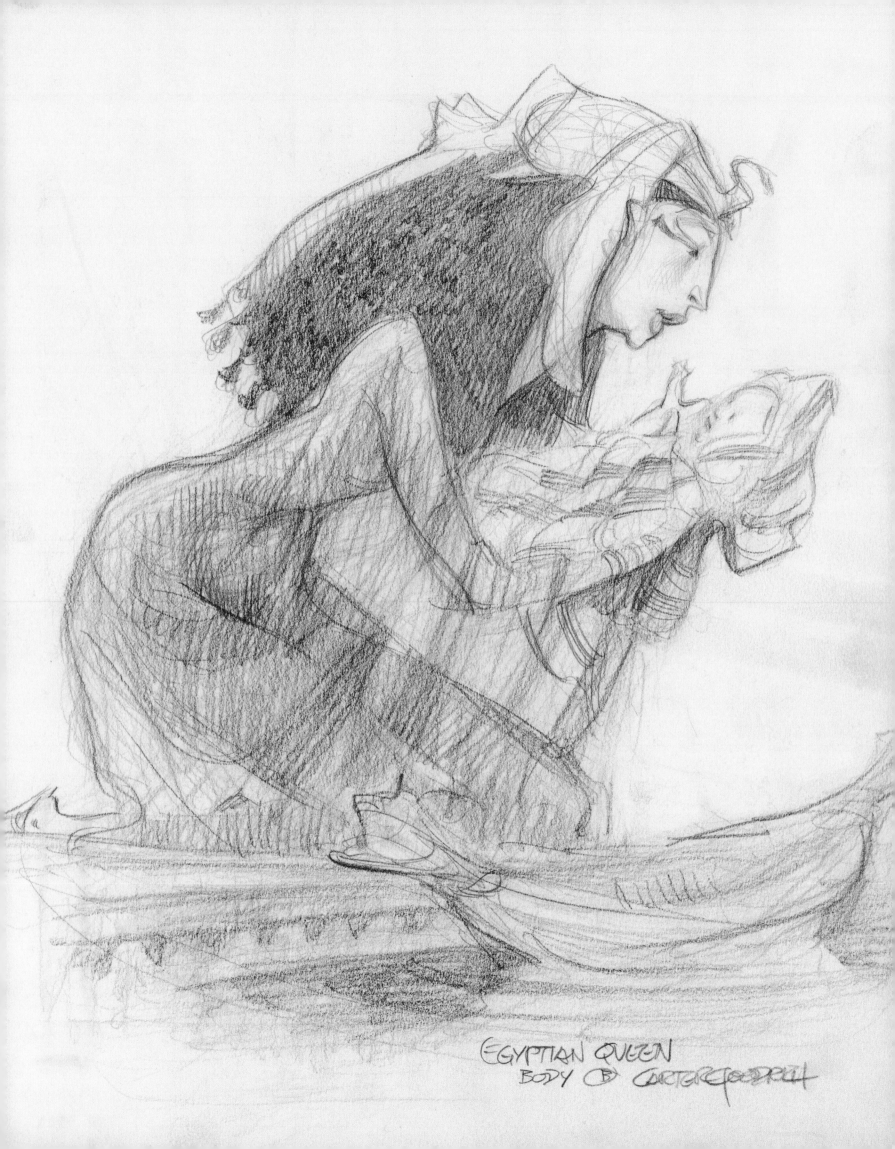

EGYPTIAN QUEEN
BODY © CARTER GOODRICH

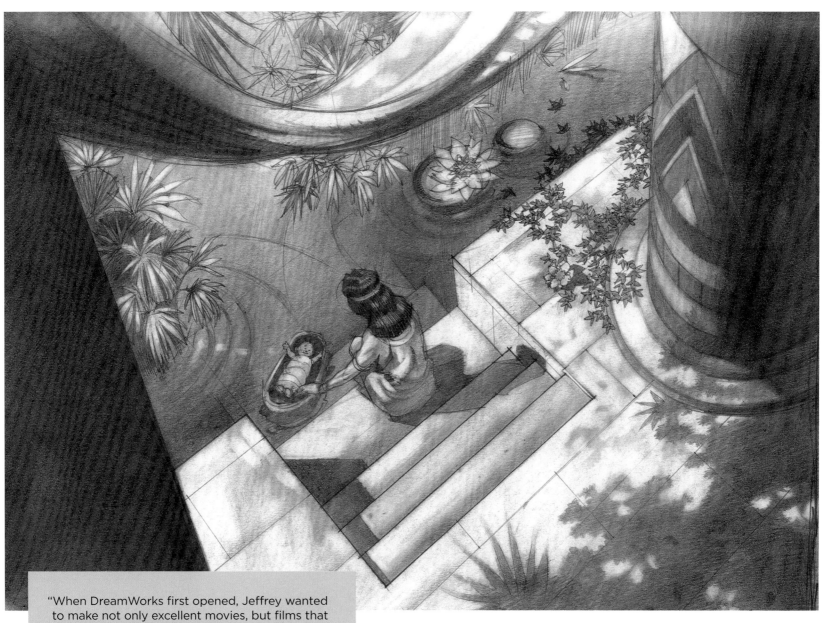

"When DreamWorks first opened, Jeffrey wanted to make not only excellent movies, but films that were different from the competition's. At the time, they were looking for a story that wasn't created exclusively for juvenile audiences . . . a movie that had weight, heart, and a deep story behind it; *The Prince of Egypt* was a perfect fit. And yes, Jeffrey also wanted to create a hugely successful studio and kick some booty."

Kathy Altieri, Art Director

Directors	**Brenda Chapman, Steve Hickner, Simon Wells**
Producers	**Penney Finkelman Cox, Sandra Rabins**
Executive Producer	**Jeffrey Katzenberg**
Associate Producer	**Ron Rocha**
Production Designer	**Darek Gogol**
Art Directors	**Kathy Altieri, Richard Chaves**
Visual Effects Supervisors	**Don Paul, Dan Philips**

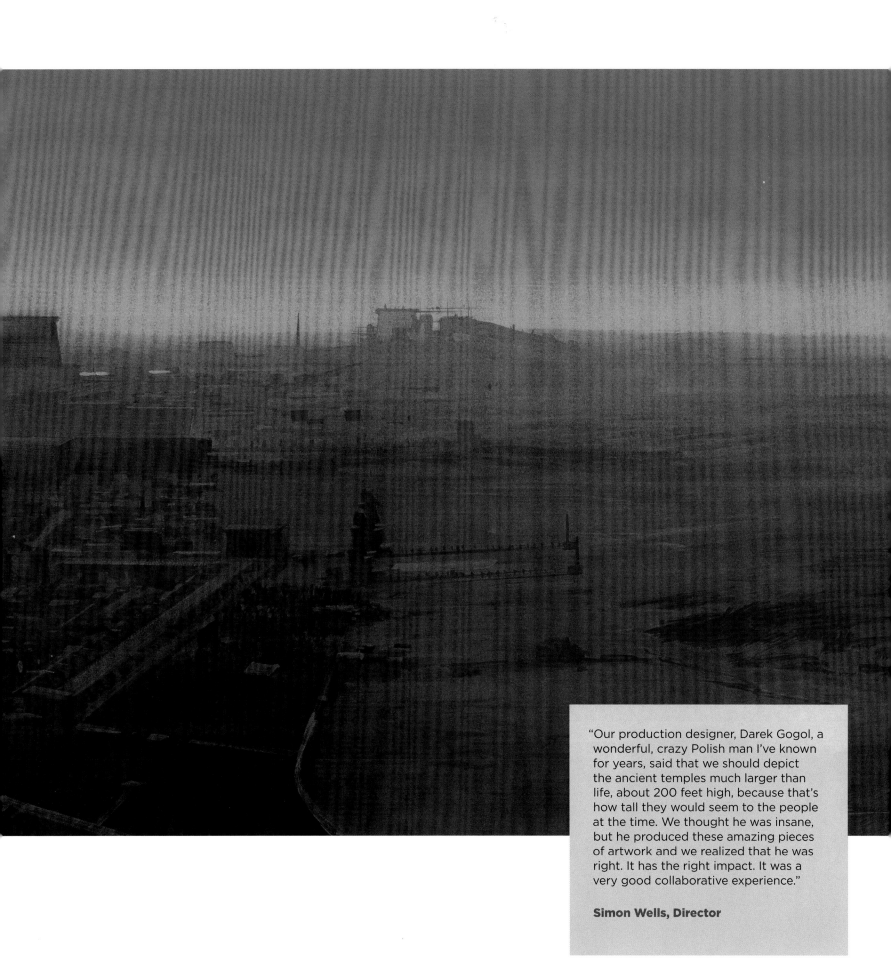

"Our production designer, Darek Gogol, a wonderful, crazy Polish man I've known for years, said that we should depict the ancient temples much larger than life, about 200 feet high, because that's how tall they would seem to the people at the time. We thought he was insane, but he produced these amazing pieces of artwork and we realized that he was right. It has the right impact. It was a very good collaborative experience."

Simon Wells, Director

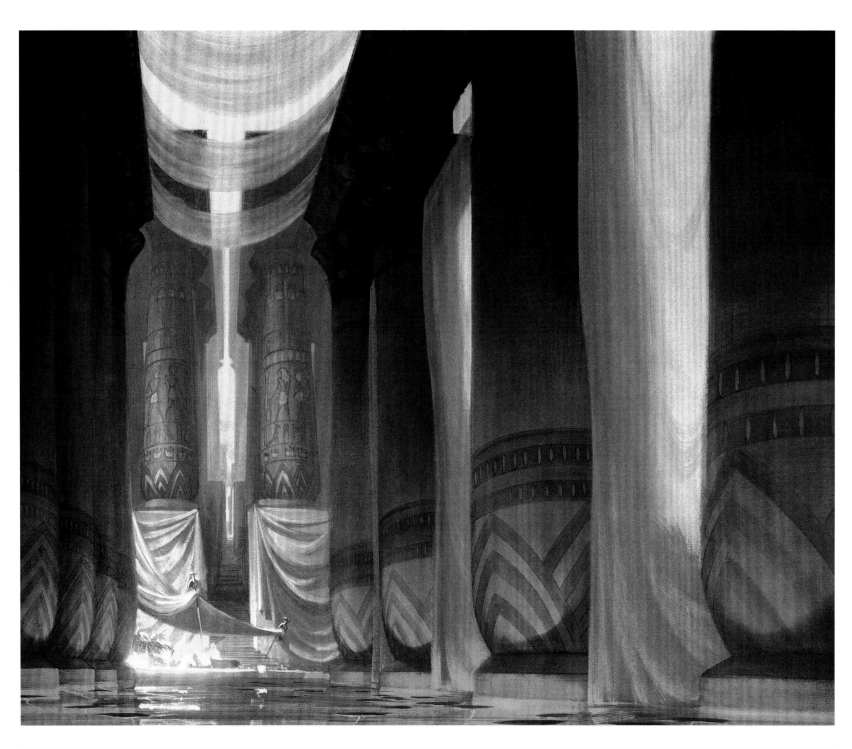

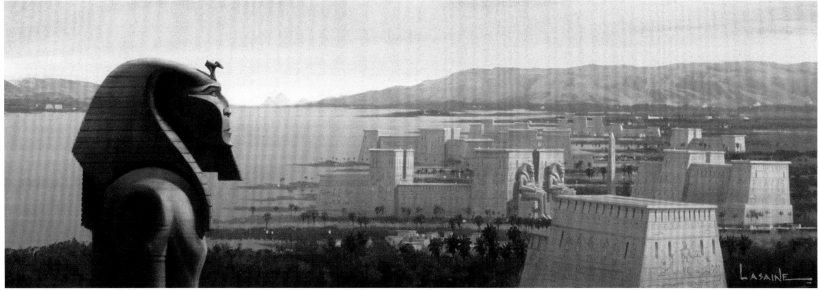

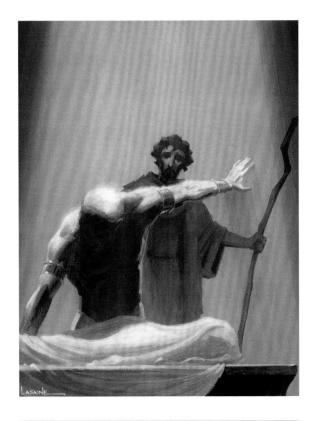

"I think what I like best about *The Prince of Egypt* was that it was an animated movie that was quite unlike anything else I have seen or worked on. There were things in that movie that you almost never see in an animated movie. My single favorite scene in the movie is the one where, after the death of his first-born, Moses goes to see Rameses. Immediately after leaving Rameses, Moses comes out of the palace and collapses, and starts crying. It's a very slow scene, and I can't think of any other animated movie in which there is that kind of genuine emotion."

Simon Wells, Director

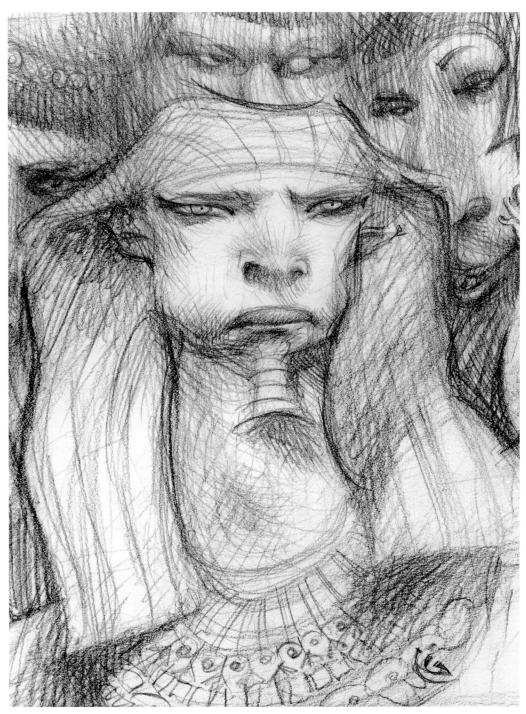

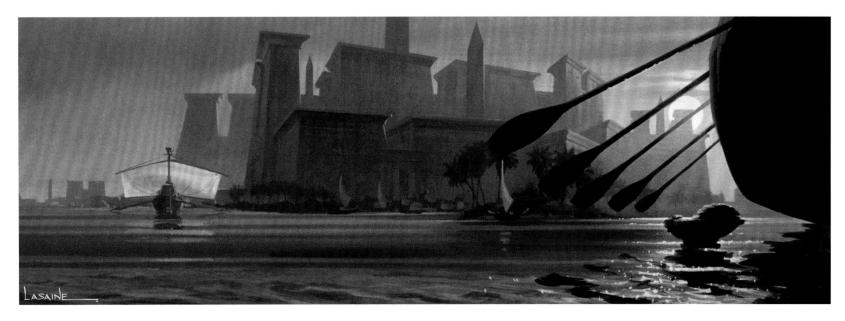

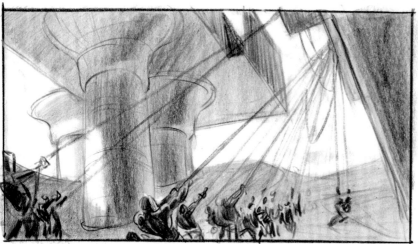

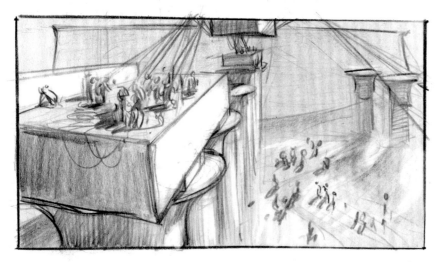

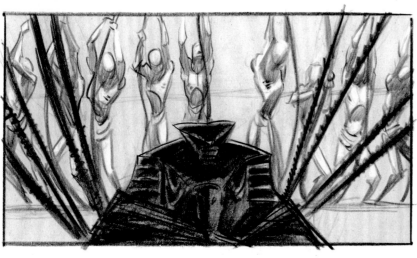

"When we were starting out on *The Prince of Egypt* in 1994, we didn't know that *Toy Story* was going to come out the next year and be a huge game changer. In hindsight, *The Prince of Egypt* was the last hurrah of hand-drawn, 2D animated movies. It was the last movie in which we used actual painted backgrounds that you could hold in your hands. There's a tactility about that movie that you could really feel on the screen."

Steve Hickner, Director

"DreamWorks sent the creative leadership of the film to Egypt and the Sinai Peninsula to do research—we took thousands of photographs, sketched and painted on location, and spoke with local scholars. We created two distinct looks for the Egyptian and Hebrew worlds: The Egyptian world was symmetrical, vertical, graphic, and clean, to reflect the Pharaoh's desire to create order out of chaos, while the Hebrew world was asymmetrical, organic, and textured, to emphasize their harmony with nature and the rhythms of God."

Kathy Altieri, Art Director

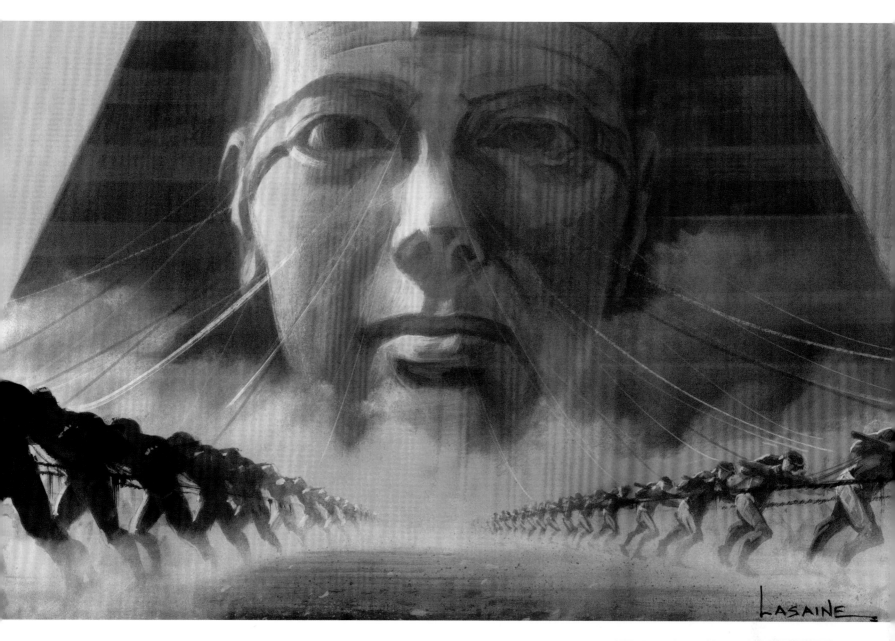

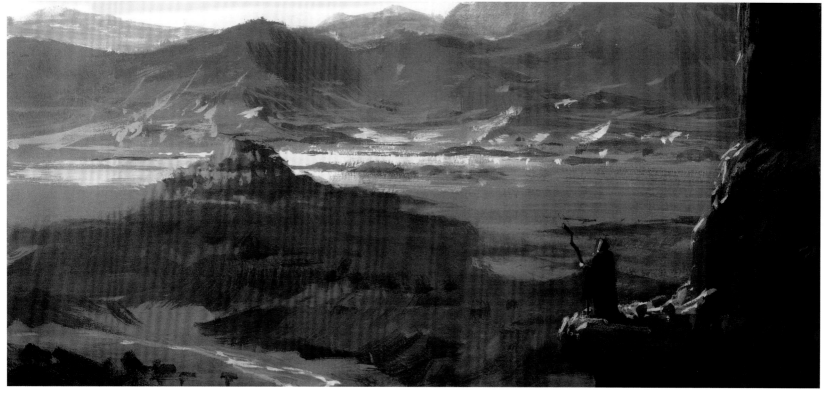

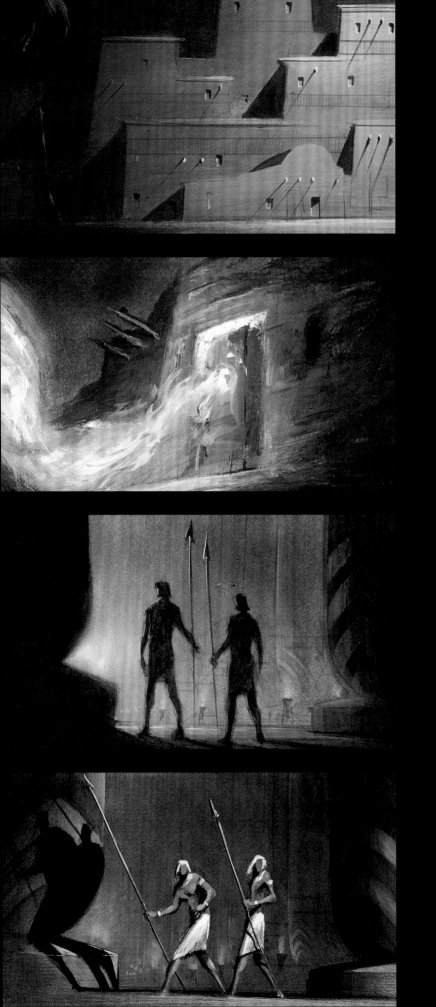

"The story of Moses is a story that is profoundly important to many people on the planet; the directors talked to rabbis, cardinals, Evangelical Christians, and Islamic scholars; then consulted Egyptologists to get another view of the history. With a story so rich in tradition and heart, we were able to break away from the conventional cartoon aesthetics and immerse ourselves into serious dramatic filmmaking—that happened to use animation as its medium. In that sense, *The Prince of Egypt* broke new ground. We proved that we could tell an epic story in a medium that had been reserved for children's entertainment. We brought together some of the best animators and fine artists in the world to bring a deeply felt, timeless story to life."

Kathy Altieri, Art Director

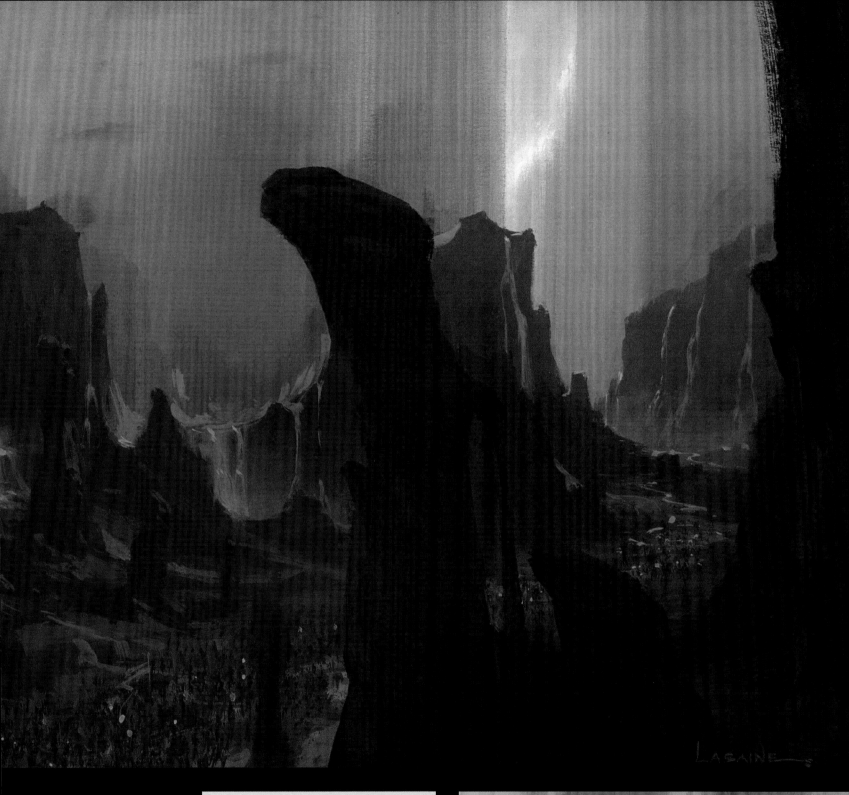

"Our artistic influences for the film were the epic cinematography of David Lean, the color palette of Claude Monet, and the theatrical lighting of Gustav Doré. We were quite consciously aiming for a high level of aesthetic sophistication that was appropriate for the story."

Kathy Altieri, Art Director

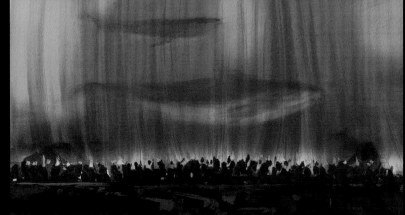

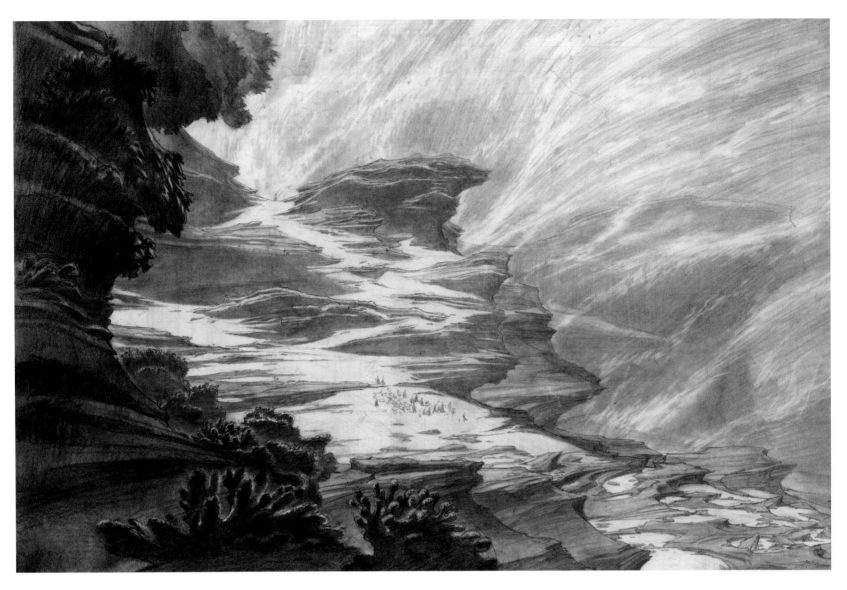

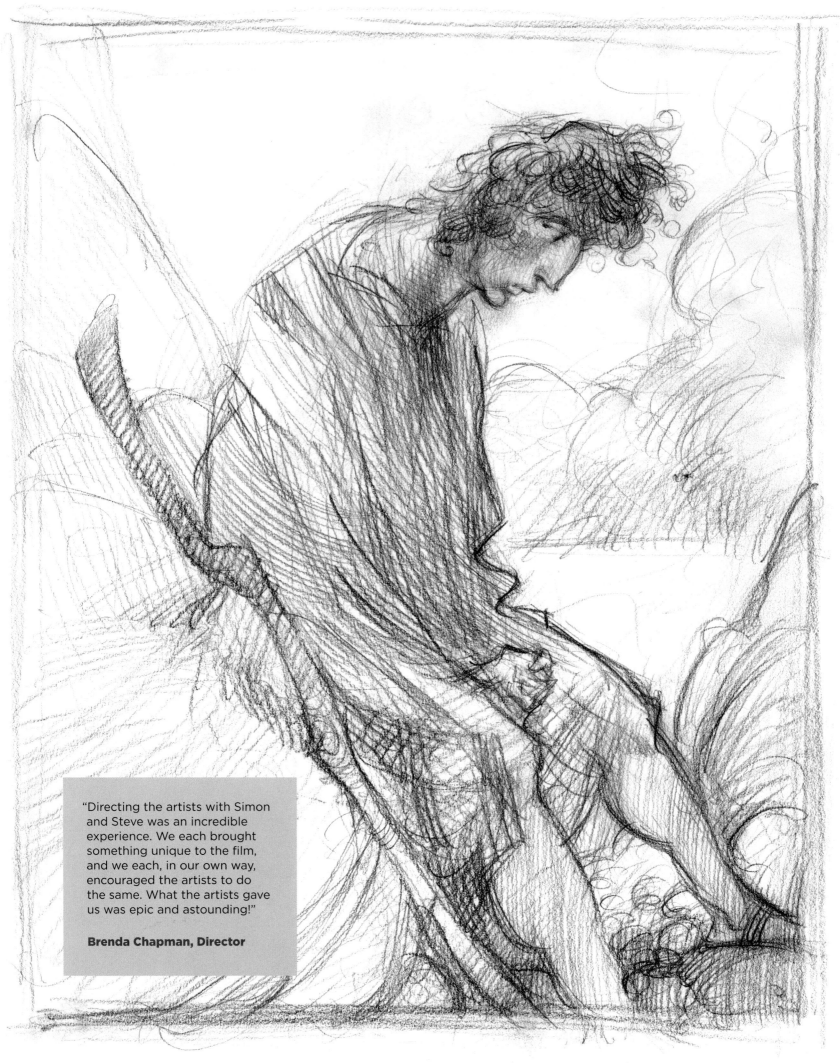

"Directing the artists with Simon and Steve was an incredible experience. We each brought something unique to the film, and we each, in our own way, encouraged the artists to do the same. What the artists gave us was epic and astounding!"

Brenda Chapman, Director

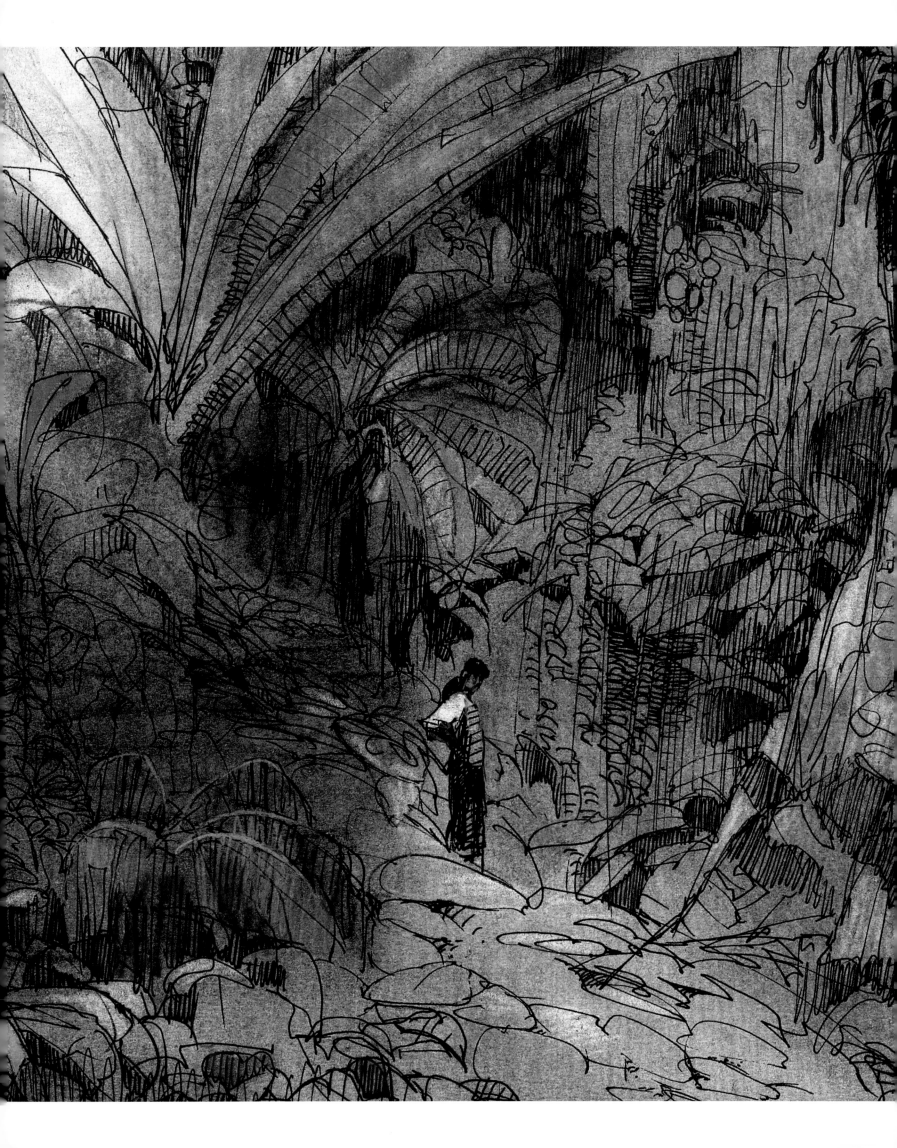

"I remember how excited I was when one of the production designers, Vicky Jenson, brought me on to do some visual development for the movie. I had sought out *El Dorado* because I had heard that DreamWorks was going to do a more stylized project, so I started just going crazy on the artwork. I thought production designer Christian Schellewald's drawings for the movie were phenomenal. They reflected his amazing compositional skills and his unique way of interpreting organic forms in nature and taking on this Mayan aesthetic at the same time."

Raymond Zibach, Art Director

Directors	**Eric "Bibo" Bergeron, Don Paul**
Executive Producer	**Jeffrey Katzenberg**
Producers	**Bonne Radford, Brooke Breton**
Co-Executive Producer	**Bill Damaschke**
Production Designer	**Christian Schellewald**
Art Directors	**Raymond Zibach, Paul Lasaine, Wendell Luebbe**
Digital Supervisor	**Dan Philips**

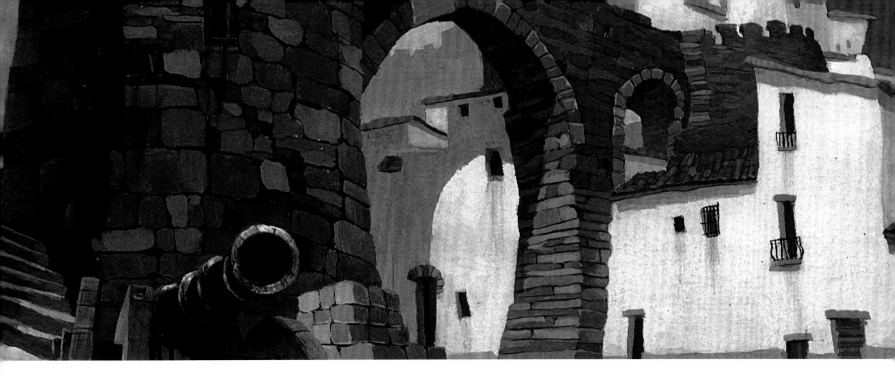

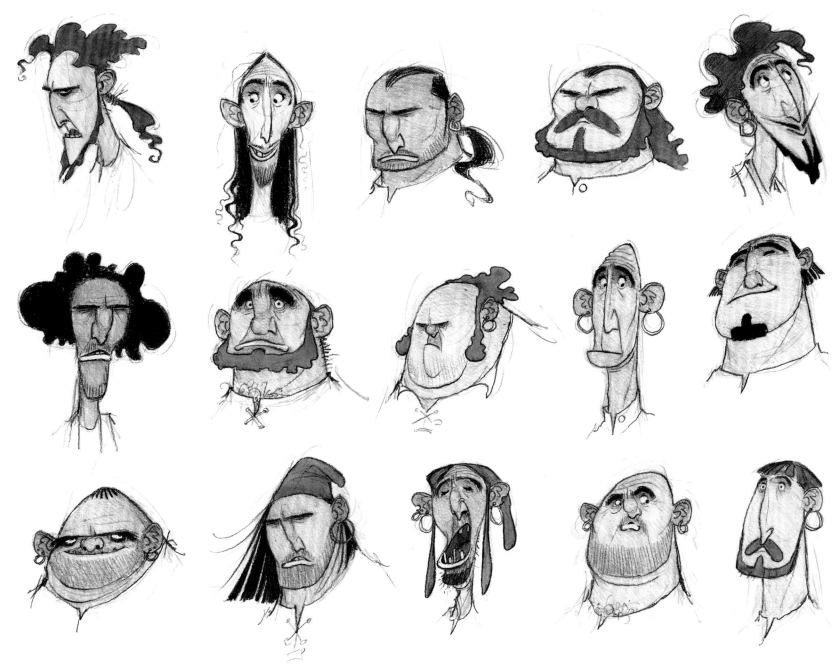

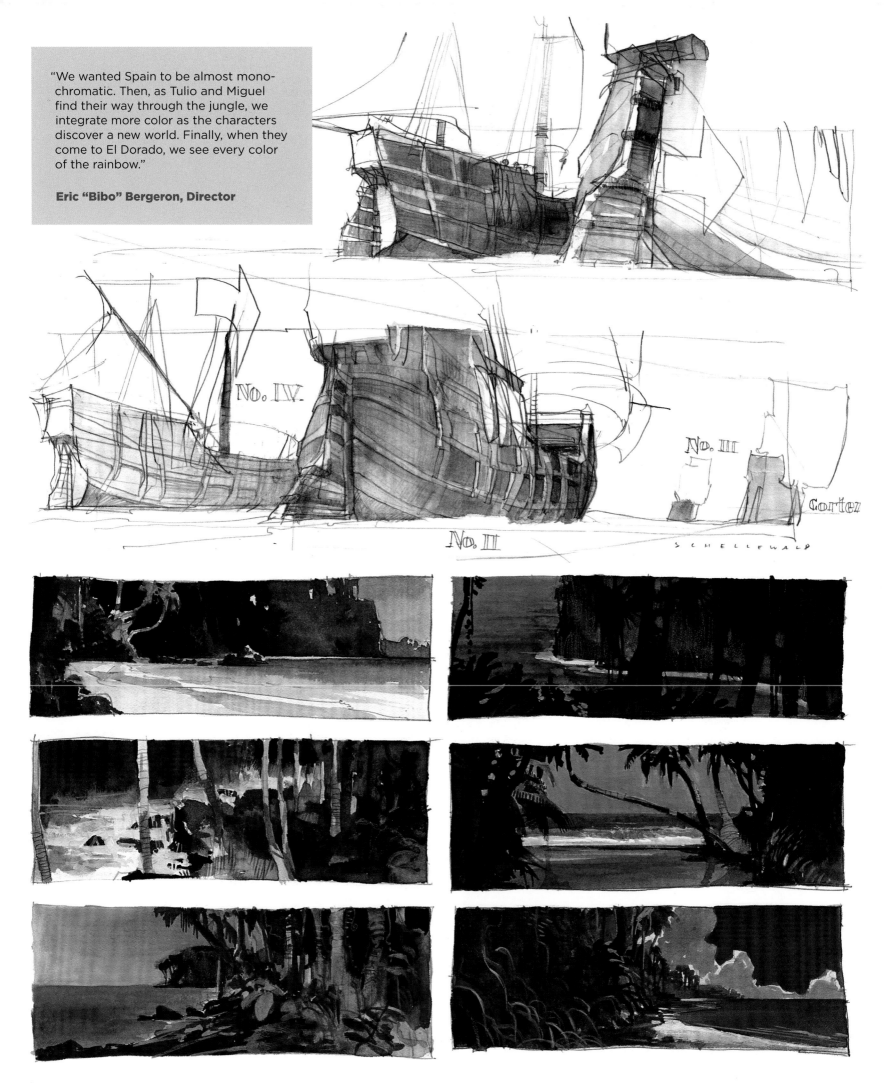

"We wanted Spain to be almost mono-chromatic. Then, as Tulio and Miguel find their way through the jungle, we integrate more color as the characters discover a new world. Finally, when they come to El Dorado, we see every color of the rainbow."

Eric "Bibo" Bergeron, Director

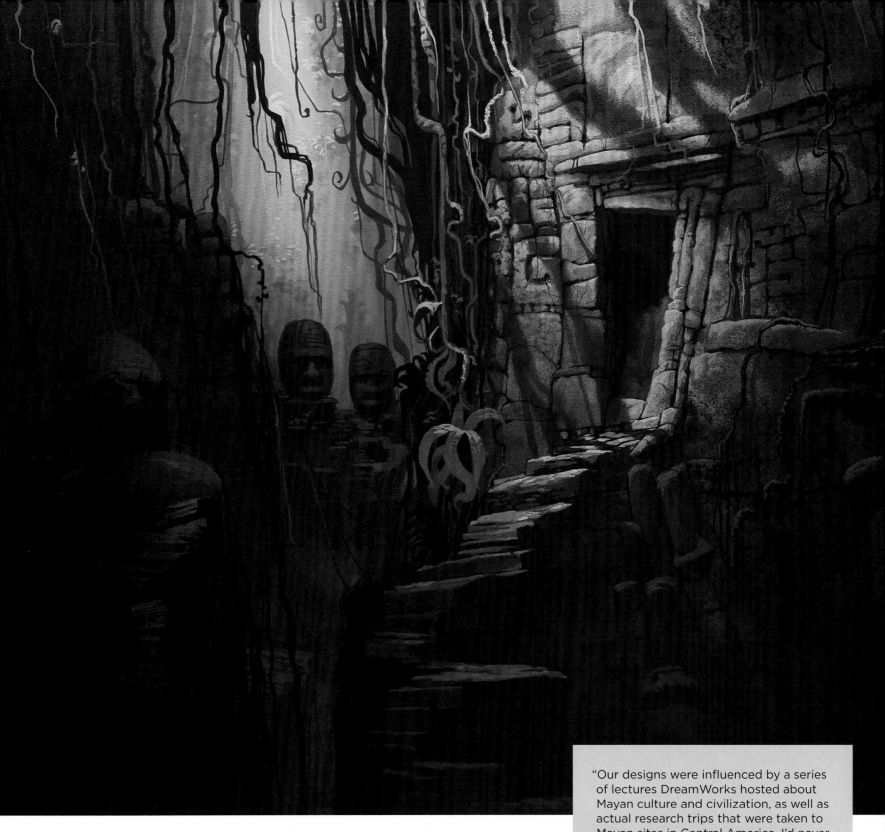

"Our designs were influenced by a series of lectures DreamWorks hosted about Mayan culture and civilization, as well as actual research trips that were taken to Mayan sites in Central America. I'd never seen anything rise to that high artistic level before. Scott Wills did an amazing finish on the paintings that we were using for backgrounds. The character designs by Nico Marlet, Carlos Grangel, and Didier Conrad were really incredible. One of the elements that really stood out was Nico's designs, which were hugely influenced by Mayan art. Overall, we tried to stay very true to Mayan art, space, and design."

Raymond Zibach, Art Director

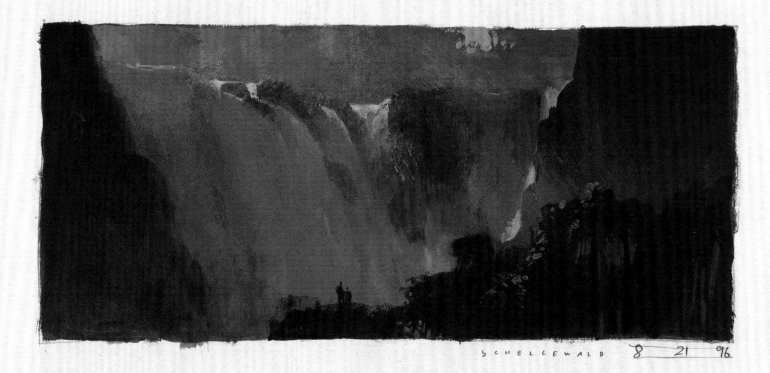

SCHELLEWALD 8 21 96

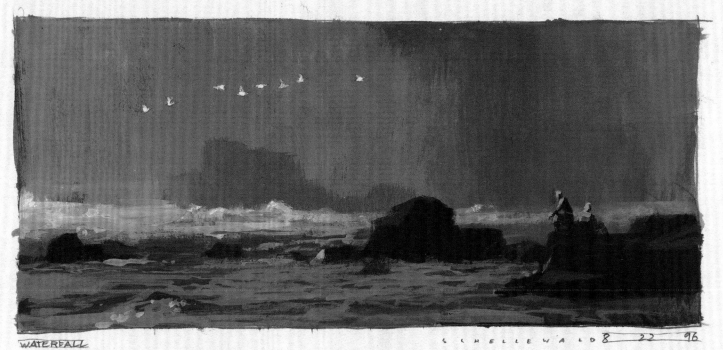

WATERFALL

SCHELLEWALD 8 22 96

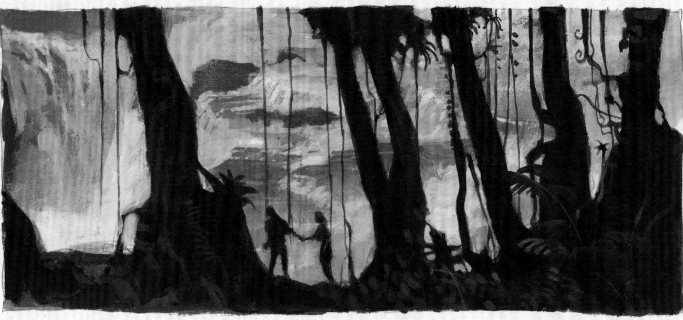

RAPIDS

SCHELLEWALD 8 23 96

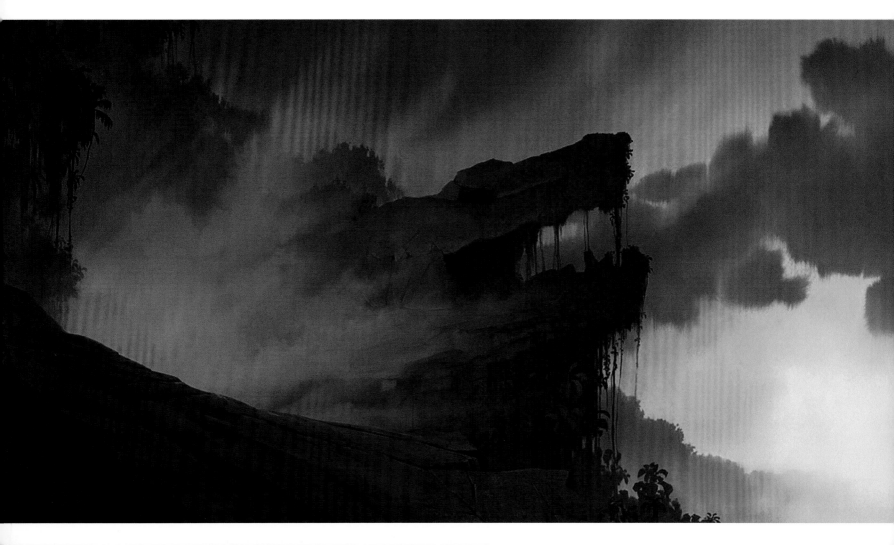

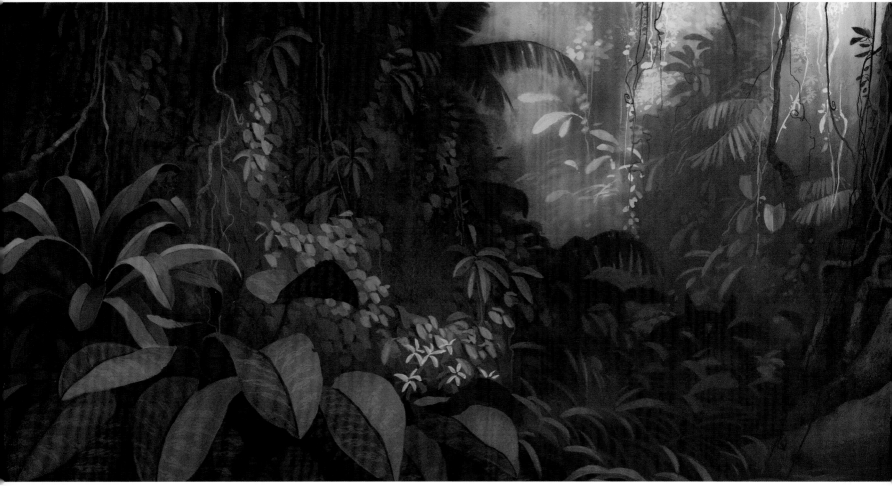

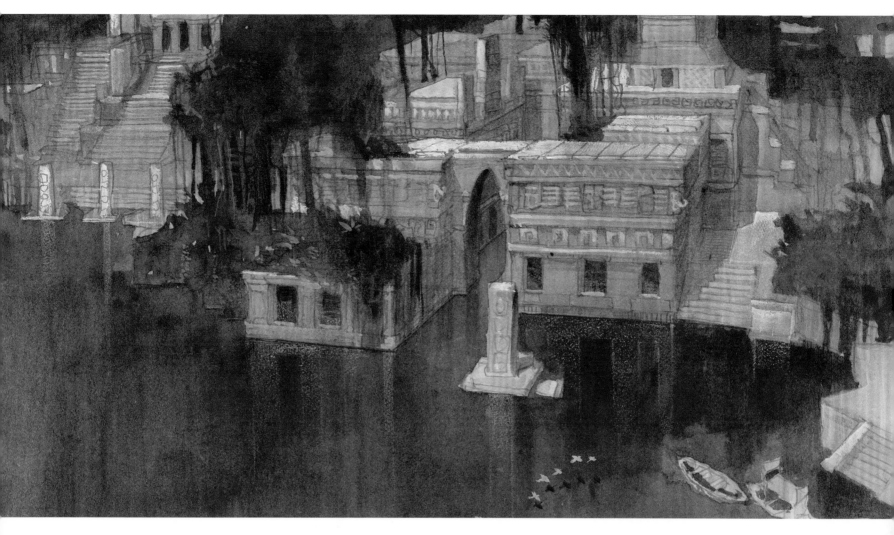

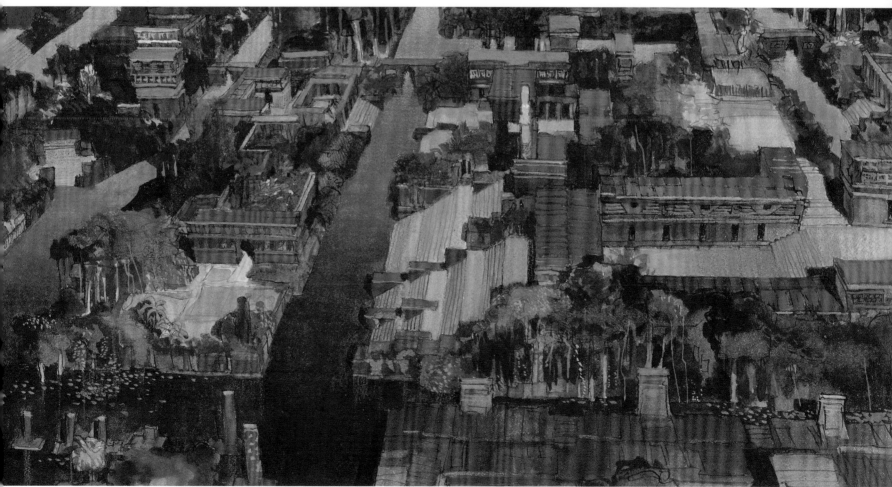

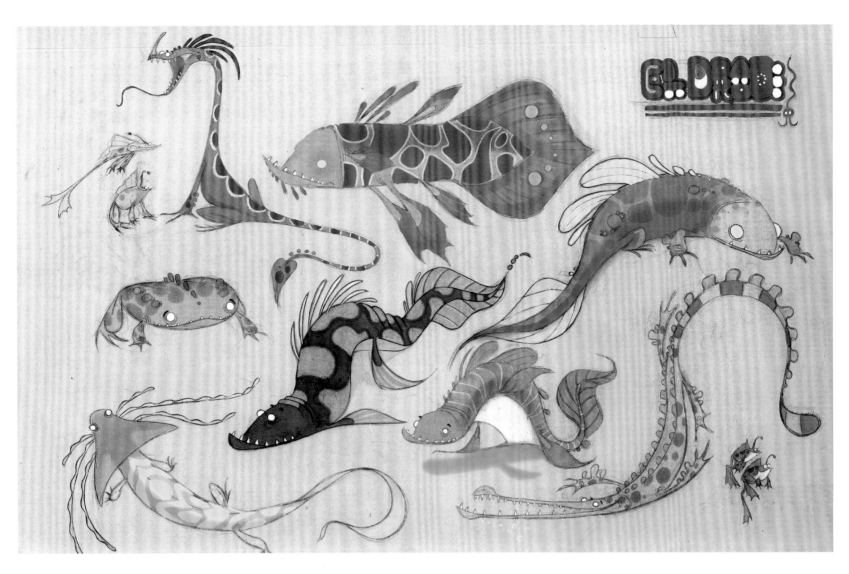

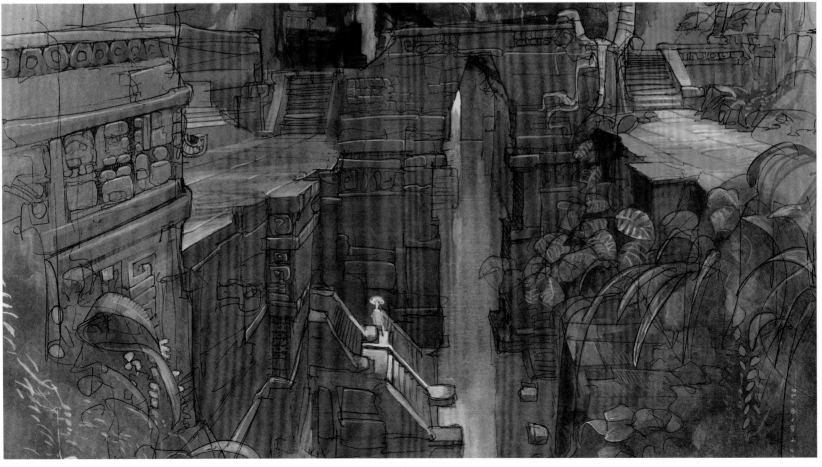

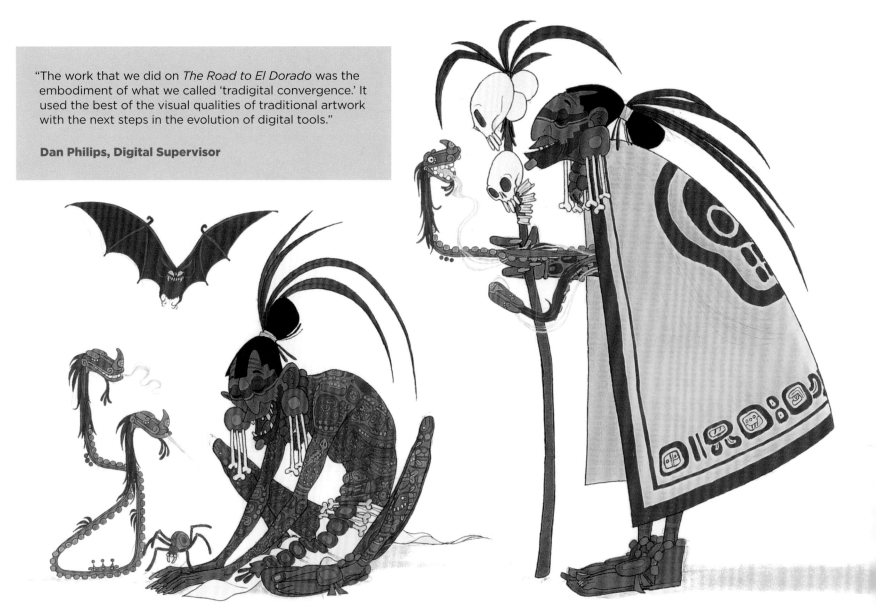

"The work that we did on *The Road to El Dorado* was the embodiment of what we called 'tradigital convergence.' It used the best of the visual qualities of traditional artwork with the next steps in the evolution of digital tools."

Dan Philips, Digital Supervisor

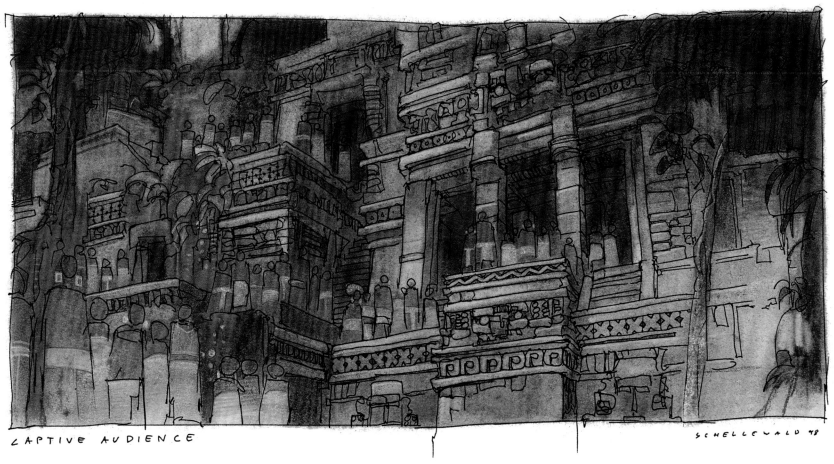

CAPTIVE AUDIENCE

SCHELLEWALD '98

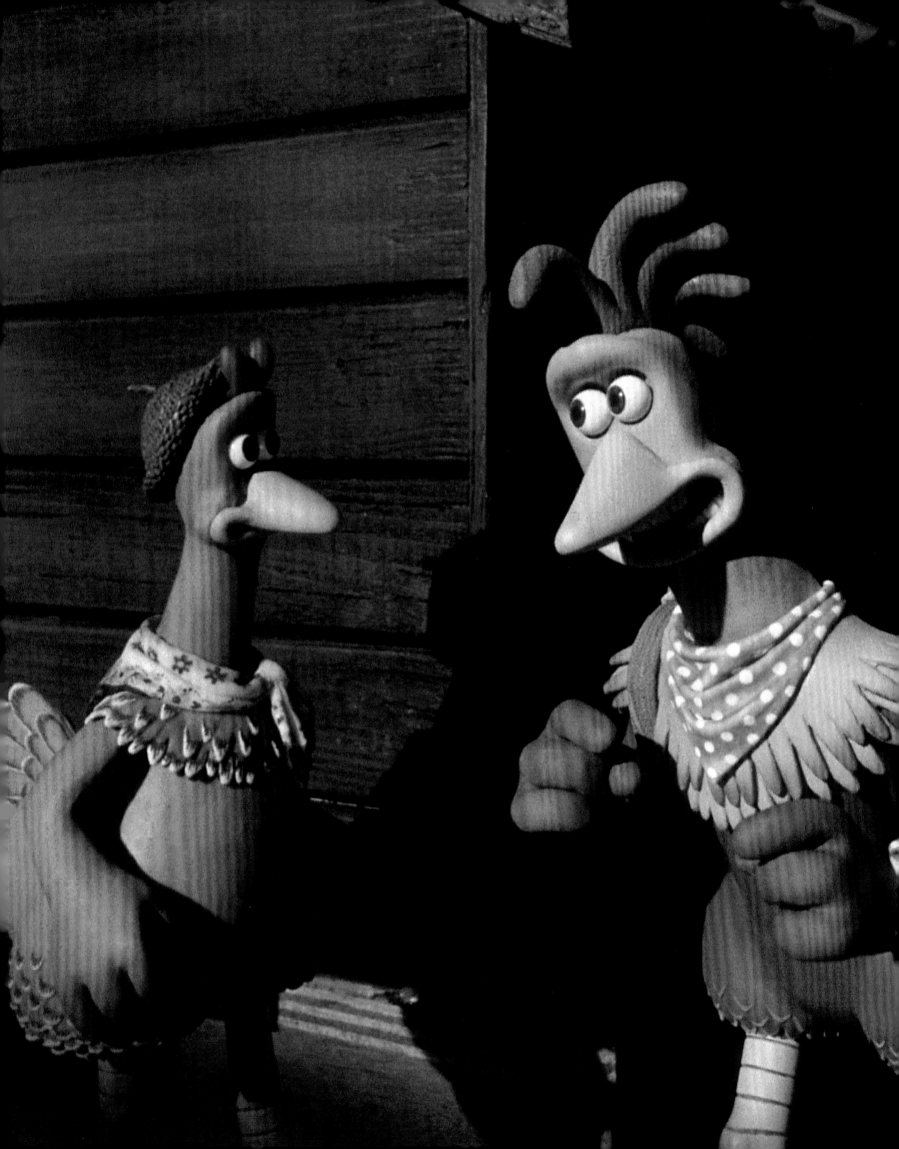

CHICKEN RUN

2000

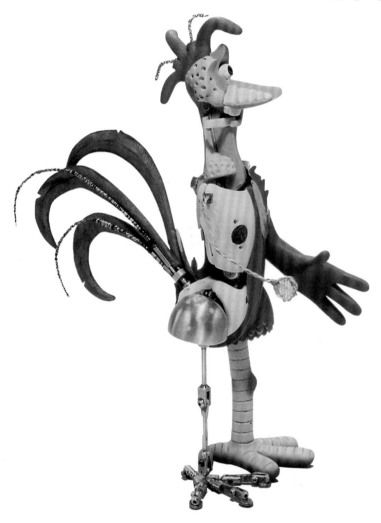

"*Chicken Run* was our first full-length feature at Aardman, and it was a challenge we couldn't resist. Although the movie was only three times as long as [our short] *The Wrong Trousers,* the whole scale of the shoot seemed to be about twenty times bigger. We had to train new animators, convert a warehouse into a customized stop-frame studio, and build hundreds of chickens. It was made by a team of hundreds of talented people—animators, model makers, and filmmakers of every description—people who love what they're doing and do it well."

Nick Park, Director, Producer

Directors	**Peter Lord, Nick Park**
Producers	**Peter Lord, David Sproxton, Nick Park**
Executive Producers	**Jake Eberts, Jeffrey Katzenberg, Michael Rose**
Line Producer	**Carla Shelley**
Production Designer	**Phil Lewis**
Art Director	**Tim Farrington**

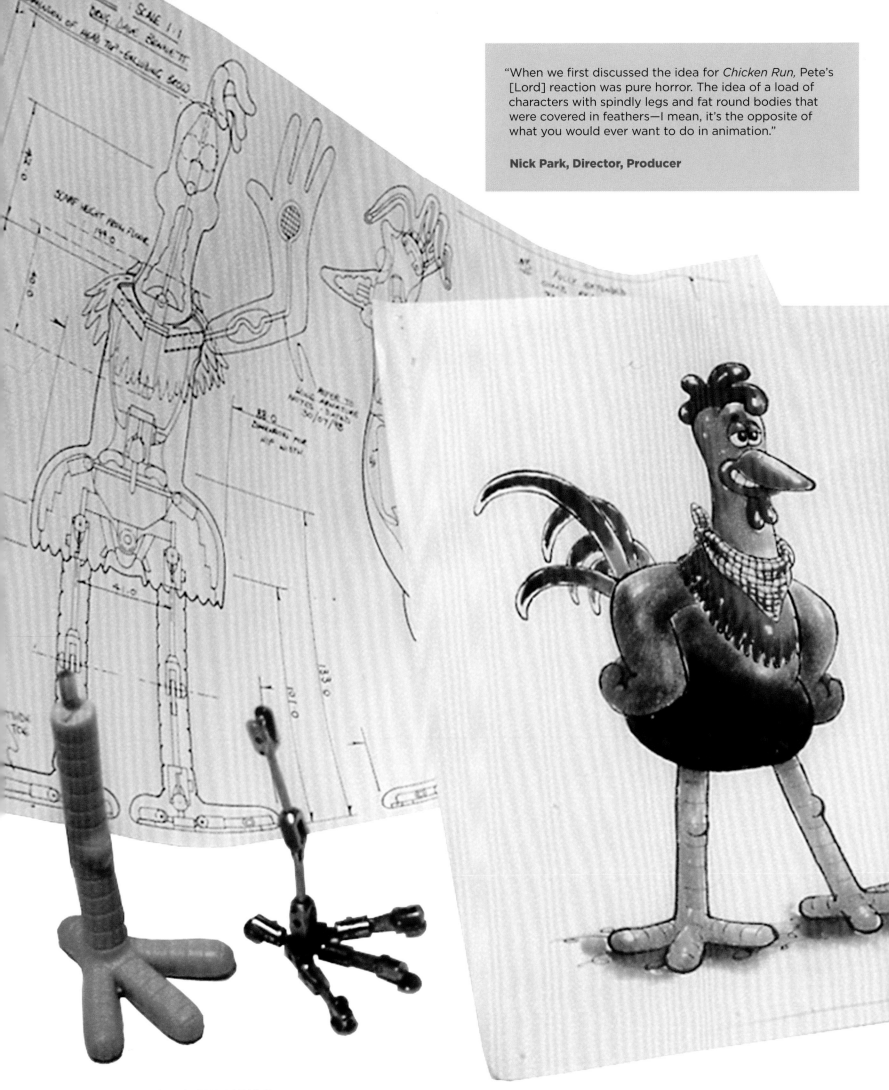

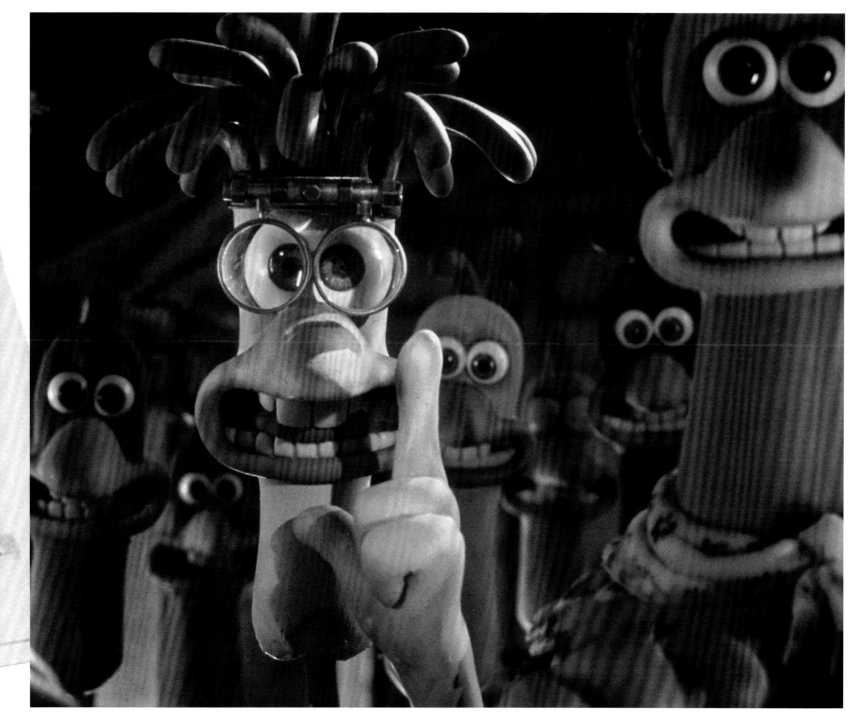

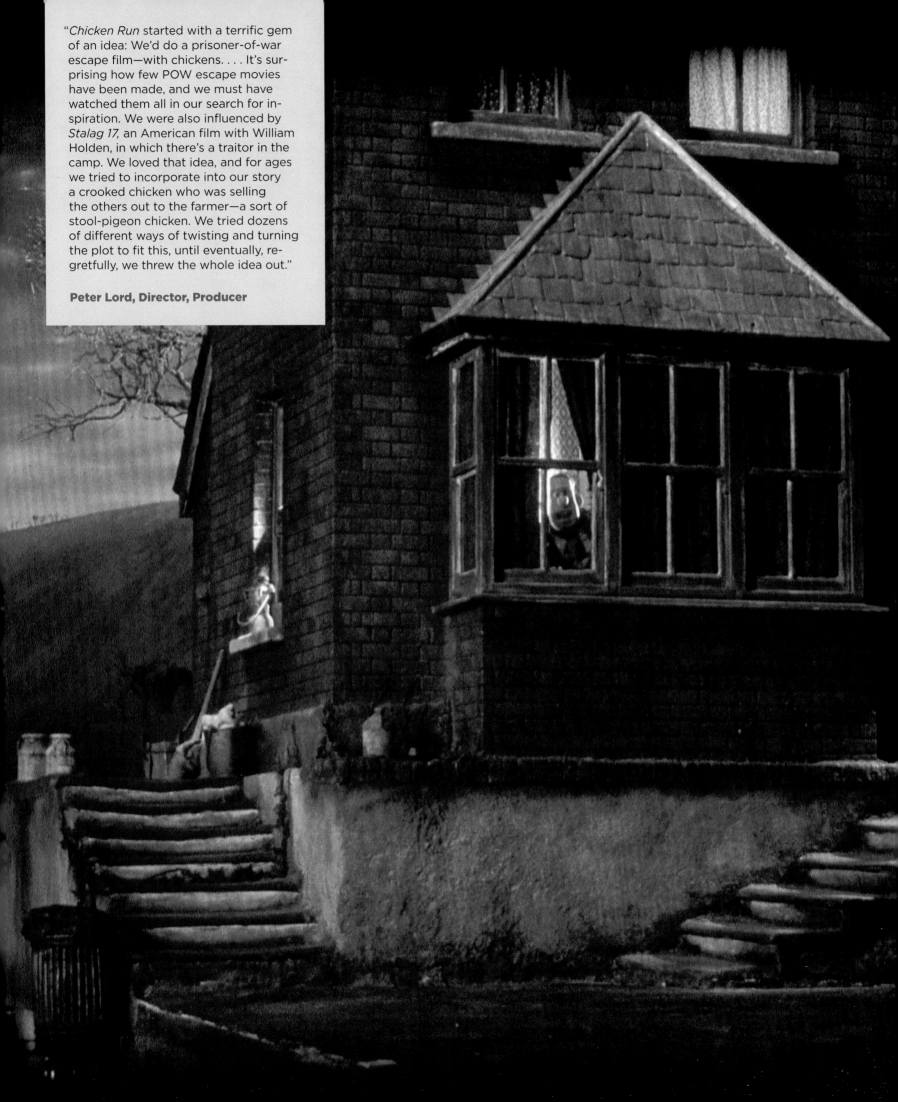

"*Chicken Run* started with a terrific gem of an idea: We'd do a prisoner-of-war escape film—with chickens. . . . It's surprising how few POW escape movies have been made, and we must have watched them all in our search for inspiration. We were also influenced by *Stalag 17,* an American film with William Holden, in which there's a traitor in the camp. We loved that idea, and for ages we tried to incorporate into our story a crooked chicken who was selling the others out to the farmer—a sort of stool-pigeon chicken. We tried dozens of different ways of twisting and turning the plot to fit this, until eventually, regretfully, we threw the whole idea out."

Peter Lord, Director, Producer

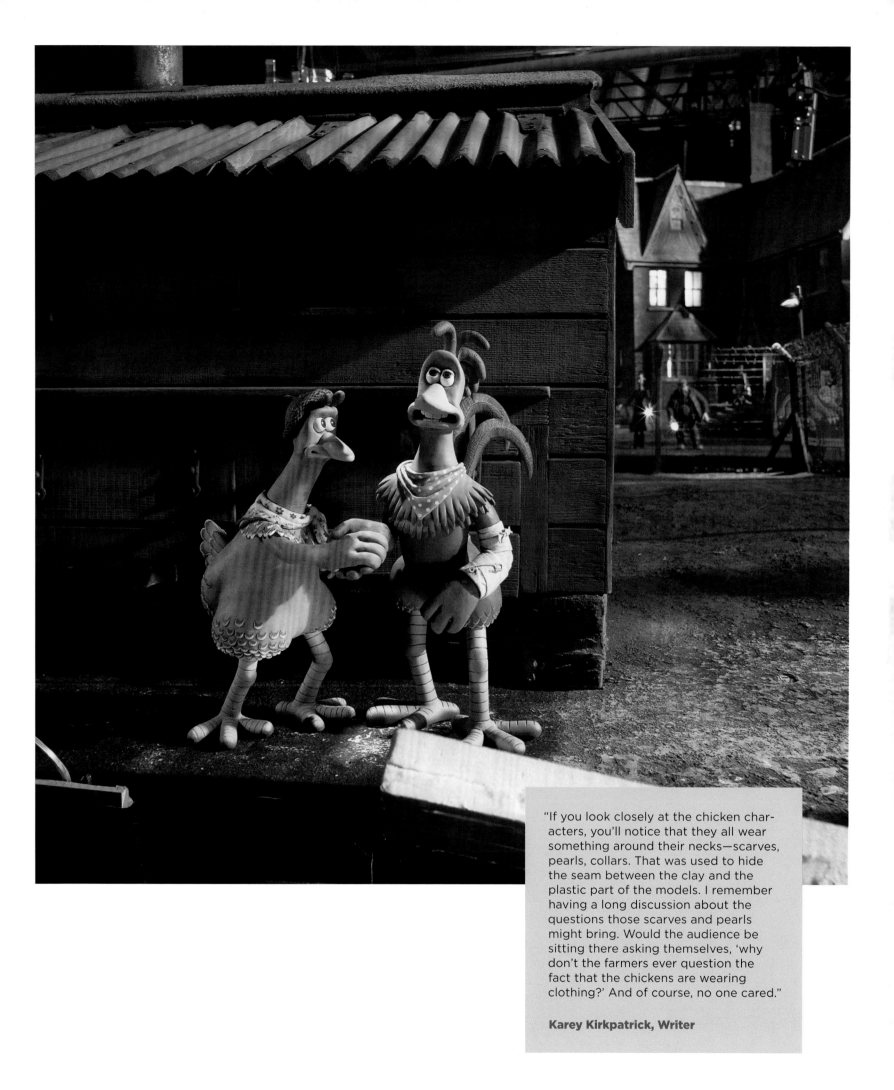

"If you look closely at the chicken characters, you'll notice that they all wear something around their necks—scarves, pearls, collars. That was used to hide the seam between the clay and the plastic part of the models. I remember having a long discussion about the questions those scarves and pearls might bring. Would the audience be sitting there asking themselves, 'why don't the farmers ever question the fact that the chickens are wearing clothing?' And of course, no one cared."

Karey Kirkpatrick, Writer

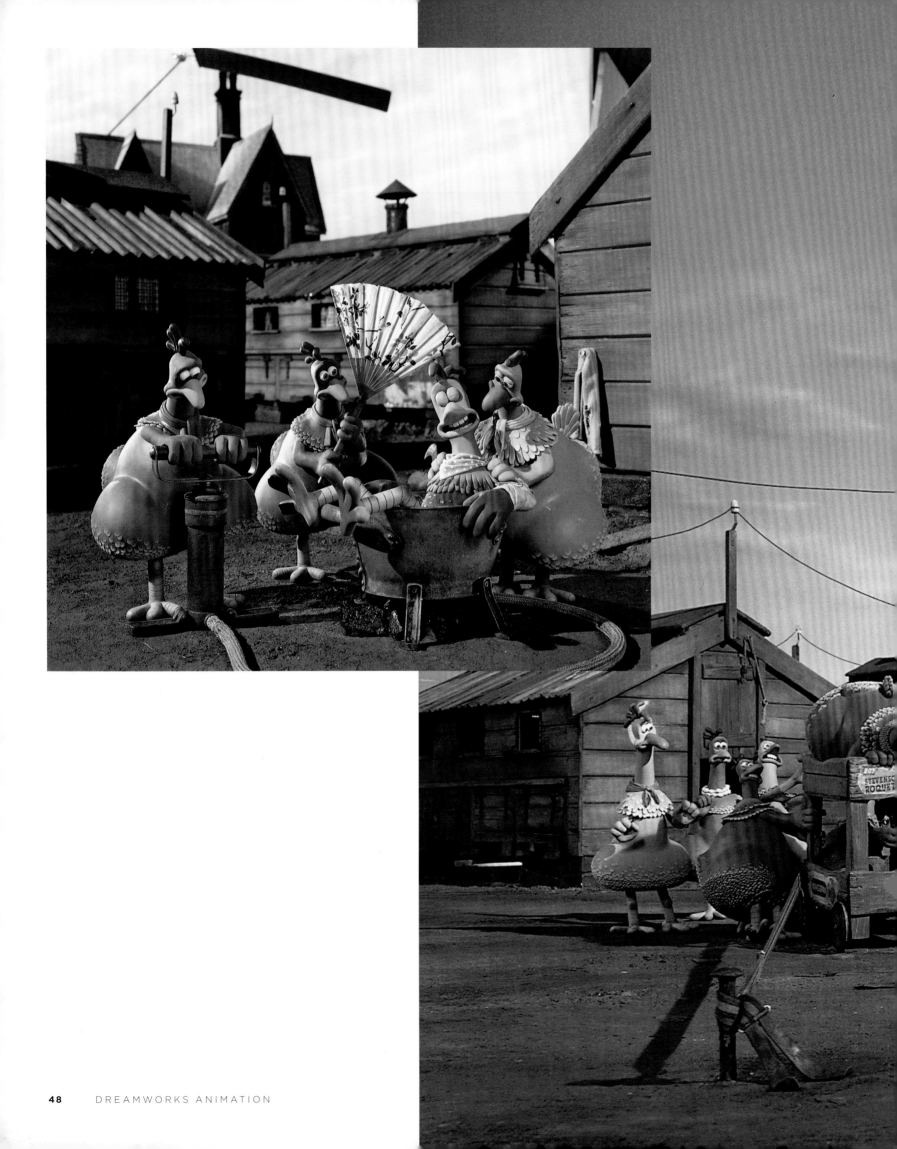

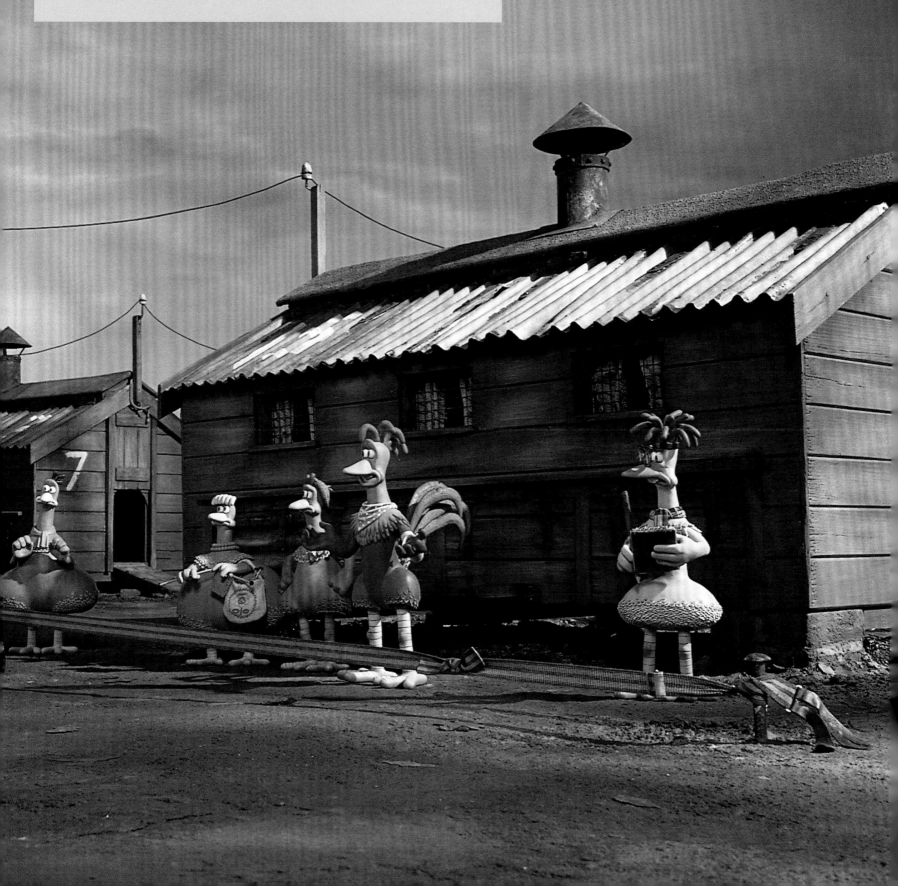

"I love the simplicity of the design; those famous Aardman trademarks, the big eyes, big smiles, big teeth. The characters are very tactile and the animation is something that you can feel and almost touch. I love that you can occasionally see thumbprints. It lets you know that there were people working really hard to bring this thing to life. Stop-motion is not that different from live action in that, unlike in computer animation, there are actual sets and lights. If the characters look three-dimensional it's because they are, and I love that look. And as a writer, it brings added pressure because the scale and scope are smaller than, say, a *Kung Fu Panda* or *How to Train Your Dragon*, which means the story better be rock solid and super engaging."

Karey Kirkpatrick, Writer

SHREK
2001

"We had gone down different roads with *Shrek* for a while, and the project was struggling tonally. Shrek wants to be a knight, or he is a nobleman in an ugly body. He is ugly and mean and wants a heart. All these directions felt very typical. We were at a point where we were wondering whether to continue with the movie or not. One day after a particularly tough screening the directors came in and sat the whole storyboard team down and we brainstormed the opening. Together we came up with the idea of taking fairy-tale characters to Shrek's swamp. So we started riffing on ways to make fun of these old fairy tales. A lot of those gags were put in. Those gags seemed to define the tone of the movie and launched us in a new direction."

Conrad Vernon, Story Artist

Directors	**Andrew Adamson, Vicky Jenson**
Producers	**Aron Warner, John H. Williams, Jeffrey Katzenberg**
Co-Producers	**Ted Elliott, Terry Rossio**
Executive Producers	**Penney Finkelman Cox, Sandra Rabins**
Co-Executive Producer	**David Lipman**
Associate Producer	**Jane Hartwell**
Production Designer	**James Hegedus**
Art Directors	**Guillaume Aretos, Douglas Rogers**
Visual Effects Supervisor	**Ken Bielenberg**

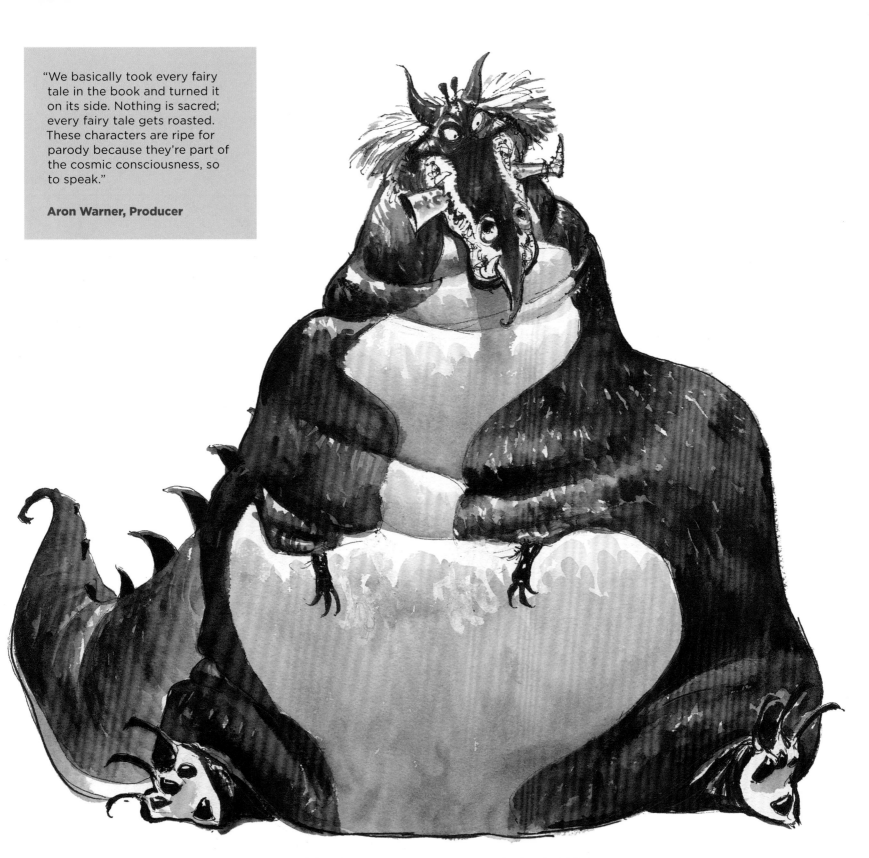

"We basically took every fairy tale in the book and turned it on its side. Nothing is sacred; every fairy tale gets roasted. These characters are ripe for parody because they're part of the cosmic consciousness, so to speak."

Aron Warner, Producer

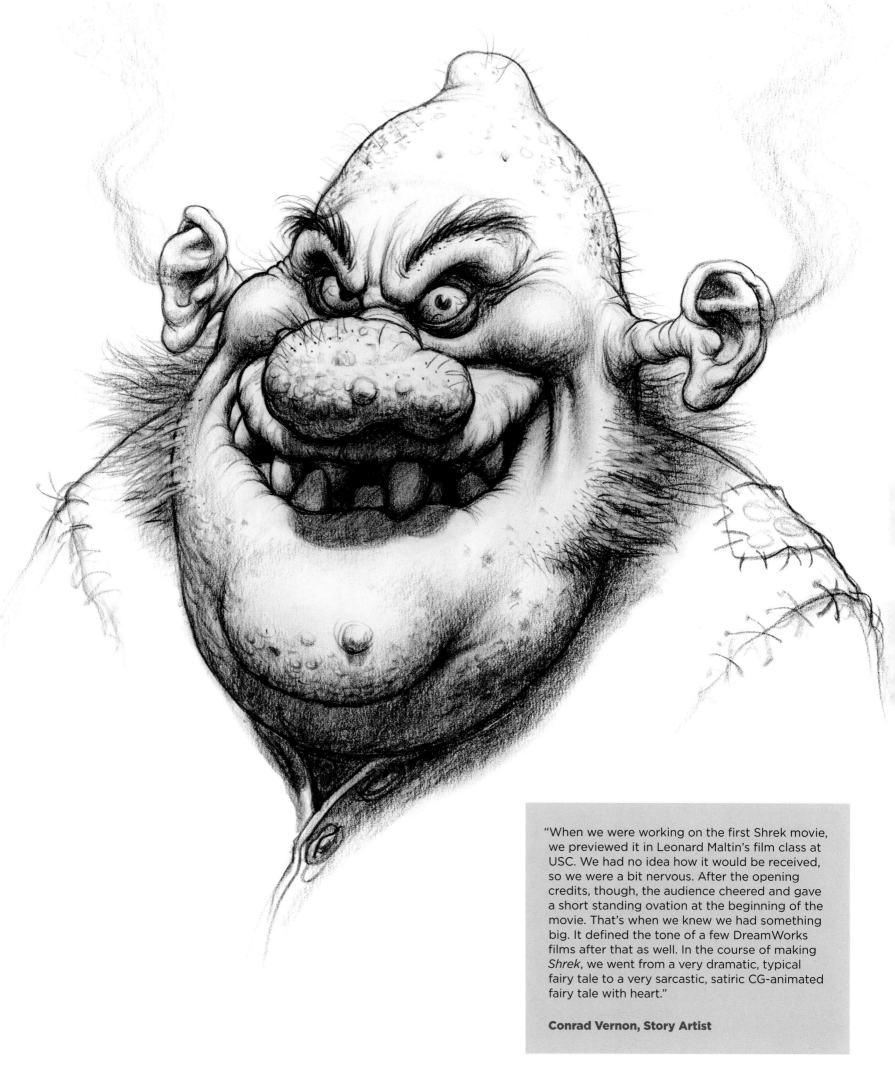

"When we were working on the first Shrek movie, we previewed it in Leonard Maltin's film class at USC. We had no idea how it would be received, so we were a bit nervous. After the opening credits, though, the audience cheered and gave a short standing ovation at the beginning of the movie. That's when we knew we had something big. It defined the tone of a few DreamWorks films after that as well. In the course of making *Shrek*, we went from a very dramatic, typical fairy tale to a very sarcastic, satiric CG-animated fairy tale with heart."

Conrad Vernon, Story Artist

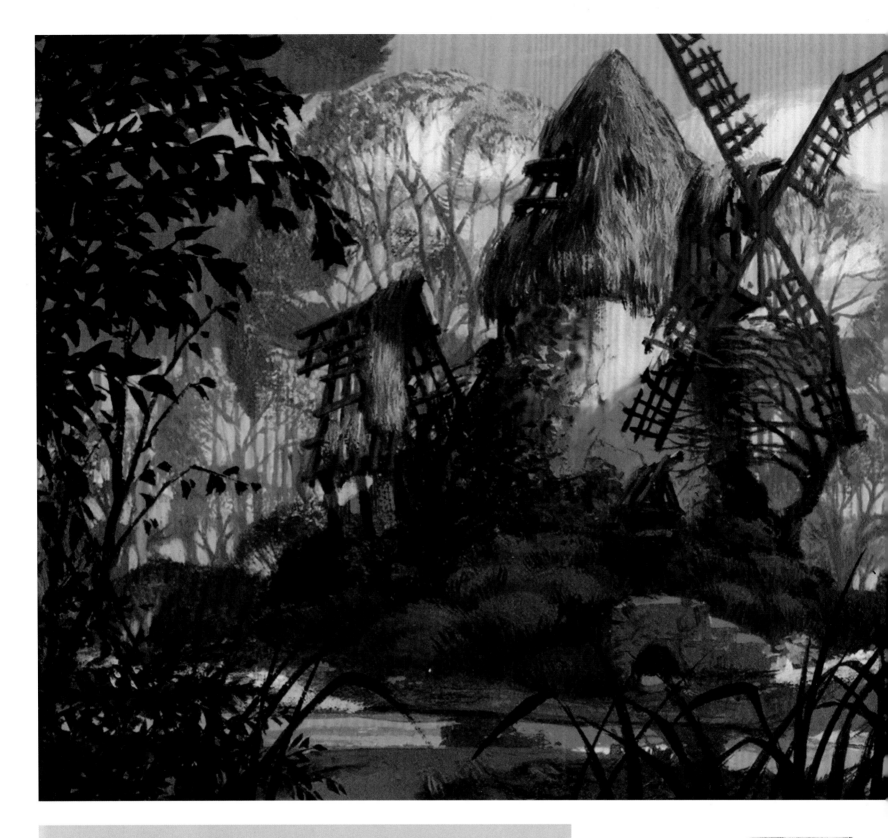

"During my early days storyboarding, there was a hesitation toward CG largely because it was new. Though the artistry had progressed to a very high level in the 2D films, the stories being told had grown stale. *Shrek* was the black sheep at that time: It wasn't the movie that everyone wanted to work on. I started storyboarding for the film during the last two years of production. There was a real camaraderie between the storyboard artists like Chris Miller, Conrad Vernon, and Cody Cameron. I remember when Conrad pitched the Gingerbread Man sequence; it really caught fire and inspired all of us in terms of the tone and style of humor. It was a great example of how the artists working in the story department could really affect the movie."

David Soren, Story Artist

"When we started *Shrek*, we wanted to make a fairy tale come to life . . . as if you opened a storybook and stepped into that world."

Andrew Adamson, Director

"The story is about self-acceptance and that things aren't always as they appear. We definitely turn the concept of beauty on its ear, which I think is a very powerful theme."

Vicky Jenson, Director

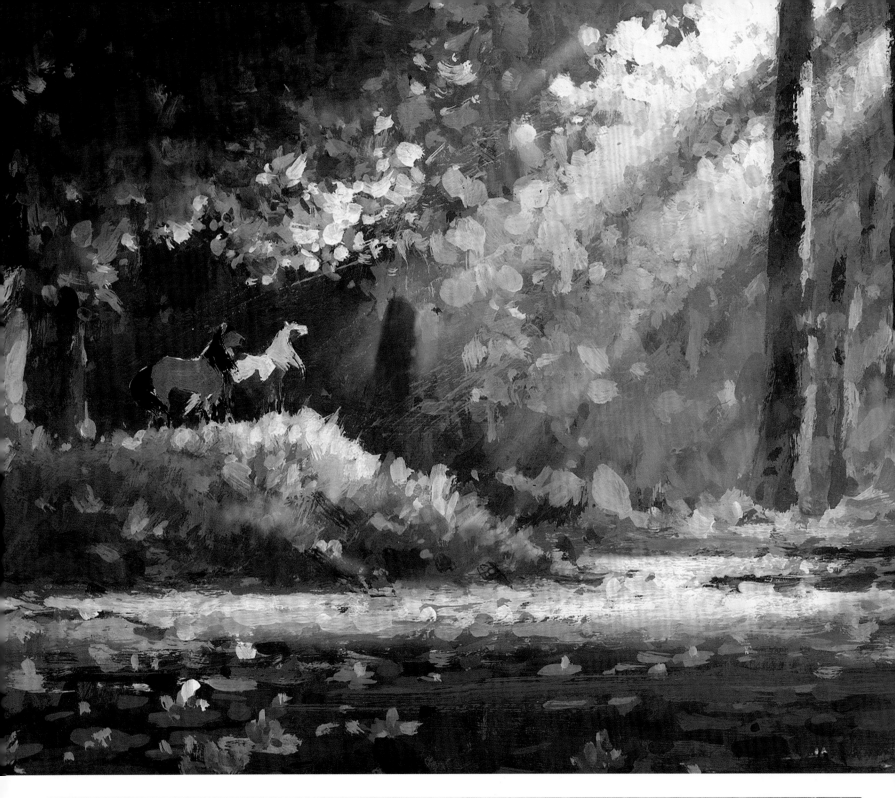
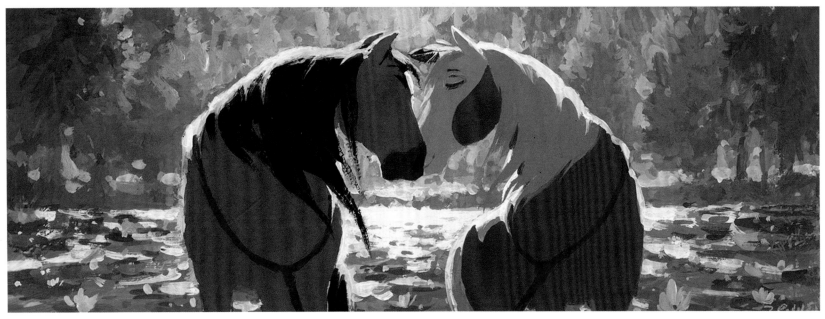

SPIRIT
STALLION OF THE CIMARRON
2002

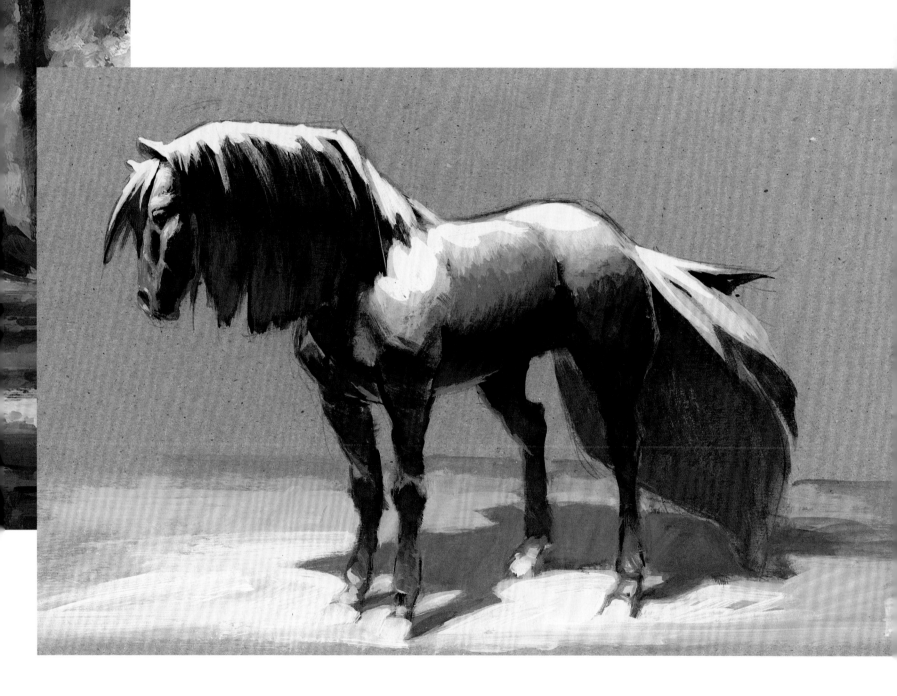

Directors	**Kelly Asbury, Lorna Cook**
Producers	**Mireille Soria, Jeffrey Katzenberg**
Co-Executive Producer	**Max Howard**
Production Designer	**Kathy Altieri**
Art Directors	**Luc Desmarchelier, Ronald W. Lukas**

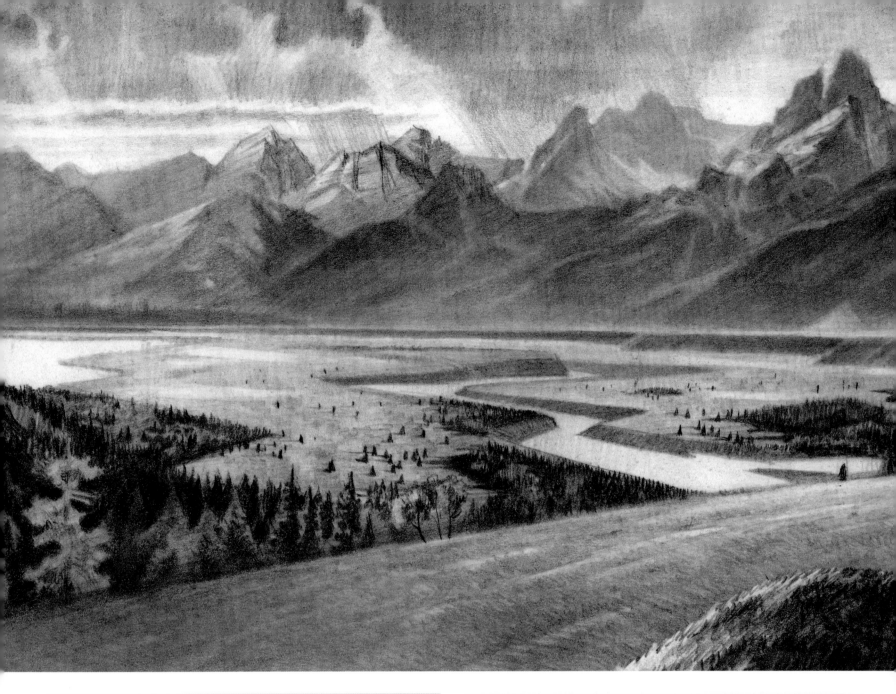

"The research trip we took for *Spirit* was intense; we traveled to eight national parks in four days and truly saw the best that America has to offer. The landscapes became the backdrop and metaphor for the horse's emotional journey. Freedom was depicted by the landscape of Wyoming: grand vistas, abundant grass and water, and snow-covered mountains. As Spirit was taken from his homeland, the terrain changed—it became hot and arid, the space was confined, and the freshness of Wyoming was replaced with the desert surrounding Monument Valley. As Spirit makes his way to the Indian camp (where he falls in love), the compositions become more lyrical and the lighting romantic. Finally he returns to his homeland with his new mate, to the lush green grass and distant vistas."

Kathy Altieri, Production Designer

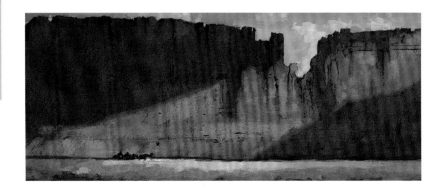

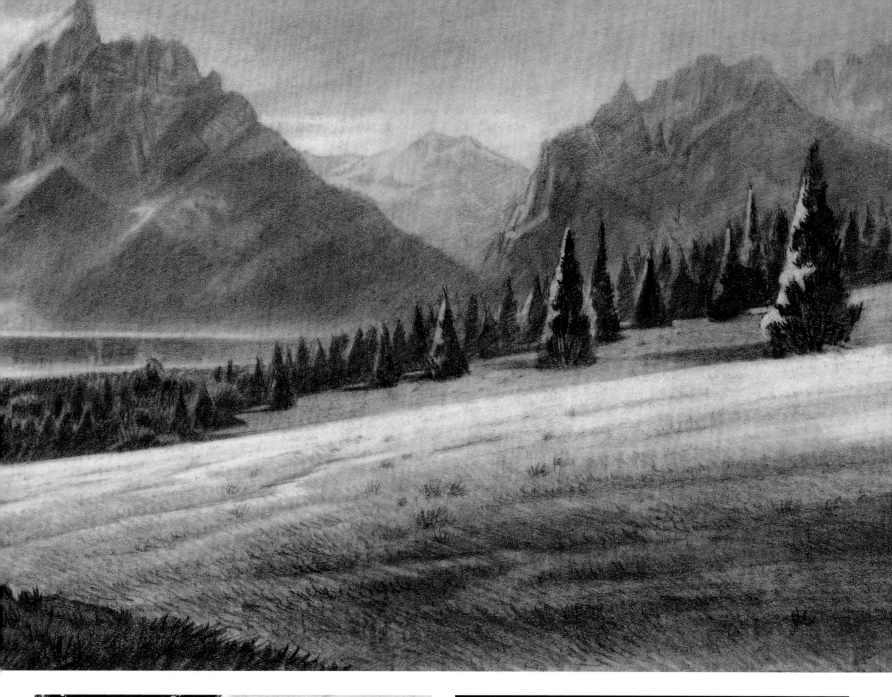

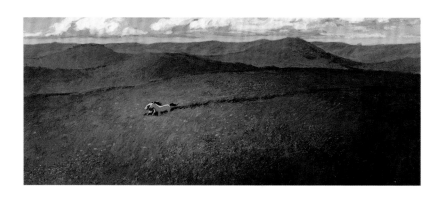

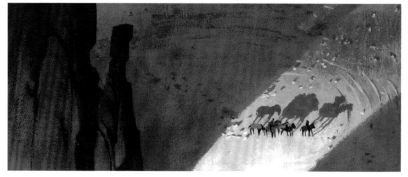

"There is something wonderful about the character of Spirit, who can endure so many trials and tribulations and still maintain his strength and courage. He has an extraordinary ability to overcome adversity. I mean, he comes from this ideal place—heaven on Earth for horses—gets captured, and is set on a path he could never have imagined. Sometimes it's those unexpected things in life that are what teach us. What Spirit goes through is a journey of perseverance, as well as self-discovery."

Lorna Cook, Director

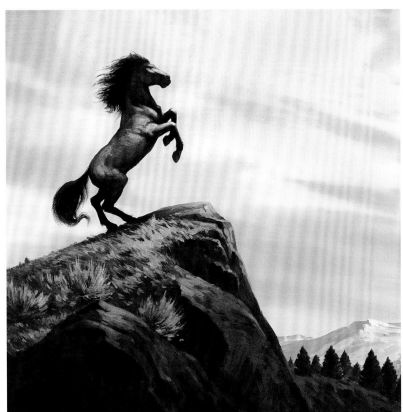

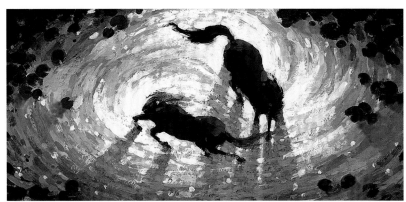

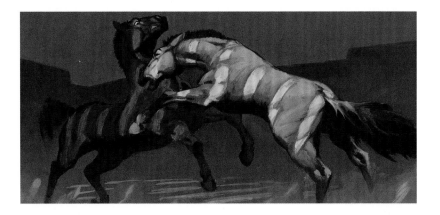

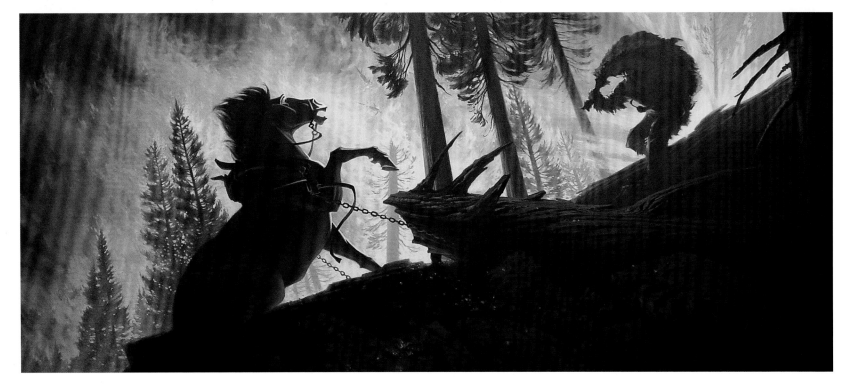

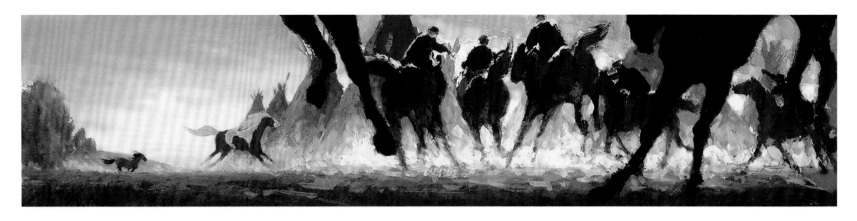

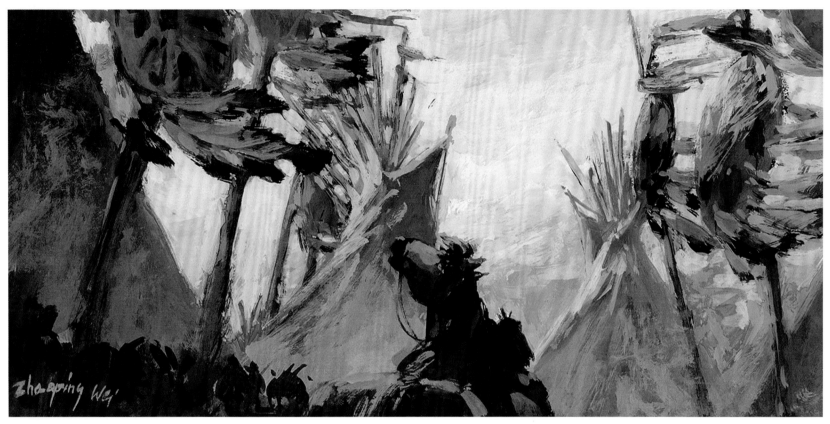

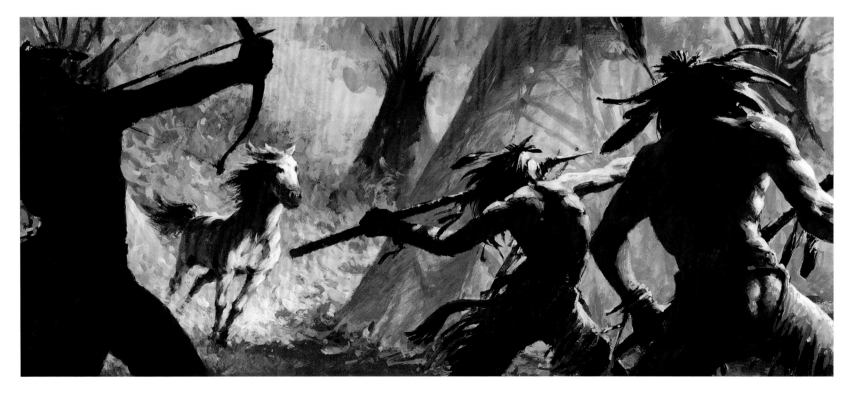

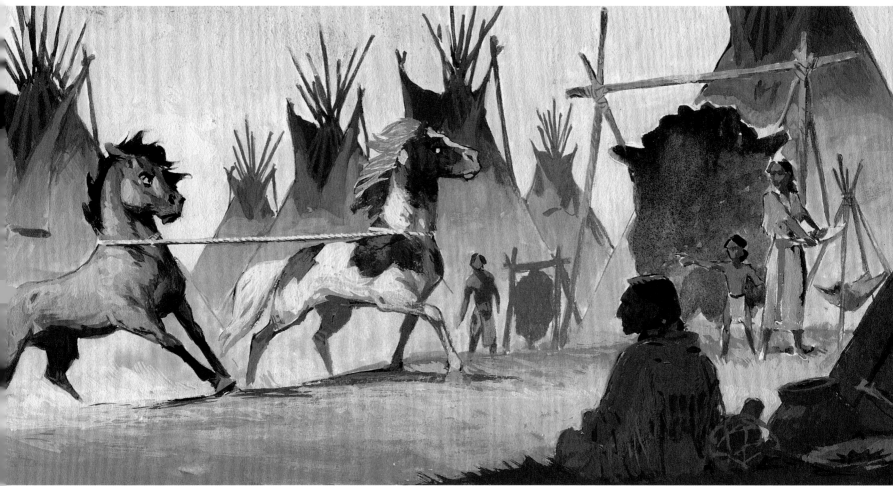

"I loved the fact that *Spirit* explored the American West and focused on themes that resonated on basic emotional and individualistic levels. One of our key challenges was telling the story without dialogue, using powerful images, some narration, and music. We took lessons and rode horses and toured the country's national parks to collect visual references for the movie. James Baxter, our head of animation, did an amazing job of bringing these beautiful horses to life. We also had the opportunity to mix CG animation with the 2D in the film. The whole *Spirit* experience taught me that it's possible to create a world in animation by imagining it and building it brick by brick."

Mireille Soria, Producer

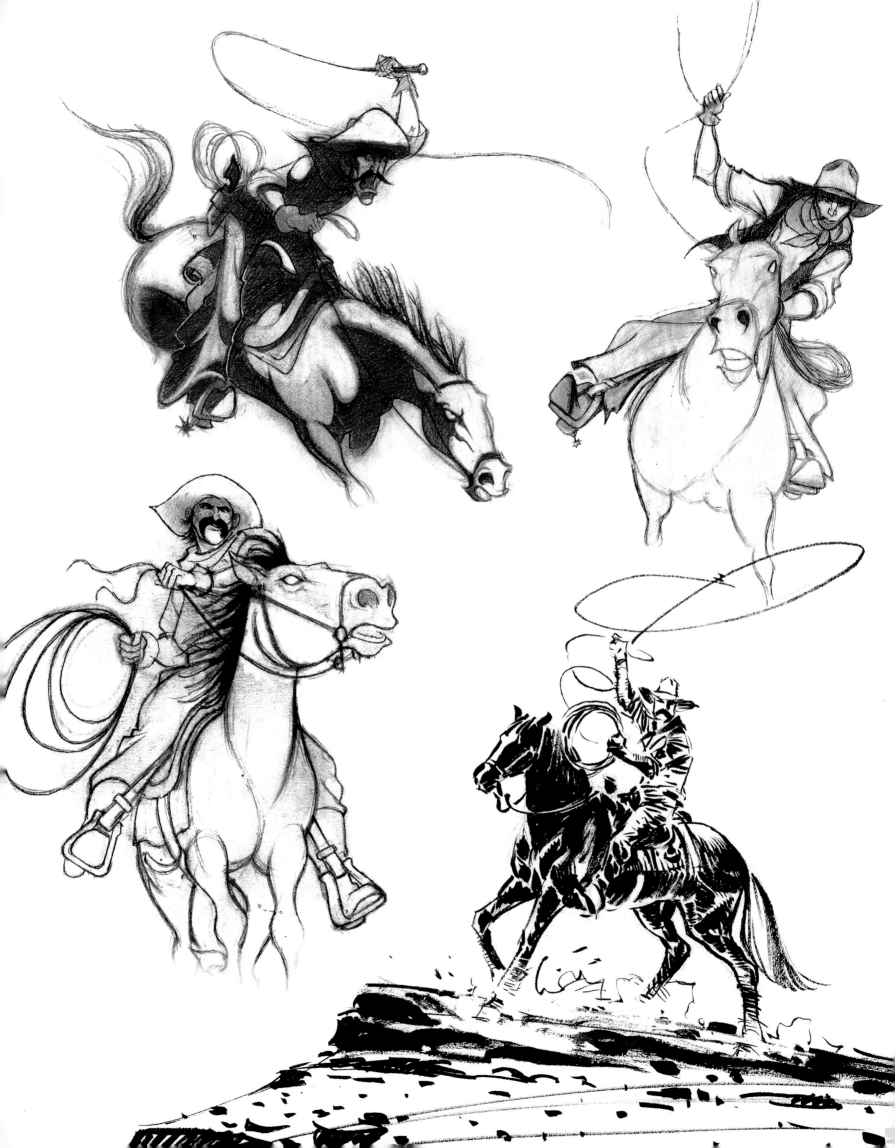

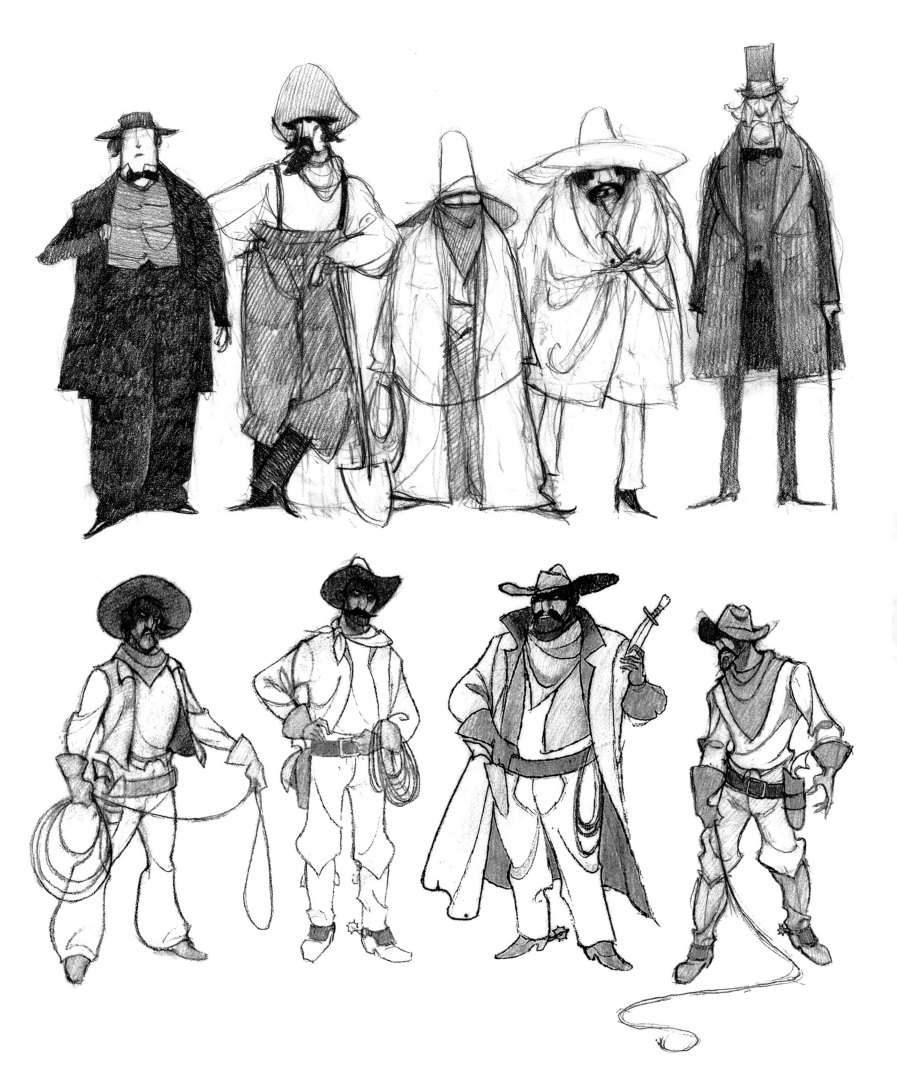

SINBAD
LEGEND OF THE
SEVEN SEAS
2003

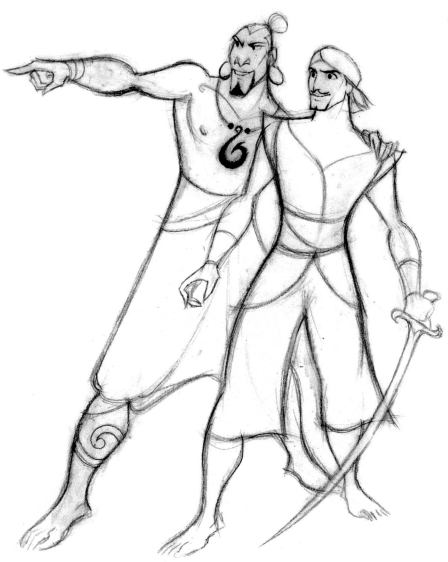

"*Sinbad* was an interesting film to work on for several reasons, namely, the story, the style, and the method. Our broad retelling of the rich Middle Eastern folk legend allowed us to explore a diverse visual style that incorporated elements ranging from Venetian and Islamic architecture to Arabic calligraphy. There was a very strong undercurrent of line-driven form and a flow from shape to shape, not just in the hand-drawn animation but in the backgrounds themselves. We used traditional materials to make the film, and although we didn't know it at the time, Sinbad would be the last 2D hand-animated feature to be made at the studio. It will remain one of the pleasures of my life to have worked in such a disciplined art form with colleagues who were masters of their craft."

David James, Art Director

Directors	**Tim Johnson, Patrick Gilmore**
Producers	**Mireille Soria, Jeffrey Katzenberg**
Associate Producer	**Jill Hopper**
Production Designer	**Raymond Zibach**
Art Directors	**Seth Engstrom, David James**
Digital Supervisor	**Craig Ring**

Entering City

GATE
LOCK

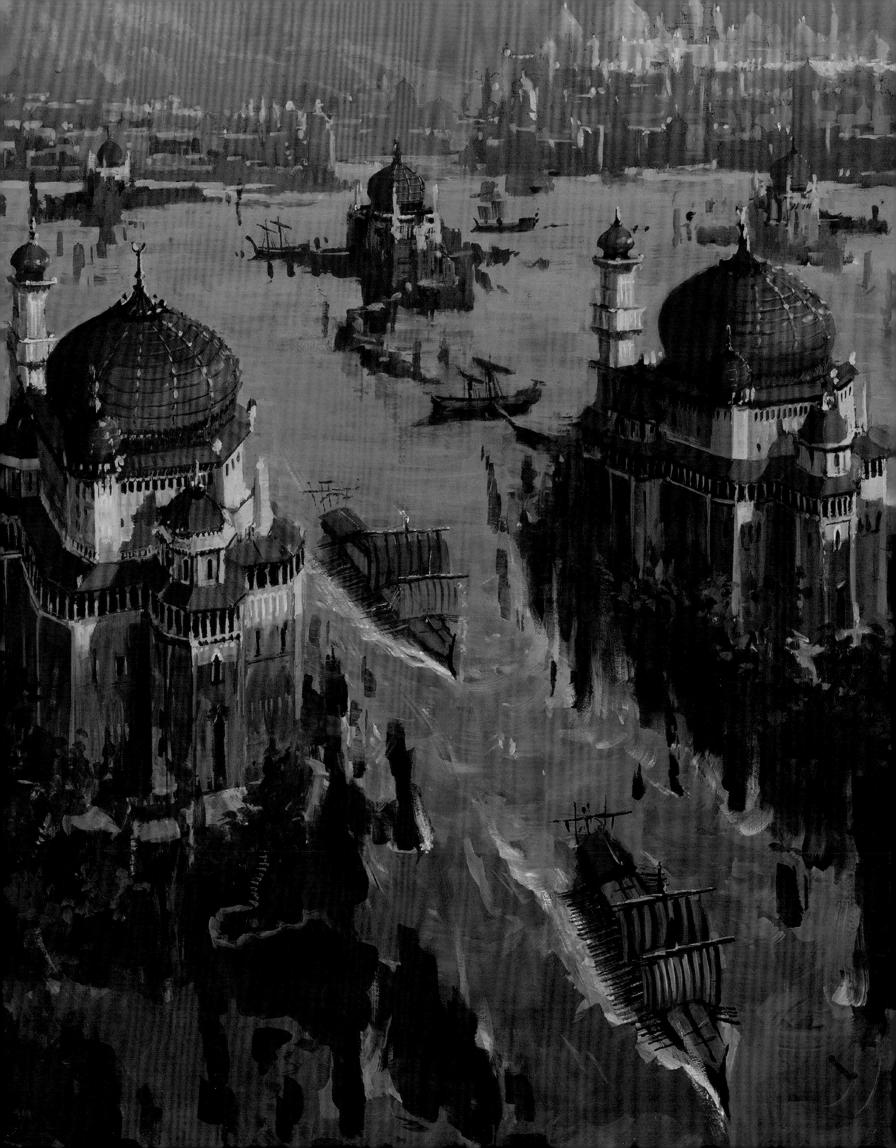

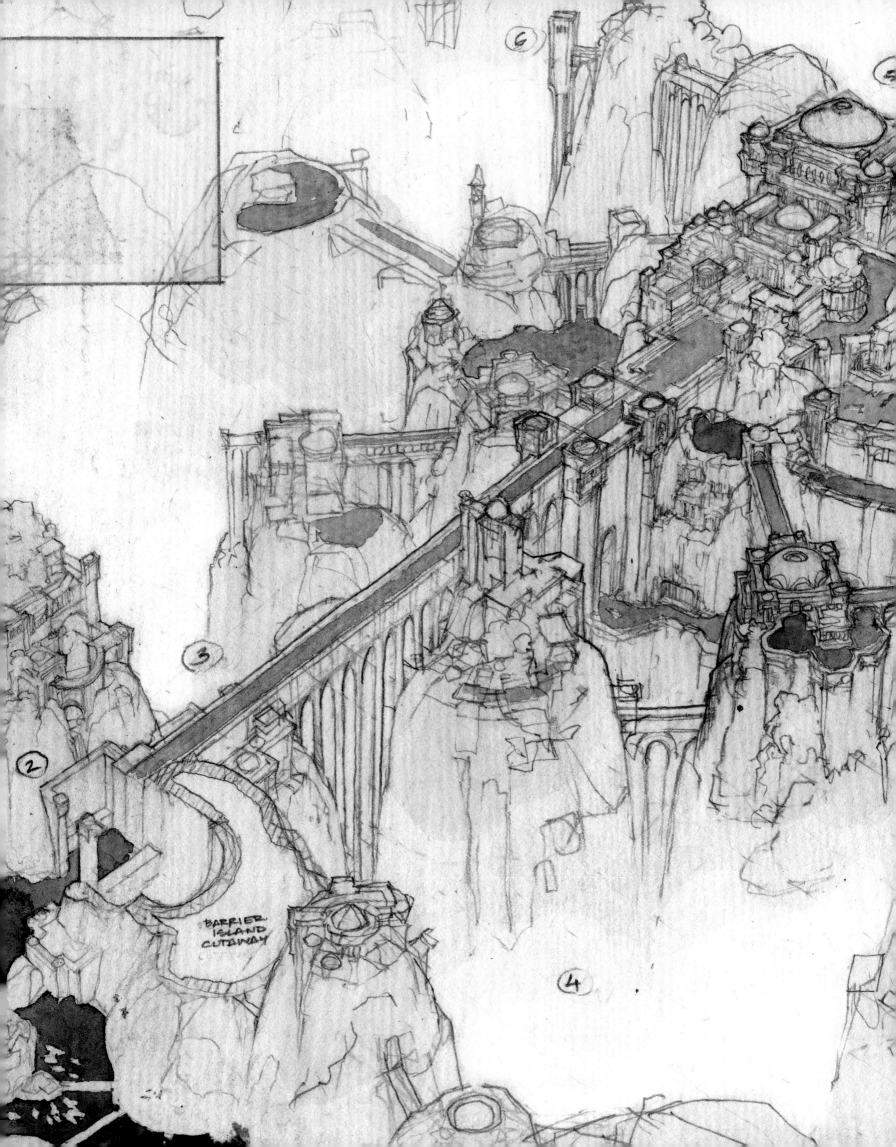

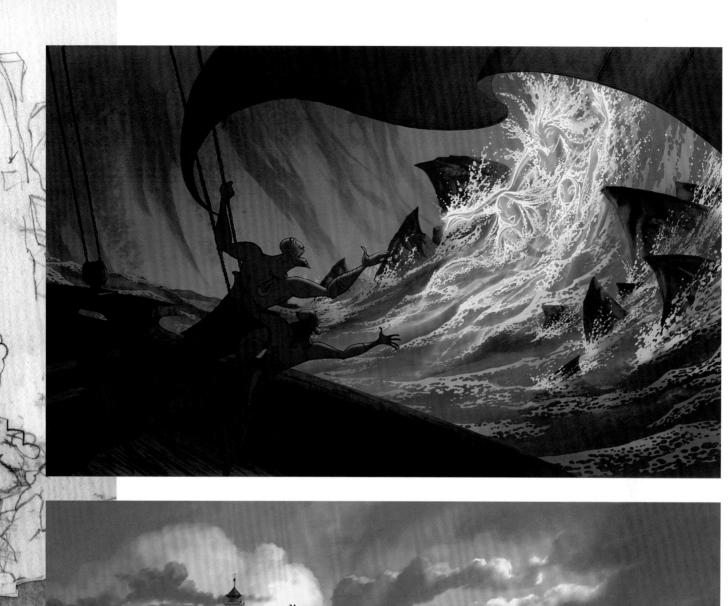

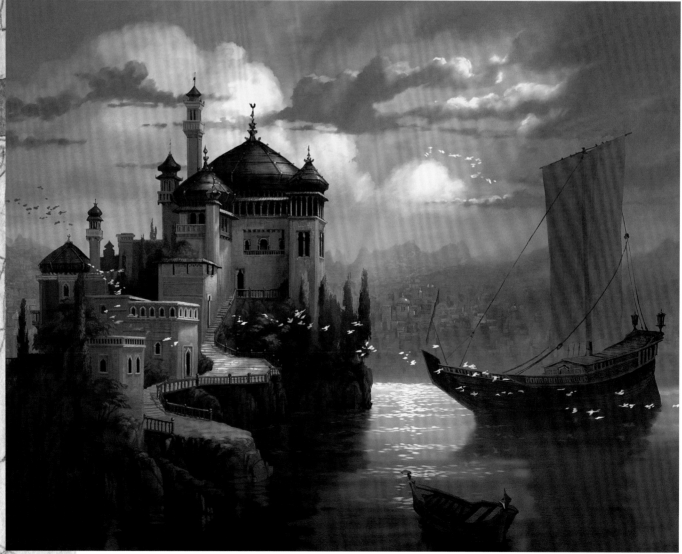

"We did a lot of research on Middle Eastern structures and art for the movie as we were trying to re-create a mythological floating city on water. The whole project had a really epic scale, and it was a difficult task to create the world architecturally. It was a difficult production because we were employing a high level of CG animation and we were marrying it with 2D. It was quite a task to incorporate 3D lighting and rendered characters with 2D ones. We were able to toon shade the crowd characters, but then the movie also had these great monsters, which needed a lot more detail. Sometimes they would look too CG, but I thought the ROC bird worked out quite well in the end. There was also the scene with the sea-monster—I can't recall how many arms he had—but it was quite a tough job, especially when you had to add the water effects to the mix."

Raymond Zibach, Production Designer

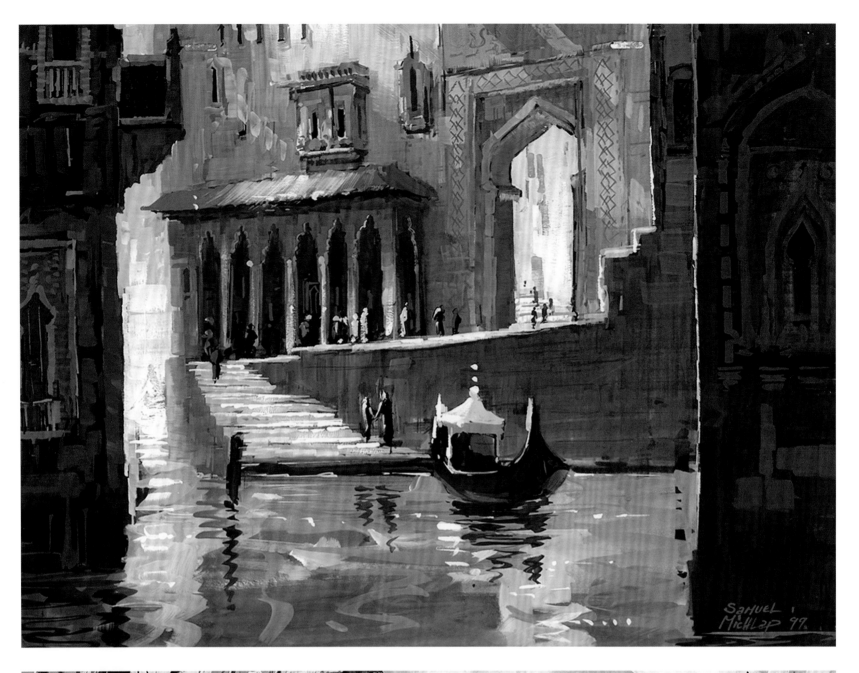

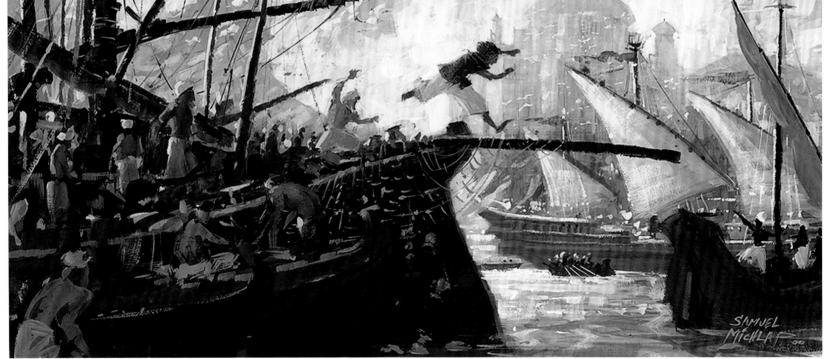

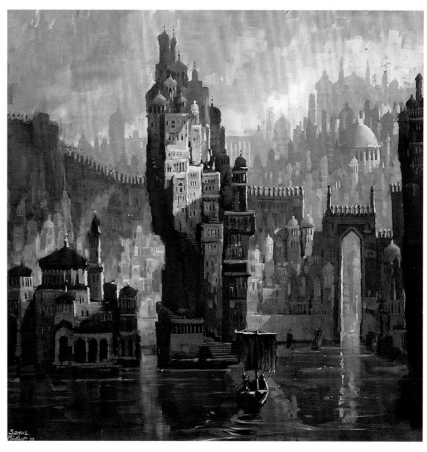

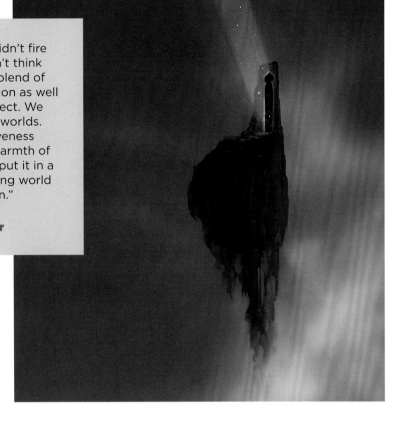

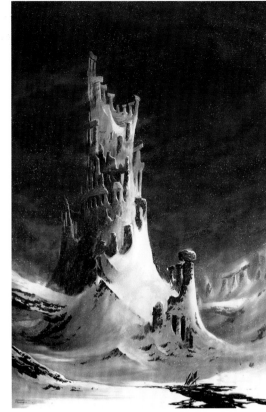

"Although the movie didn't fire up the audience, I don't think anyone has done the blend of CG and drawn animation as well as we did on that project. We took the best of both worlds. You take the expressiveness and immediacy and warmth of drawn animation and put it in a rich dimensional moving world of computer animation."

Tim Johnson, Director

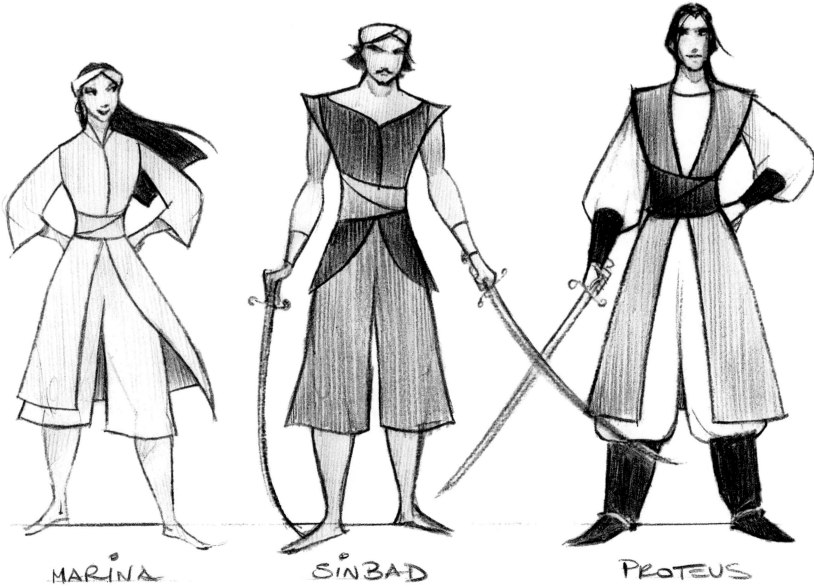

MARINA

SINBAD

PROTEUS

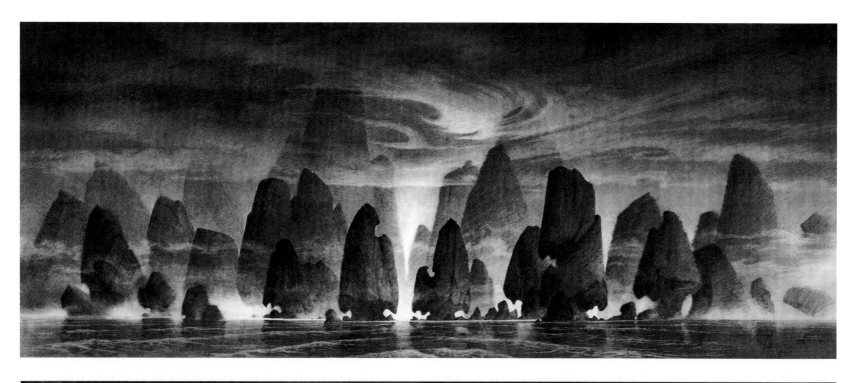

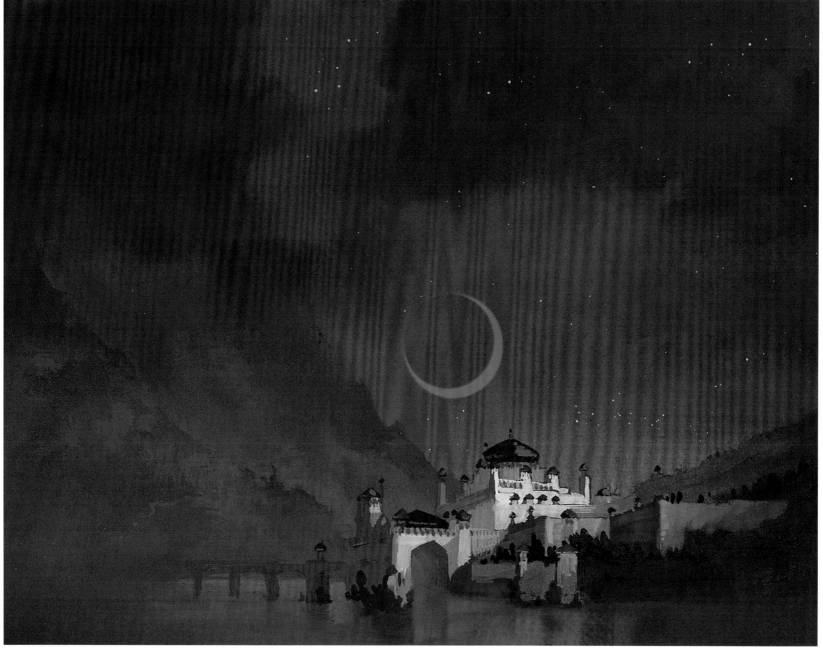

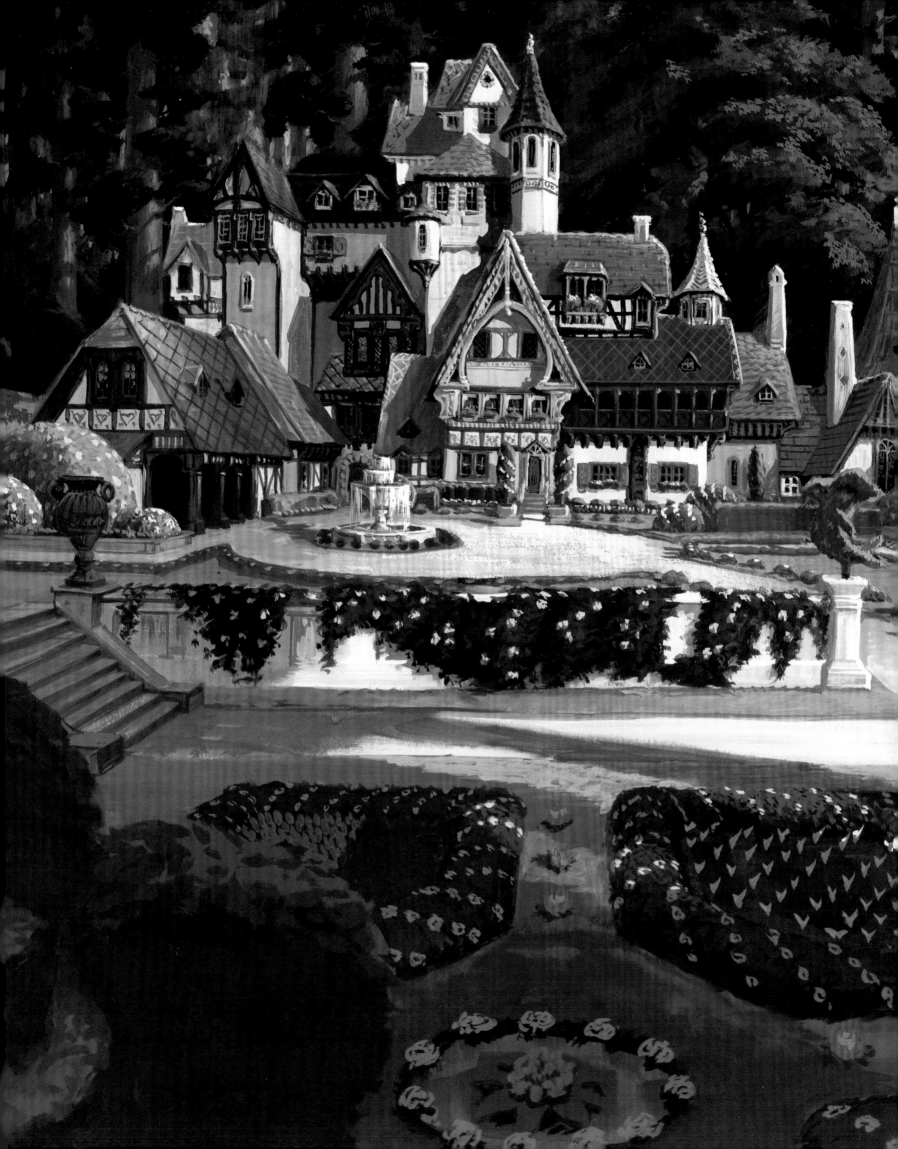

SHREK 2

2004

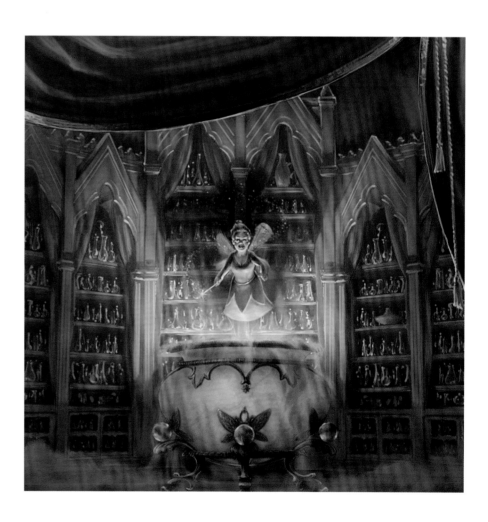

Directors	**Andrew Adamson, Kelly Asbury, Conrad Vernon**
Producers	**Aron Warner, David Lipman, John H. Williams**
Executive Producer	**Jeffrey Katzenberg**
Production Designer	**Guillaume Aretos**
Art Director	**Steve Pilcher**
Visual Effects Supervisor	**Ken Bielenberg**
Co-Visual Effects Supervisor	**Philippe Gluckman**

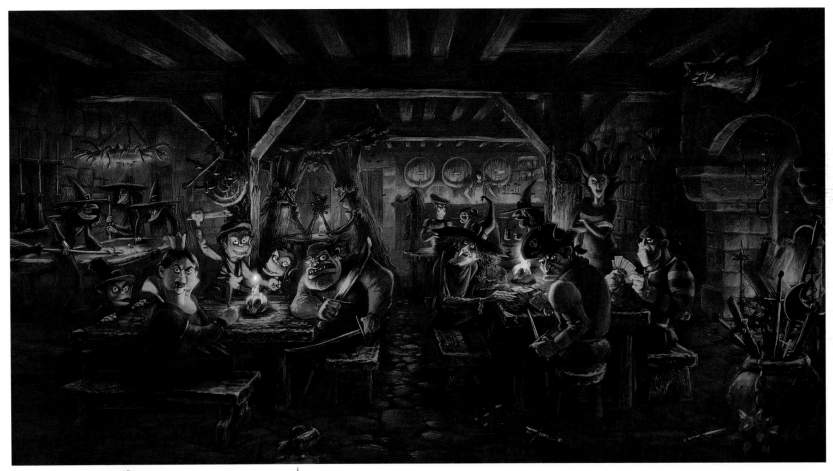

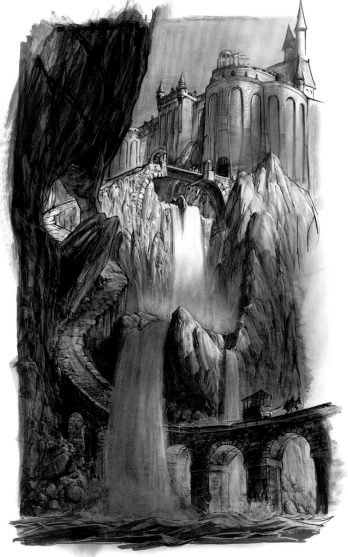

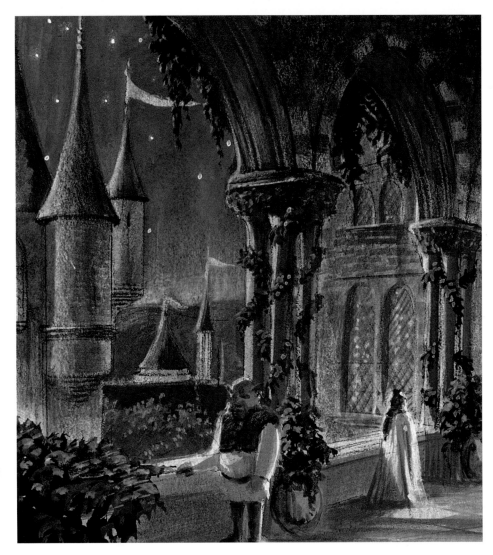

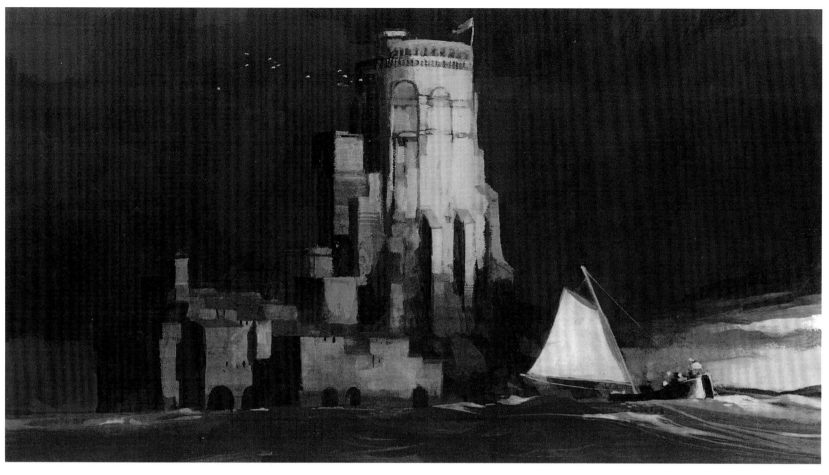

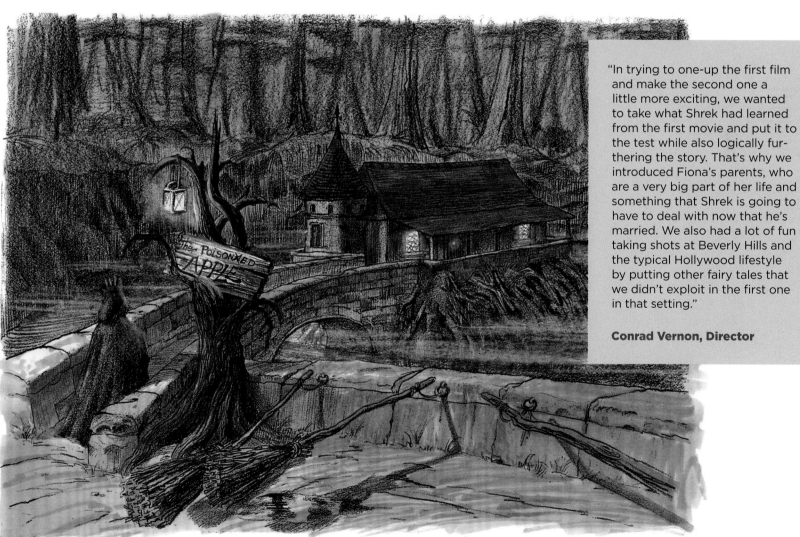

"In trying to one-up the first film and make the second one a little more exciting, we wanted to take what Shrek had learned from the first movie and put it to the test while also logically furthering the story. That's why we introduced Fiona's parents, who are a very big part of her life and something that Shrek is going to have to deal with now that he's married. We also had a lot of fun taking shots at Beverly Hills and the typical Hollywood lifestyle by putting other fairy tales that we didn't exploit in the first one in that setting."

Conrad Vernon, Director

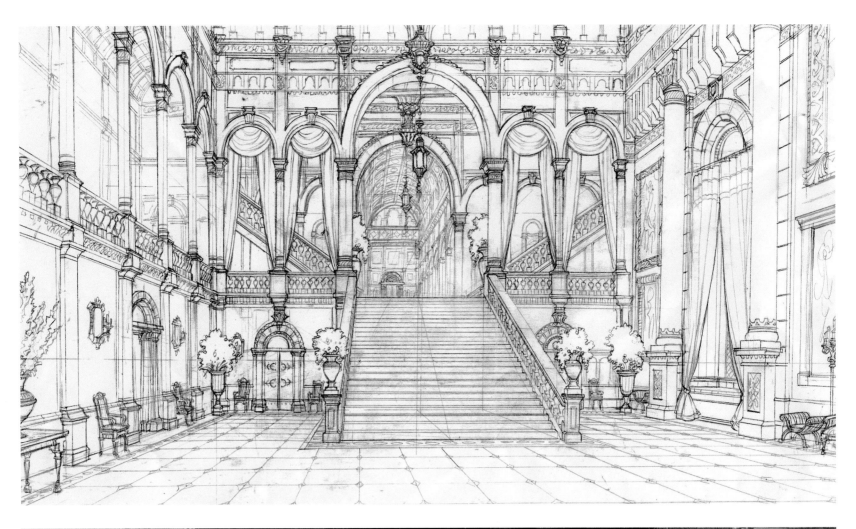

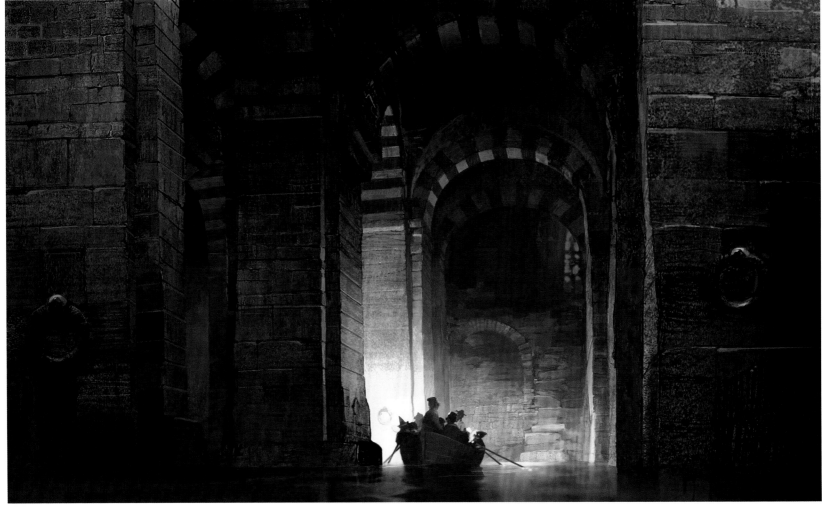

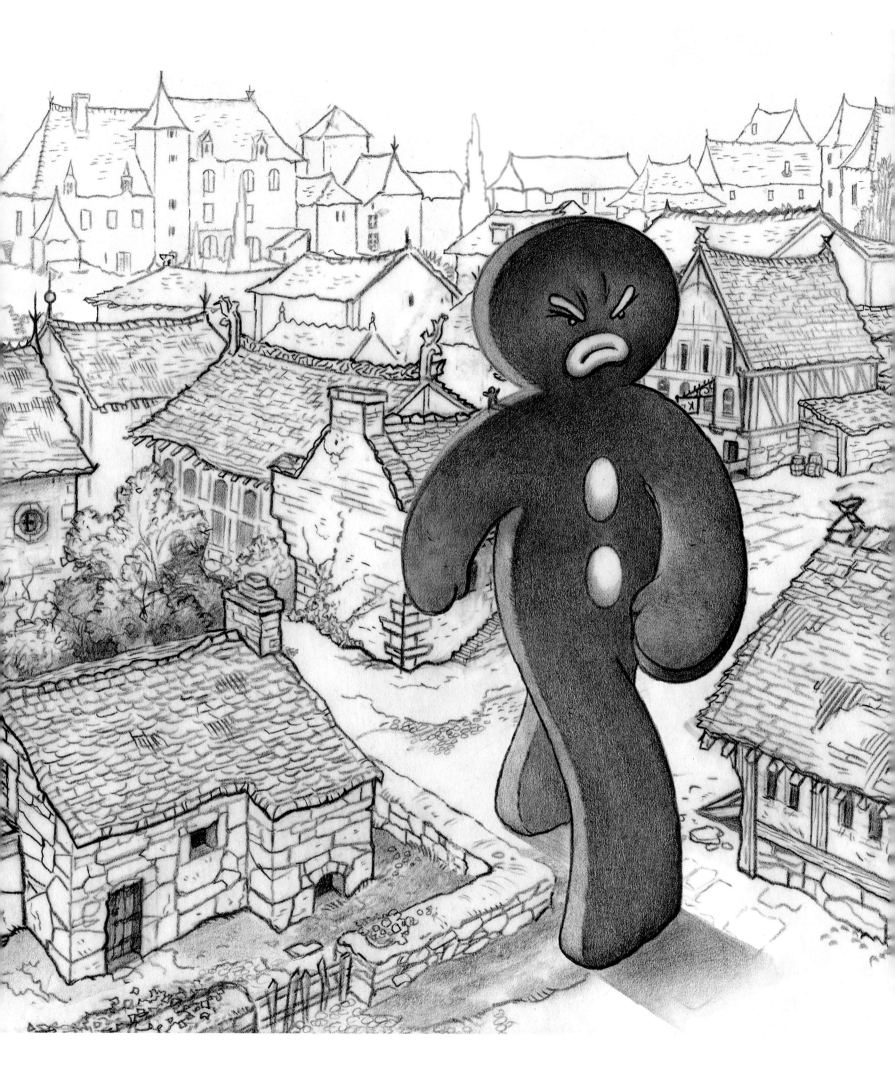

SHARK TALE

2004

"It has elements of a pop-culture parody, but it's also a romantic comedy and an action comedy and also has moments in which we root for the characters and believe in them. I think it has something in it for everybody."

Rob Letterman, Director

Directors	**Vicky Jenson, Bibo Bergeron, Rob Letterman**
Producers	**Bill Damaschke, Janet Healy, Allison Lyon Segan**
Executive Producer	**Jeffrey Katzenberg**
Associate Producer	**Mark Swift**
Production Designer	**Daniel St. Pierre**
Art Directors	**Samuel Michlap, Seth Engstrom**
Visual Effects Supervisor	**Doug Cooper**

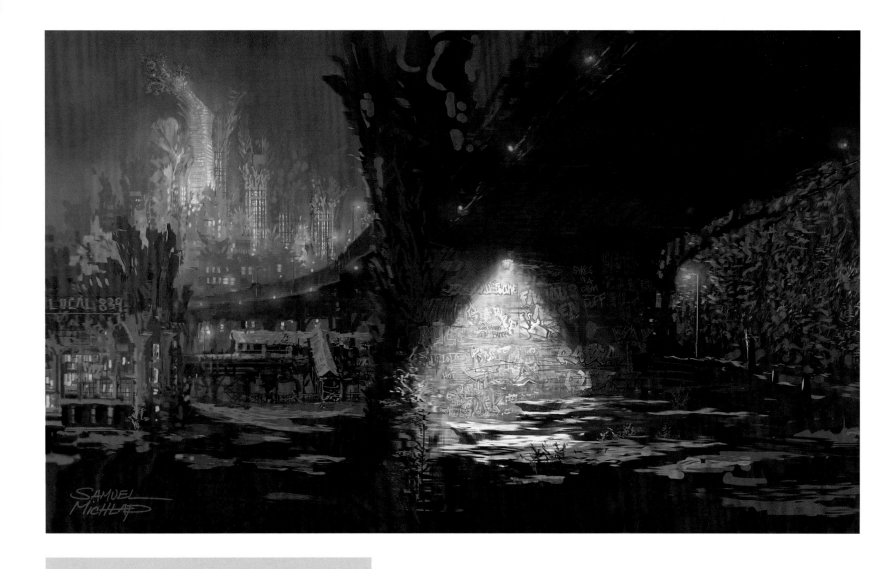

"When a scene is more action oriented, you show off the underwater effects a little more. I drove people crazy, though, with my floaties [the team's term for particles in the water]. I thought it would be the simplest thing to do, but it wasn't. You have to be sure that they don't have the same patterns of movement or look like dust on an old film."

Bibo Bergeron, Director

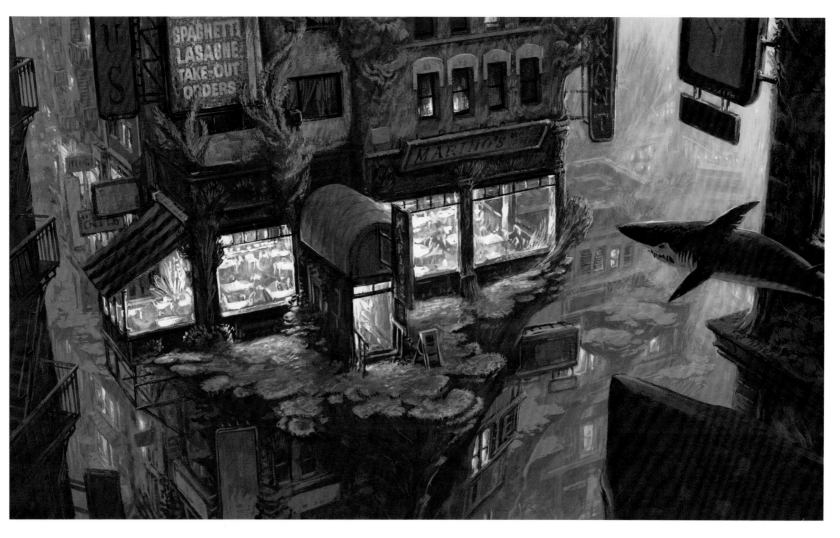

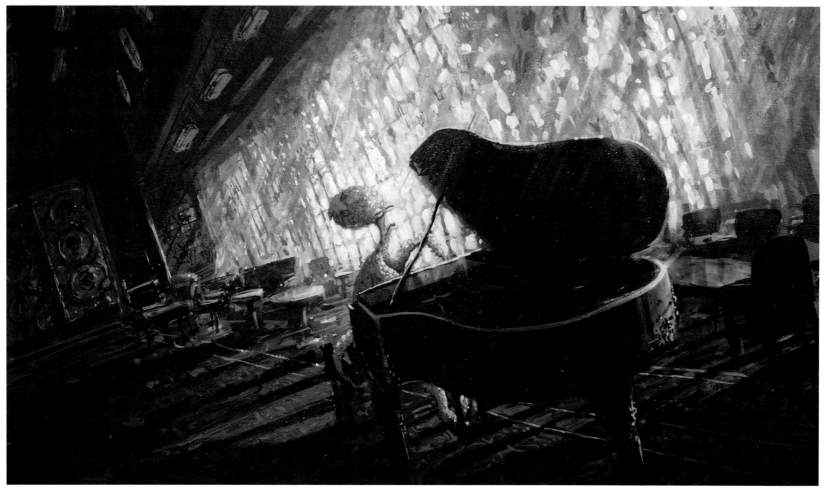

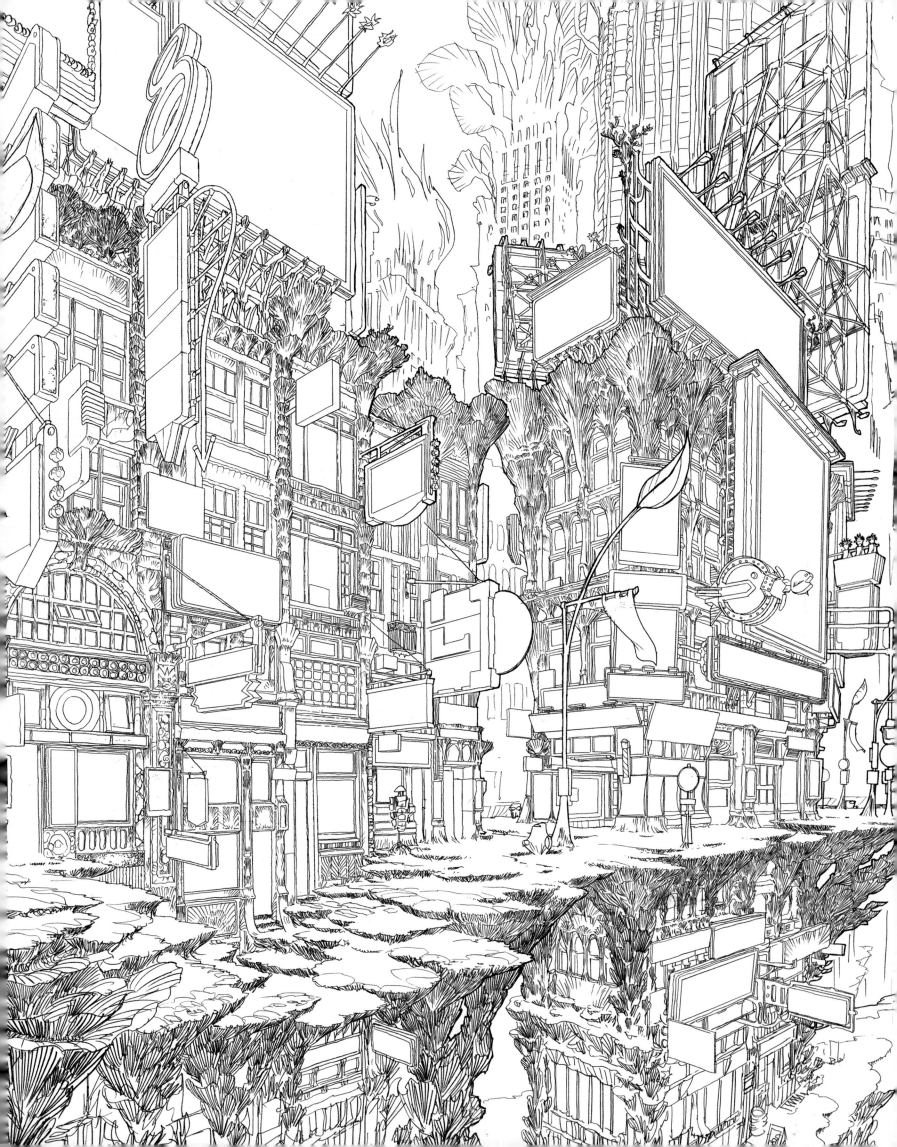

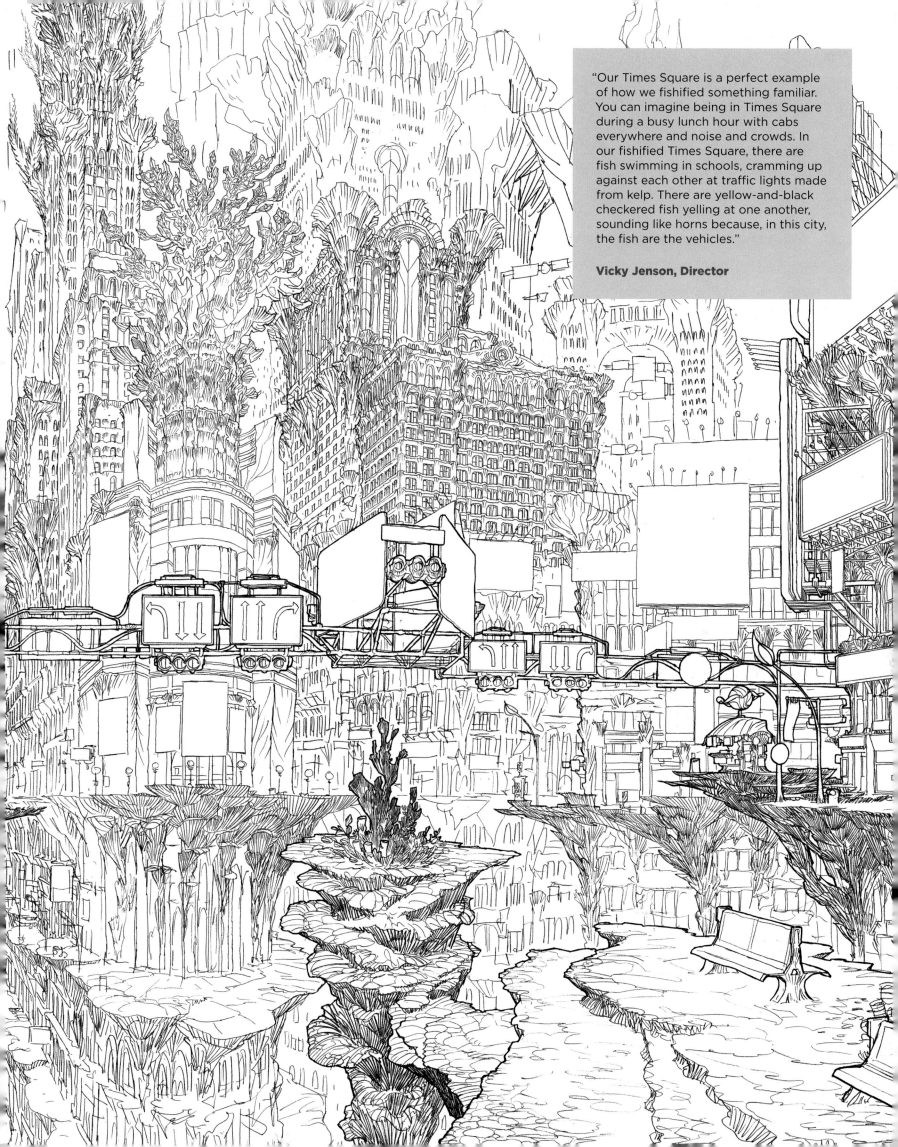

"Our Times Square is a perfect example of how we fishified something familiar. You can imagine being in Times Square during a busy lunch hour with cabs everywhere and noise and crowds. In our fishified Times Square, there are fish swimming in schools, cramming up against each other at traffic lights made from kelp. There are yellow-and-black checkered fish yelling at one another, sounding like horns because, in this city, the fish are the vehicles."

Vicky Jenson, Director

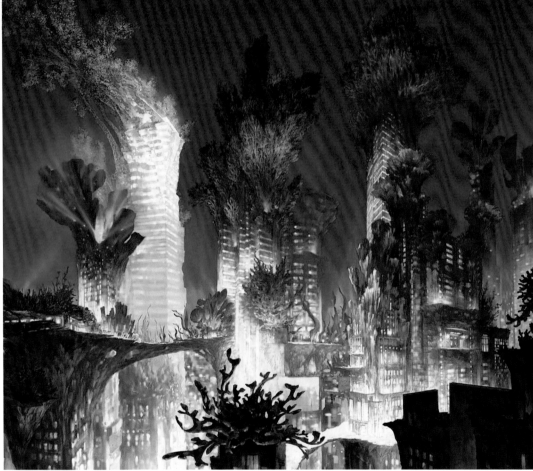

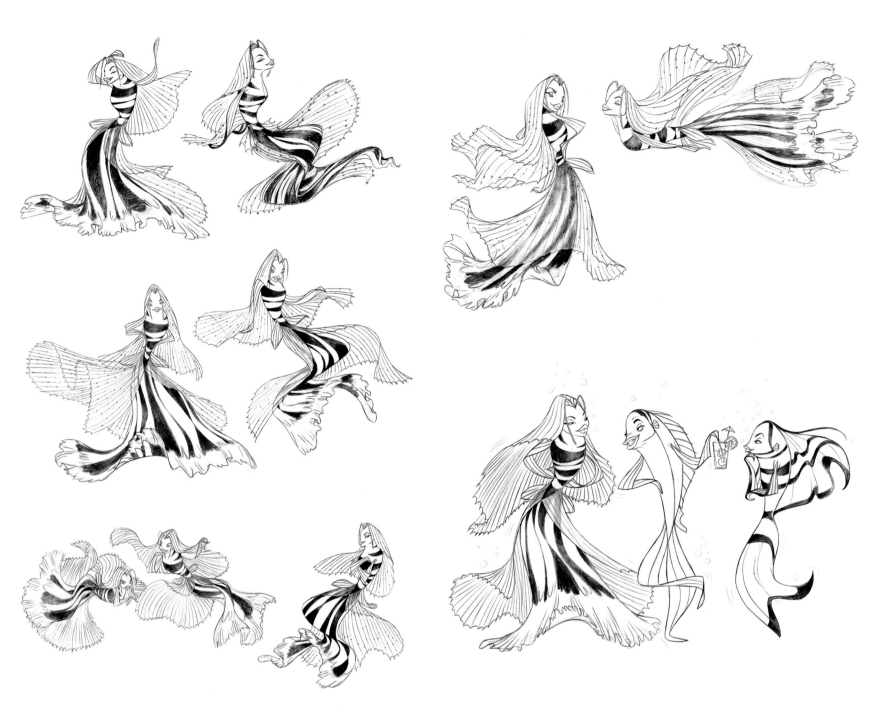

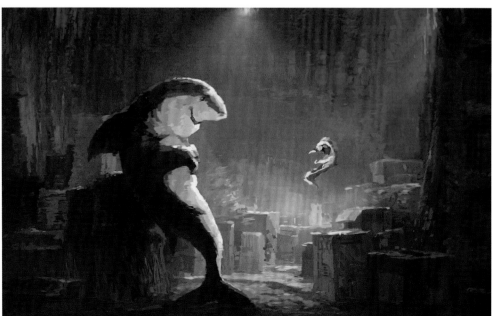

"In the beginning we decided to make everything 50 percent human and 50 percent fish, not only in the architecture and props, but in the characters as well—the way they're modeled and the way they act. We wanted to find that balance between human behavior and fish behavior."

Bibo Bergeron, Director

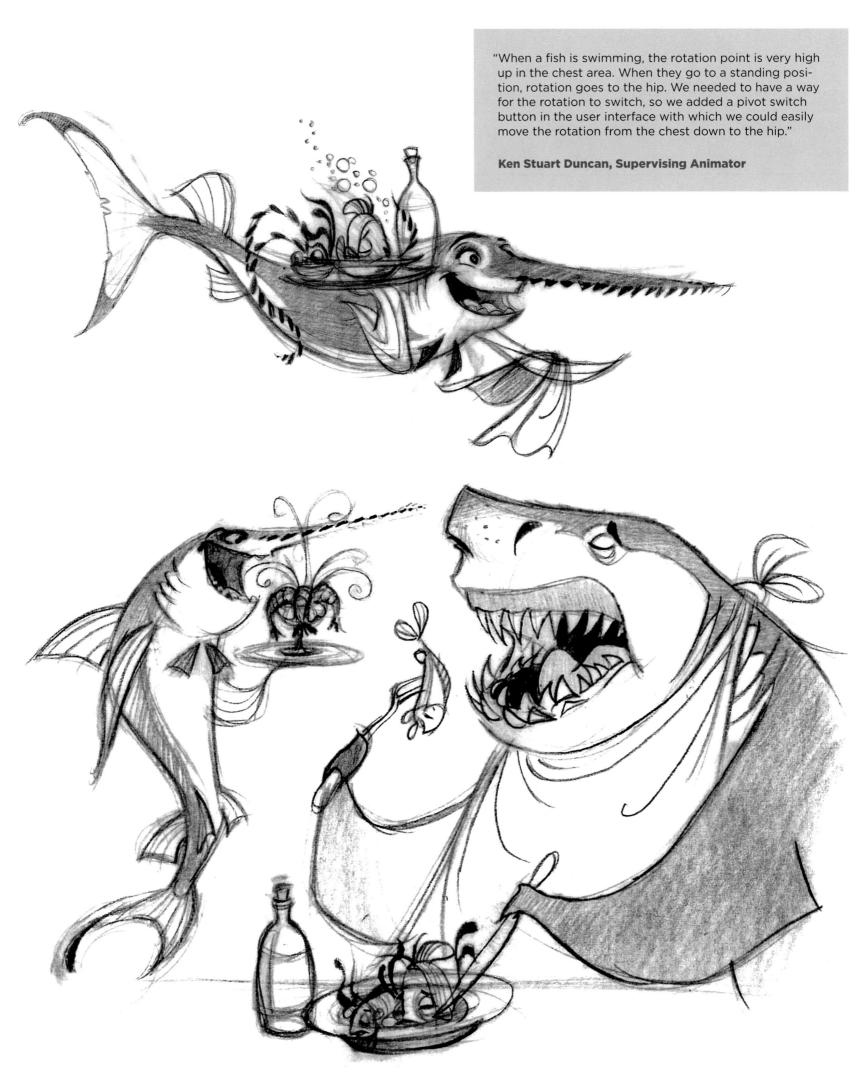

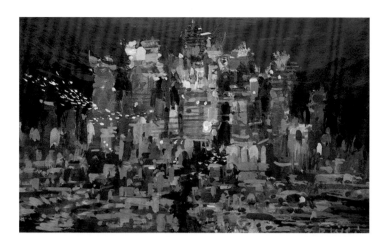

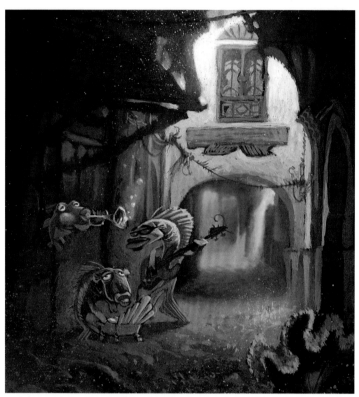

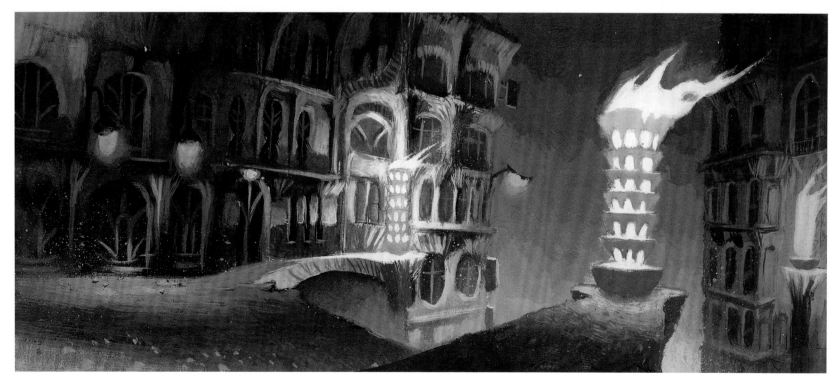

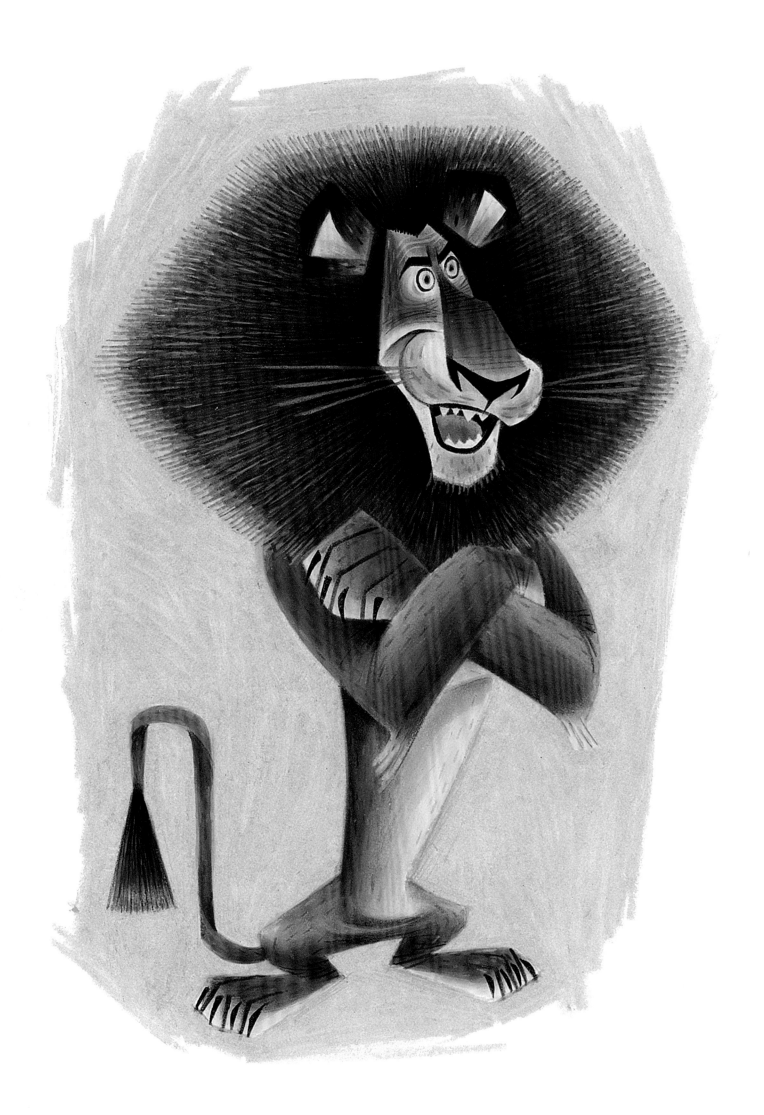

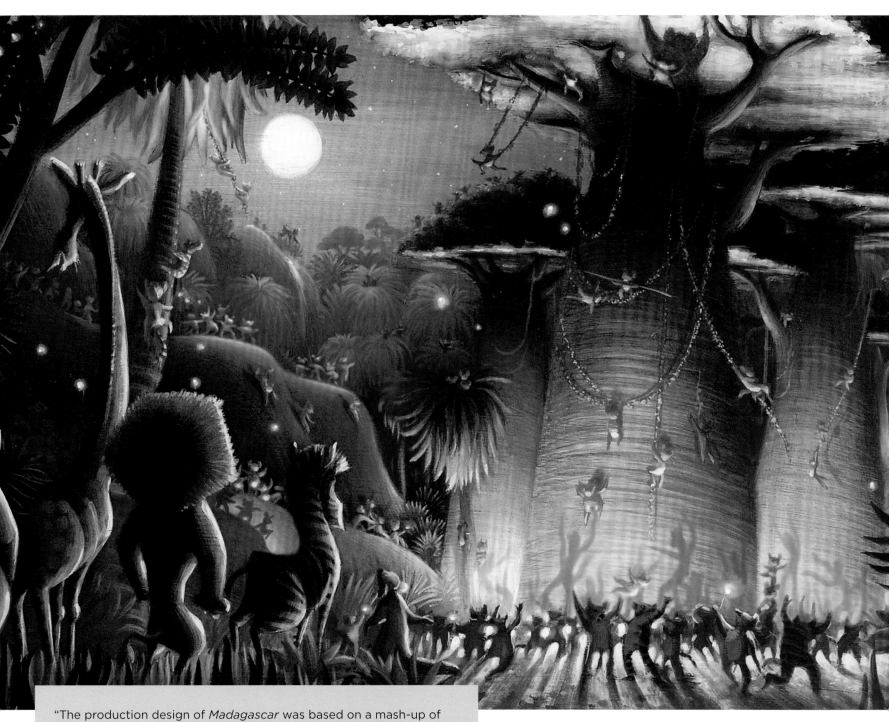

"The production design of *Madagascar* was based on a mash-up of the cartoons of the 1950s and '60s, Golden Books from that era, and the jungle paintings of Henri Rousseau. The design rules that came out of the '60s informed our characters and their world. The pushed proportions and squash and stretch in the animation style came from the cartoons, and the naïve, landscaped garden jungle style came from Rousseau. The contemporary translation of these ideas came from the imaginations of our character designer and art team."

Kendal Cronkhite, Production Designer

Directors	**Eric Darnell, Tom McGrath**
Producer	**Mireille Soria**
Co-Producer	**Teresa Cheng**
Production Designer	**Kendal Cronkhite**
Art Director	**Shannon Jeffries**
Visual Effects Supervisor	**Philippe Gluckman**

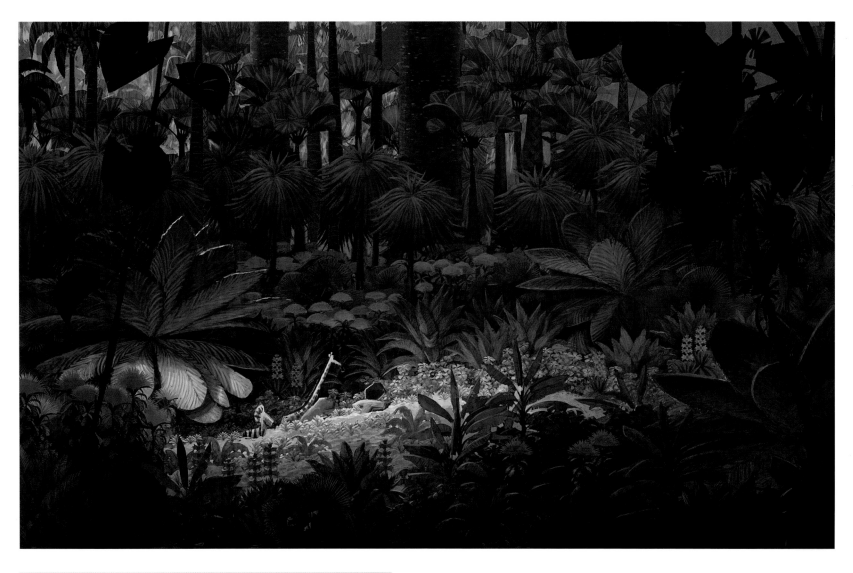

"We care about the main *Madagascar* characters because their friendship is the heart of the movie. They are like these four figures that stand out in the center of this Cecil B. DeMille cast of characters. There's an absurdity of tone in the *Madagascar* movies; the animation is cartoony, the characters are very broad. And yet, they are New Yorkers. We recognize ourselves in them. They offer a unique blend of broad silliness and sophistication, which makes the movie a lot of fun."

Mireille Soria, Producer

"This film is definitely more cartoony than anything we've done before. We applied that style to the characters and to the overall design of the movie."

Mireille Soria, Producer

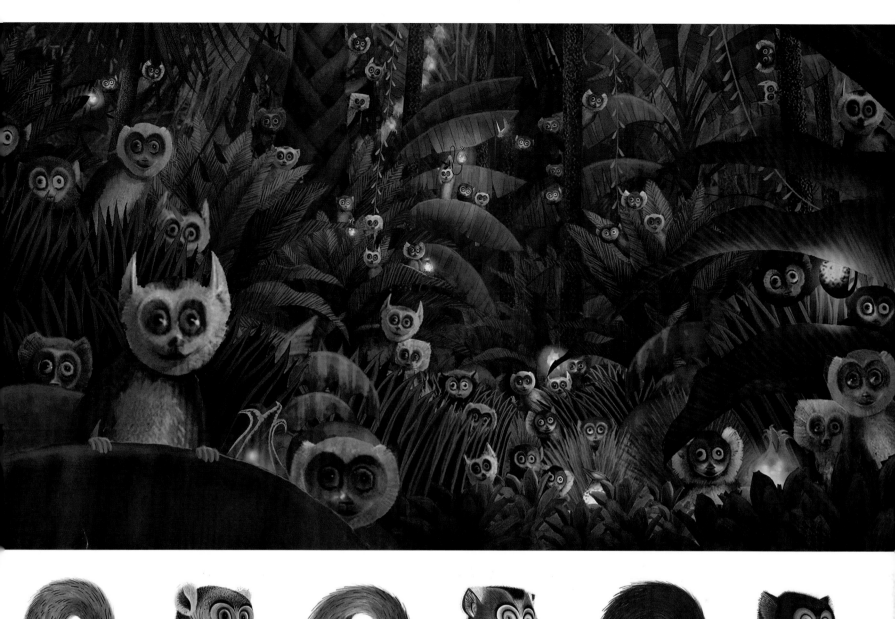

WESTERN GREY
BAMBOO LEMUR
COLOR
(NEW "HAIRCUT" #1)

MALE CROWNED
LEMUR
COLOR
(NEW "HAIRCUT" #2)

MALE BLUE-EYED
BLACK LEMUR
COLOR

GOLDEN BAMBOO
LEMUR
COLOR

FEMALE MONGOOSE
LEMUR
COLOR

FEMALE CROWNED
LEMUR
COLOR

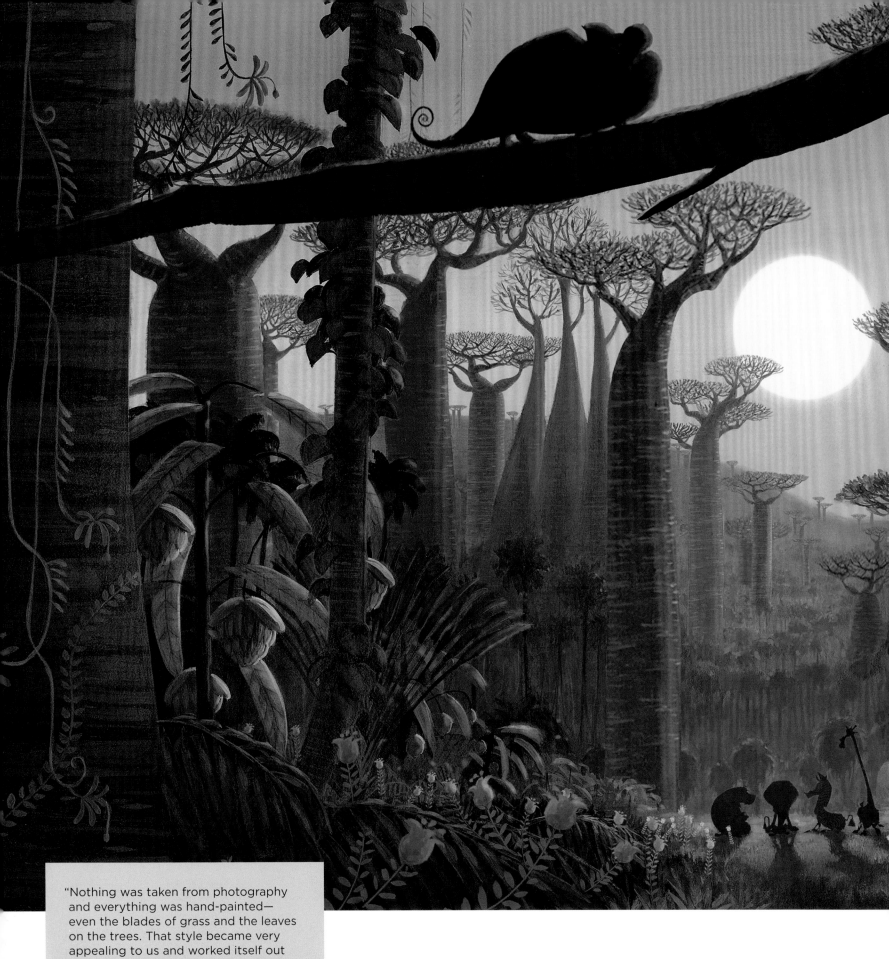

"Nothing was taken from photography and everything was hand-painted— even the blades of grass and the leaves on the trees. That style became very appealing to us and worked itself out through all the movies. It paved the way for the studio to create more styl- ized worlds in the future."

Tom McGrath, Director

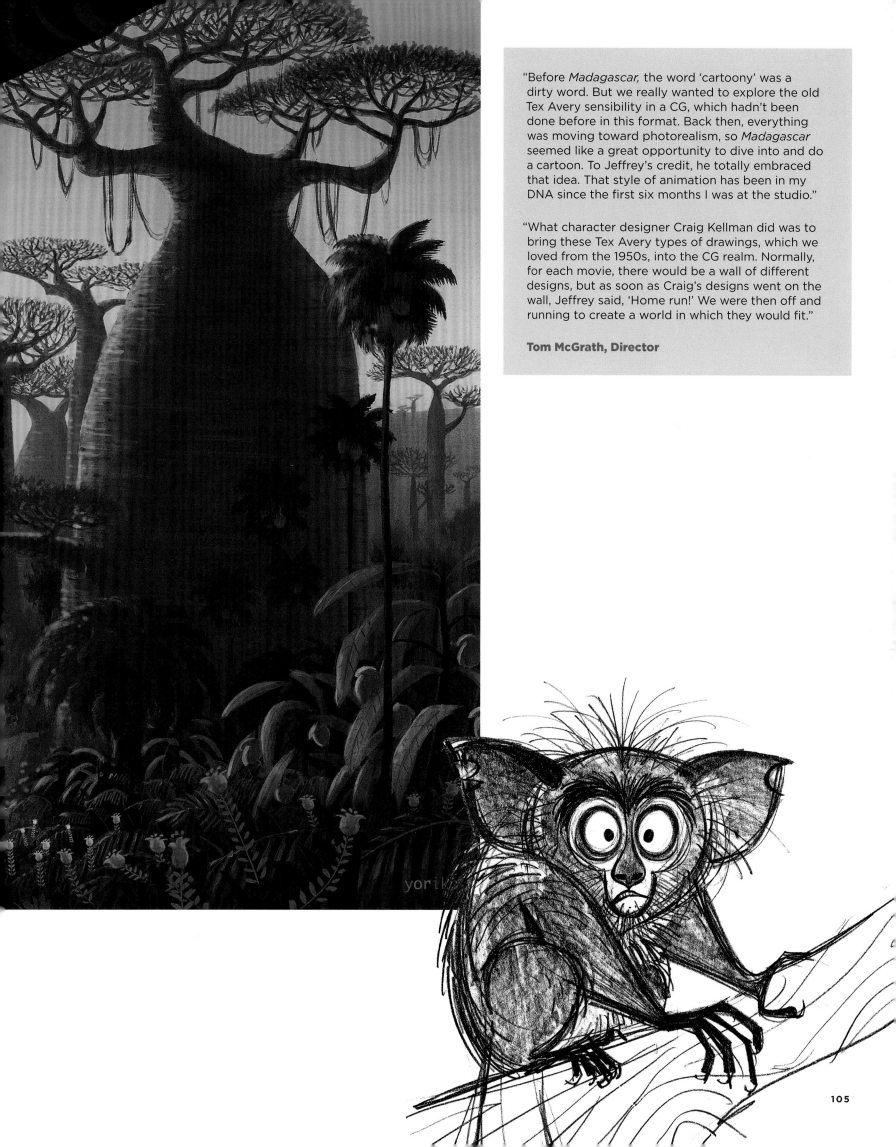

"Before *Madagascar,* the word 'cartoony' was a dirty word. But we really wanted to explore the old Tex Avery sensibility in a CG, which hadn't been done before in this format. Back then, everything was moving toward photorealism, so *Madagascar* seemed like a great opportunity to dive into and do a cartoon. To Jeffrey's credit, he totally embraced that idea. That style of animation has been in my DNA since the first six months I was at the studio."

"What character designer Craig Kellman did was to bring these Tex Avery types of drawings, which we loved from the 1950s, into the CG realm. Normally, for each movie, there would be a wall of different designs, but as soon as Craig's designs went on the wall, Jeffrey said, 'Home run!' We were then off and running to create a world in which they would fit."

Tom McGrath, Director

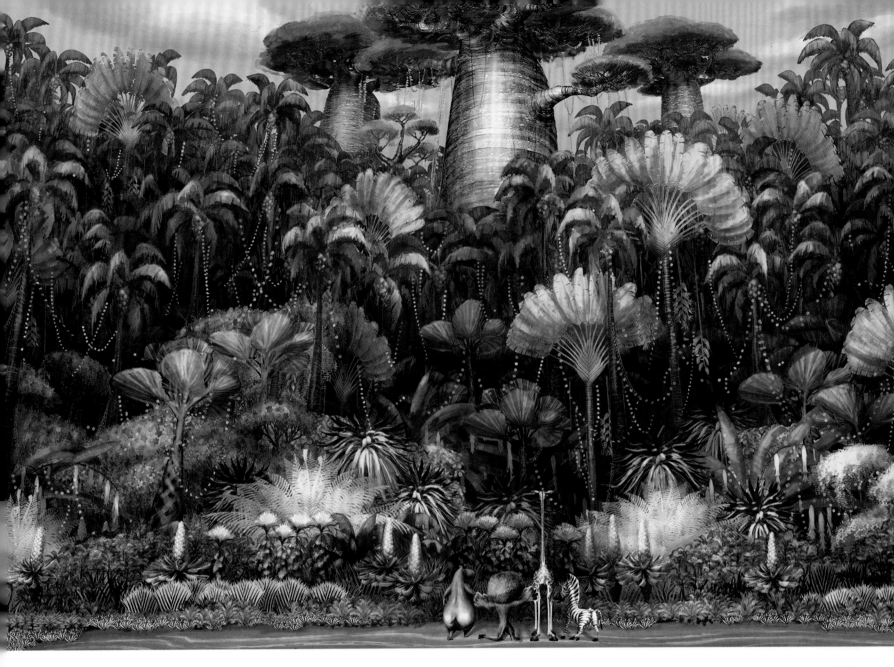

"Kendal Cronkhite created the wack factor—everything is slightly askew in the movie. The environment was pushed and stylized like no other CG movie had done before it."

Tom McGrath, Director

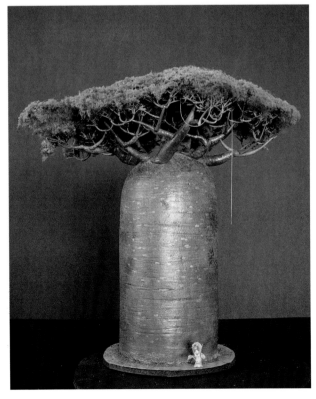

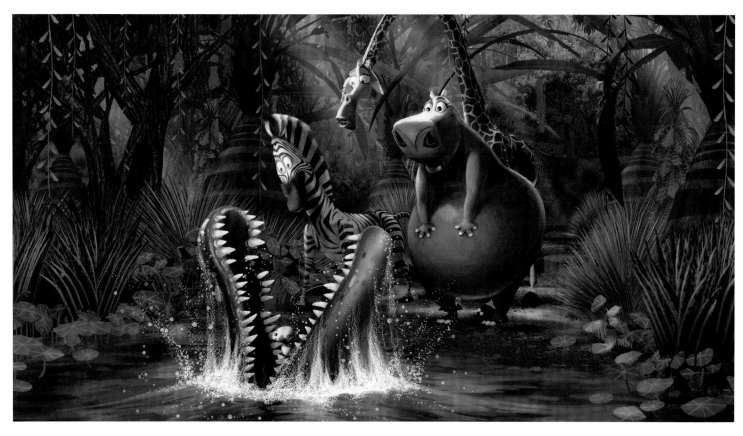

"Craig Kellman did an amazing job in coming up with the look of these characters. He captured what we were going for, which was a more cartoony approach that carried over to all the design elements of the film. We called it 'whacking our characters.'"

Mireille Soria, Producer

"We also knew that the backdrop was going to be a stylized New York, and in fact the Zoo was inspired by the actual zoo from the 1960s, not the modern-day zoo. For the island parts of the movie, we looked at the paintings of Henri Rousseau to bring that magical quality to the location. We actually never went to Madagascar for research. We had plans to visit, but they had a political coup there, which was ironic because the country was taken over by a self-appointed ruler, who is very much like our lemur leader Julien."

Eric Darnell, Director

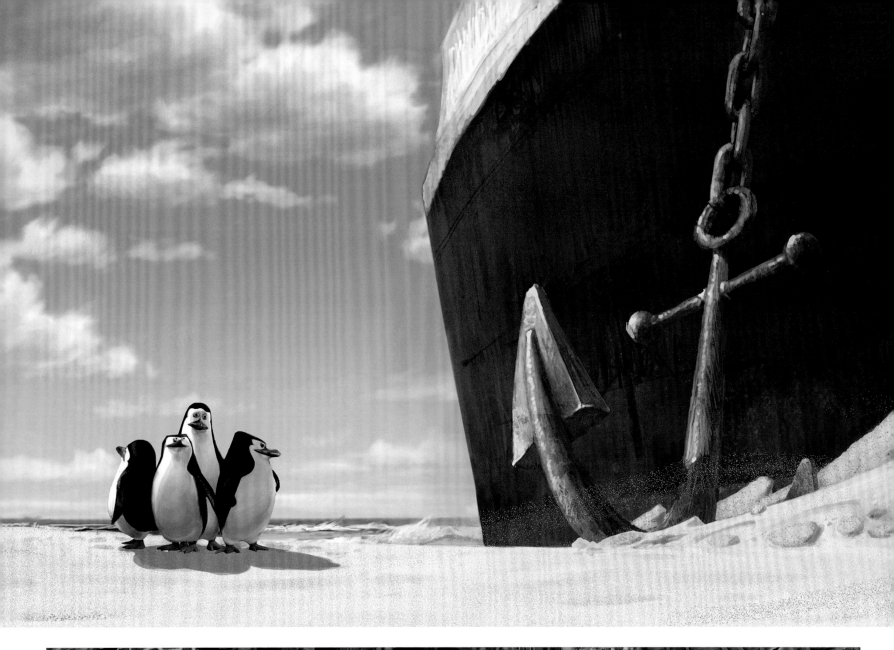

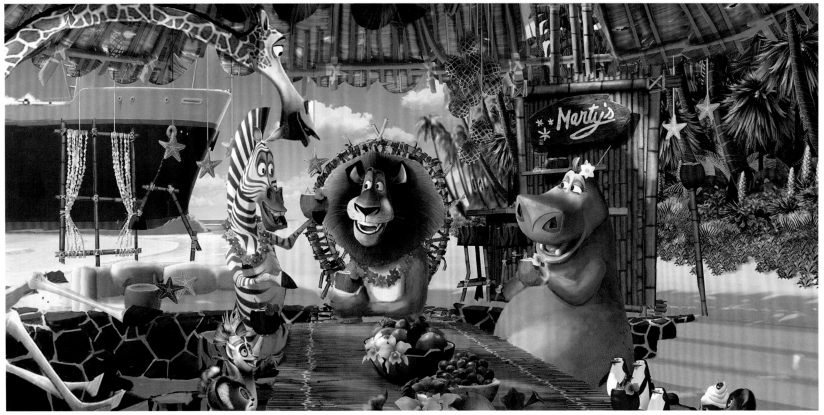

"When the characters were built, they weren't built with bones and muscles like Shrek was. They were approached in a whole new way so that we could squash and stretch these characters and animate them like those old cartoons."

Eric Darnell, Director

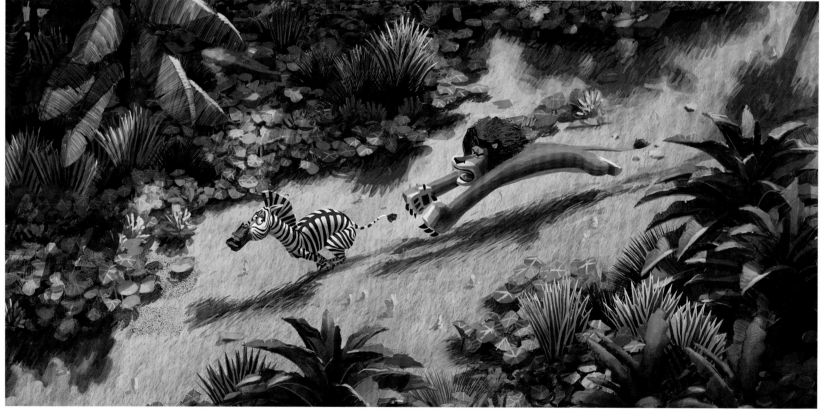

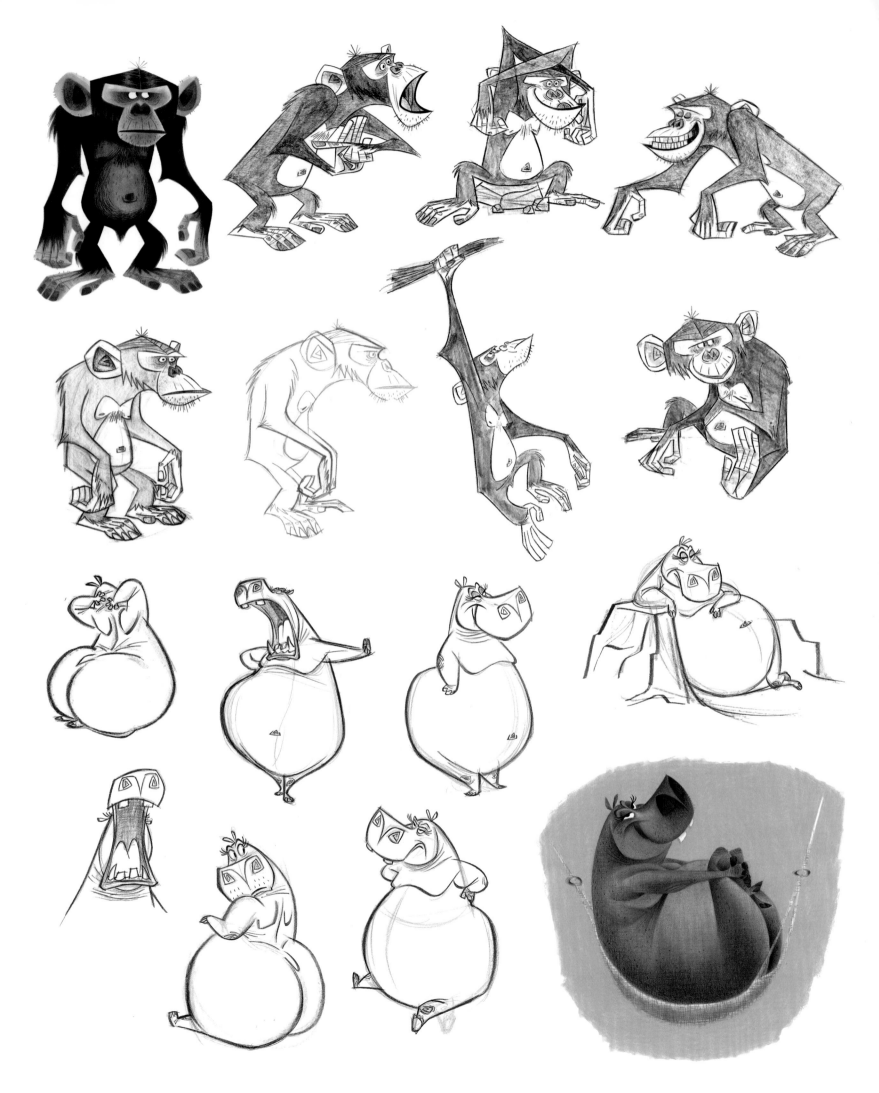

fossa
color

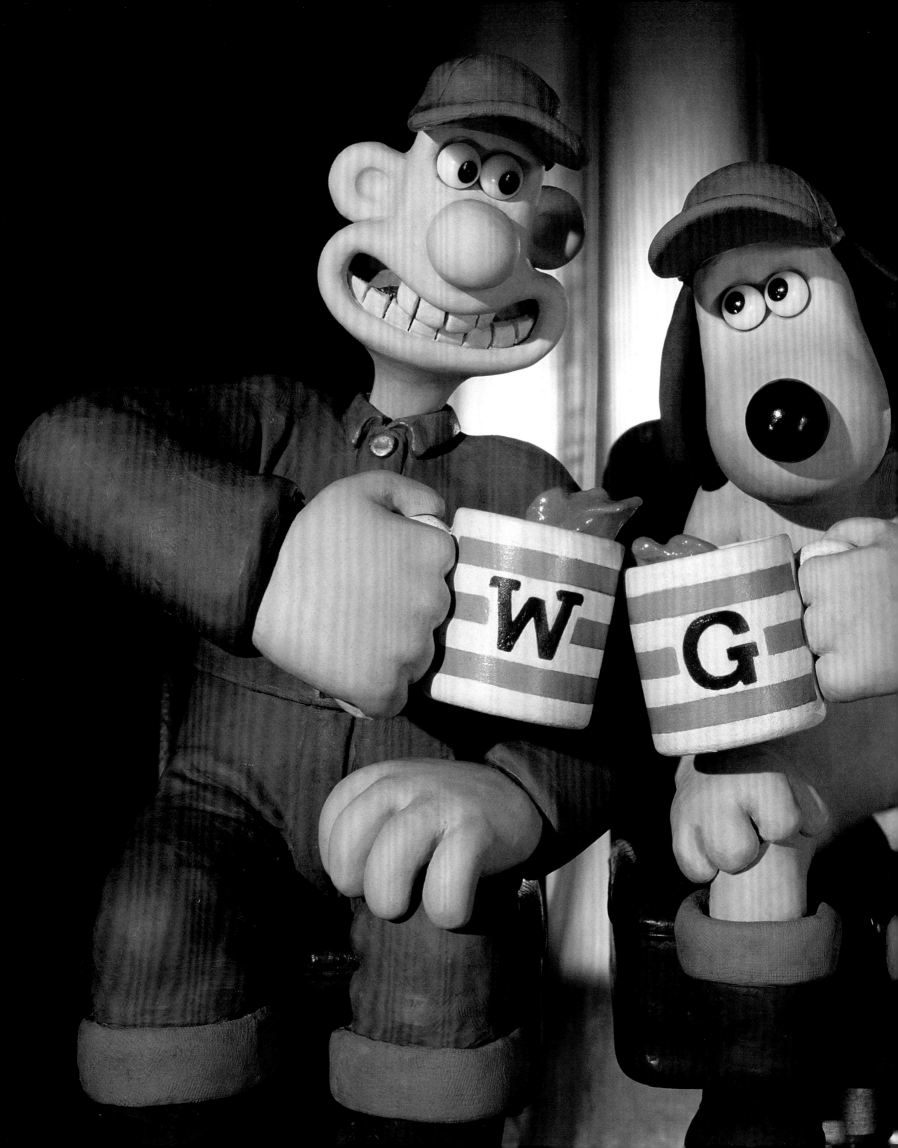

WALLACE & GROMIT
THE CURSE OF THE
WERE-RABBIT
2005

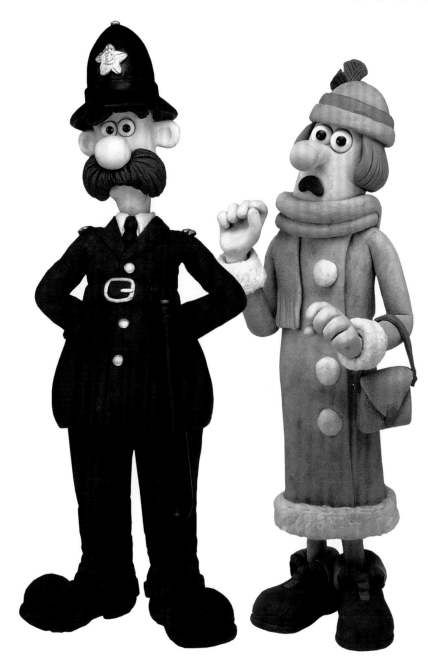

Directors	**Nick Park, Steve Box**
Producers	**Peter Lord, David Sproxton, Nick Park, Claire Jennings, Carla Shelley**
Executive Producers	**Michael Rose, Cecil Kramer**
Production Designer	**Phil Lewis**
Art Directors	**Alastair Green, Matt Perry**
Visual Effects Supervisor	**Paddy Eason**

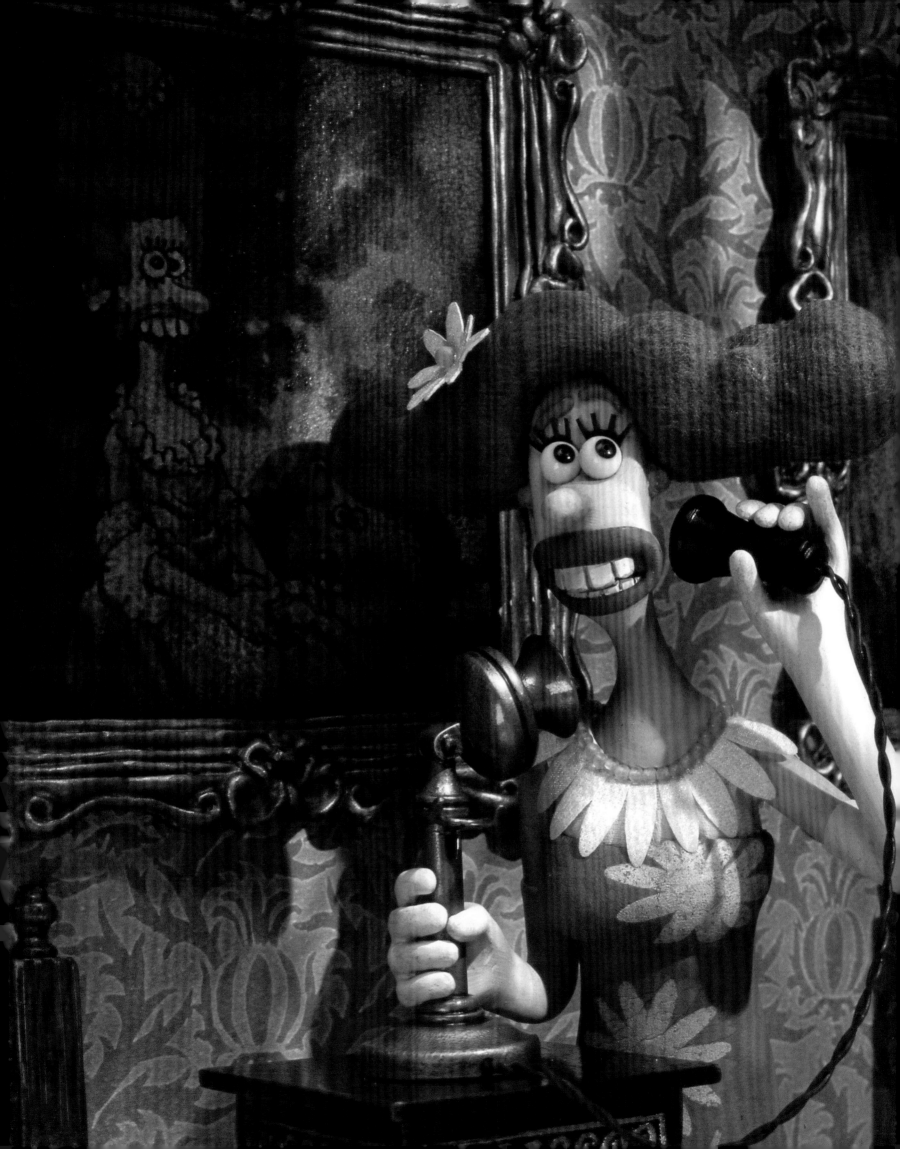

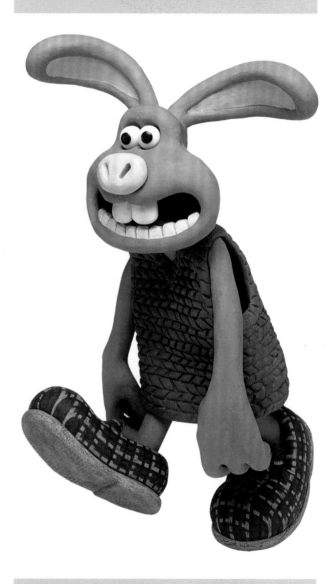

"Steve [Box] and I split the directing duties and we had about thirty animators working with us. We worked on twenty to thirty sets. On a very good day, each animator got to finish two or three seconds. That means by the end of the week, we got a maximum of two minutes."

Nick Park, Director, Producer

"We had used CG technology before this movie to create flames or fog. The sequence involving the bunnies in the Vac would be extremely difficult to do solely in stop-motion. We were very careful, though, not to make it look like CG, and we used it very sparingly."

Nick Park, Director, Producer

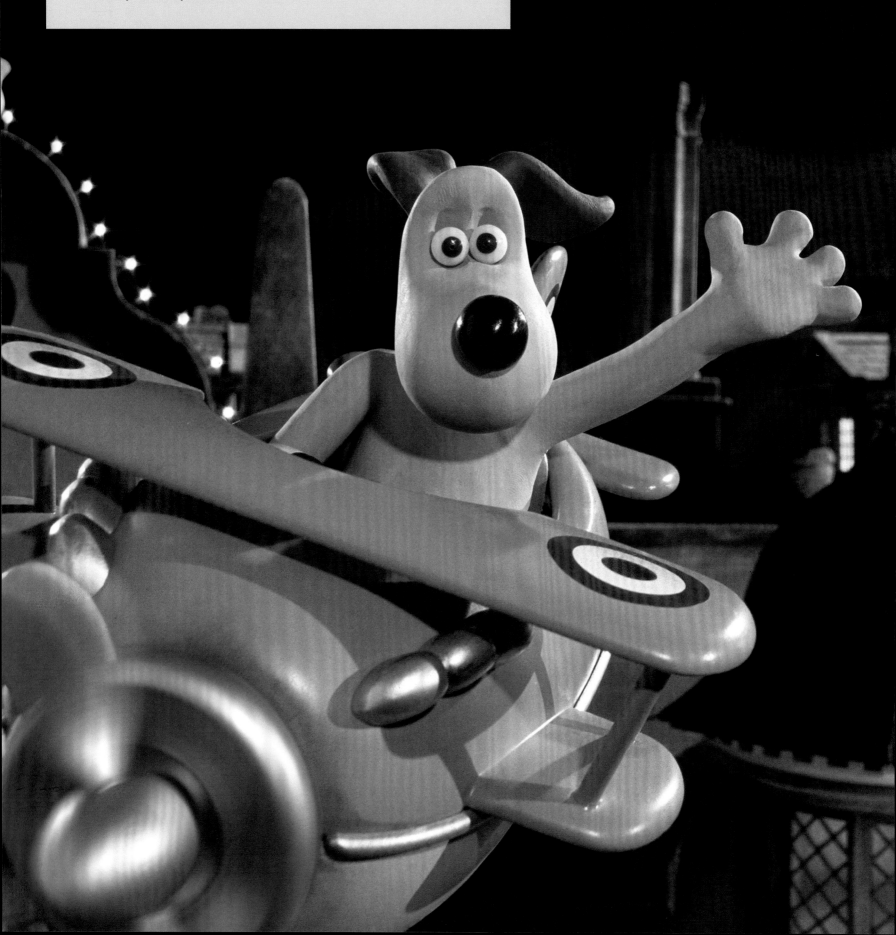

"We are always thinking about a catalog of movies that we've admired in our lives. We looked at all the Universal horror movies—*The Mummy, Frankenstein*—all the werewolf movies, the Hammer horror titles. Then, because part of our movie was set against this stately, aristocratic home, we went over *The Hound of the Baskervilles,* as well as the *Brideshead Revisited* TV series. We even looked at *Barry Lyndon* and *The Go-Between.* Any particular sequence can spark the memory of another movie and that always resonates with us."

Nick Park, Director, Producer

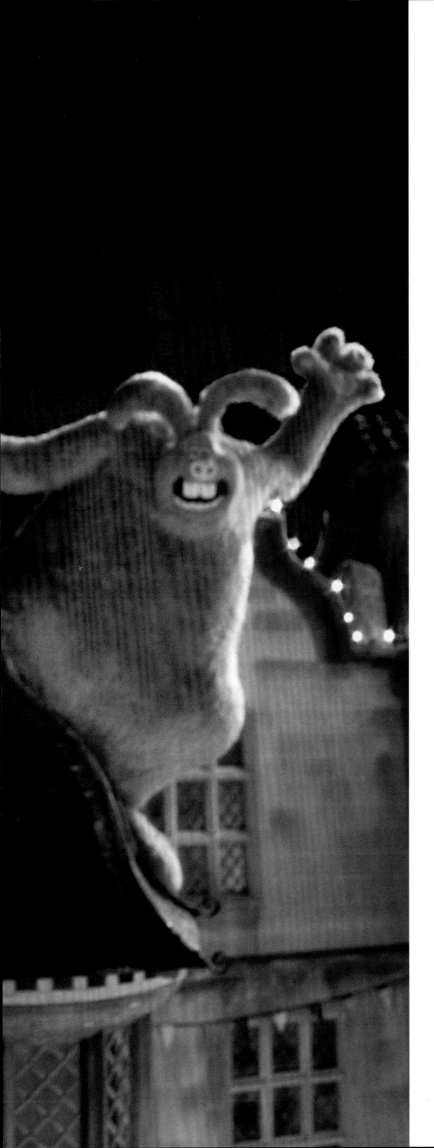

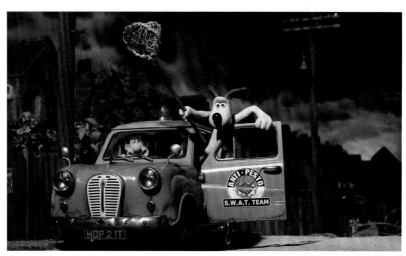

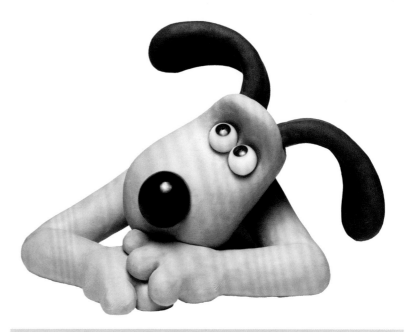

"Everyone responds to the classic double act of a man and his dog. We realize that Gromit is much smarter than Wallace. It's a situation that is eternally humorous. Gromit is also silent, and that appeals to people in every language. It allows viewers this great way to see the world through Gromit's eyes."

Steve Box, Director

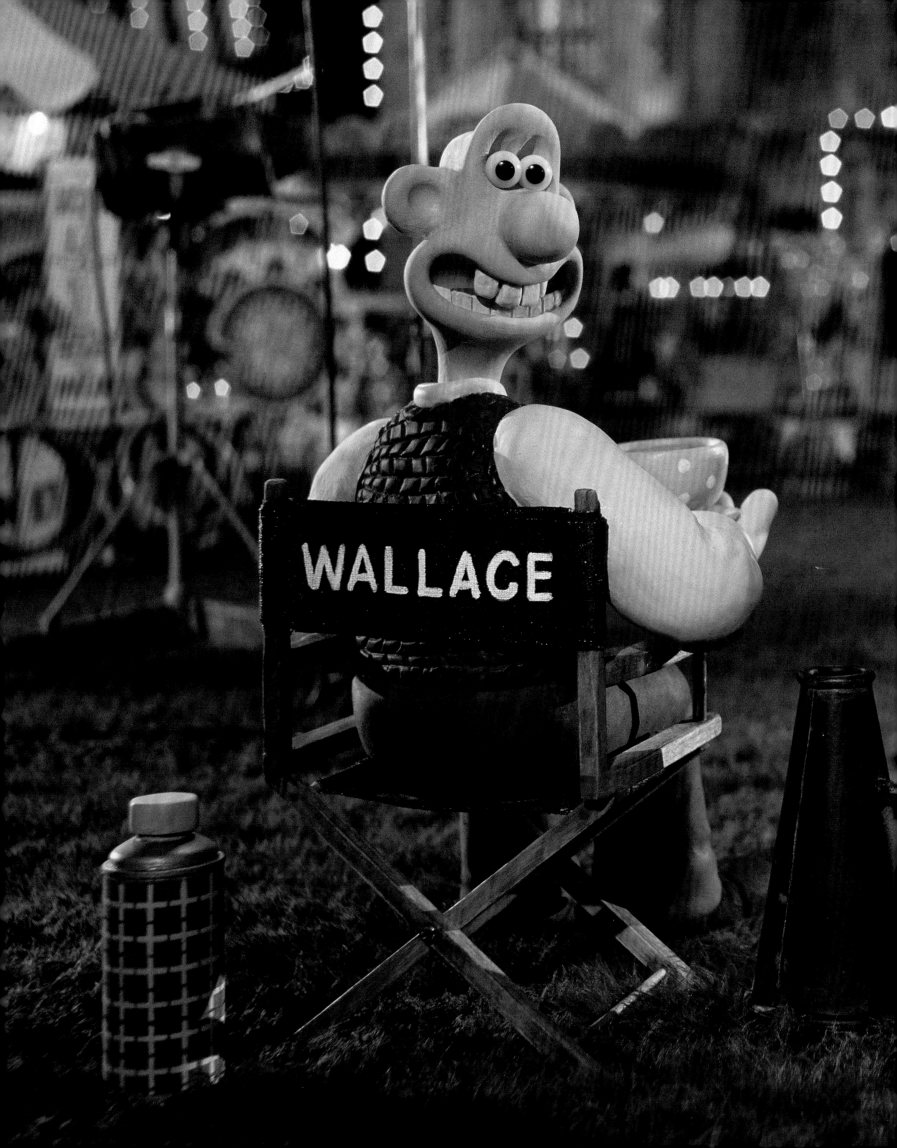

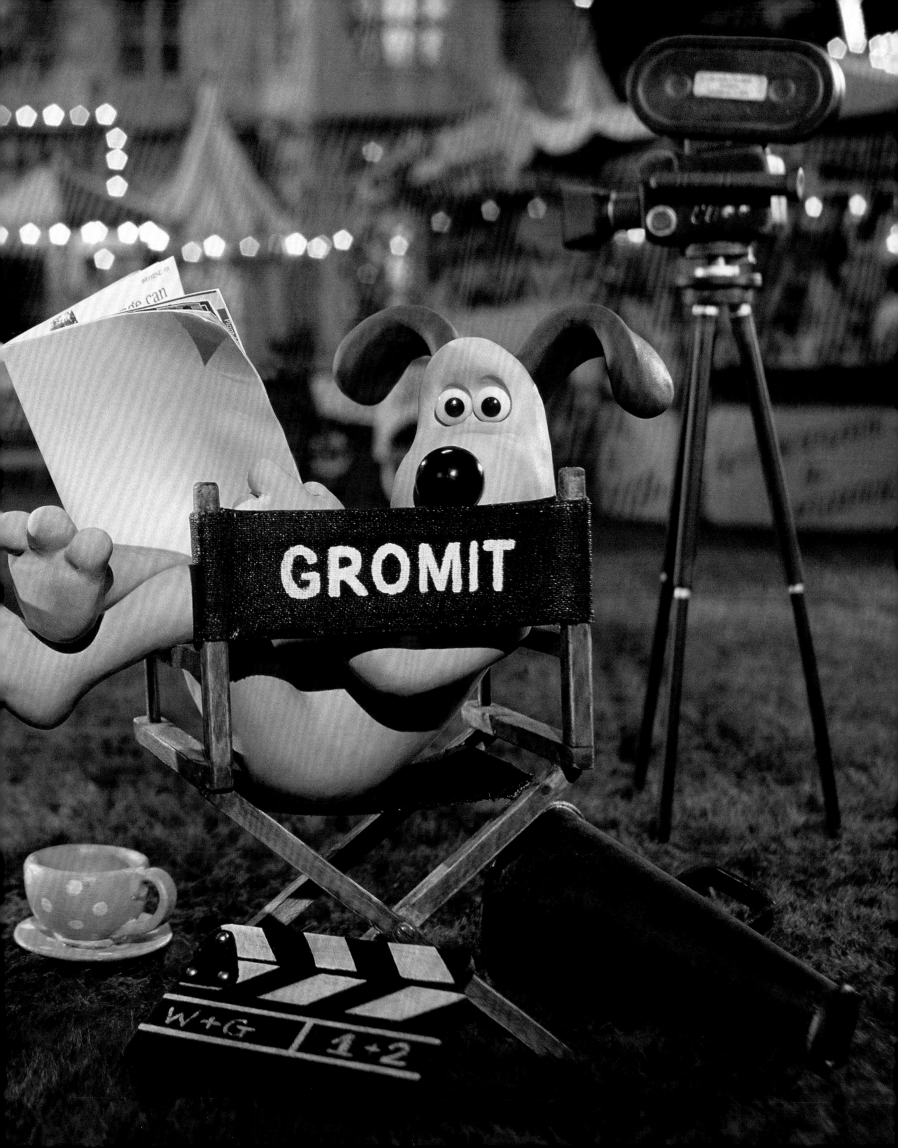

"Really, it is we who are in the animals' backyard; they are not in ours. The comic strip and now the movie are about how suburban sprawl impacts the animals' lives and how they have to adjust to survive in this new environment."

Bonnie Arnold, Producer

Directors	**Tim Johnson, Karey Kirkpatrick**
Producer	**Bonnie Arnold**
Executive Producer	**Bill Damaschke**
Co-Executive Producer	**Jim Cox**
Associate Producer	**Ellen Coss**
Production Designer	**Kathy Altieri**
Art Directors	**Christian Schellewald, Paul Shardlow**
Visual Effects Supervisor	**Craig Ring**

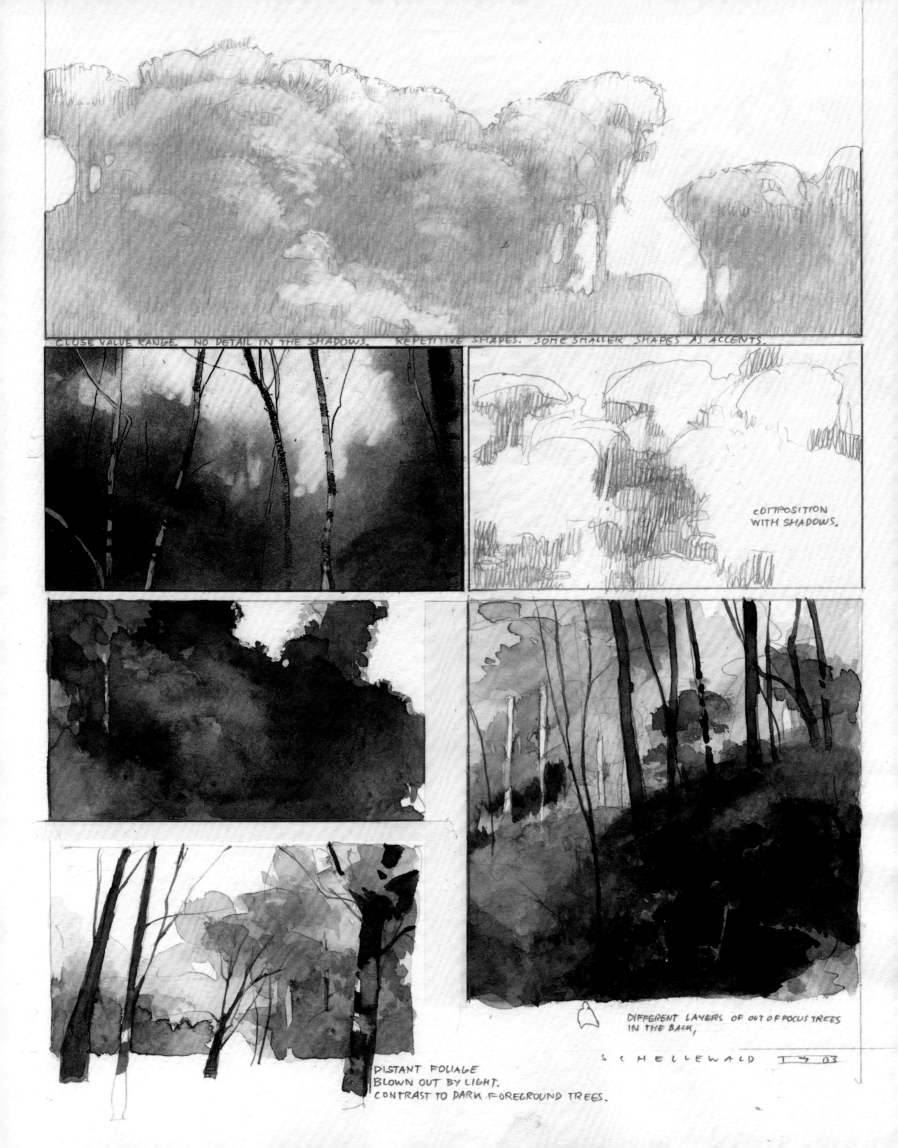

CLOSE VALUE RANGE. NO DETAIL IN THE SHADOWS. REPETITIVE SHAPES. SOME SMALLER SHAPES AS ACCENTS.

COMPOSITION WITH SHADOWS.

DIFFERENT LAYERS OF OUT OF FOCUS TREES IN THE BACK.

SCHELLEWALD I 4 03

DISTANT FOLIAGE BLOWN OUT BY LIGHT. CONTRAST TO DARK FOREGROUND TREES.

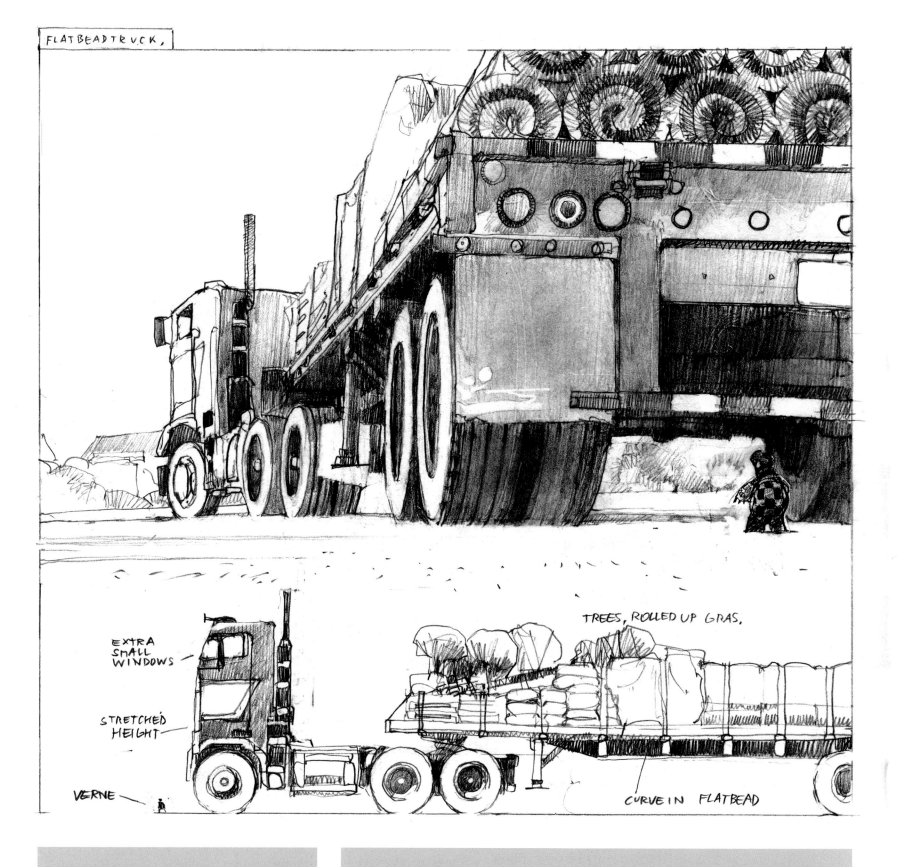

FLATBEADTRUCK,

EXTRA SMALL WINDOWS

STRETCHED HEIGHT

VERNE

TREES, ROLLED UP GRAS.

CURVE IN FLATBEAD

"We look at a six-foot hedge and it's not that big a deal to us, but this movie is about seeing the world from a different perspective. Every person coming on this film was required to stand at the base of that wall to get a feel for what it would be like for the animals in that situation and, hopefully, apply some of that insight to the work they were doing."

Karey Kirkpatrick, Director

"The key challenge in *Over the Hedge* was that we didn't have one single hero. It was a buddy picture with Vern, our turtle, and RJ the raccoon, but it wasn't a two-hander; you had a whole group of animals. I still can't believe the amazing casting we got on that show . . . Garry Shandling, Bruce Willis, William Shatner, Wanda Sykes. It was really fun to tell a story in which every one of these characters had a moment in the limelight. It wasn't like we had two and a half hours to do *The Avengers*. We had less than ninety minutes to let these characters shine. I saw the movie as a wry take on consumer suburban culture, but it also had a lot of great voices in terms of storytelling."

Tim Johnson, Director

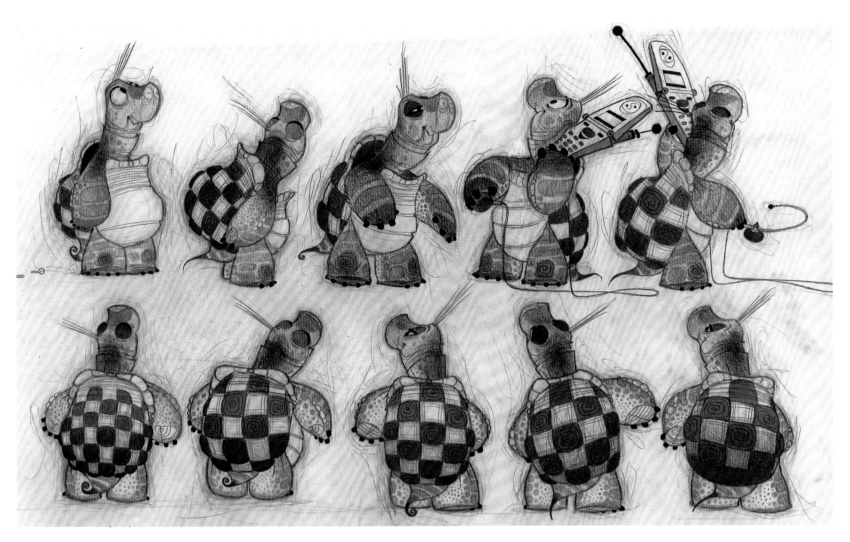

"*Over the Hedge* was my first CG film and was a big adjustment for me. We utilized the same design and color principles as we had in traditional animation, but I had to learn a whole new vocabulary related to the technology of CG filmmaking. The story was told from the animals' point of view; we used a low camera angle and shallow depth of field to give us a very intimate view of the natural and urban world. In addition, there was a buoyant sense of light, color, and atmosphere to enhance the warmth, charm, and humor of the animation."

Kathy Altieri, Production Designer

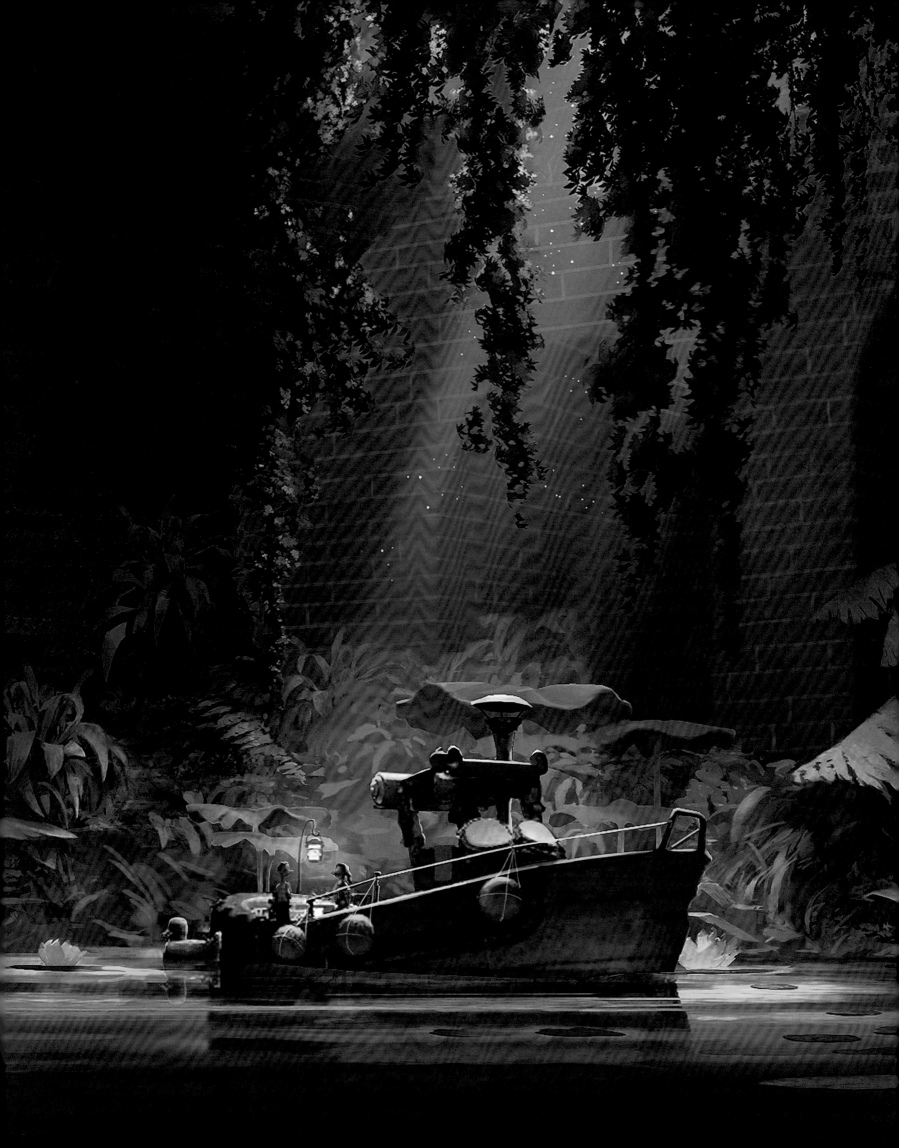

FLUSHED AWAY

2006

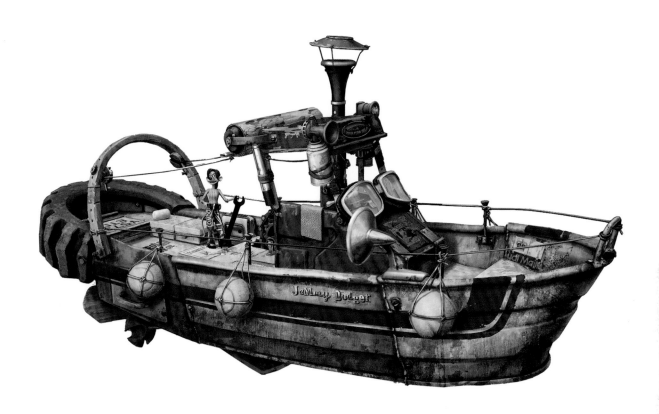

"The *Jammy Dodger* has quite a bit of screen time, so we knew it had to be very interesting to look at. There are tennis balls for the bumpers. The back of the boat is a tire. The cabin is made from a gas can. The helm is a water tap, the throttle is from an old slot car racing set, the secret devices are triggered by typewriter keys . . . the list just keeps going."

**David A. S. James,
Production Designer**

Directors	**David Bowers, Sam Fell**
Producers	**Cecil Kramer, Peter Lord, David Sproxton**
Co-Producer	**Maryann Garger**
Production Designer	**David A. S. James**
Art Directors	**Pierre-Olivier Vincent, Scott Wills**
Visual Effects Supervisor	**Wendy Rogers**

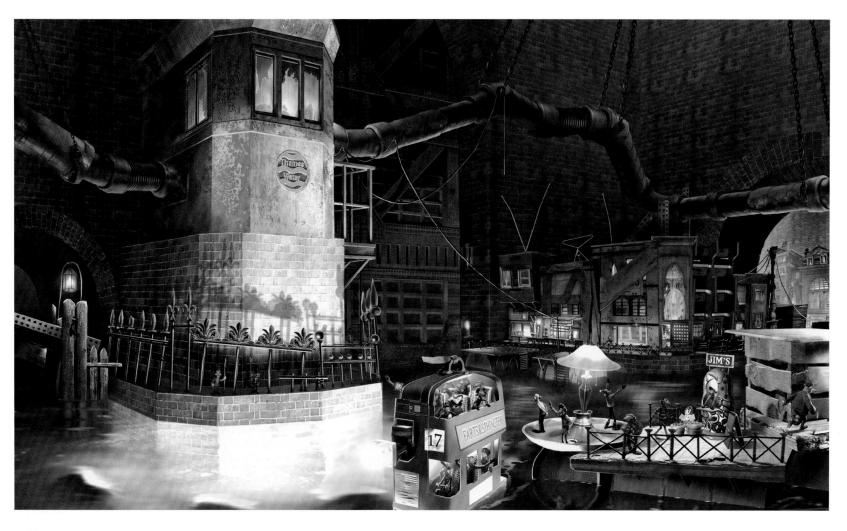

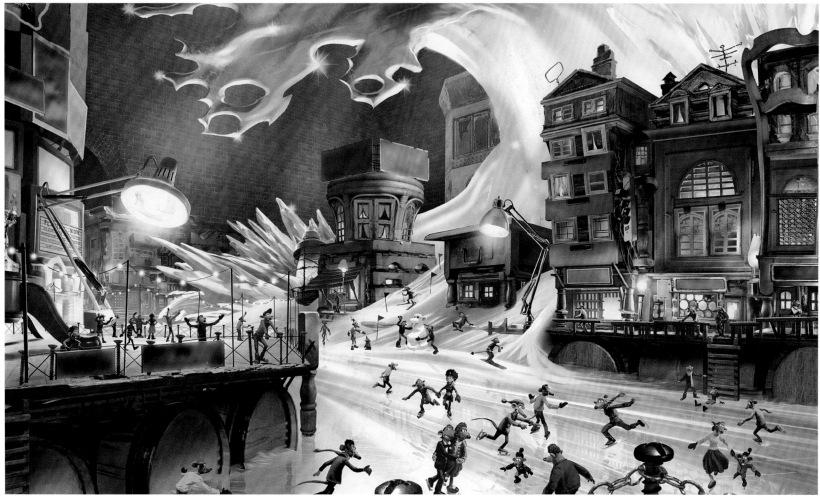

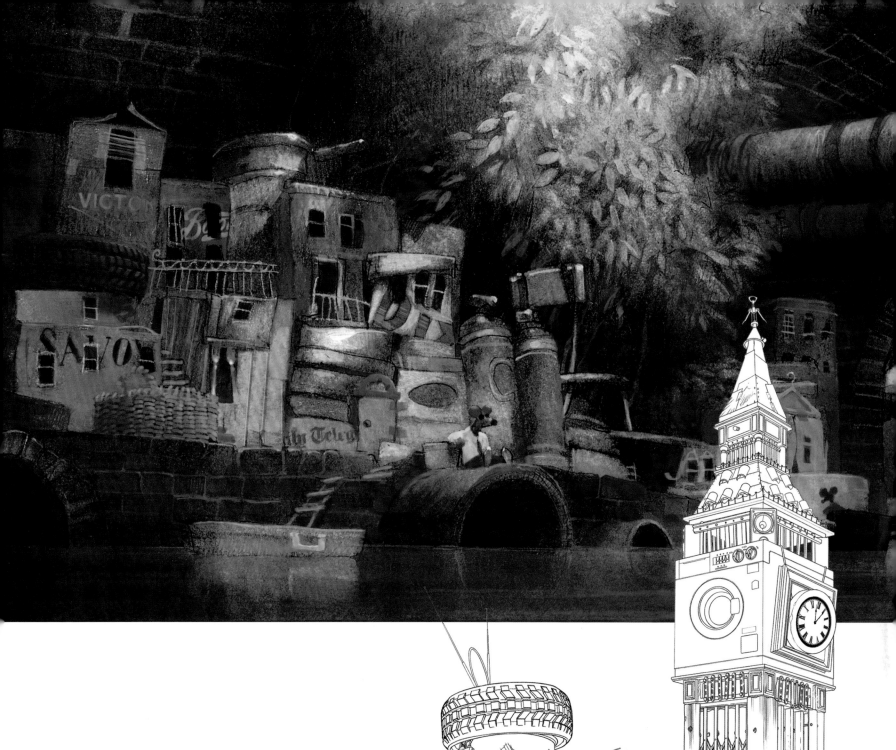

"We had this crowd scene toward the end of the movie that is set in an underworld version of Piccadilly Circus in London's West End. The scene features close to 1,000 background characters walking around, reading newspapers, just going about their business. Having a thousand people animating puppets would be close to impossible. CG allowed us to do that and we could refine it and animate over and over again. I love stop-frame animation, but once it's been shot, you have to live with it. In CG, you can go back and punch up something, sharpen and edit—it's more flexible and a lot less painful."

Sam Fell, Director

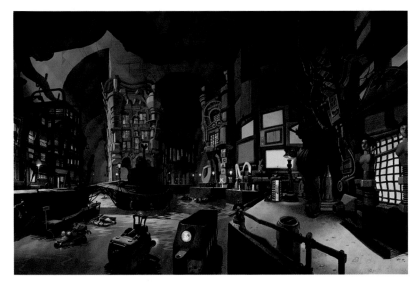

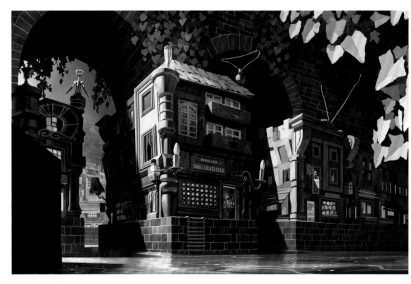

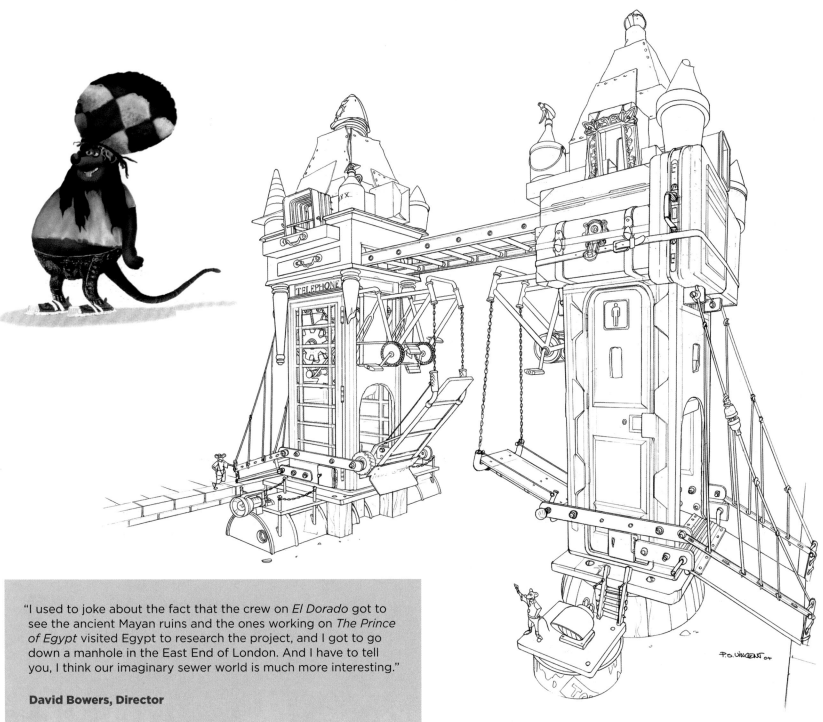

"I used to joke about the fact that the crew on *El Dorado* got to see the ancient Mayan ruins and the ones working on *The Prince of Egypt* visited Egypt to research the project, and I got to go down a manhole in the East End of London. And I have to tell you, I think our imaginary sewer world is much more interesting."

David Bowers, Director

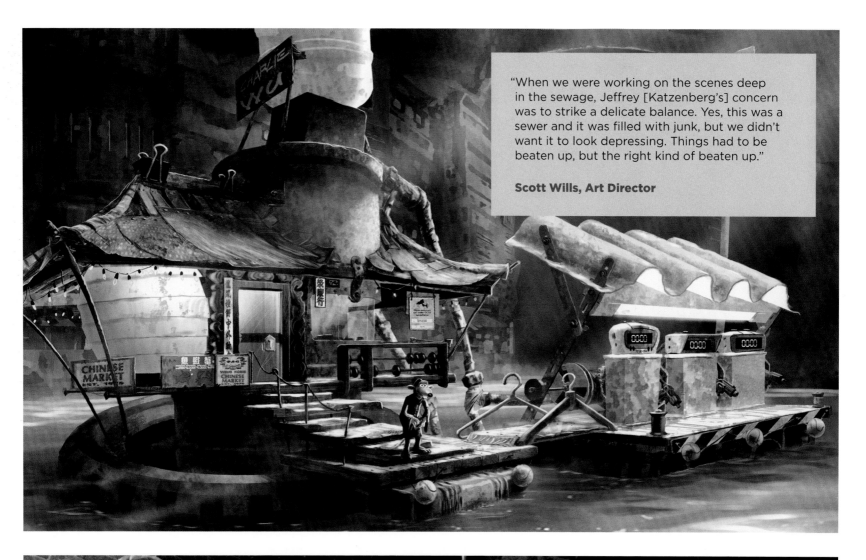

"When we were working on the scenes deep in the sewage, Jeffrey [Katzenberg's] concern was to strike a delicate balance. Yes, this was a sewer and it was filled with junk, but we didn't want it to look depressing. Things had to be beaten up, but the right kind of beaten up."

Scott Wills, Art Director

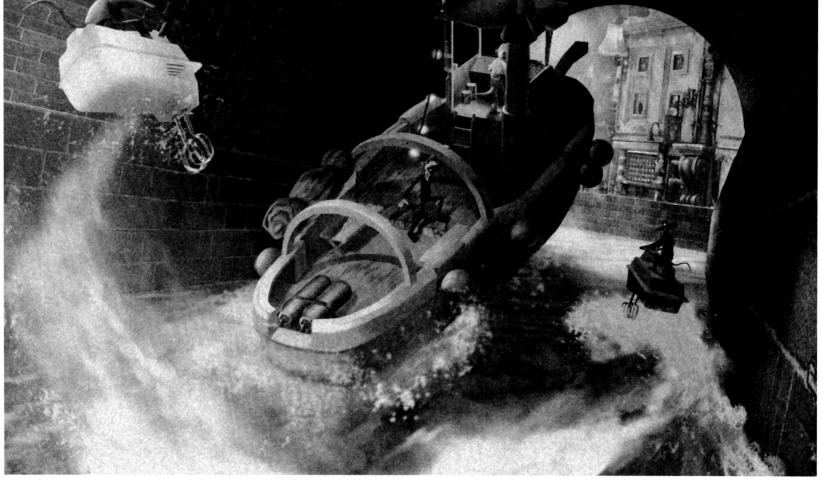

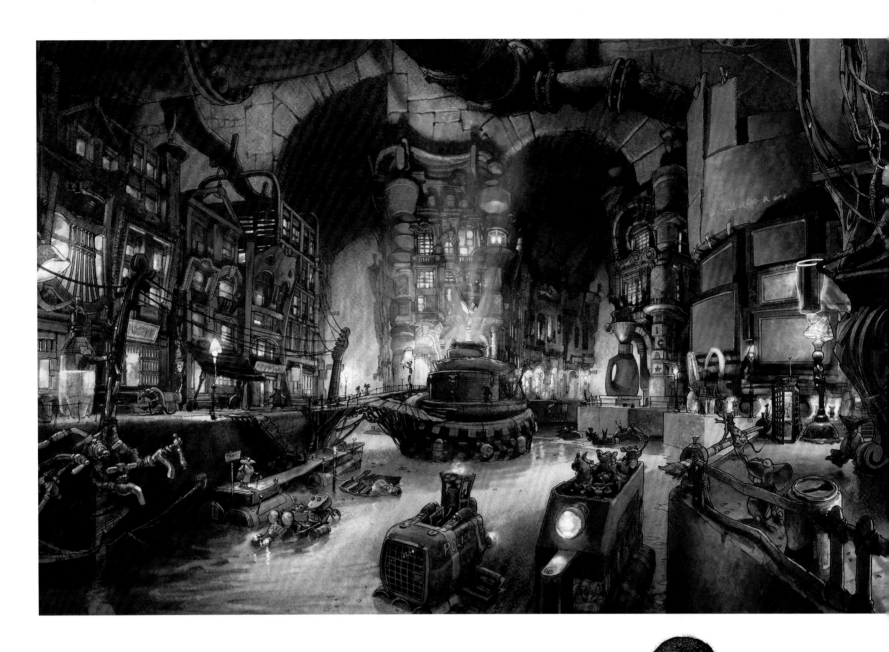

"We made a special effort to make sure everything was a bit wonky. In the computer world, you can create a perfectly animated bottle, but we wanted to make them a bit uneven. Nothing was allowed to be clinical. We made the sets and the objects all a bit scuffed up. It's a bit ironic to think that we spent so much money to make things that look like a pile of rubbish, since they do live in a London sewer!"

Sam Fell, Director

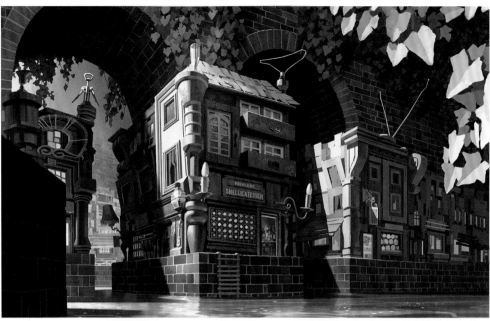

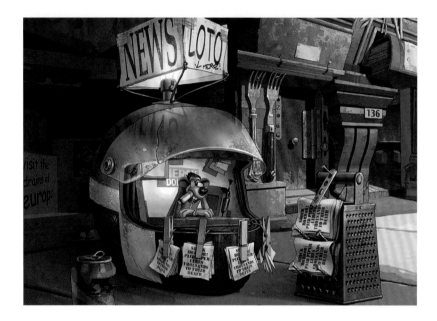

"Looking back, it was a pretty easy transition, because so much of the crew was in place for the third movie. There was such great continuity, and the team was so good. My goal was to stay out of their way!"

Chris Miller, Director

Director	**Chris Miller**
Producer	**Aron Warner**
Executive Producers	**Andrew Adamson, John H. Williams**
Co-Director	**Raman Hui**
Co-Producer	**Denise Nolan Cascino**
Production Designer	**Guillaume Aretos**
Art Director	**Peter Zaslav**
Visual Effects Supervisors	**Philippe Gluckman, Ken Bielenberg**

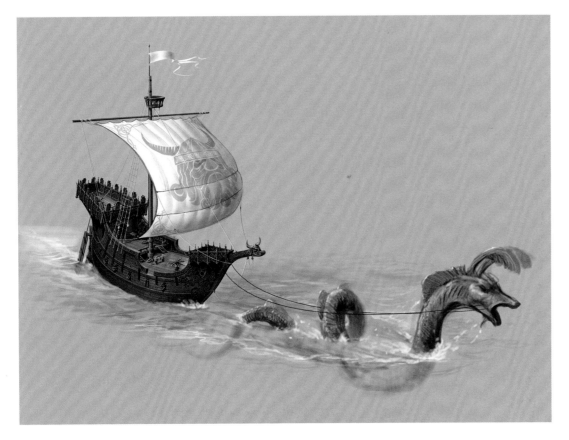

"It is absolutely stunning. The moment we saw the pencil sketches we knew this was going to be something special. We have a different kind of environment for *Shrek the Third* and it stands out as something very special."

Denise Nolan Cascino, Co-Producer

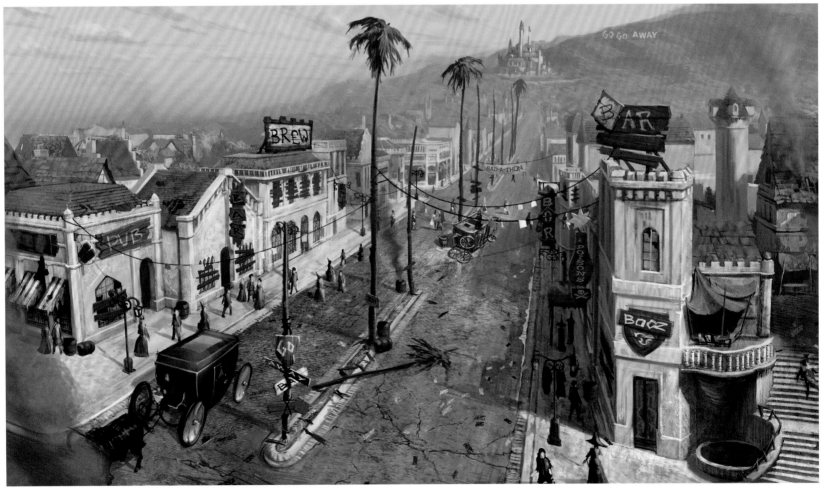

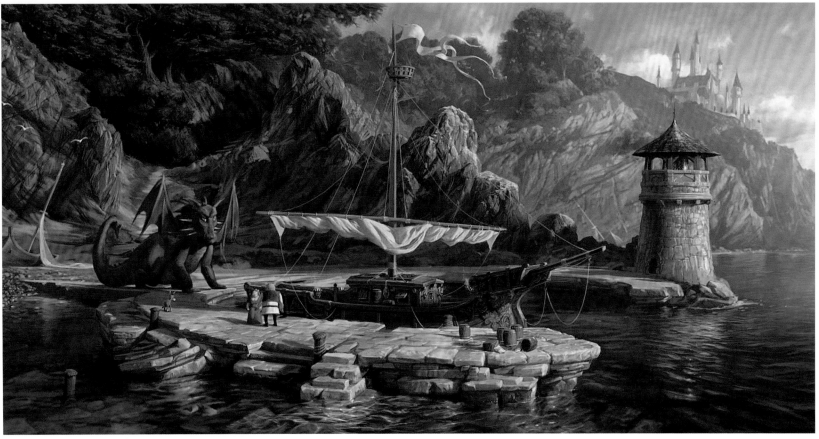

"For the third movie, we had the characters venture out into the world more than the previous Shrek outings. We had to create eighty-two locations, only fifteen of which had been seen before. The first movie, we were influenced by the Mediterranean tones of Italy and the second one, we went for the polished look of Beverly Hills. For this one, we opted for more of the northern European look. Worcestershire High School, where Shrek finds the teenage Artie, was inspired by Irish and English castles."

**Guillaume Aretos,
Production Designer**

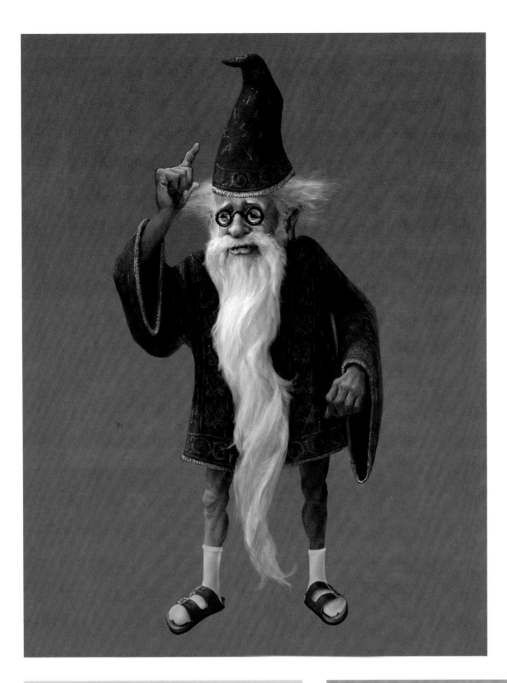

"The costumes also got an upgrade in the third movie. There was more texture and variety involved. Shrek and Fiona were wearing costumes similar to those worn by Louis XVI and Marie Antoinette for a scene in which everything goes wrong and their tight costumes fly apart with funny results. Those outfits had to both look good and disassemble in just the right way."

Guillaume Aretos, Production Designer

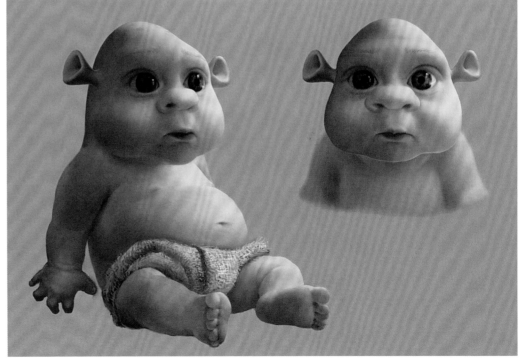

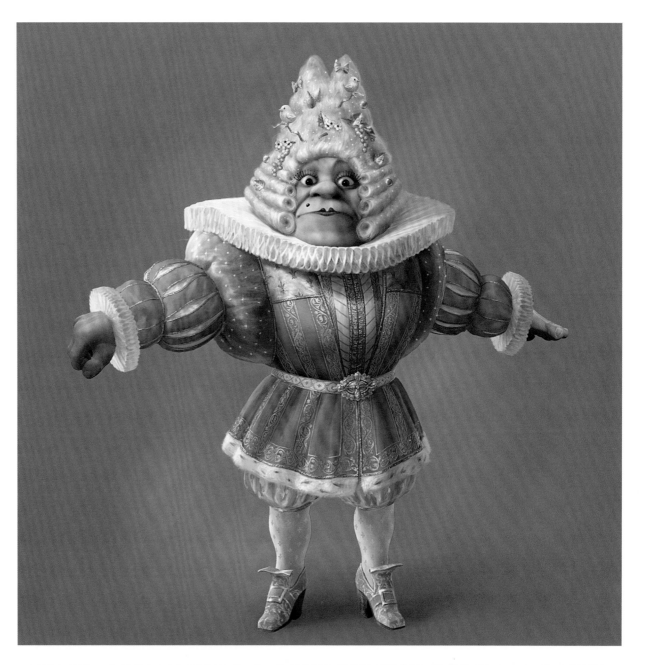

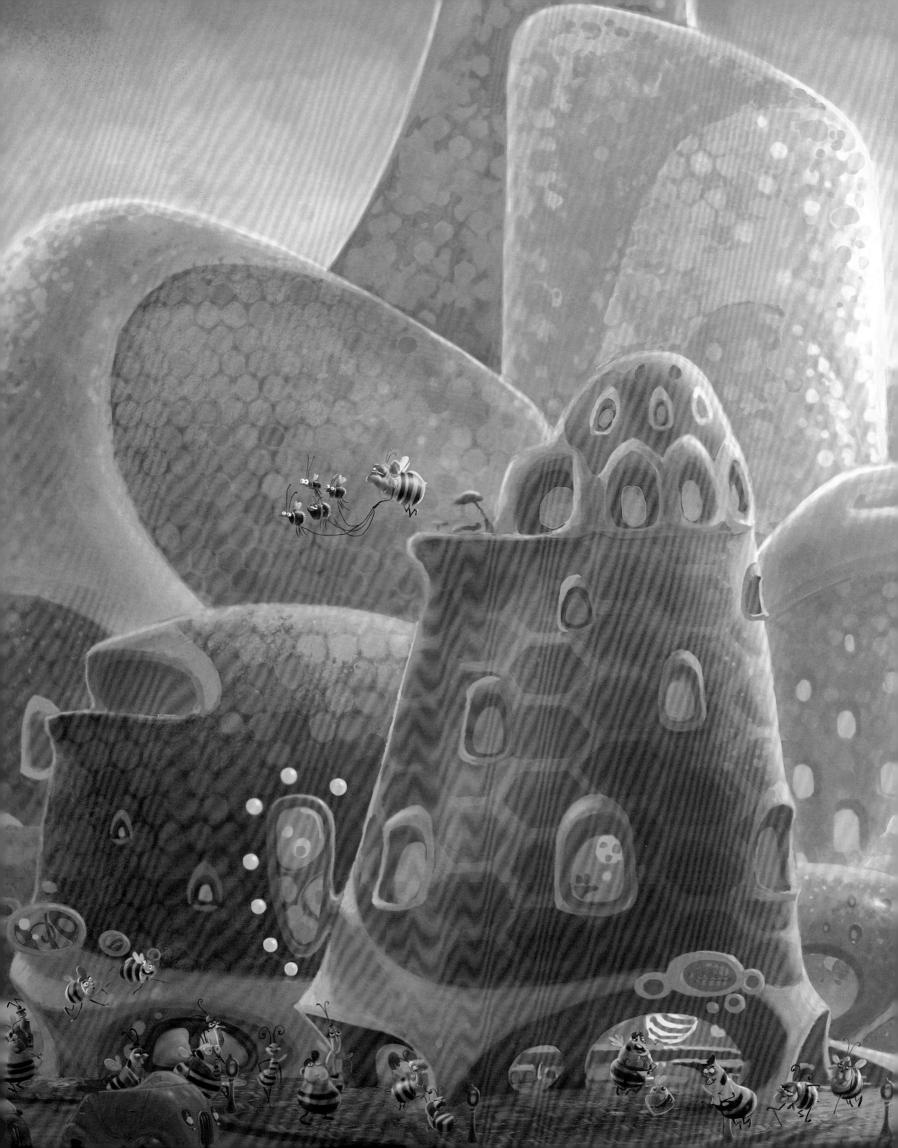

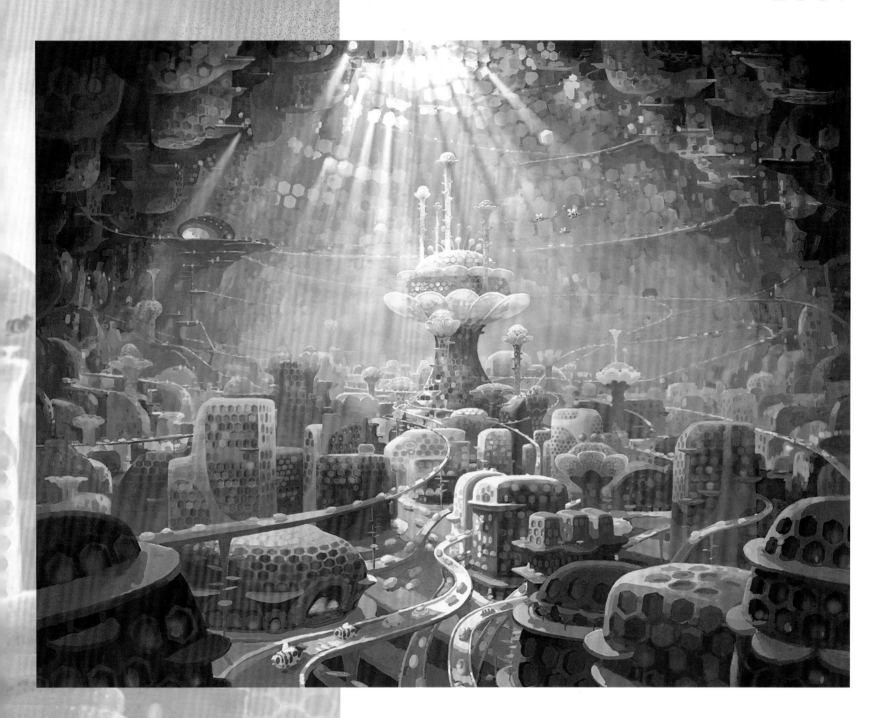

"We didn't want just a honey-colored palette for the bee world. That would be dull, so our character designer, Christophe Lautrette, looked at honey very closely. There are lots of different colors in honey, shades of purples, oranges, etc., so that allowed us to go beyond a monochromatic world inside the beehive."

Steve Hickner, Director

Directors	**Simon J. Smith, Steve Hickner**
Producers	**Jerry Seinfeld, Christina Steinberg**
Associate Producer	**Cameron Stevning**
Production Designer	**Alex McDowell, RDI**
Art Direction and Character Design	**Christophe Lautrette**
Visual Effects Supervisor	**Doug Cooper**

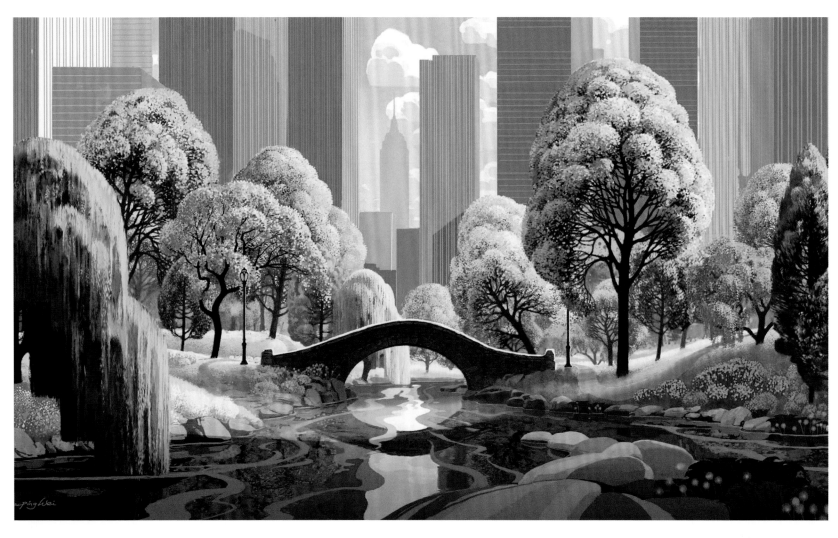

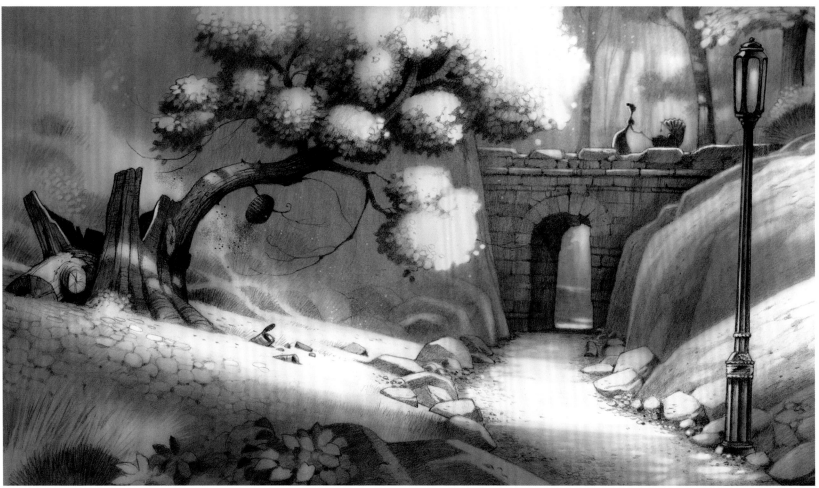

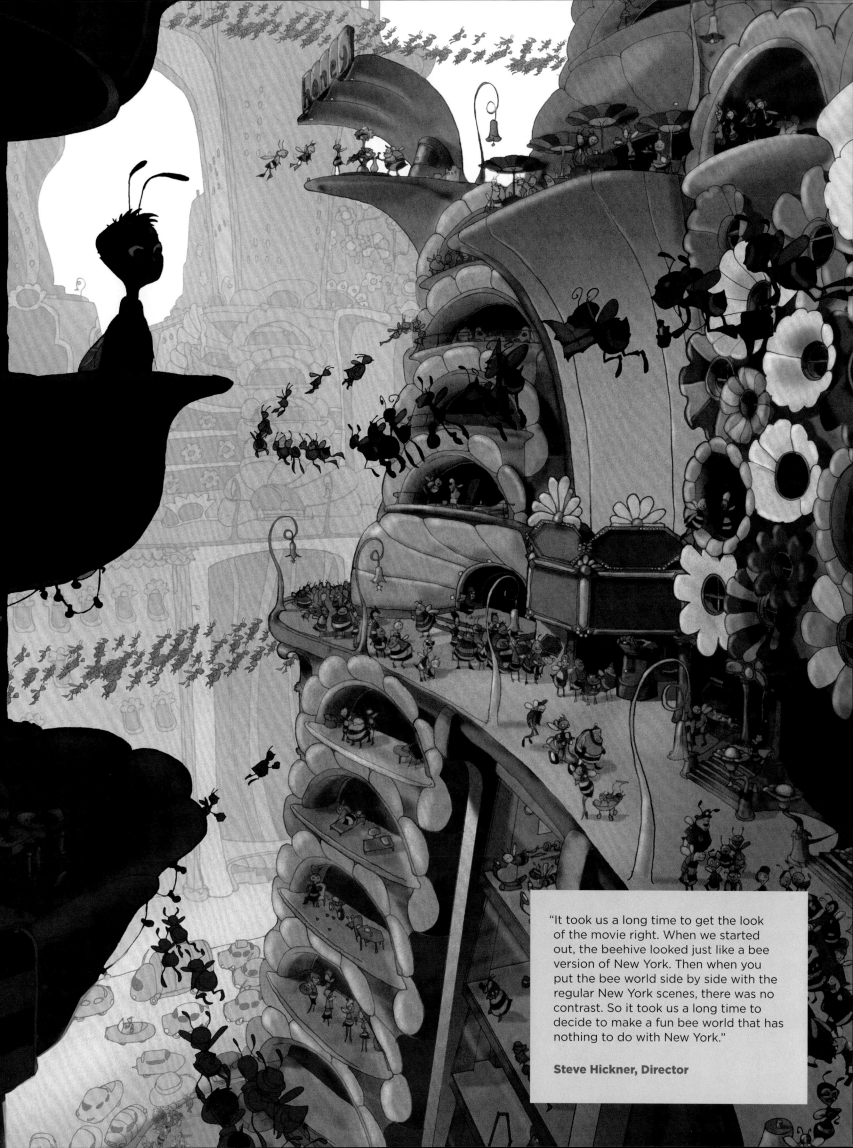

"It took us a long time to get the look of the movie right. When we started out, the beehive looked just like a bee version of New York. Then when you put the bee world side by side with the regular New York scenes, there was no contrast. So it took us a long time to decide to make a fun bee world that has nothing to do with New York."

Steve Hickner, Director

primary
reservoirs

steam
valves

secondary
reservoirs

testing
area

triple filter

administration
area

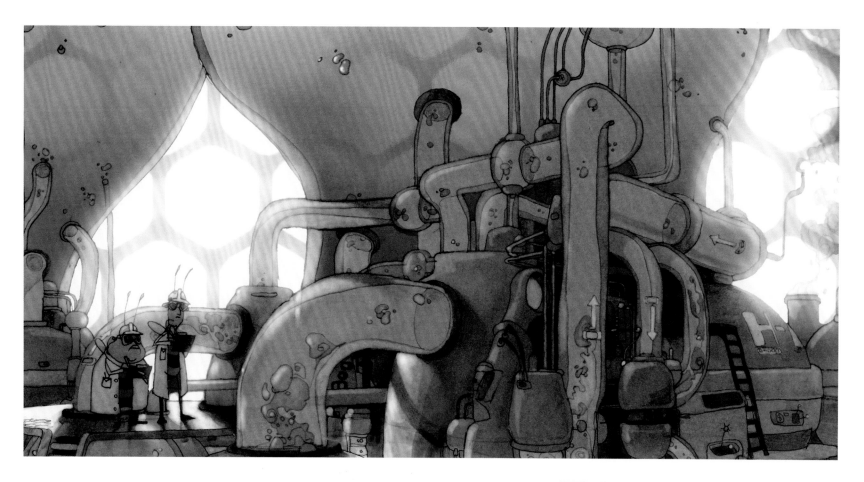

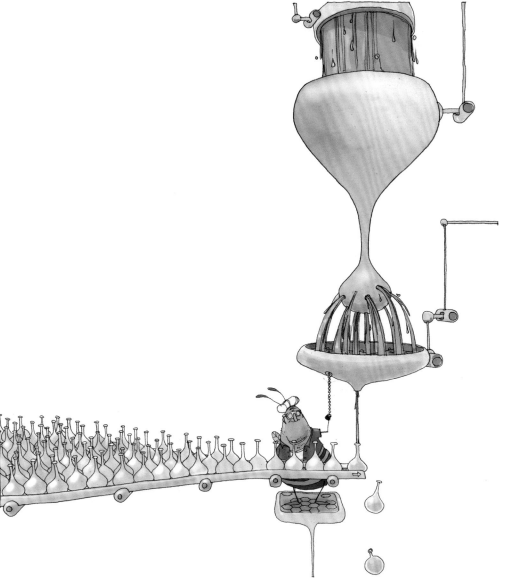

"The thing I recall about *Bee Movie* was the time we spent designing the bee-hive world—we wanted it to be small and organic, but also whimsical and fun. But we wanted the bee world to be in sharp contrast with the human world, which ended up having lots of straight lines, metals, and ultimately, being quite cold. If I could do it again, I wouldn't make the human world so cold, because it really shaped the whole movie. But you learn from your mistakes."

Christophe Lautrette, Art Director

"Bees are very fashion-conscious, except they can't veer from black and yellow. That's it. They don't wear any other colors. But within that, they're very stylish. In the early character designs, Barry looked a little like me in a sweater, which wasn't quite right, so he became, well, rounder and kind of sillier-looking. That worked for me."

Jerry Seinfeld, Producer

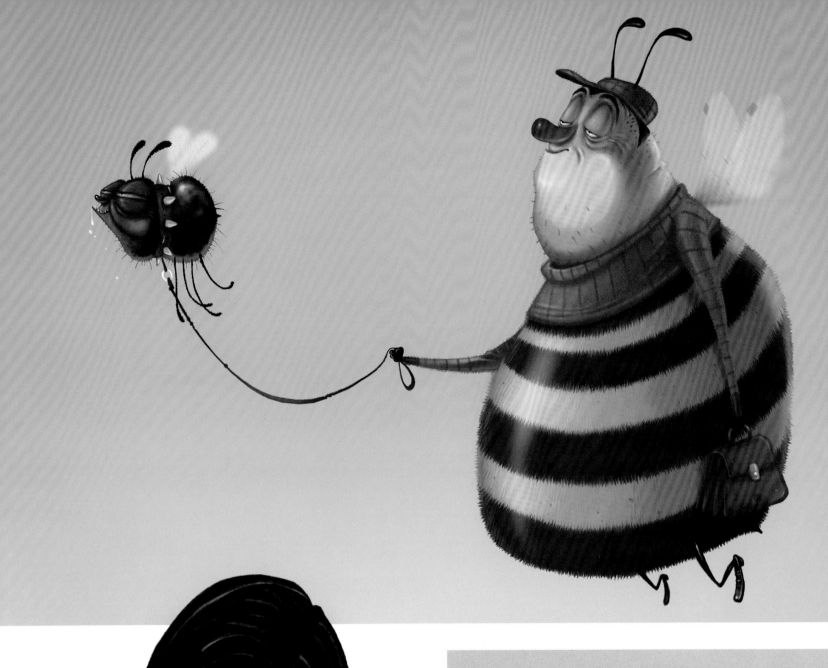

"Renée Zellweger's character, Vanessa, took up most of our rig-wrecking time. In many ways, she was the biggest accomplishment of the film. We made a human female character who's believable, appealing, and stylized."

Doug Cooper, Visual Effects Supervisor

"One of the main challenges of that movie was the scale because you had a human being who had a relationship with this one-inch-tall bee. If we had to work in stereoscopic 3D like they do now, we would have run into some trouble because some of the cheats that we were doing worked fine on a flat 2D movie. Sometimes Barry the Bee was a quarter of an inch from the camera and the human would have to be way across the room to make the shot work. This would definitely not have worked in a 3D space. We lucked out because as it turned out, we were one of the studio's last nonstereoscopic movies."

Steve Hickner, Director

"Jerry is a huge car aficionado and the cars that the characters drove were important to him. I think one of his friends who designs cars for Porsche created some designs for what a bee version of the car would be. . . . We took it to a more fanciful level than just original cars."

Steve Hickner, Director

"I remember at one point in the movie someone said, 'Hey, how come Barry doesn't know the difference between a light bulb and the sun, but he knows about *Italian Vogue* and TiVo? It doesn't make sense!' Jerry said, 'Look, you either like Yogi Bear's tie or you don't, but we're not going to discuss why the bear is wearing a tie. That's the essence of comedy. You either get it or you don't. If you have to explain the world, it's not going to be funny. The bear is wearing a tie and that's it!' "

Steve Hickner, Director

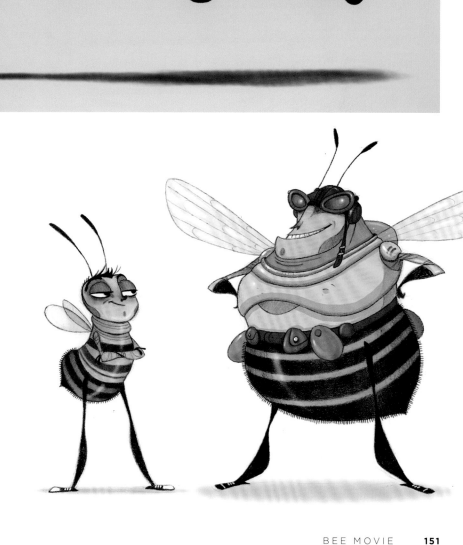

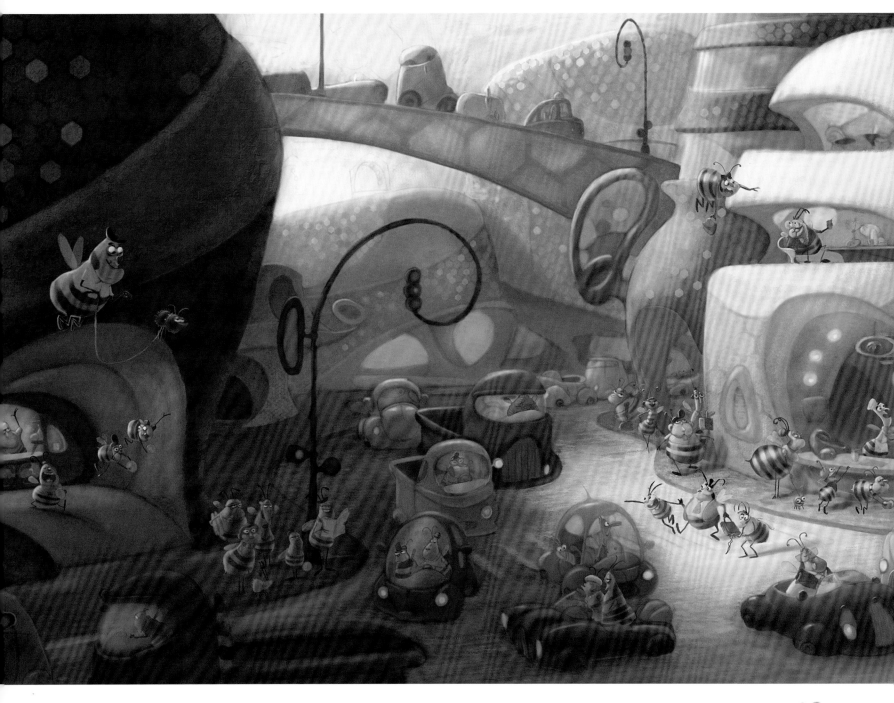

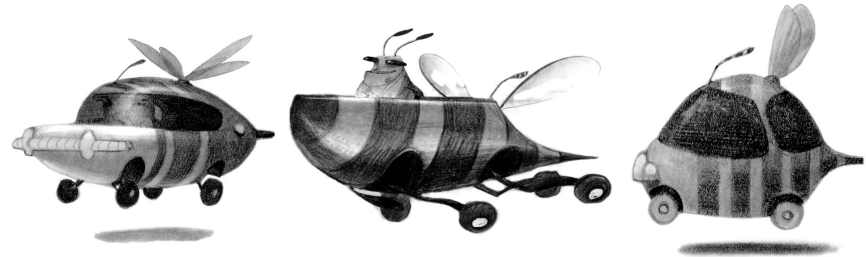

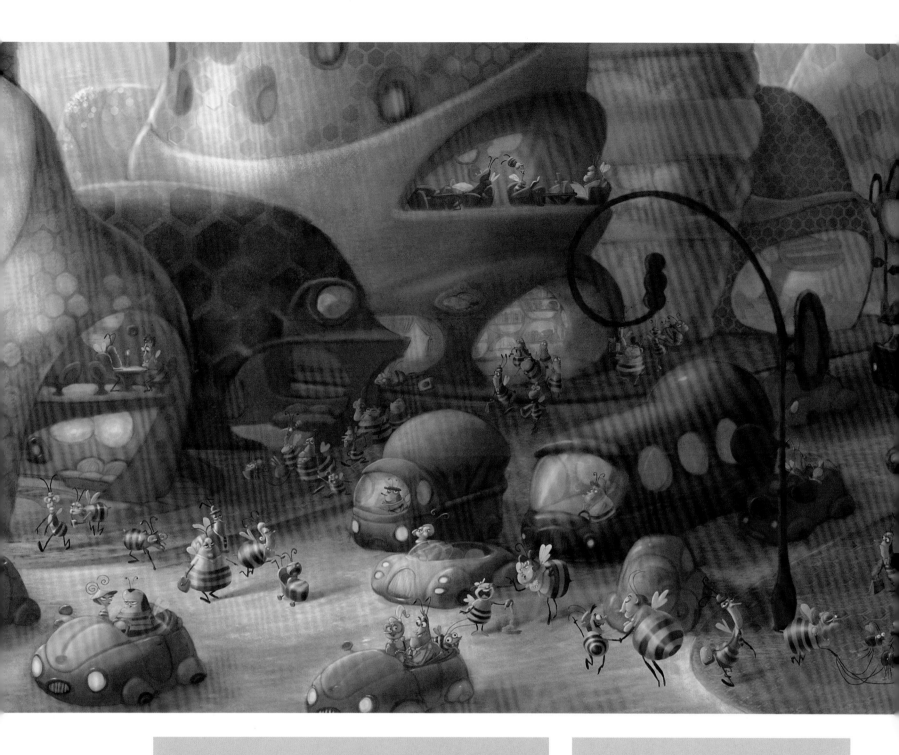

"I think there may have been a moment when Jerry thought he would just turn over the script to us and we would make the movie and he would show up at the premiere. And then he ended up living at the studio and being involved every day for at least eight hours a day. For the animators, what Jerry brought was access to him both as one of the writers of the movie and its lead actor. He performed every line for them—doing his own stand-up in front of them twice a day. And they literally got a three-hour daily session during which they could mimic and learn from him. You started out learning about his acting and his style, and ended up absorbing his comedic timing."

Christina Steinberg, Producer

"I have used the analogy of a sandbox before, but animation is like creating in a big sandbox. It's like they say to you, 'We are gonna give you a sandbox in which you can make anything you want. You can mold the sand into any shape, into any character—you can do it in any way, in any style, and create any universe you wish. But we're gonna give you the sand one grain at a time, and it's gonna take you four years.' That was the little catch."

Jerry Seinfeld, Producer

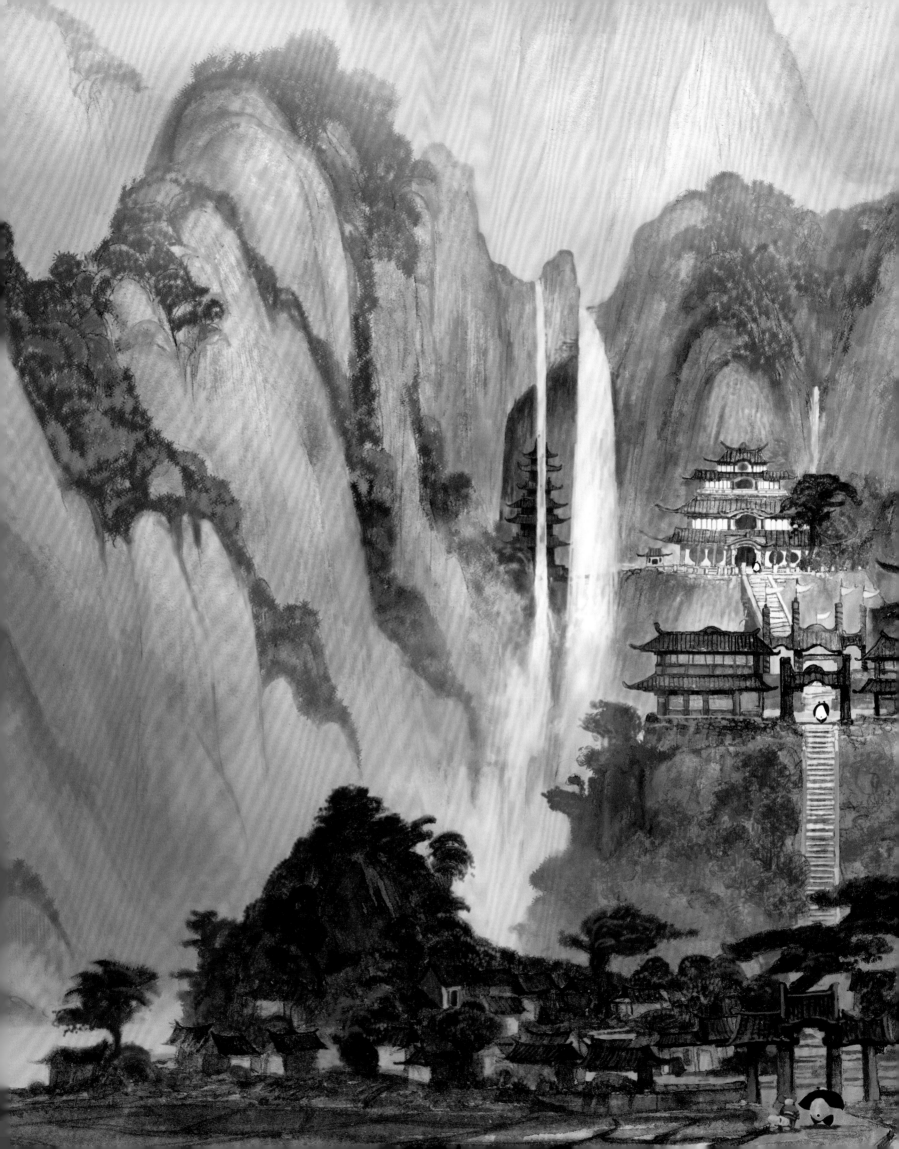

KUNG FU PANDA

2008

"Our big goal was to make the most beautiful kung fu film ever made. I loved that the movie was a great mix—that it ended up being a comedy that had poetic and dramatic moments, that it was a project with heavily art-directed moments but still could be a fish-out-of-water comedy about a panda. Everyone who worked on it was so proud of it, and they took some of the work they did on the film with them and are still using it."

Raymond Zibach, Production Designer

Directors	**John Stevenson, Mark Osborne**
Producer	**Melissa Cobb**
Executive Producer	**Bill Damaschke**
Co-Producers	**Jonathan Aibel, Glenn Berger**
Associate Producer	**Kristina Reed**
Production Designer	**Raymond Zibach**
Art Director	**Tang Kheng Heng**
Visual Effects Supervisor	**Markus Manninen**

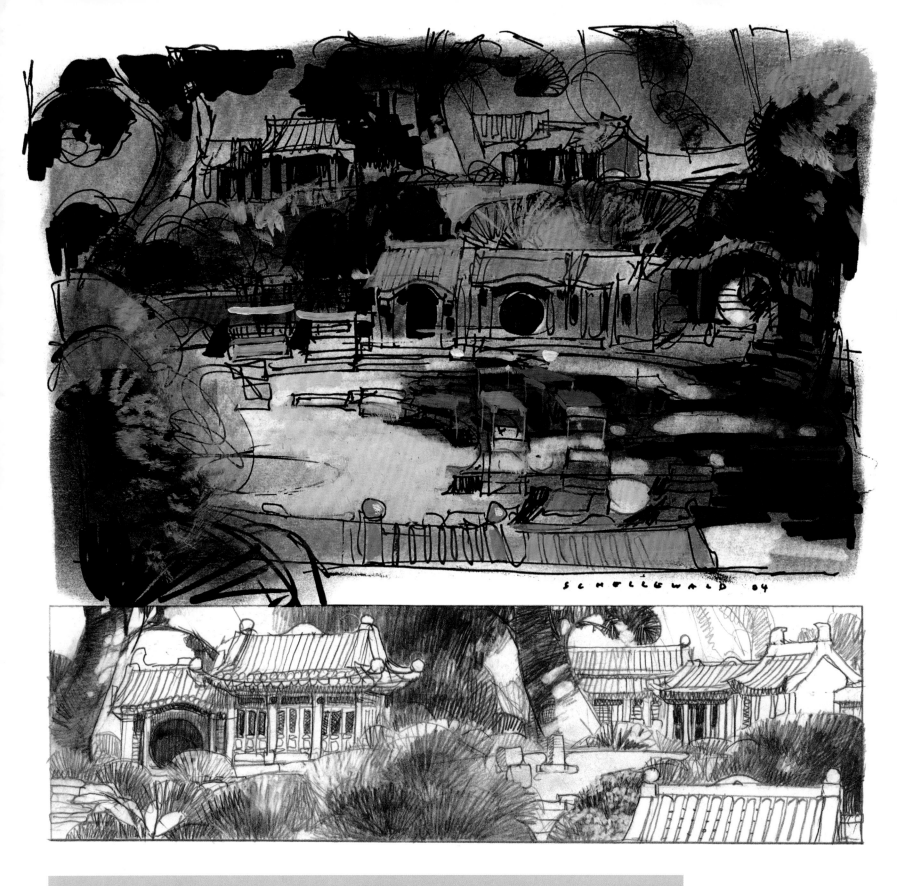

"We weren't able to go to China for the first *Kung Fu Panda* movie, but fortunately, we got to visit between the two movies for the first time and do hands-on research. When people found out who we were, we would be mobbed on the streets, and they were amazed by the fact that a group of artists in Glendale, California, had captured the art, the spirit, and all the details of their culture in an animated movie. They were struck by things that you wouldn't notice in a million years—like the color of the jade on a scroll. They'd say, 'The color of the jade is exactly right.' It's so interesting how those little details shape someone's perception of your work."

Melissa Cobb, Producer

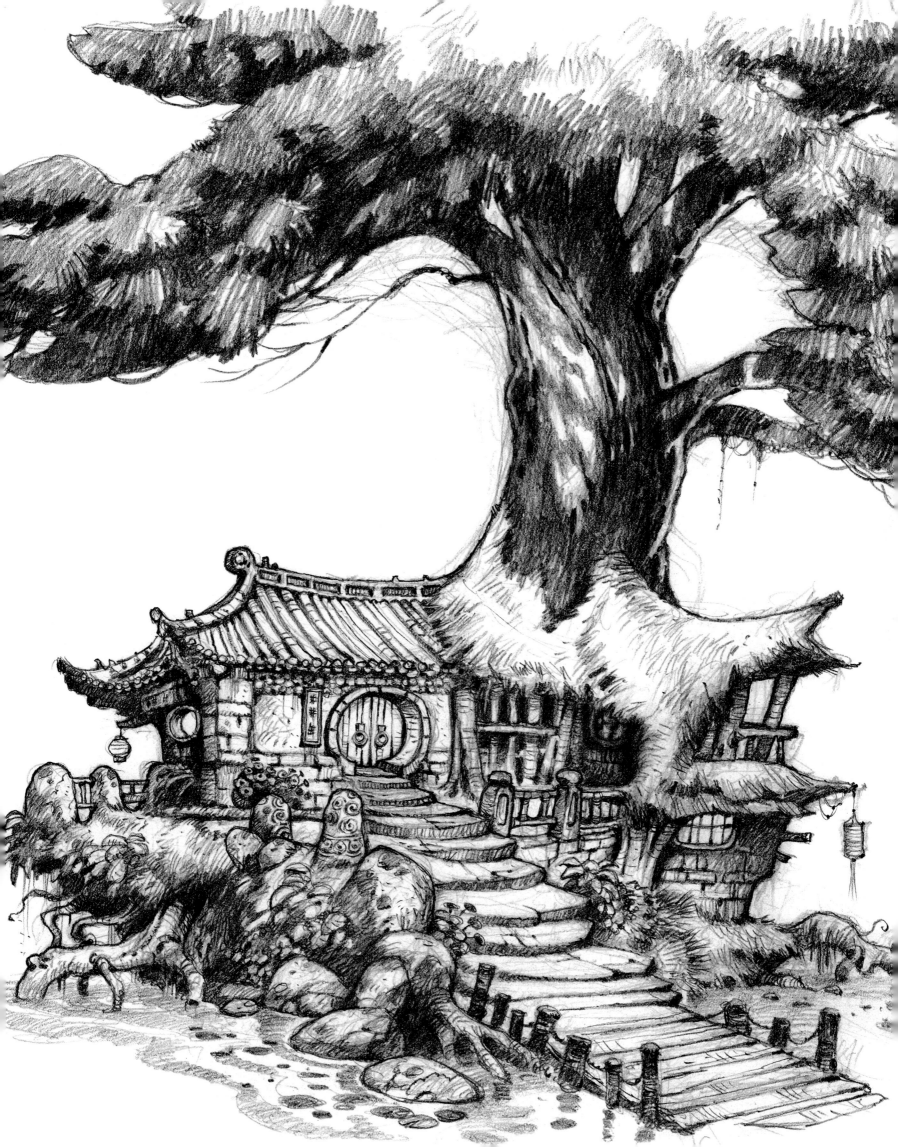

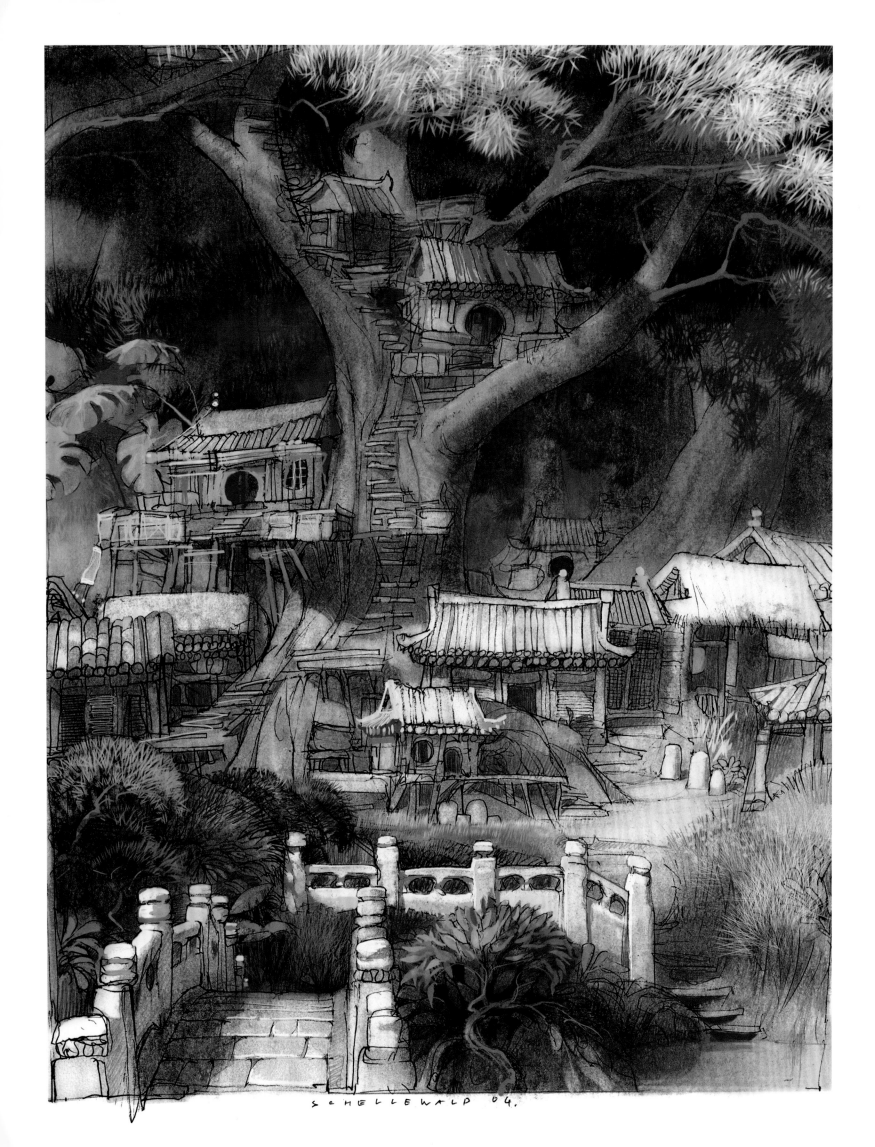

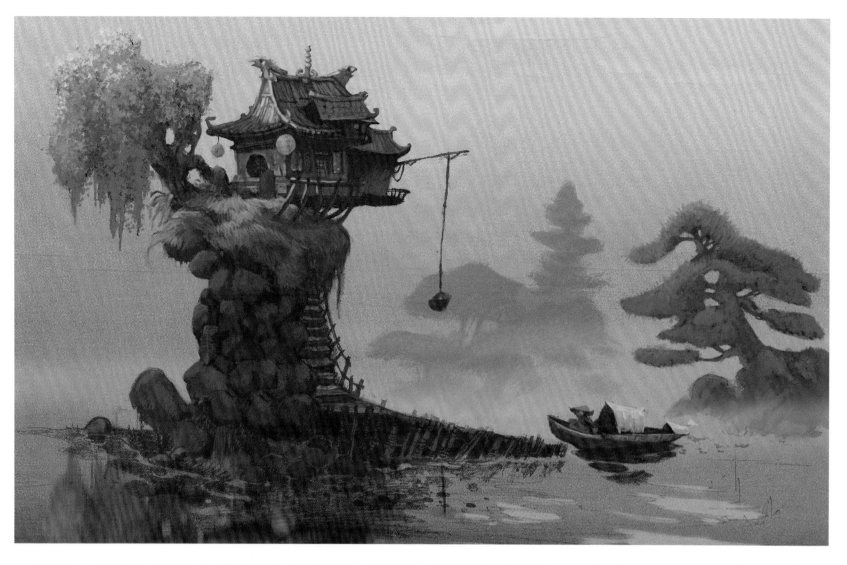

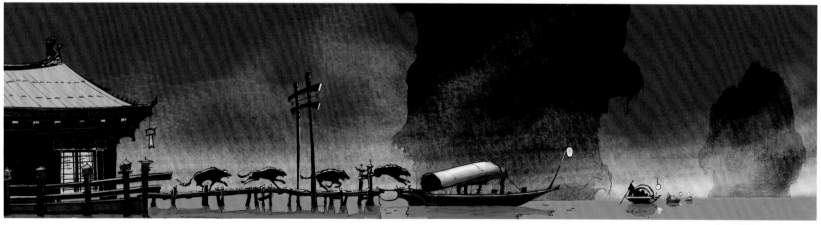

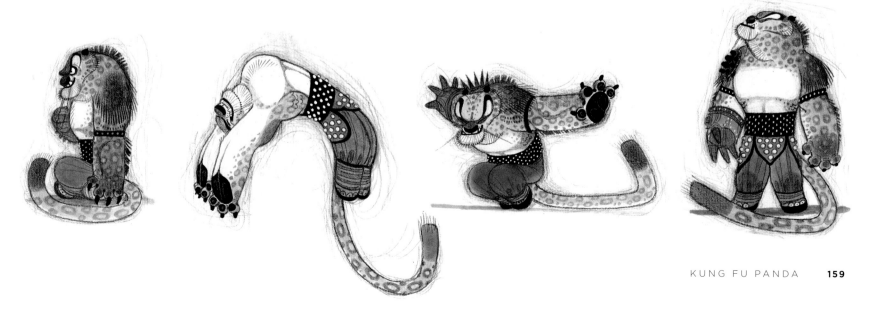

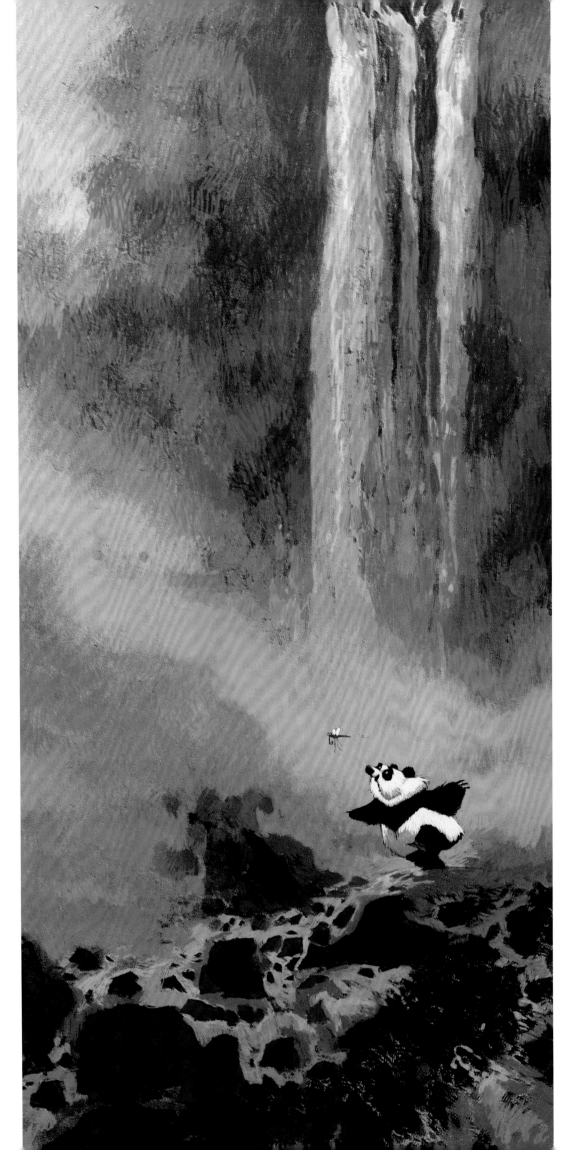

"People seem to relate to the movie's main character, Po, on a basic level. He has this insecurity that he never loses, and I believe he'll have it through every movie that we make about him. Even though his situation is different—he's in ancient China and he's fighting a bird or a cat—he still has that human vulnerability. Even when he tied himself to a chair with a rocket, flung himself in the air, and got smashed into the ground like Wile E. Coyote, he still has grounded human emotions. The physical stuff is crazy but the emotions are real."

Melissa Cobb, Producer

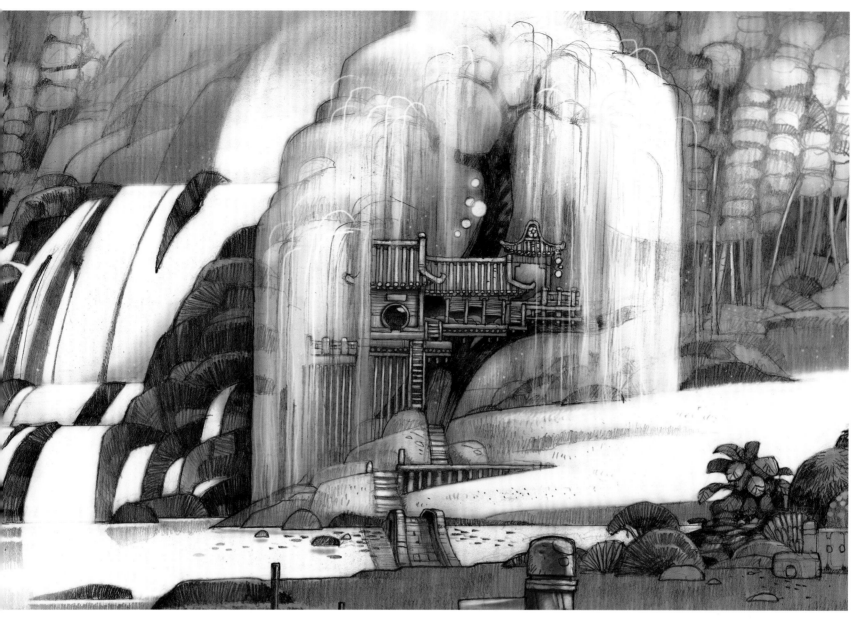

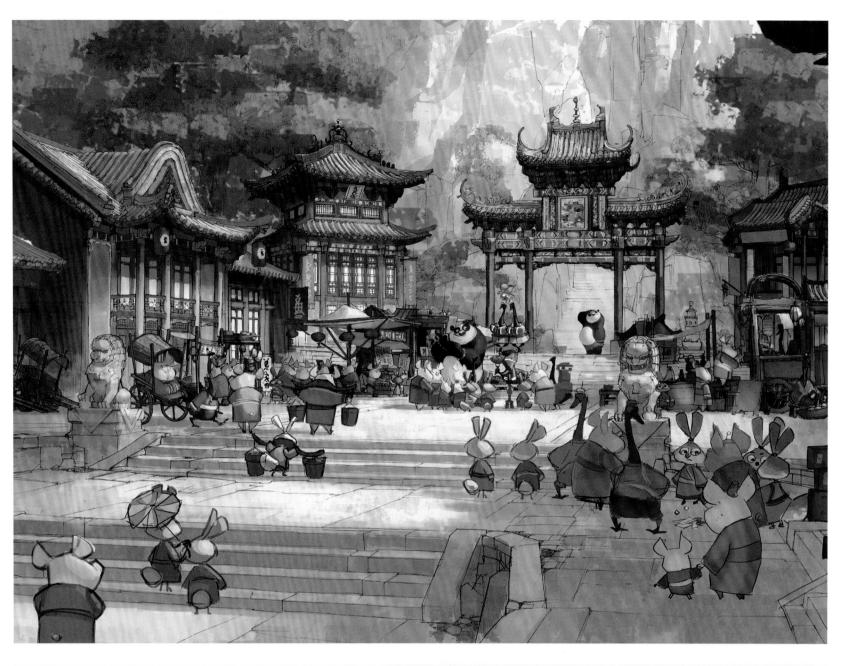

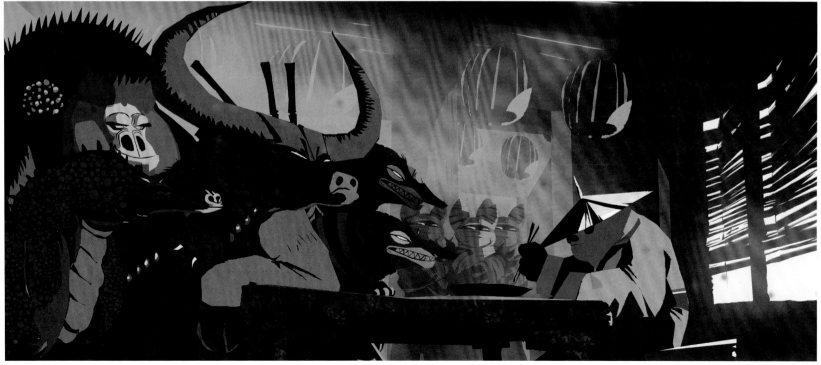

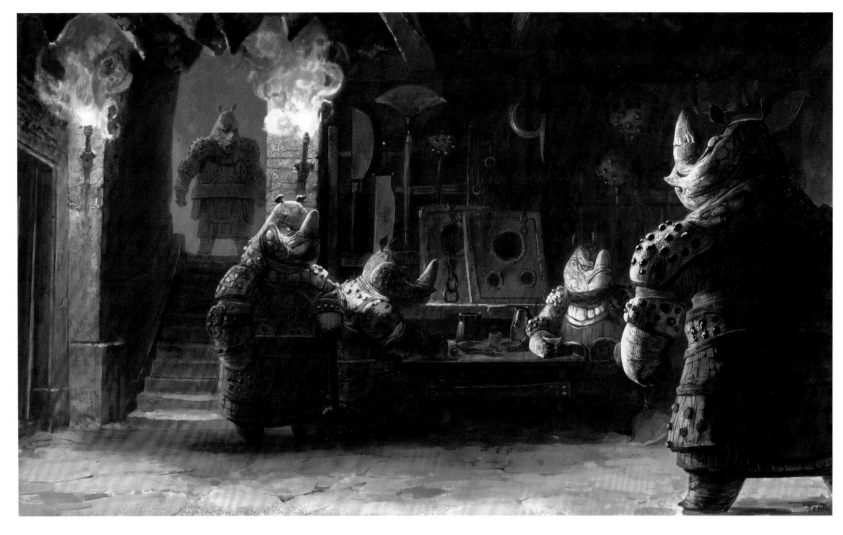

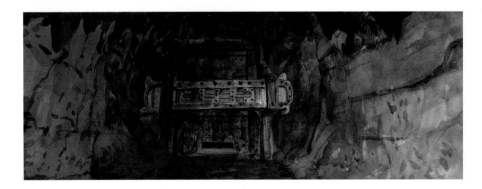

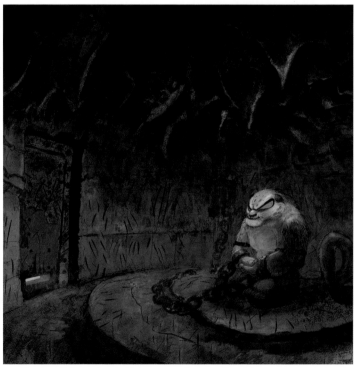

"We all wanted to see really adorable stuffed animals beat the crap out of each other."

Mark Osborne, Director

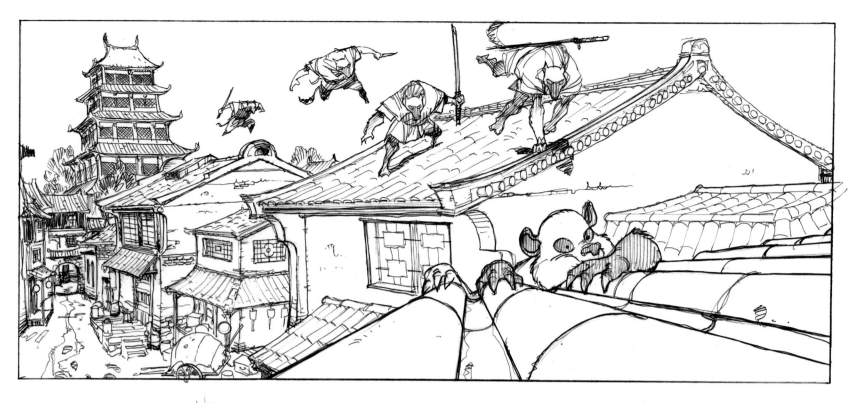

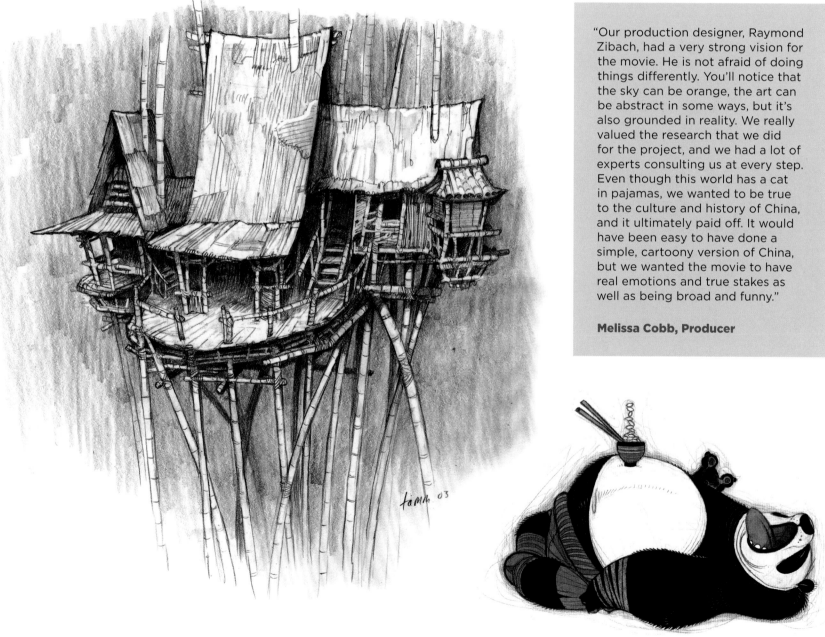

"Our production designer, Raymond Zibach, had a very strong vision for the movie. He is not afraid of doing things differently. You'll notice that the sky can be orange, the art can be abstract in some ways, but it's also grounded in reality. We really valued the research that we did for the project, and we had a lot of experts consulting us at every step. Even though this world has a cat in pajamas, we wanted to be true to the culture and history of China, and it ultimately paid off. It would have been easy to have done a simple, cartoony version of China, but we wanted the movie to have real emotions and true stakes as well as being broad and funny."

Melissa Cobb, Producer

MADAGASCAR
ESCAPE 2 AFRICA
2008

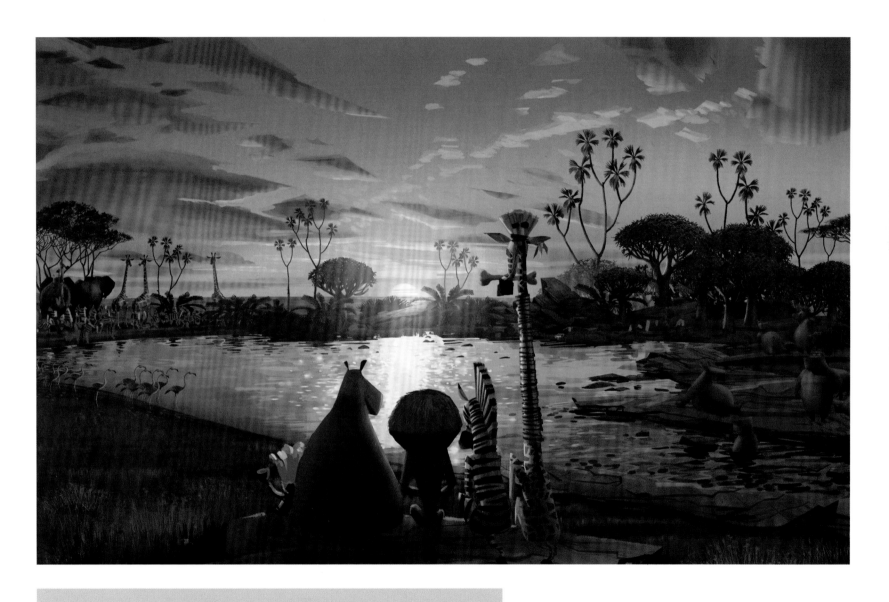

"There is something about the design that people love. And I think that's part of it—they're very graphic—along with being smart and funny. The first movie was about the importance of friendship and what it means to be a good friend. One of the things that is so great about New York is its diversity, and that is reflected in our group—a lion, a giraffe, a zebra, and a hippo who are best friends. And that was something we thought we could explore even further. And we could also celebrate that."

Mireille Soria, Producer

Directors	**Eric Darnell, Tom McGrath**
Producers	**Mireille Soria, Mark Swift**
Production Designer	**Kendal Cronkhite**
Art Director	**Shannon Jeffries**
Visual Effects Supervisor	**Philippe Gluckman**

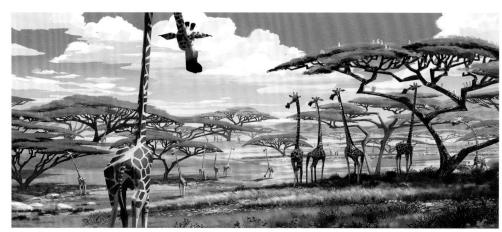

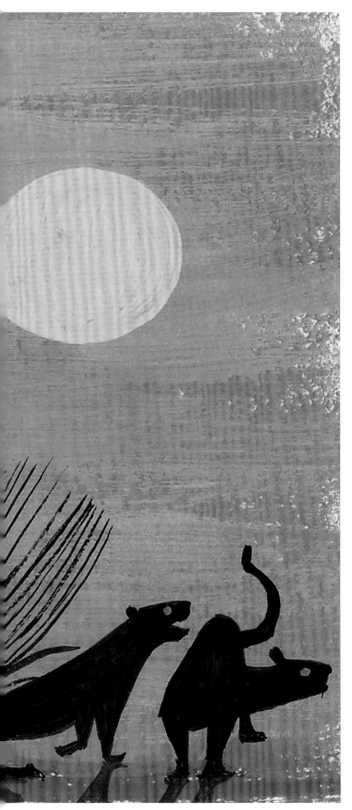

"It was one of those instances when art and technological capability just had to go hand in hand. There are shots in *Madagascar 2* where the savannah stretches on for miles and miles, and there are literally a million blades of grass waving in the wind. Each of them is independent from the others, which is computationally intensive, but worth it. It grabs you and puts you inside that world. You feel like this place is real. You get this sense that you know exactly what it would feel like when you put your bare foot down on this soil—to run your hand through that grass. We couldn't have achieved that level of complexity in the first *Madagascar* movie."

Eric Darnell, Director

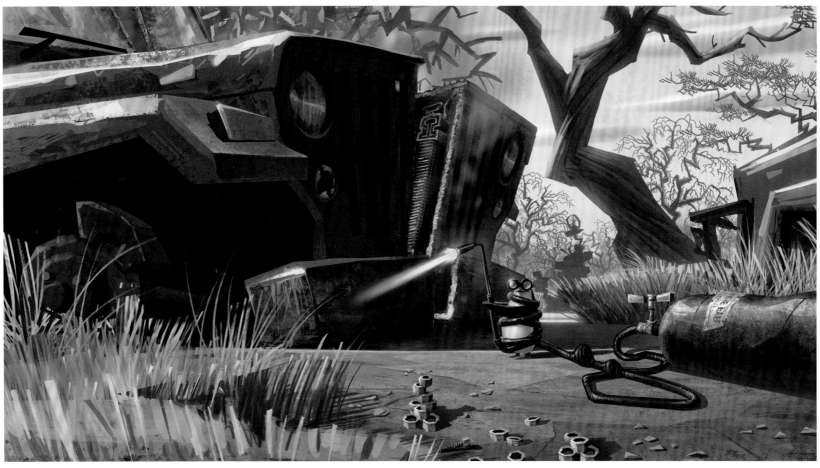

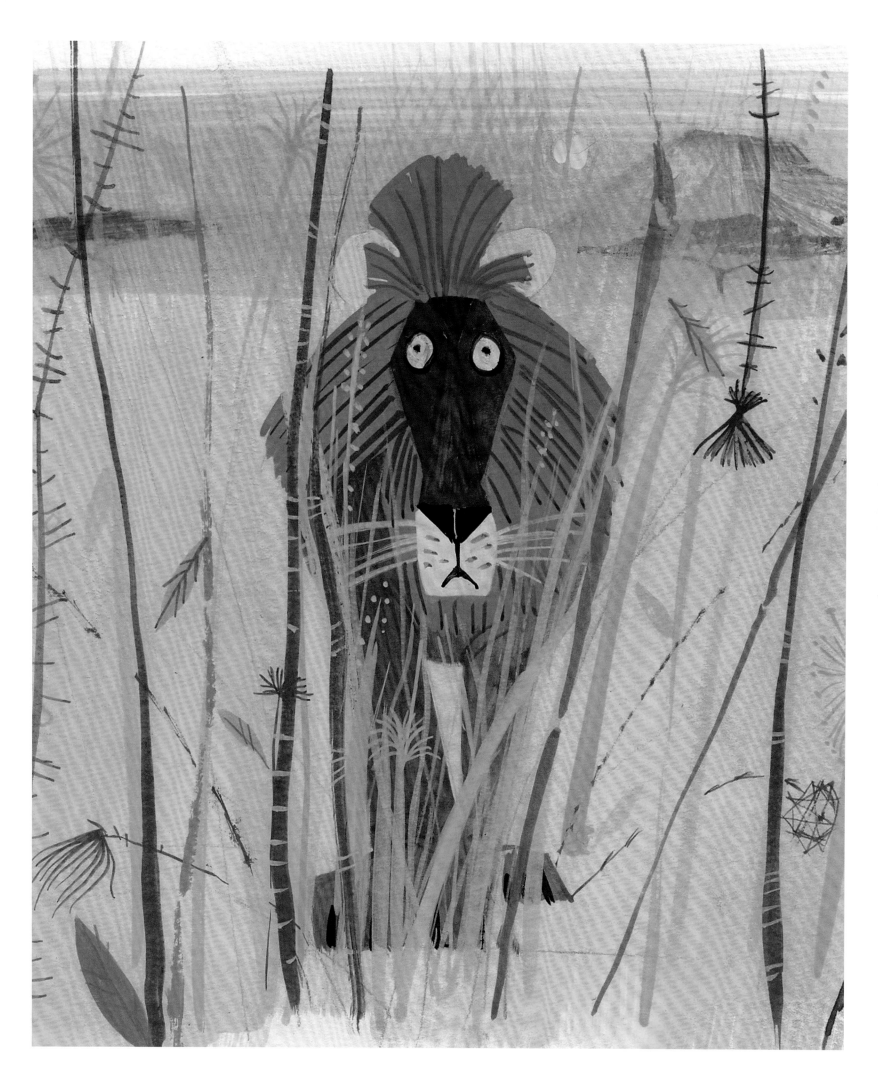

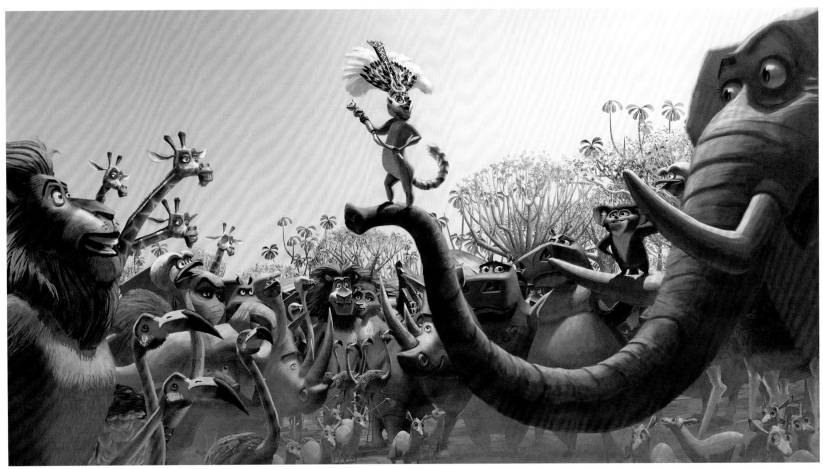

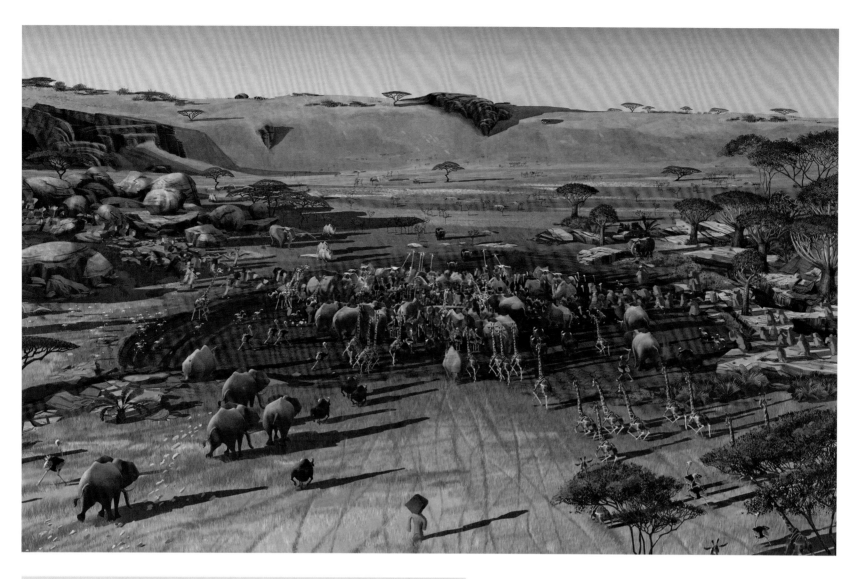

"We were brainstorming about what the second movie was going to be about while the first one was still in theater. I remember talking about the movie to Jeffrey [Katzenberg] with Mireille and Eric on a flight to Norway because he had business there, and we came up with the idea of the gang going to Africa. So we all actually visited Africa, which was mind-blowing and amazing. We took over 15,000 photos and numerous hours of video footage as blueprints for our adventure."

"When you get to Africa, you realize just how big the continent is. About two-thirds of what you see when you're there is sky. And we just realized that it also had to be a huge part of our set."

Tom McGrath, Director

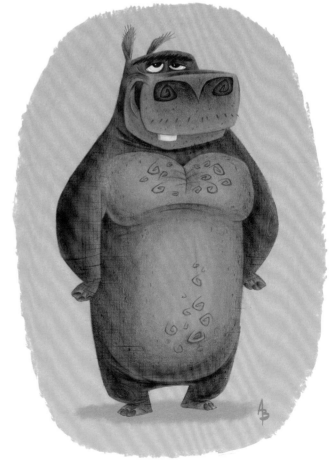

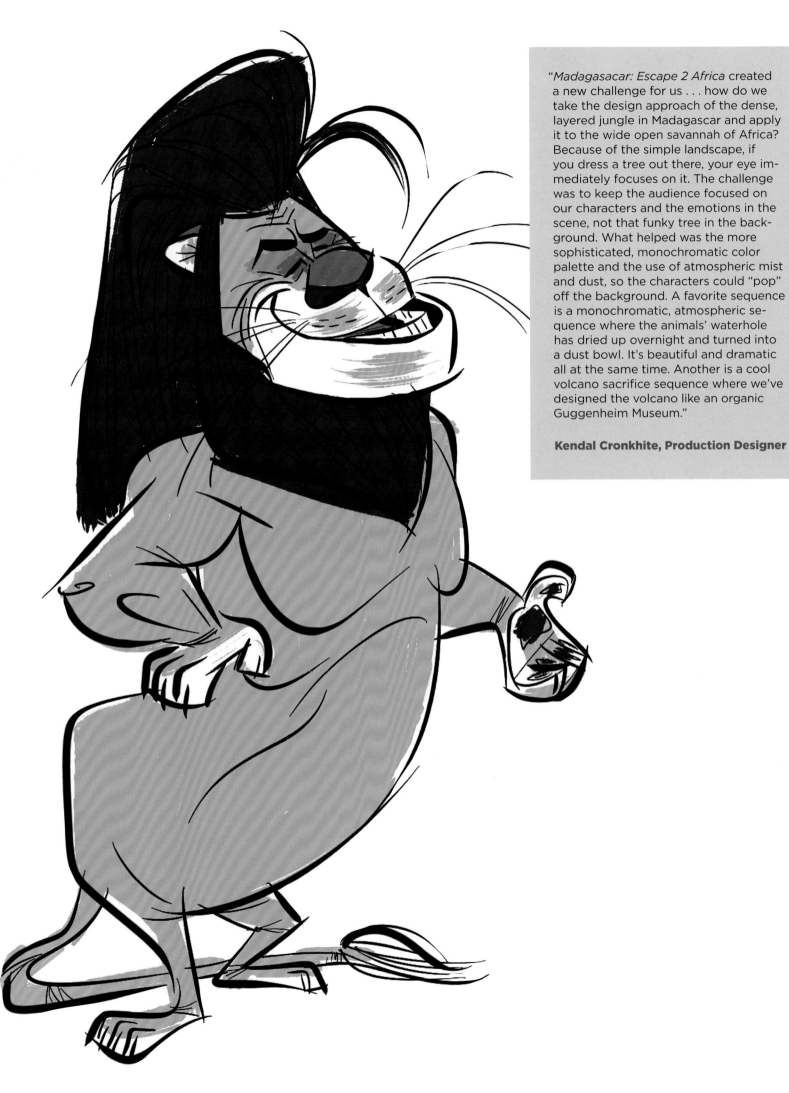

"*Madagasacar: Escape 2 Africa* created a new challenge for us . . . how do we take the design approach of the dense, layered jungle in Madagascar and apply it to the wide open savannah of Africa? Because of the simple landscape, if you dress a tree out there, your eye immediately focuses on it. The challenge was to keep the audience focused on our characters and the emotions in the scene, not that funky tree in the background. What helped was the more sophisticated, monochromatic color palette and the use of atmospheric mist and dust, so the characters could "pop" off the background. A favorite sequence is a monochromatic, atmospheric sequence where the animals' waterhole has dried up overnight and turned into a dust bowl. It's beautiful and dramatic all at the same time. Another is a cool volcano sacrifice sequence where we've designed the volcano like an organic Guggenheim Museum."

Kendal Cronkhite, Production Designer

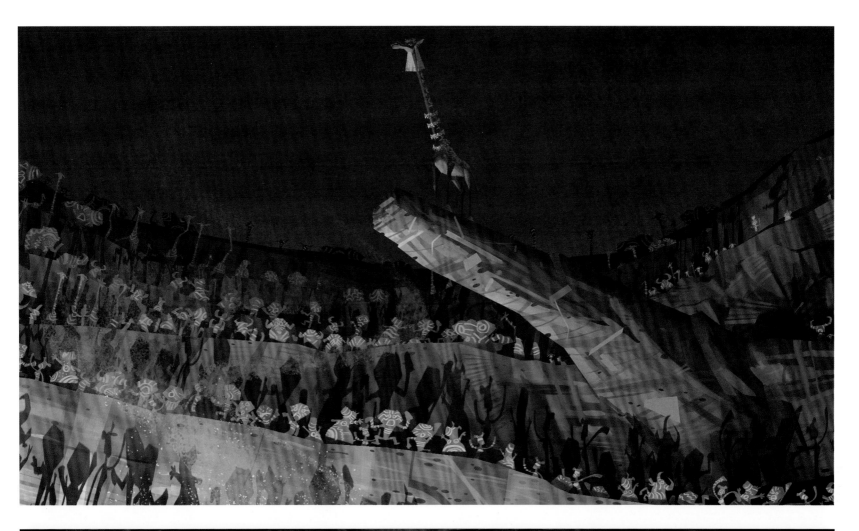

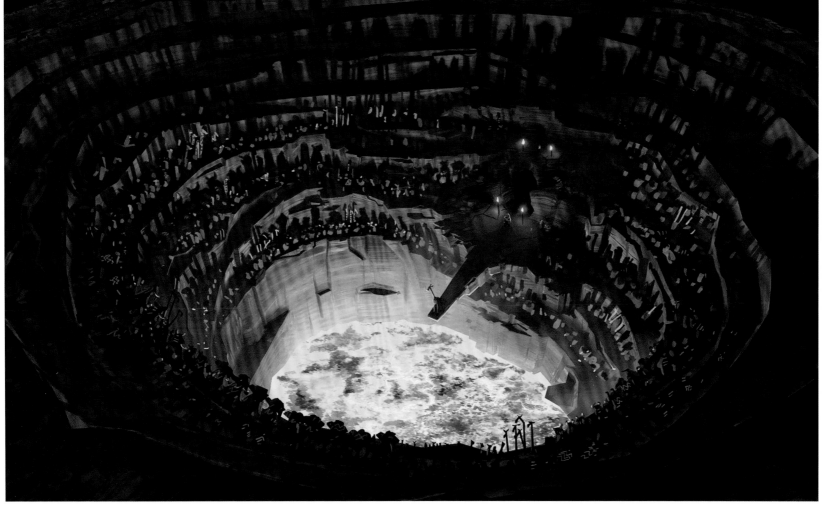

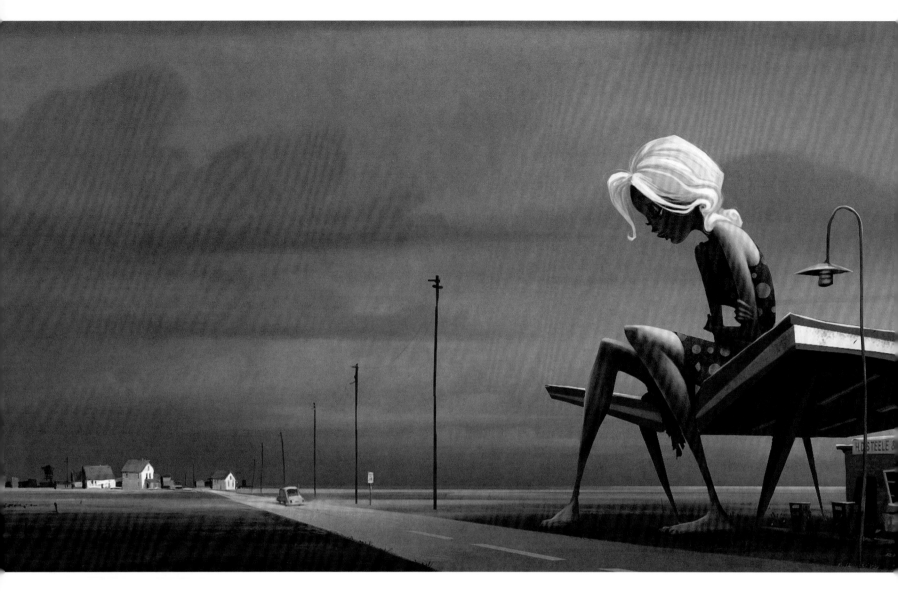
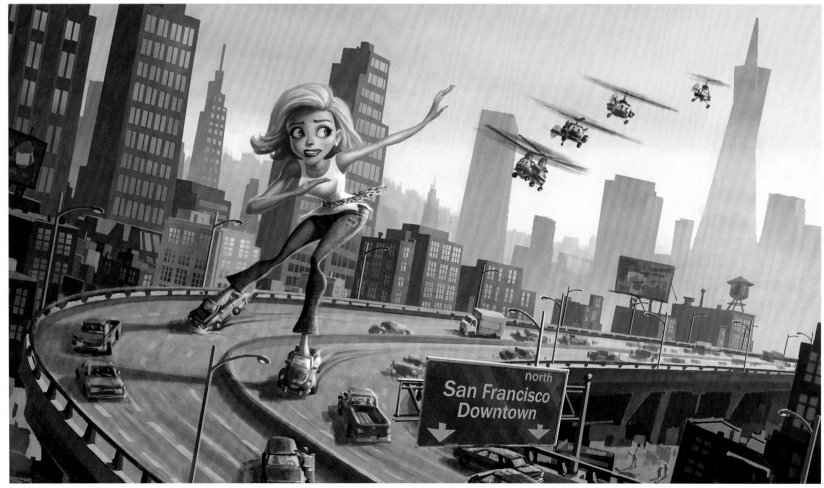

MONSTERS VS. ALIENS

2009

"I can clearly recall that one of the main things that made me want to get involved with this project was a piece of art depicting the movie's heroine, Susan, sitting sadly at this gas station. I immediately wanted to know more about her. Why is this enormous woman looking so heartbroken and why is she sitting there? What was her story? We also had the privilege of working with an unbelievably funny cast. And I loved the fact that our movie had such a strong female lead."

Lisa Stewart, Producer

Directors	**Conrad Vernon, Rob Letterman**
Producer	**Lisa Stewart**
Co-Producers	**Jill Hopper Desmarchelier, Latifa Ouaou**
Associate Producer	**Susan Slagle Rogers**
Production Designer	**David James**
Art Directors	**Scott Wills, Michael Isaak**
Visual Effects Supervisor	**Ken Bielenberg**

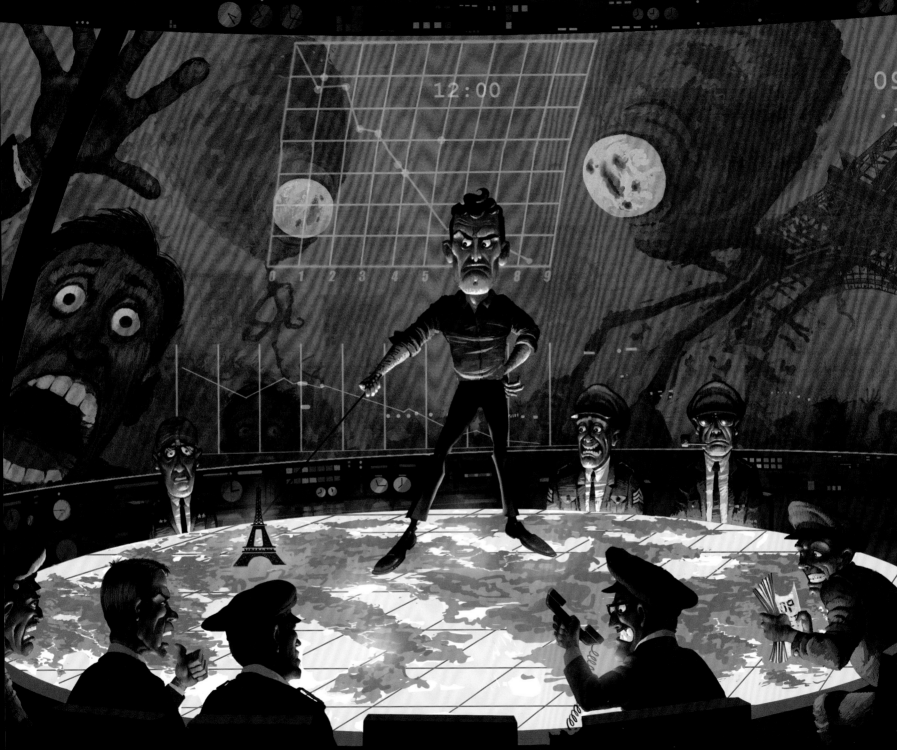

"That was one of the things that attracted me to the project, was just pushing it as far as we possibly could. And the funny thing is, we were already pushing the visual effects before we started down the road of 3D, so the 3D made it even bigger. The interesting thing was that 3D proved beneficial to our film's scale. Ginormica is 49 feet 11 inches tall; Insectosaurus is 350 feet tall. And we have other characters that are 6 or 8 feet tall. So we were dealing with a lot of scale—it would have been very difficult to put that kind of scale on a regular movie screen. But the 3D actually helped us enhance that and get the feeling of standing below a skyscraper, which is the size of some of these monsters. So it's not a gimmick as much as it's something that actually helped us, which is what attracted me to the whole process—it enabled us to tell our story."

Rob Letterman, Director

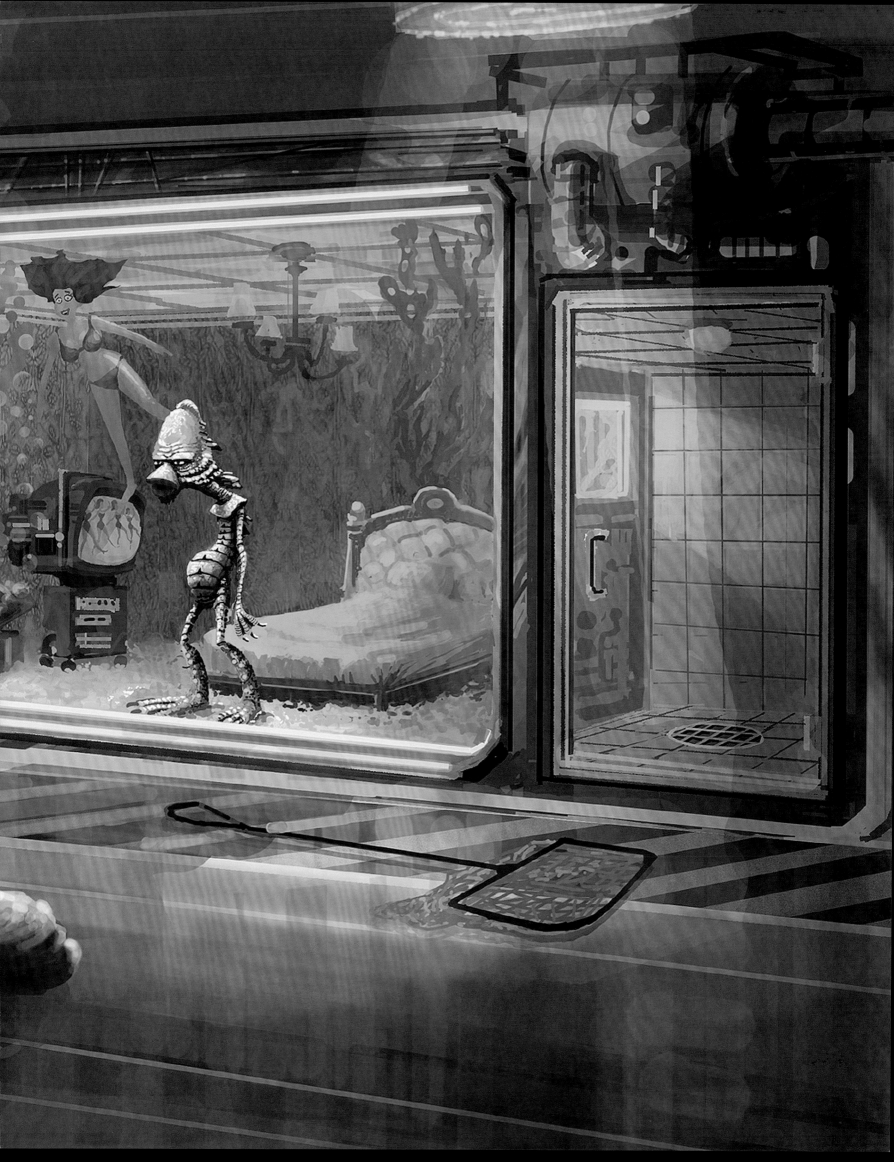

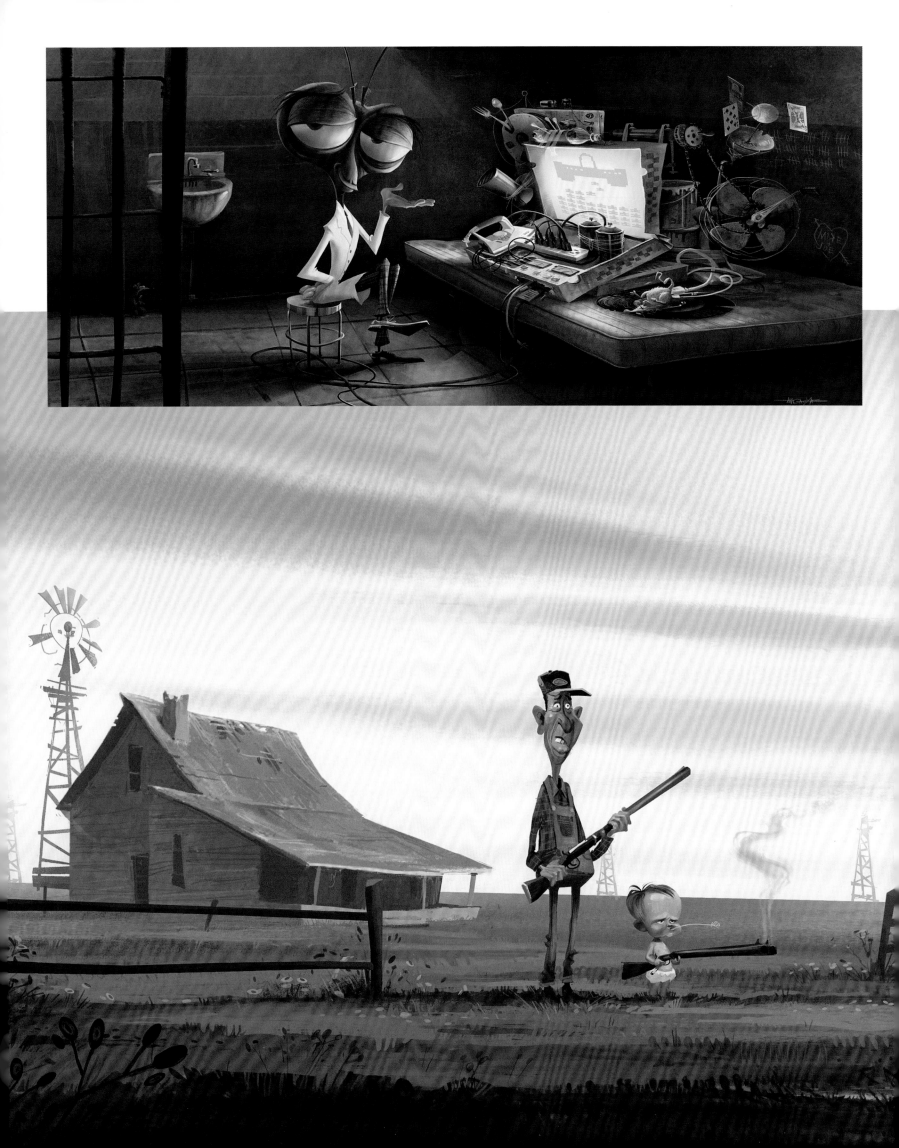

"Back when we started to work on *Monsters vs. Aliens*, there was a little bit of fear about doing CG-animated humans. We were doing a lot of anthropomorphic animals then. There was this thing called the uncanny valley which was the more realistic you made the humans, the creepier they looked. It caused the studio to shy away from putting humans into any other movies other than the sequels to *Shrek*. But I believed if you designed them to be more animated, more cartoony, the unsettling effect would not be there. People know what real humans look and act like because we watch and study them everyday in life, at work, on TV, on 30-foot movie screens. But cartoony humans wouldn't necessarily have to follow the rules of the way normal humans move and act. We could caricature them and the uncanny valley would cease to exist. People would accept that a cartoony human would move differently than a real one."

Conrad Vernon, Director

"Our production designer, David James, did a lot of research, looking at all the *Mad Magazine* styles, as well as actually going to San Francisco and taking thousands of pictures of streets, lamps, fire hydrants, and curbs and filtering all of those real images through the *Mad Magazine* sensibilities, making it all look very unique. Any time you take reference or inspiration and filter it through your brain, it's going to change it into something unique. He really did a wonderful job of adding that special 'wack factor,' skewing all the buildings and the Golden Gate Bridge ever so lightly. Our visual development artist Rachel Tiep-Daniels remodeled the entire Golden Gate Bridge in the same way and figured out how to break it down for the big destruction scene."

Conrad Vernon, Director

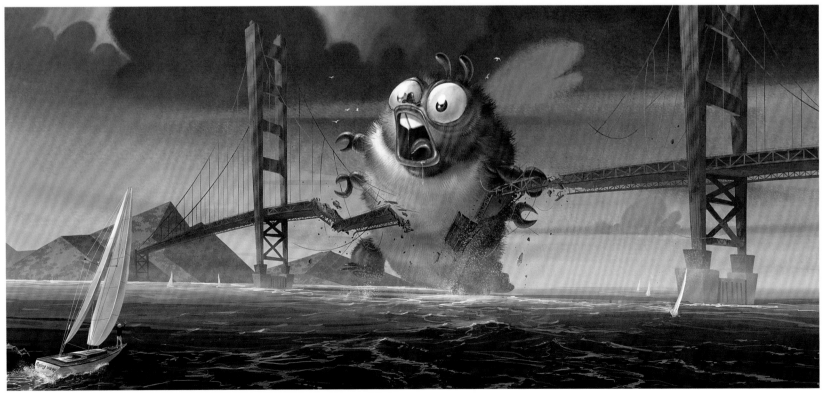

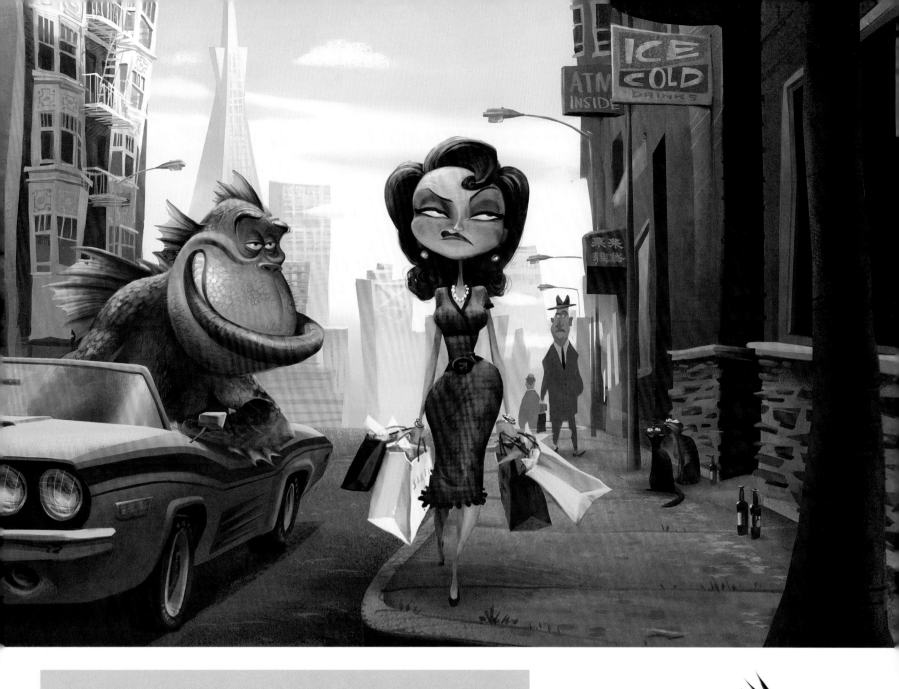

"*Monster vs. Aliens* is at its heart a very silly movie about what were, at heart, very silly movies. The design of the film pays homage to the golden age of B-movies with irreverence and affection. The whole production felt a bit like we were all reading *Mad Magazine* by flashlight after lights out. *Monsters* was also the first film that we made entirely with stereographic virtual filmmaking, which proved to be a huge learning experience for all of us. One of the most spectacular stereo moments in the film takes place on the Golden Gate Bridge as Ginormica and the other monsters battle a 450-foot-tall robot and in the process manage to destroy the middle section of the bridge. We actually chartered a helicopter so that we could photograph the entire structure to help us more convincingly demolish it. I live in the Bay Area and every time I cross the bridge I still get a little nervous on that one section."

David James, Production Designer

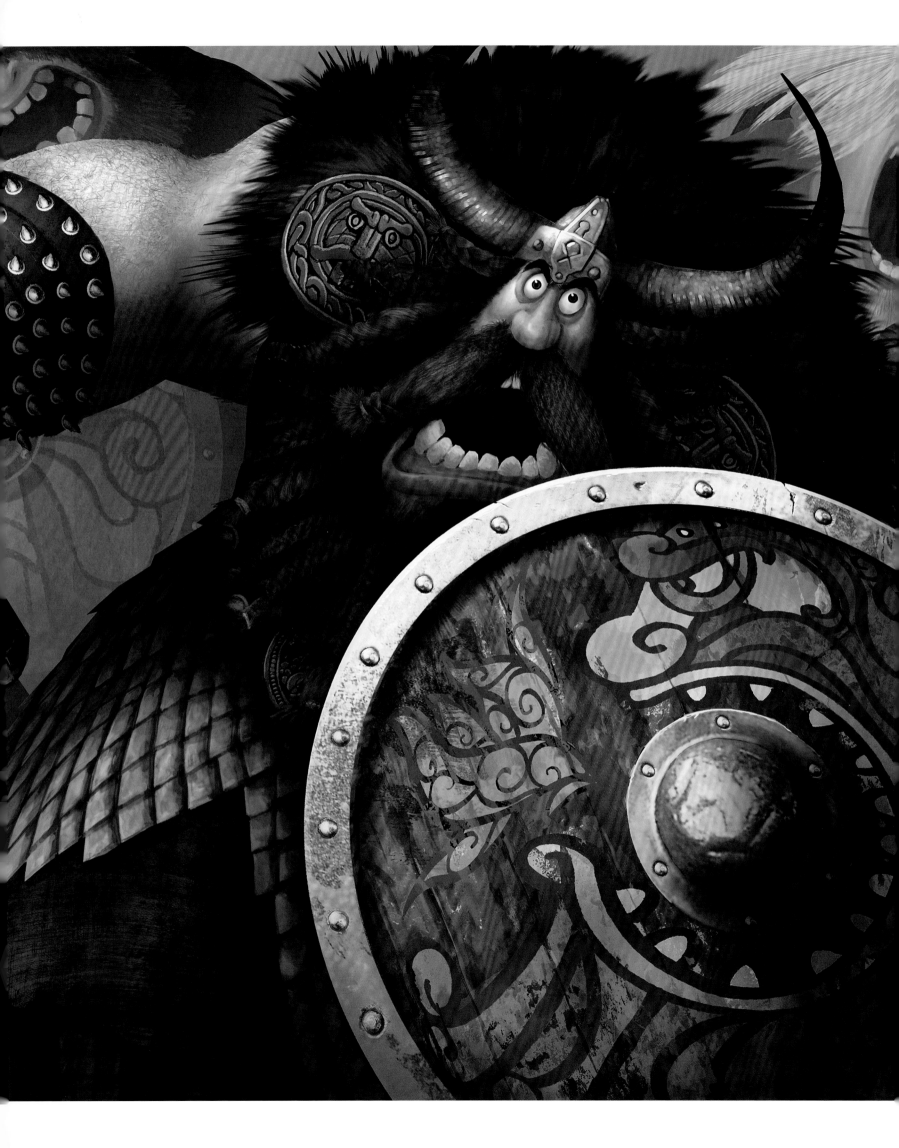

HOW TO TRAIN YOUR DRAGON

2010

"I wanted to work on *How to Train Your Dragon* because I felt a great connection with Cressida Cowell's story and characters. The directors, Dean DeBlois and Chris Sanders, took the book's narrative and gave it a real movie story. I think the audience relates to Hiccup's dilemma of feeling like an outsider. It's a very universal theme. Hiccup's relationship with his pet dragon, Toothless, was something that all audiences could identify with. He found something that he was good at, flying dragons, and that allowed him to be respected by his family, friends, and village. The interesting thing about Toothless is that it reminded people of their favorite cat, dog, horse. Everyone saw something in that dragon that made them remember their favorite pet. It was a simple story well told and that's the key to its appeal, whether you are six or sixty. We are still getting emails and letters from people all around the world who are just discovering the movie, and they are really looking forward to the second and third films."

Bonnie Arnold, Producer

Directors	**Chris Sanders, Dean DeBlois**
Producer	**Bonnie Arnold**
Executive Producers	**Kristine Belson, Tim Johnson**
Co-Producer	**Karen Foster**
Associate Producer	**Bruce Seifert**
Production Designer	**Kathy Altieri**
Art Director	**Pierre-Olivier Vincent "POV"**
Visual Effects Supervisor	**Craig Ring**

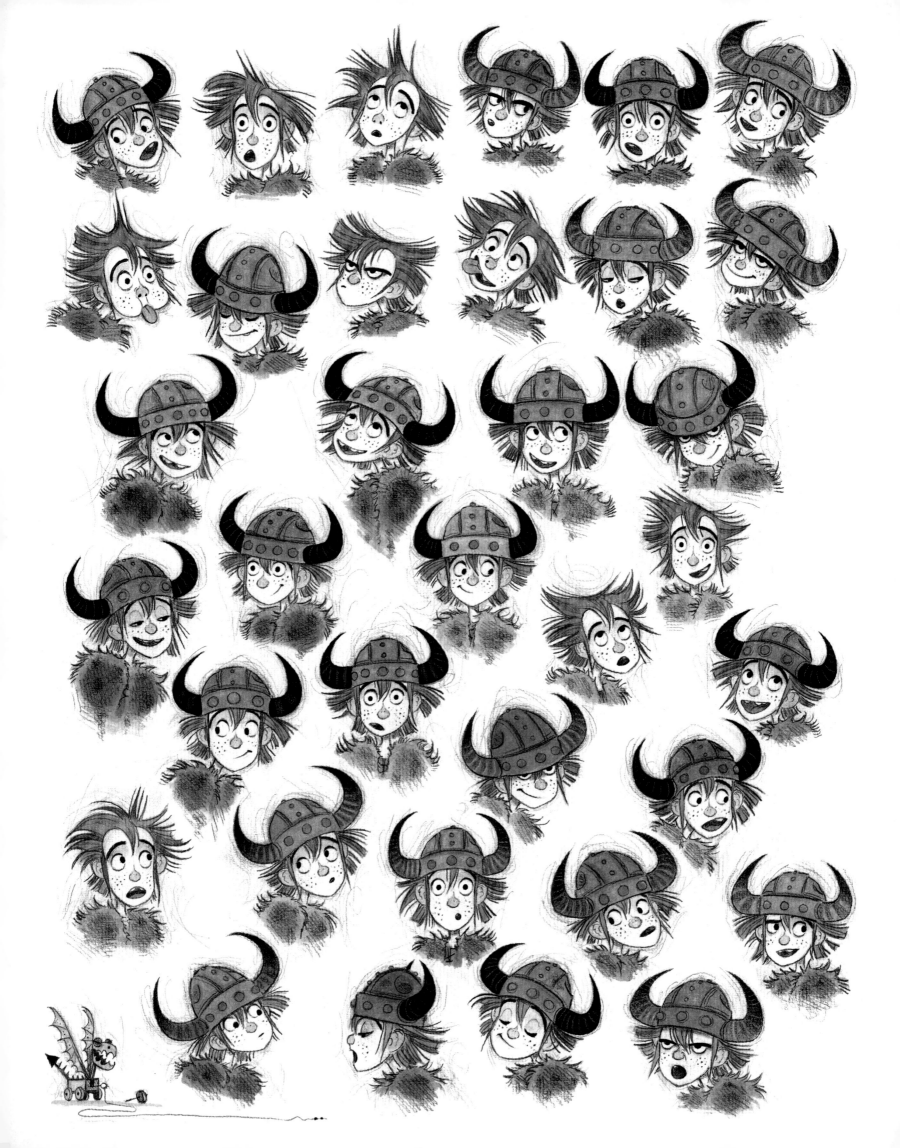

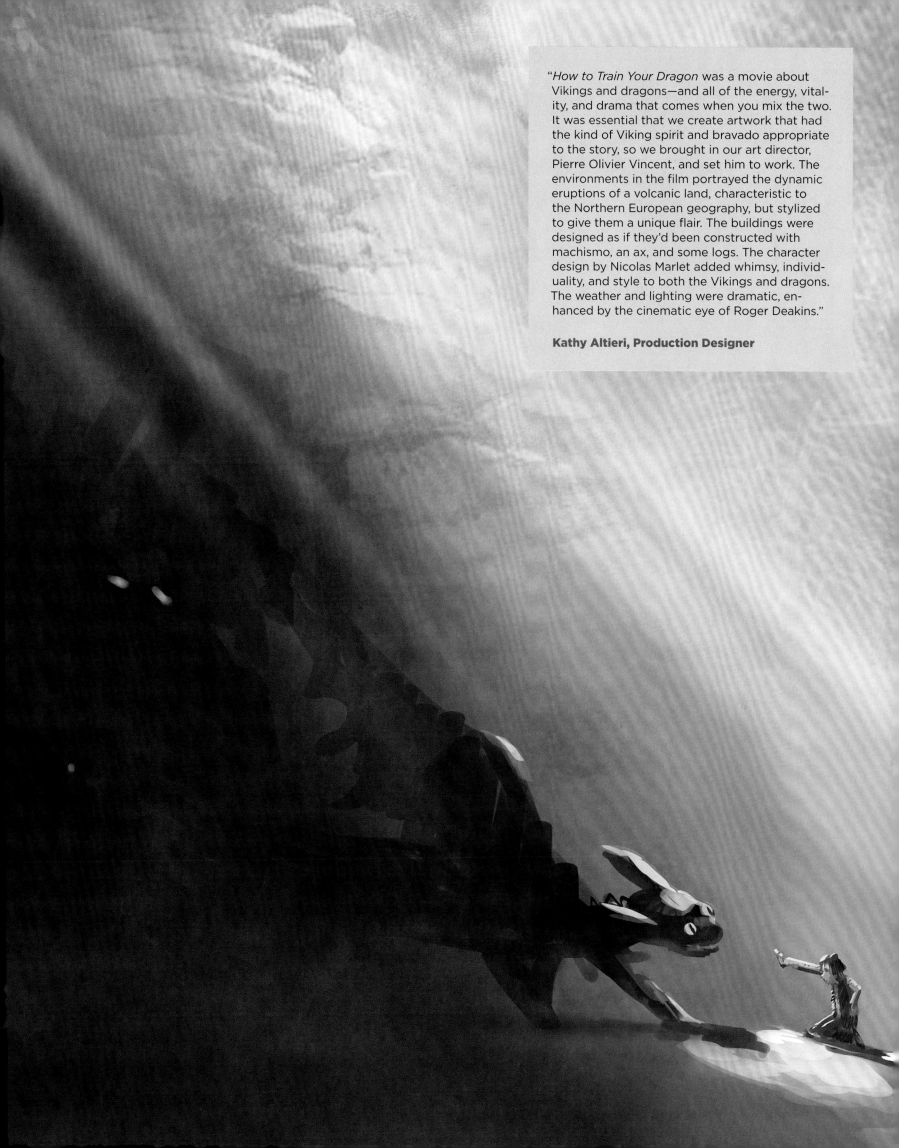

"*How to Train Your Dragon* was a movie about Vikings and dragons—and all of the energy, vitality, and drama that comes when you mix the two. It was essential that we create artwork that had the kind of Viking spirit and bravado appropriate to the story, so we brought in our art director, Pierre Olivier Vincent, and set him to work. The environments in the film portrayed the dynamic eruptions of a volcanic land, characteristic to the Northern European geography, but stylized to give them a unique flair. The buildings were designed as if they'd been constructed with machismo, an ax, and some logs. The character design by Nicolas Marlet added whimsy, individuality, and style to both the Vikings and dragons. The weather and lighting were dramatic, enhanced by the cinematic eye of Roger Deakins."

Kathy Altieri, Production Designer

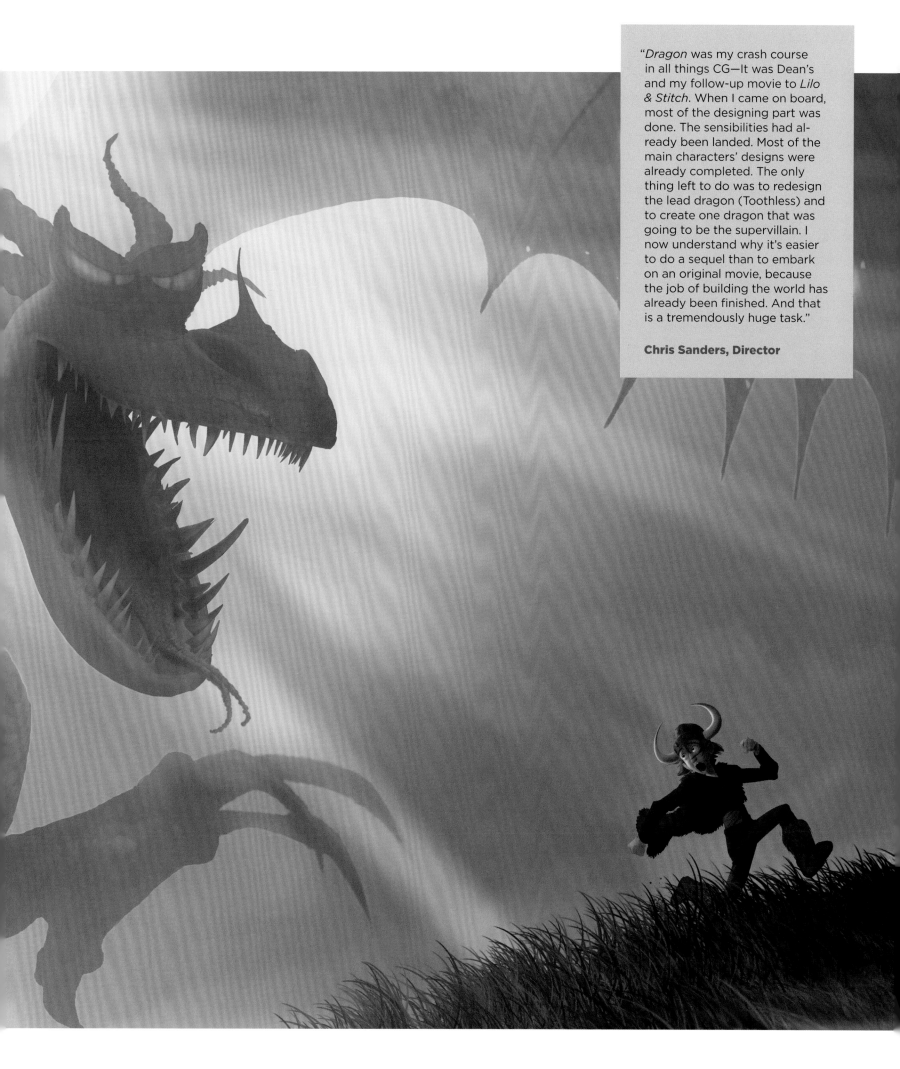

"*Dragon* was my crash course in all things CG—It was Dean's and my follow-up movie to *Lilo & Stitch*. When I came on board, most of the designing part was done. The sensibilities had already been landed. Most of the main characters' designs were already completed. The only thing left to do was to redesign the lead dragon (Toothless) and to create one dragon that was going to be the supervillain. I now understand why it's easier to do a sequel than to embark on an original movie, because the job of building the world has already been finished. And that is a tremendously huge task."

Chris Sanders, Director

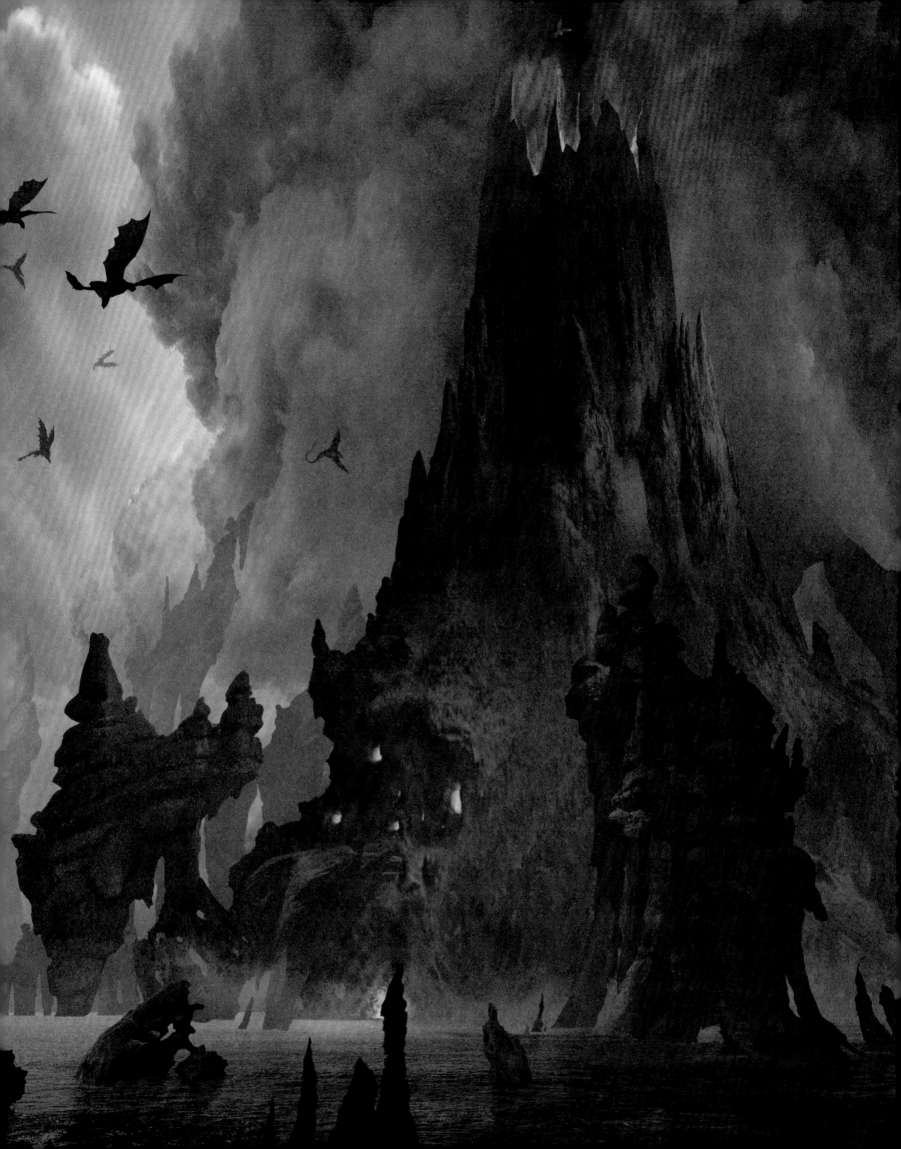

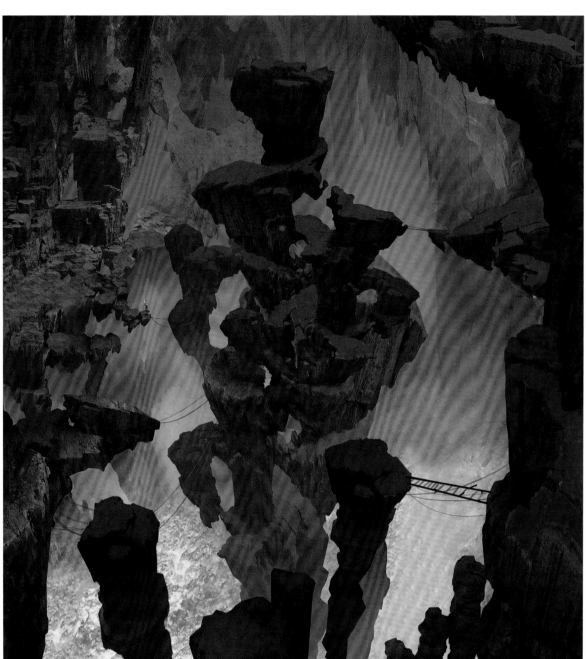

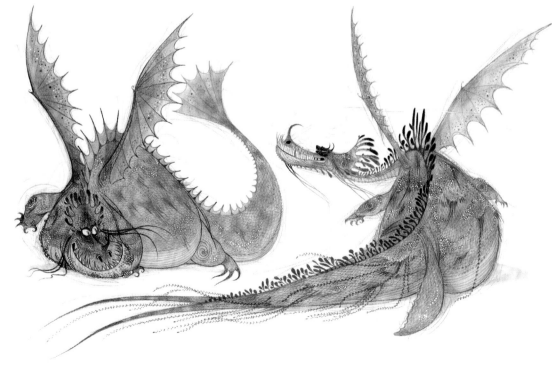

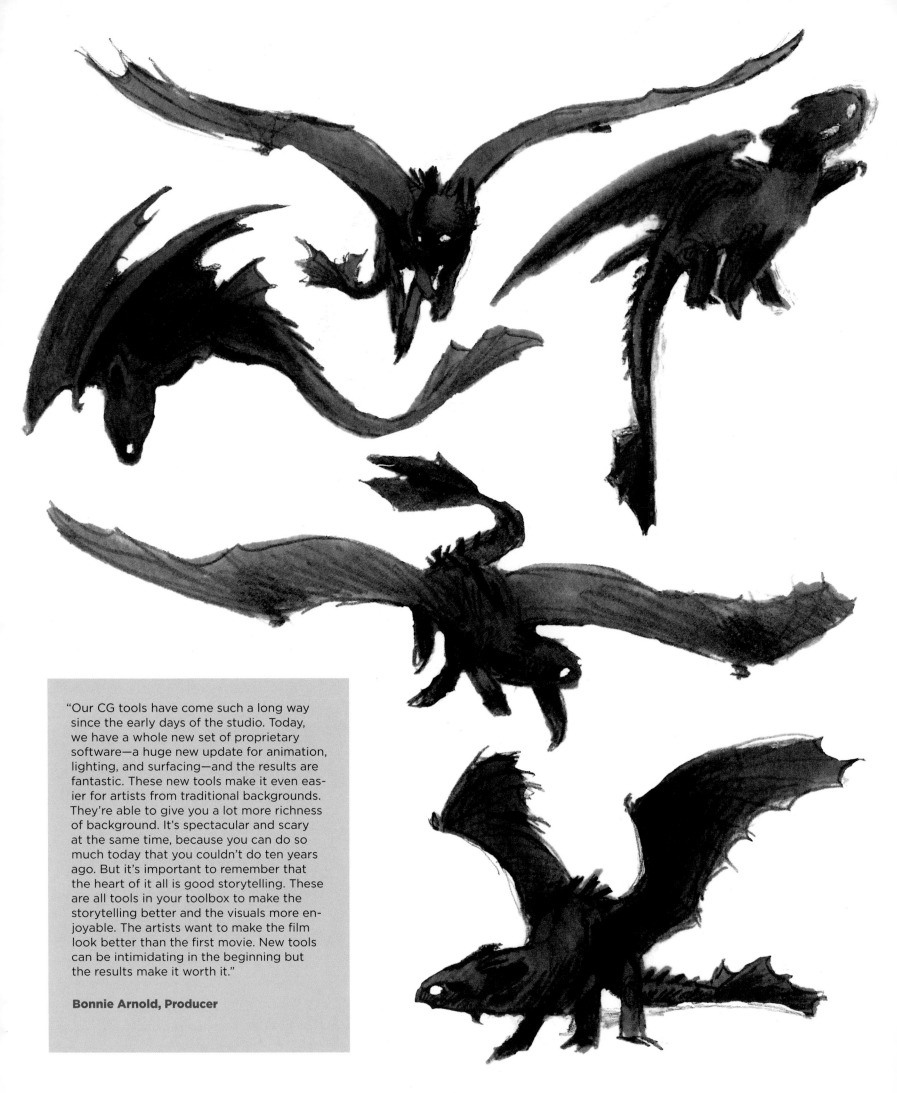

"Our CG tools have come such a long way since the early days of the studio. Today, we have a whole new set of proprietary software—a huge new update for animation, lighting, and surfacing—and the results are fantastic. These new tools make it even easier for artists from traditional backgrounds. They're able to give you a lot more richness of background. It's spectacular and scary at the same time, because you can do so much today that you couldn't do ten years ago. But it's important to remember that the heart of it all is good storytelling. These are all tools in your toolbox to make the storytelling better and the visuals more enjoyable. The artists want to make the film look better than the first movie. New tools can be intimidating in the beginning but the results make it worth it."

Bonnie Arnold, Producer

"One of the fun things about *Dragon* was that it had a very unique visual scheme. We followed this design philosophy that was about making Hiccup feel very small in his world, so everything is depicted as larger than life. This world is filled with peril, but it's rendered in a very believable way. Everything—from the texture of the fur and hair, the clothing, the rocks, the bark, the water—is rendered in a very realistic way. Having acclaimed cinematographer Roger Deakins as a visual consultant on the movie helped bring a very sophisticated, live-action quality to our animated characters. I loved the fact that adding this beautiful sense of believable lighting and texture to the caricatured characters and environments forced the movie to exist in this middle zone between animation and live action. This is a very interesting area that is also occupied by James Cameron's *Avatar*. There's enough whimsy present to make it feel fantastical and enough reality to make it believable. For our project, this is a very important quality because this is a movie that you want audiences to believe that if you fall from a great height, you might die, or if you get in the way of dragon fire, you will get burned. Having Hiccup lose his leg at the end of the first movie is indicative of the real stakes involved in this world. There is real risk and peril and sacrifice, and the look of the movie went a long way to reinforce that fact."

Dean DeBlois, Director

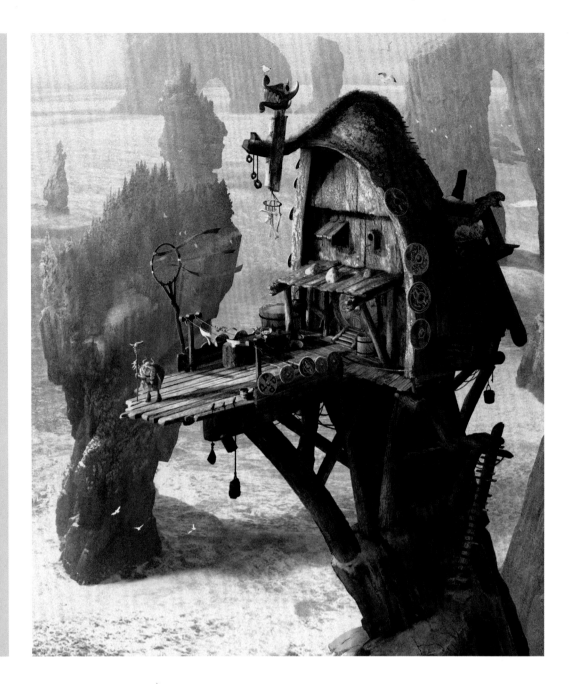

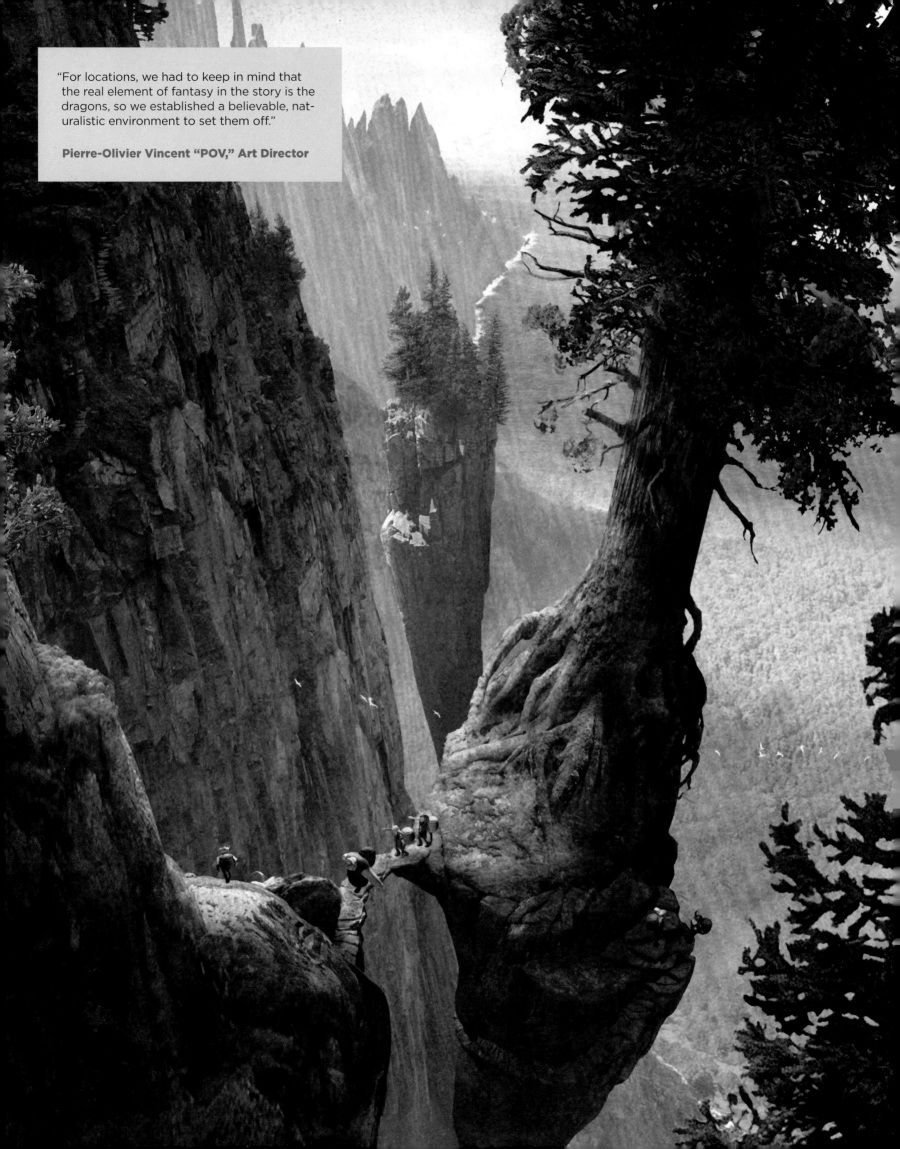

"For locations, we had to keep in mind that the real element of fantasy in the story is the dragons, so we established a believable, naturalistic environment to set them off."

Pierre-Olivier Vincent "POV," Art Director

"We wanted the audience to walk away knowing that maybe there is no such thing as a perfect happy ending after all, but even with all its flaws, life is really great. We also wanted them to have experienced the ultimate *Shrek* movie."

Mike Mitchell, Director

Director	**Mike Mitchell**
Producers	**Gina Shay, Teresa Cheng**
Executive Producers	**Aron Warner, Andrew Adamson, John H. Williams**
Associate Producer	**Patty Kaku-Bueb**
Production Designer	**Peter Zaslav**
Art Directors	**Max Boas, Michael Andrew Hernandez**
Visual Effects Supervisor	**Doug Cooper**

"Our goal was to have this film be as endearing and as emotional as the first movie. We also wanted to bring back that really tough Shrek. I think of Shrek as the animated Tony Soprano. He's allowed to be grumpy and yet still has heart. That's a unique trait for a lead character in a family film."

Mike Mitchell, Director

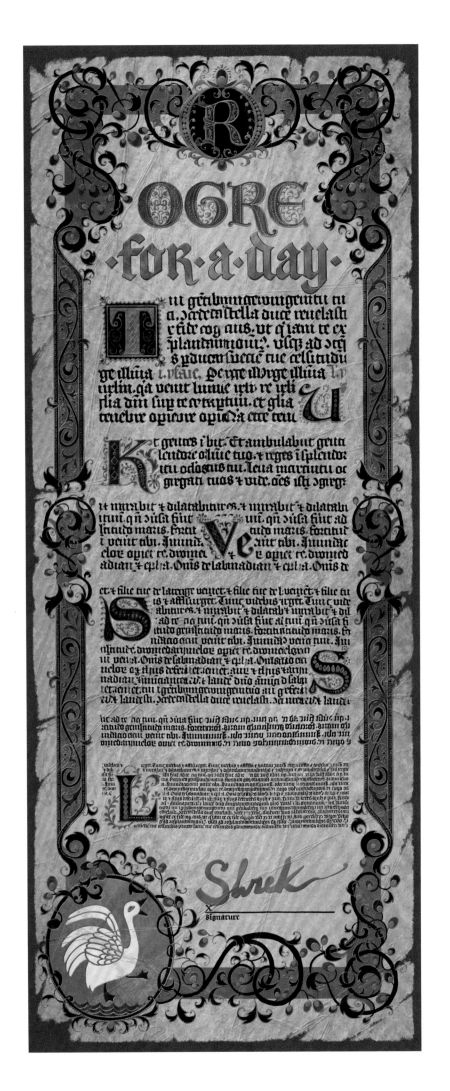

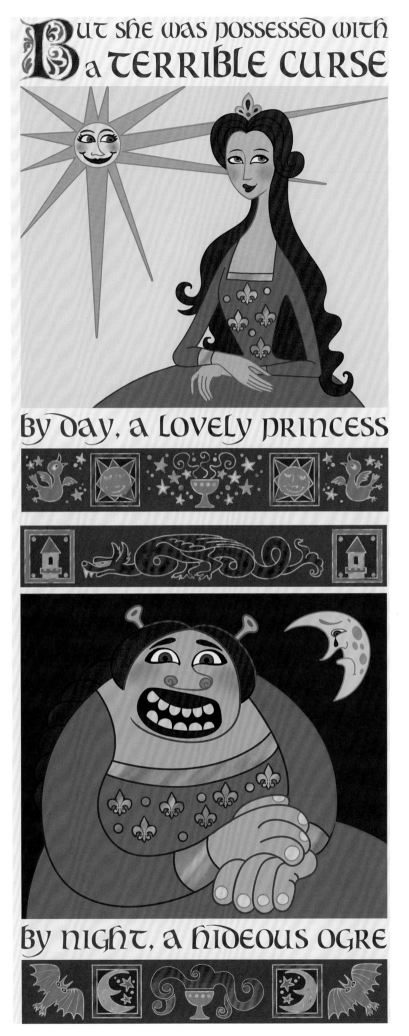

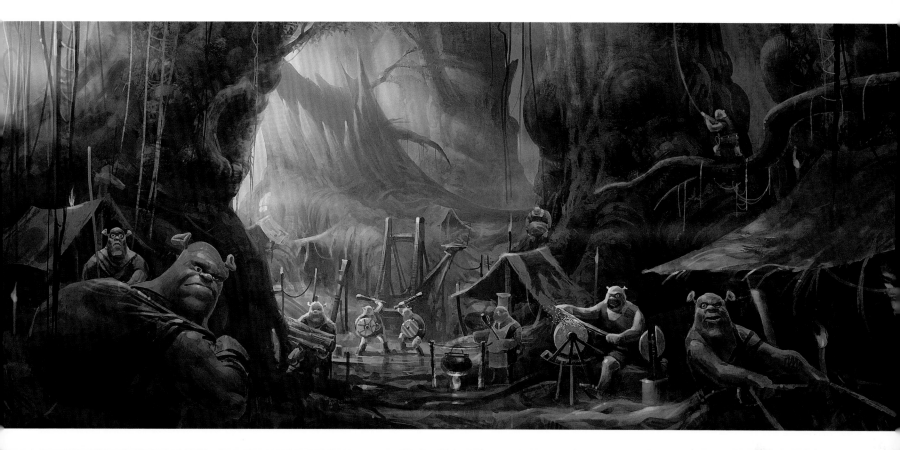

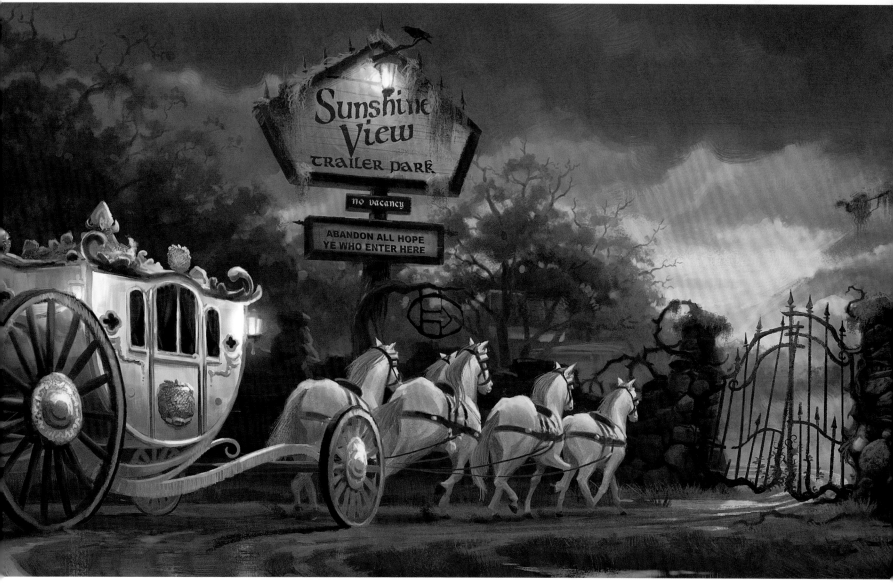

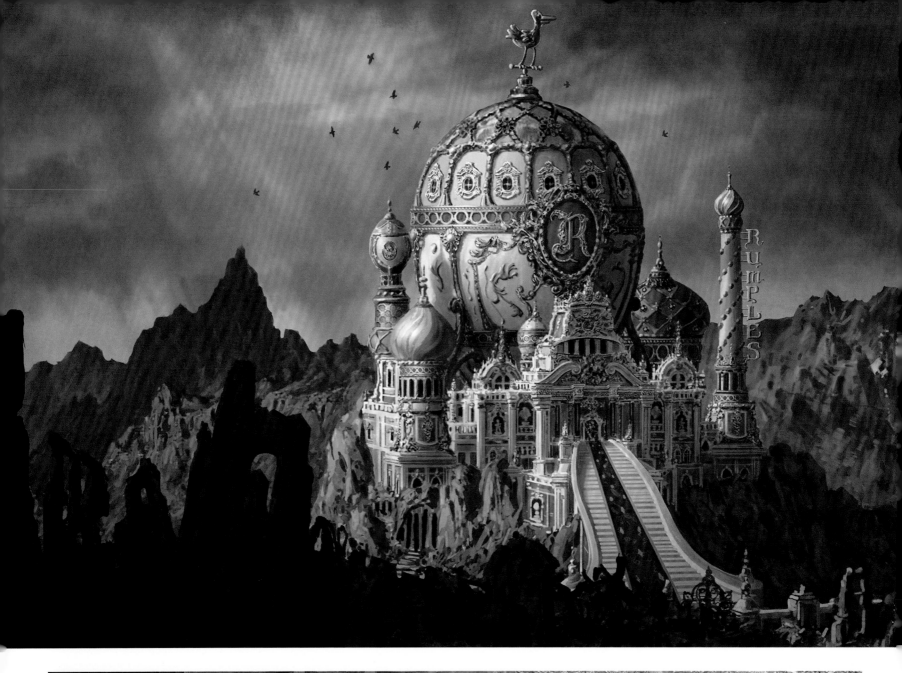

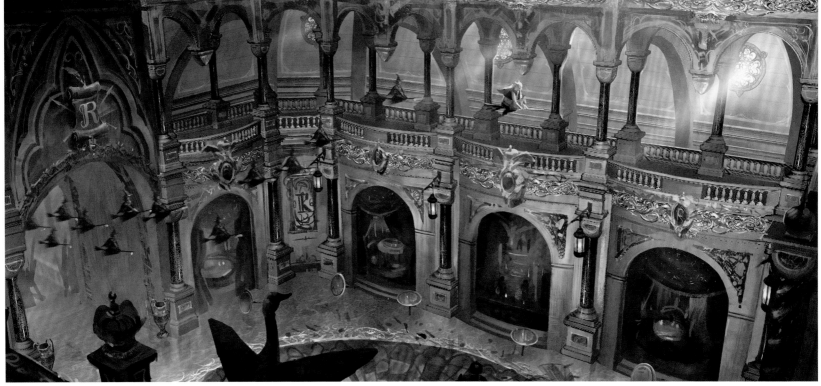

"The fourth movie was just a natural evolution of the movies and the character. We'd seen Shrek fall in love, have a family, become a father, and finally, it was more about him accepting himself as part of a larger community. It felt natural to question his impact on the world."

Walt Dohrn, Head of Story

"In the first film, Shrek learns to love himself; in the second, he learns what it is like being part of a family; in *Shrek the Third*, he comes to terms with accepting responsibility as a father and husband. In the fourth and final film, he is faced with a big question: What if his life had turned out differently? Once we integrated those concepts into the story, we realized what a complete circle this makes in terms of the story arc serving as a natural conclusion and ending to the series of *Shrek* films."

Aron Warner, Executive Producer

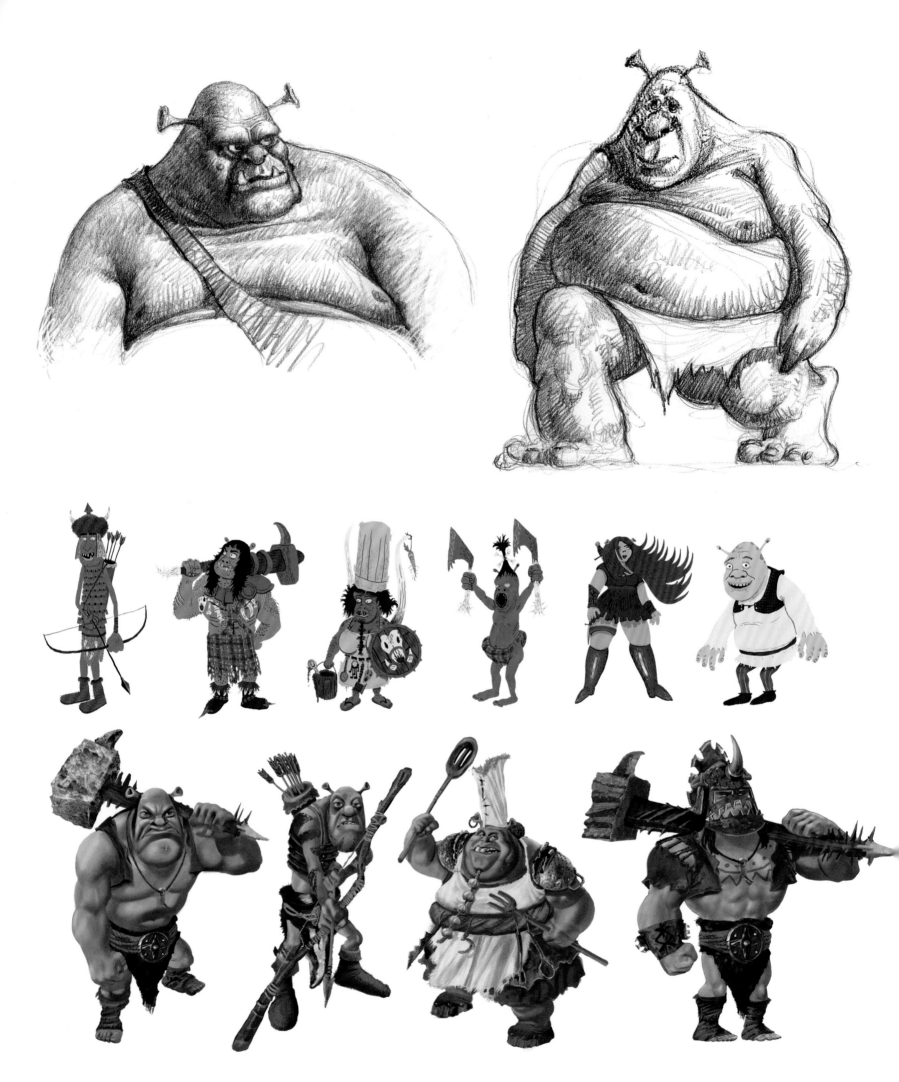

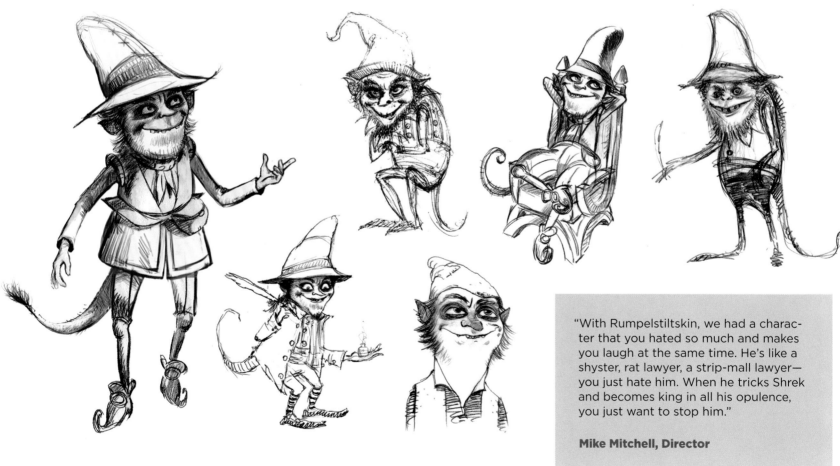

"With Rumpelstiltskin, we had a character that you hated so much and makes you laugh at the same time. He's like a shyster, rat lawyer, a strip-mall lawyer—you just hate him. When he tricks Shrek and becomes king in all his opulence, you just want to stop him."

Mike Mitchell, Director

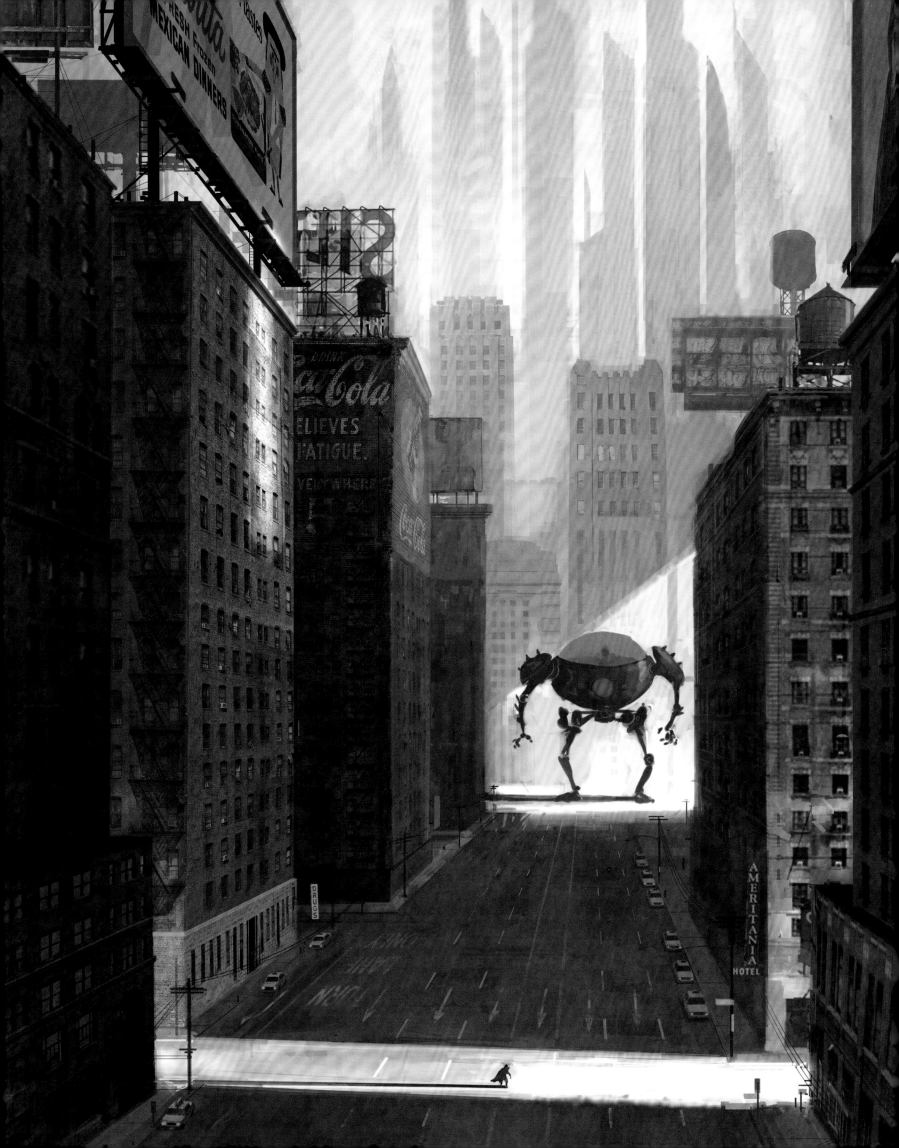

MEGAMIND

2010

Director	**Tom McGrath**
Producers	**Lara Breay, Denise Nolan Cascino**
Executive Producers	**Stuart Cornfeld, Ben Stiller**
Associate Producer	**Holly Edwards**
Production Designer	**David James**
Art Director	**Timothy J. Lamb**
Visual Effects Supervisor	**Philippe Denis**

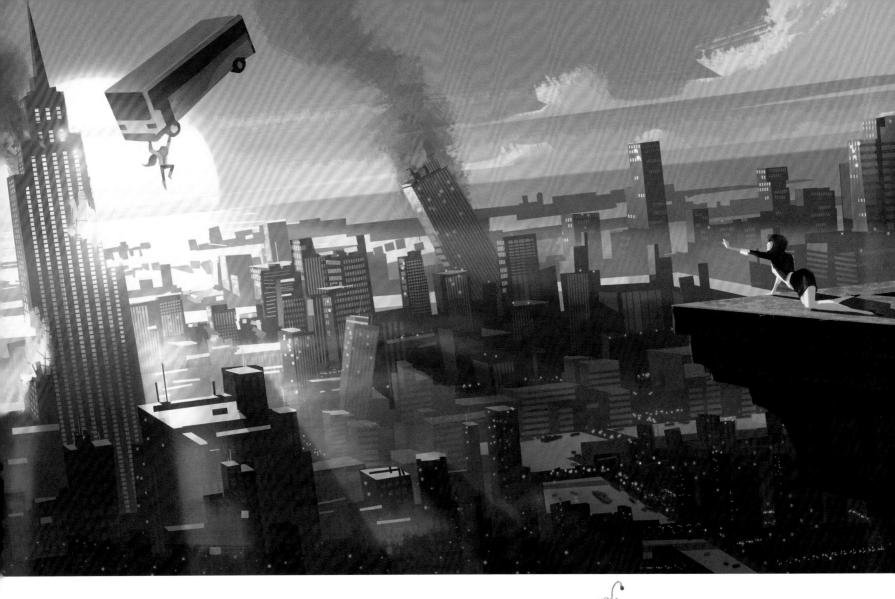

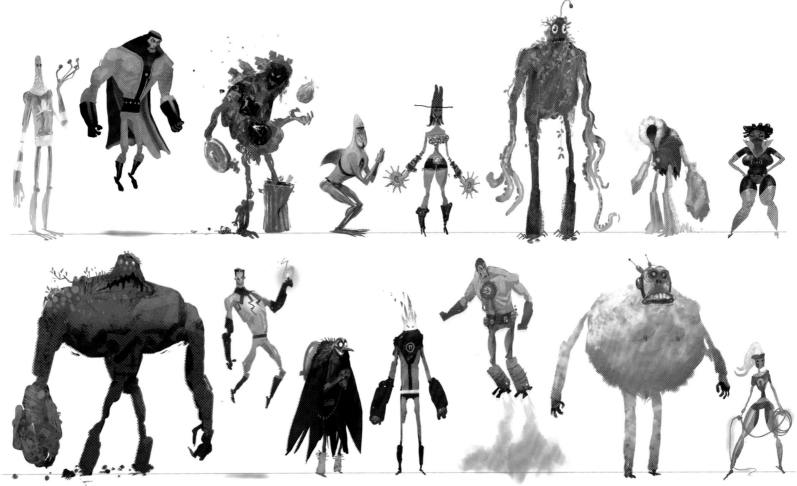

"*Megamind* was a great change of pace and lots of fun for me, because in *Madagascar,* we really didn't have a strong villain, and I have a passion for villains. This movie had a great supervillain, and I grew up on the superhero genre. It was really fun to get inside the mind of a villain, and the tone of the movie was slightly different from *Madagascar,* since we were speaking to a slightly older audience and playing with tropes of the superhero genre. In this world, we needed to believe that characters would get hurt if they fell off buildings, so the tone needed to be less cartoony. When you have cartoon physics in your work, it's like Bugs Bunny's world: You know your characters aren't going to get hurt even if they have anvils thrown on their heads. Here we created an environment where there was real risk involved just like the real world. Our hero had to be vulnerable: The audience had to feel that he might get hurt or killed at some point."

Tom McGrath, Director

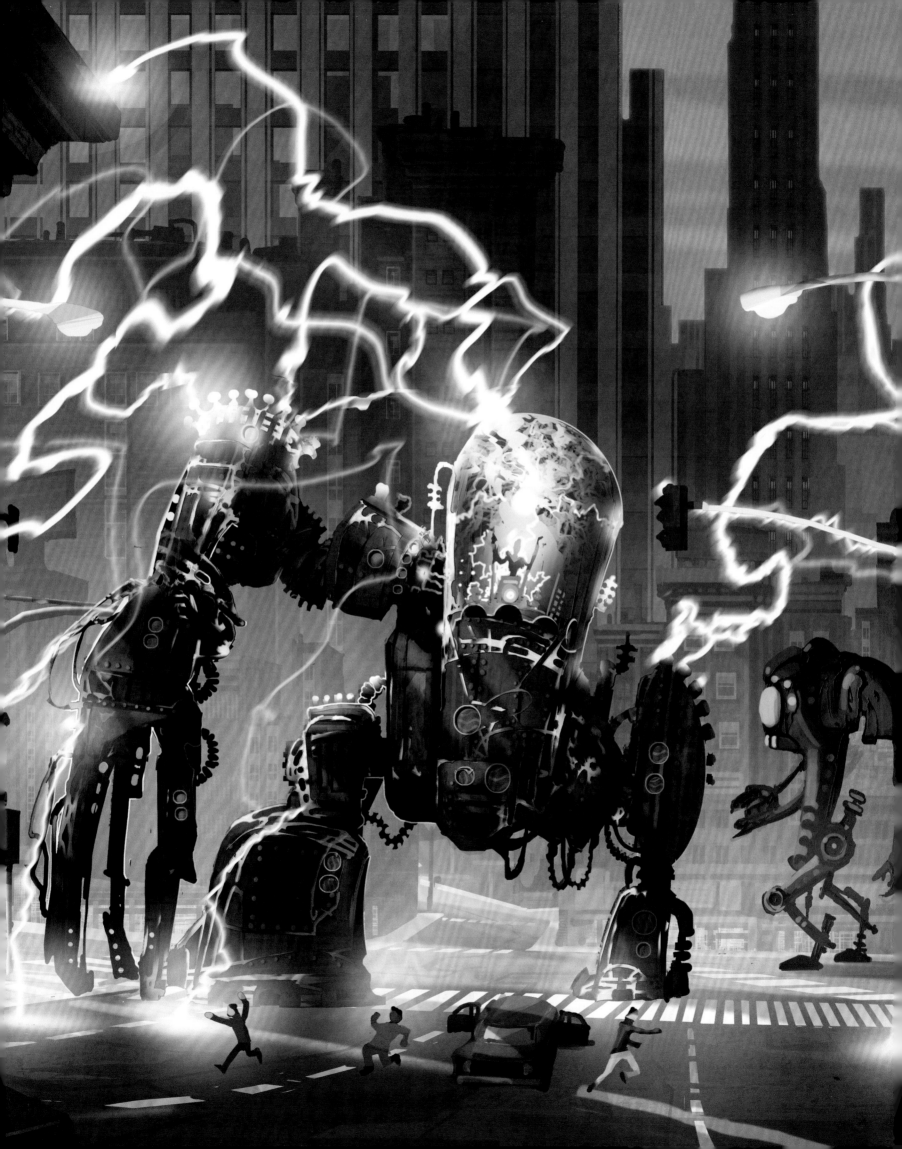

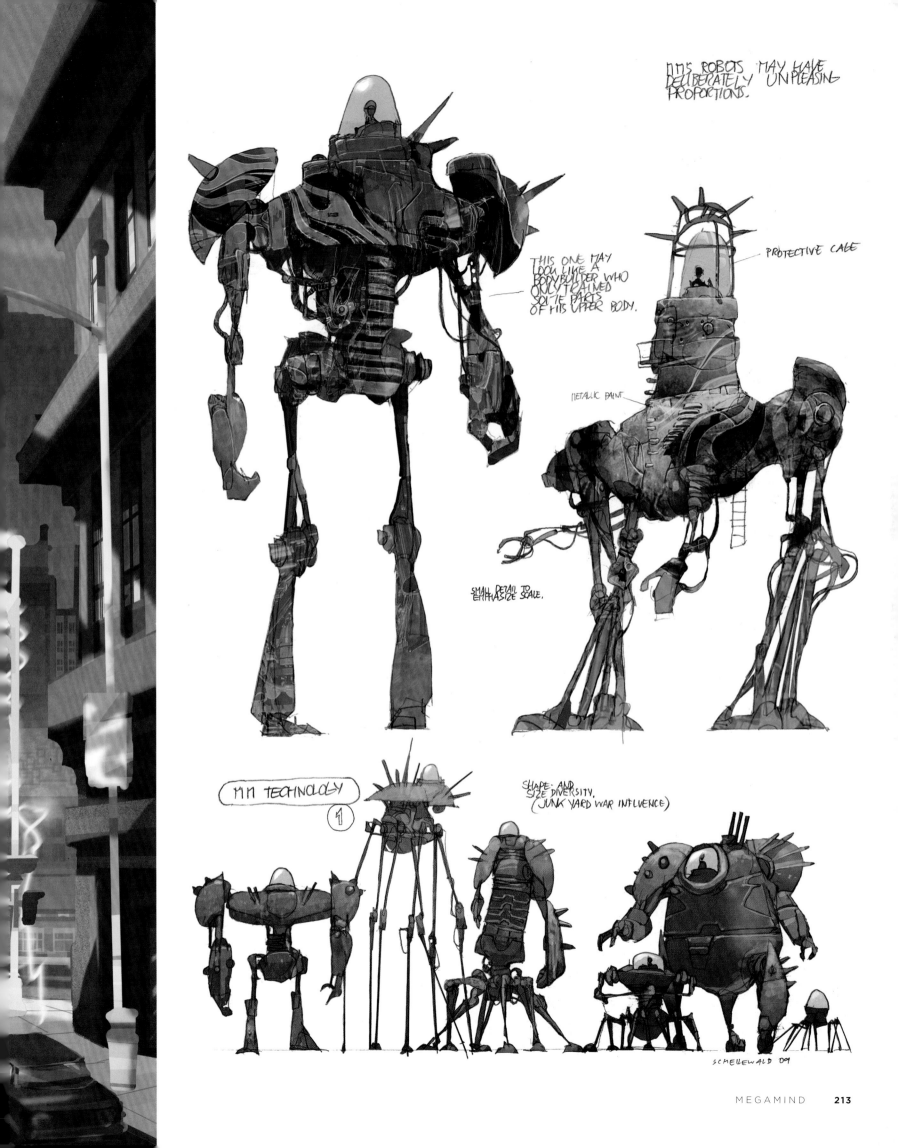

MMS ROBOTS MAY HAVE
DELIBERATELY UNPLEASING
PROPORTIONS.

THIS ONE MAY
LOOK LIKE A
BODYBUILDER WHO
ONLY TRAINED
SOME PARTS
OF HIS UPPER BODY.

PROTECTIVE CAGE

METALLIC PAINT

SMALL DETAIL TO
EMPHASIZE SCALE.

MM TECHNOLOGY

1

SHAPE- AND
SIZE DIVERSITY.
(JUNK YARD WAR INFLUENCE)

SCHELLEWALD 09

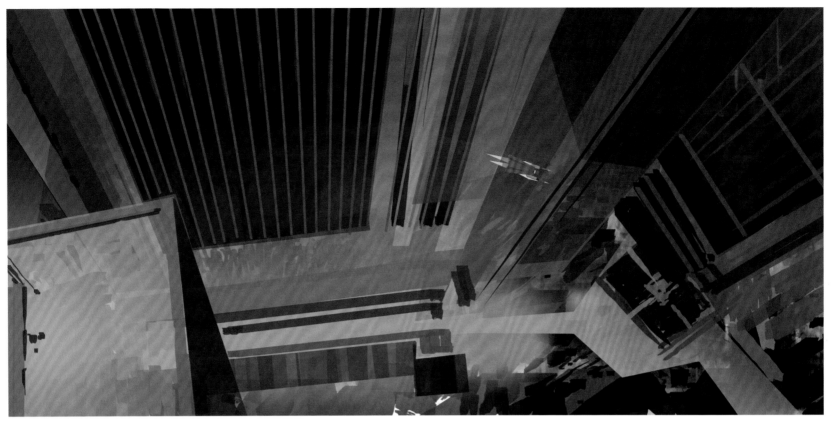

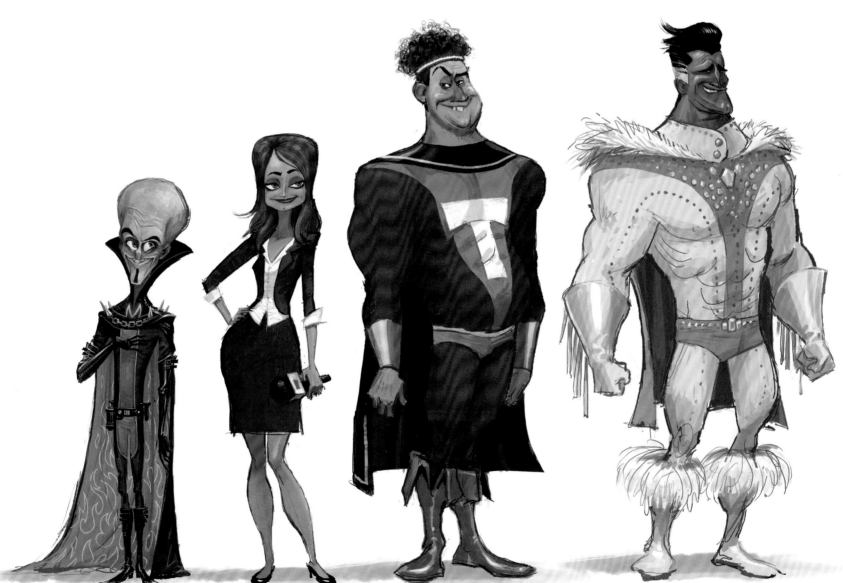

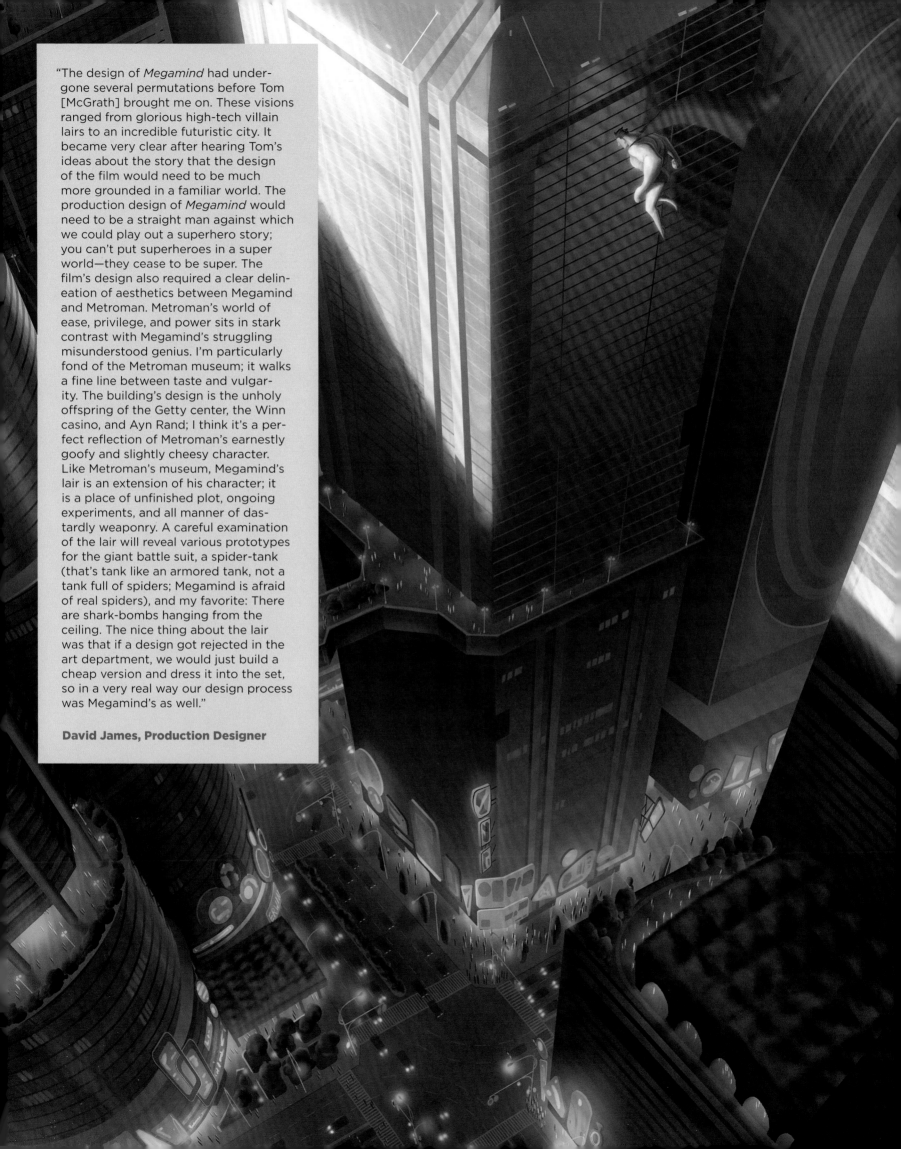

"The design of *Megamind* had undergone several permutations before Tom [McGrath] brought me on. These visions ranged from glorious high-tech villain lairs to an incredible futuristic city. It became very clear after hearing Tom's ideas about the story that the design of the film would need to be much more grounded in a familiar world. The production design of *Megamind* would need to be a straight man against which we could play out a superhero story; you can't put superheroes in a super world—they cease to be super. The film's design also required a clear delineation of aesthetics between Megamind and Metroman. Metroman's world of ease, privilege, and power sits in stark contrast with Megamind's struggling misunderstood genius. I'm particularly fond of the Metroman museum; it walks a fine line between taste and vulgarity. The building's design is the unholy offspring of the Getty center, the Winn casino, and Ayn Rand; I think it's a perfect reflection of Metroman's earnestly goofy and slightly cheesy character. Like Metroman's museum, Megamind's lair is an extension of his character; it is a place of unfinished plot, ongoing experiments, and all manner of dastardly weaponry. A careful examination of the lair will reveal various prototypes for the giant battle suit, a spider-tank (that's tank like an armored tank, not a tank full of spiders; Megamind is afraid of real spiders), and my favorite: There are shark-bombs hanging from the ceiling. The nice thing about the lair was that if a design got rejected in the art department, we would just build a cheap version and dress it into the set, so in a very real way our design process was Megamind's as well."

David James, Production Designer

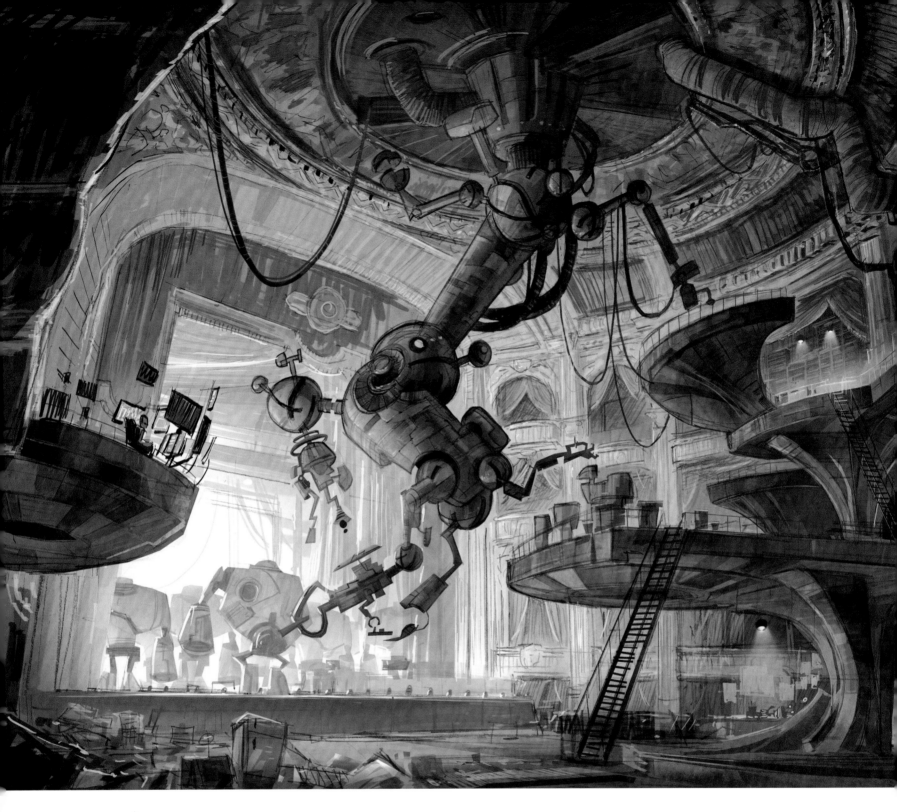

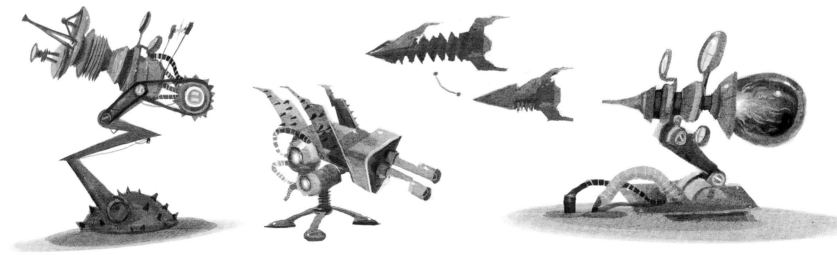

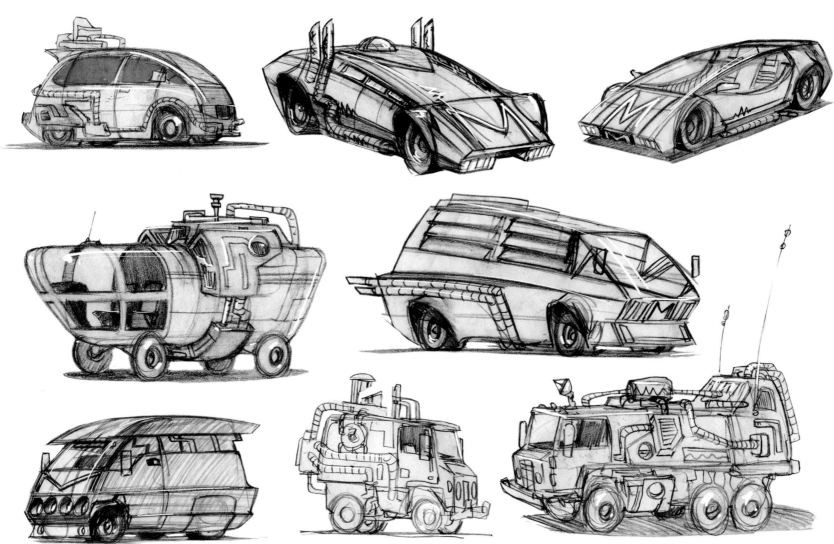

KUNG FU PANDA 2

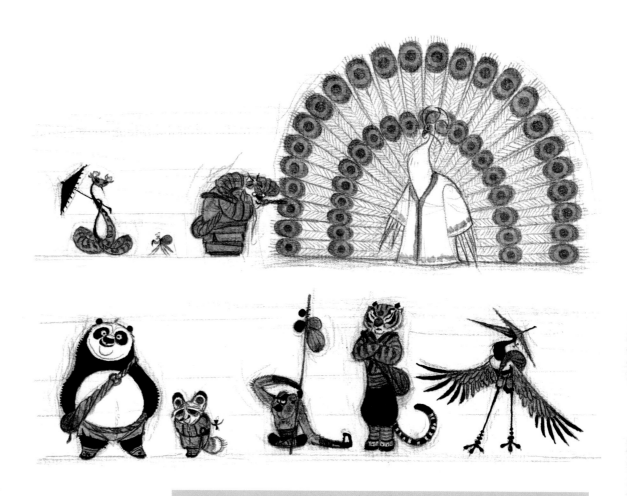

"I was so lucky to have a lot of support from my crew. I'd worked with them for many years, so it was ultimately so rewarding to see the results of all our work on the big screen, after several years of dealing with the challenges of directing a huge movie like that and people giving you at least three years of their creative lives. I remember how they screened the movie for the crew at Universal and they had the whole street made up to look like a Chinese street. The artists would come to me and say, 'Oh, I'm so proud of what I did and was able to create for the movie.' You know that's the best thing you can hear an artist say, to say that they're proud of the work that they did for a movie."

Jennifer Yuh Nelson, Director

Director	**Jennifer Yuh Nelson**
Producer	**Melissa Cobb**
Co-Producers	**Jonathan Aibel, Glenn Berger, Suzanne Buirgy**
Production Designer	**Raymond Zibach**
Art Director	**Tang Kheng Heng**
Visual Effects Supervisor	**Alex Parkinson**

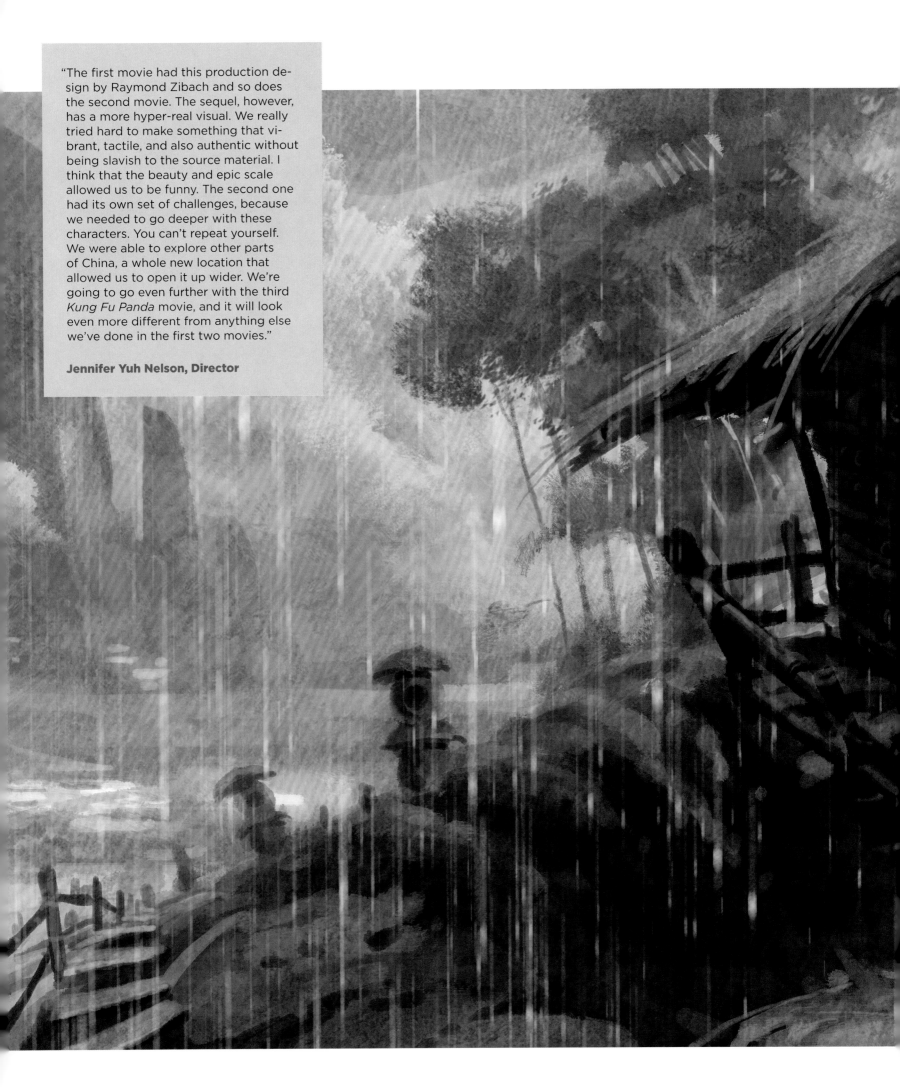

"The first movie had this production design by Raymond Zibach and so does the second movie. The sequel, however, has a more hyper-real visual. We really tried hard to make something that vibrant, tactile, and also authentic without being slavish to the source material. I think that the beauty and epic scale allowed us to be funny. The second one had its own set of challenges, because we needed to go deeper with these characters. You can't repeat yourself. We were able to explore other parts of China, a whole new location that allowed us to open it up wider. We're going to go even further with the third *Kung Fu Panda* movie, and it will look even more different from anything else we've done in the first two movies."

Jennifer Yuh Nelson, Director

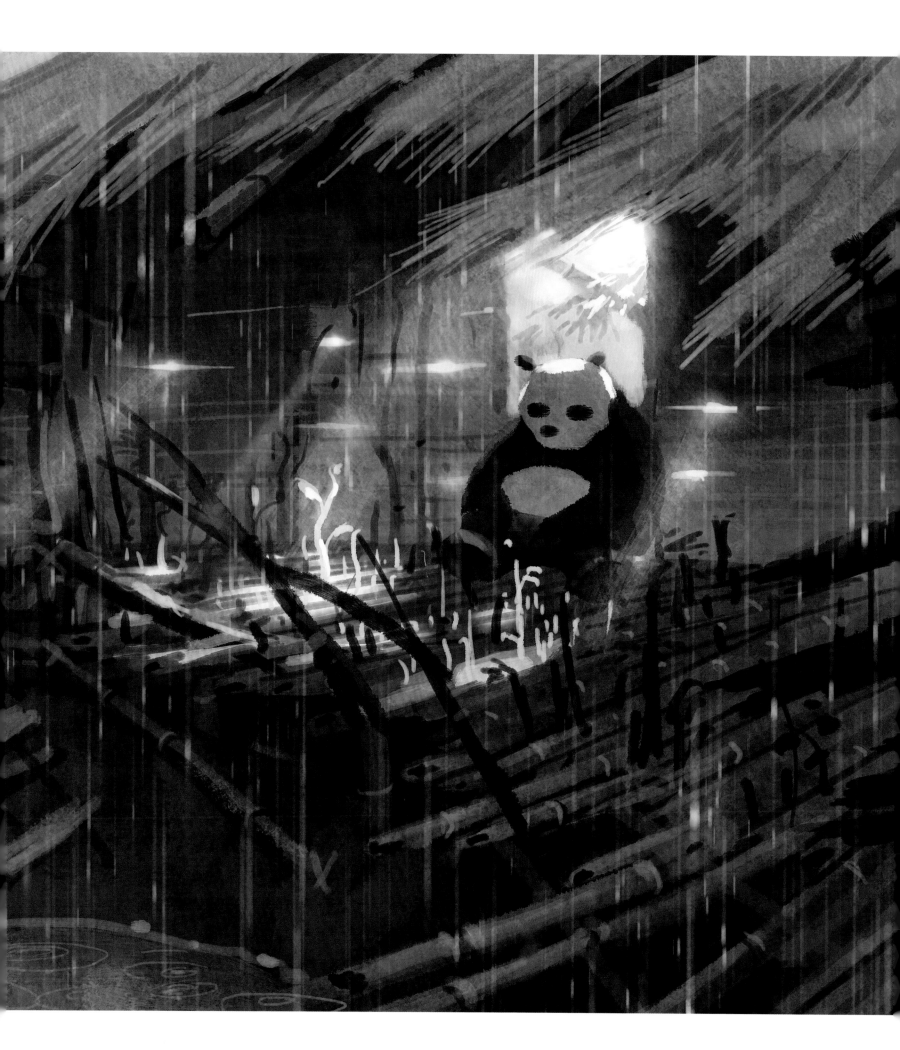

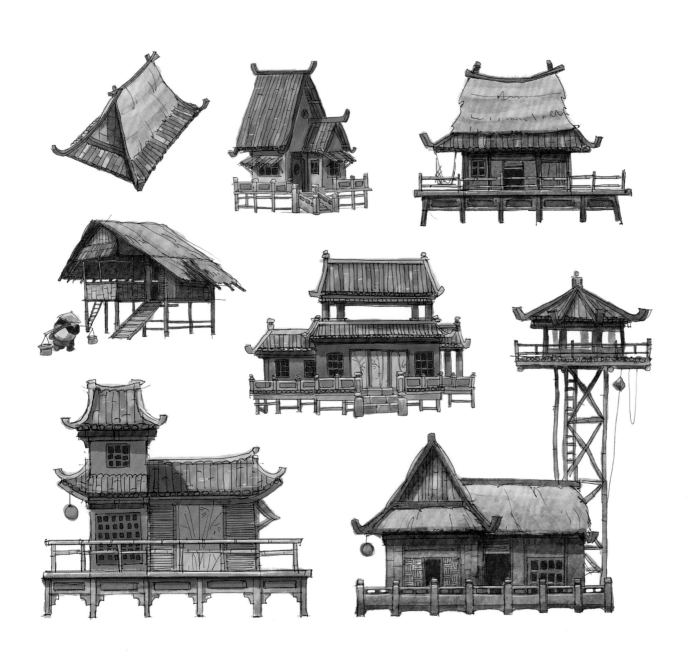

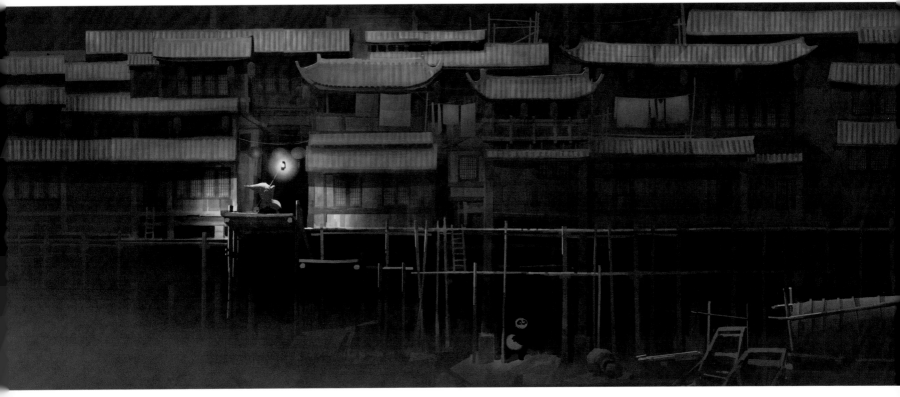

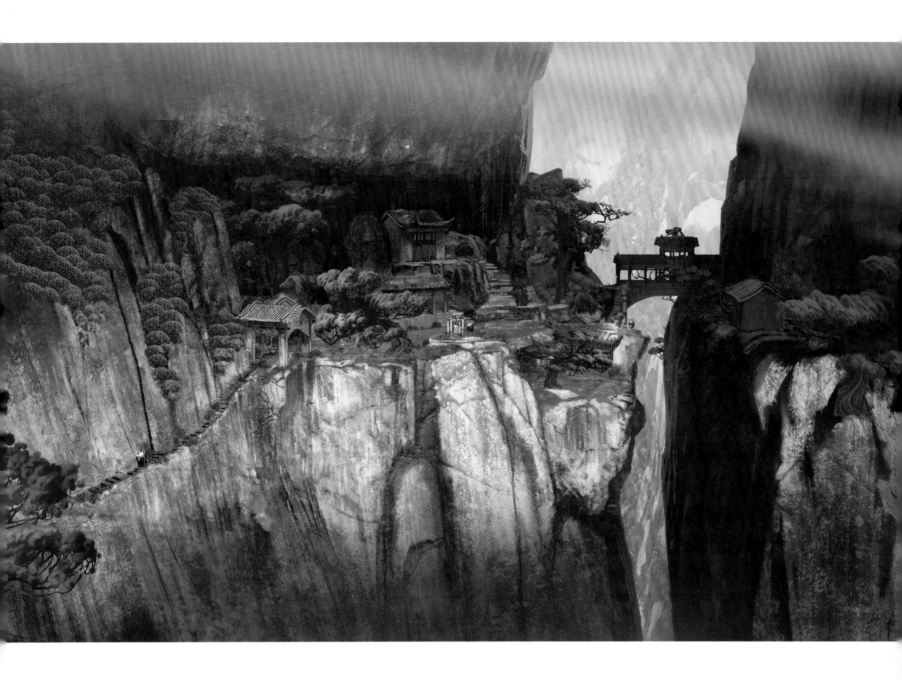

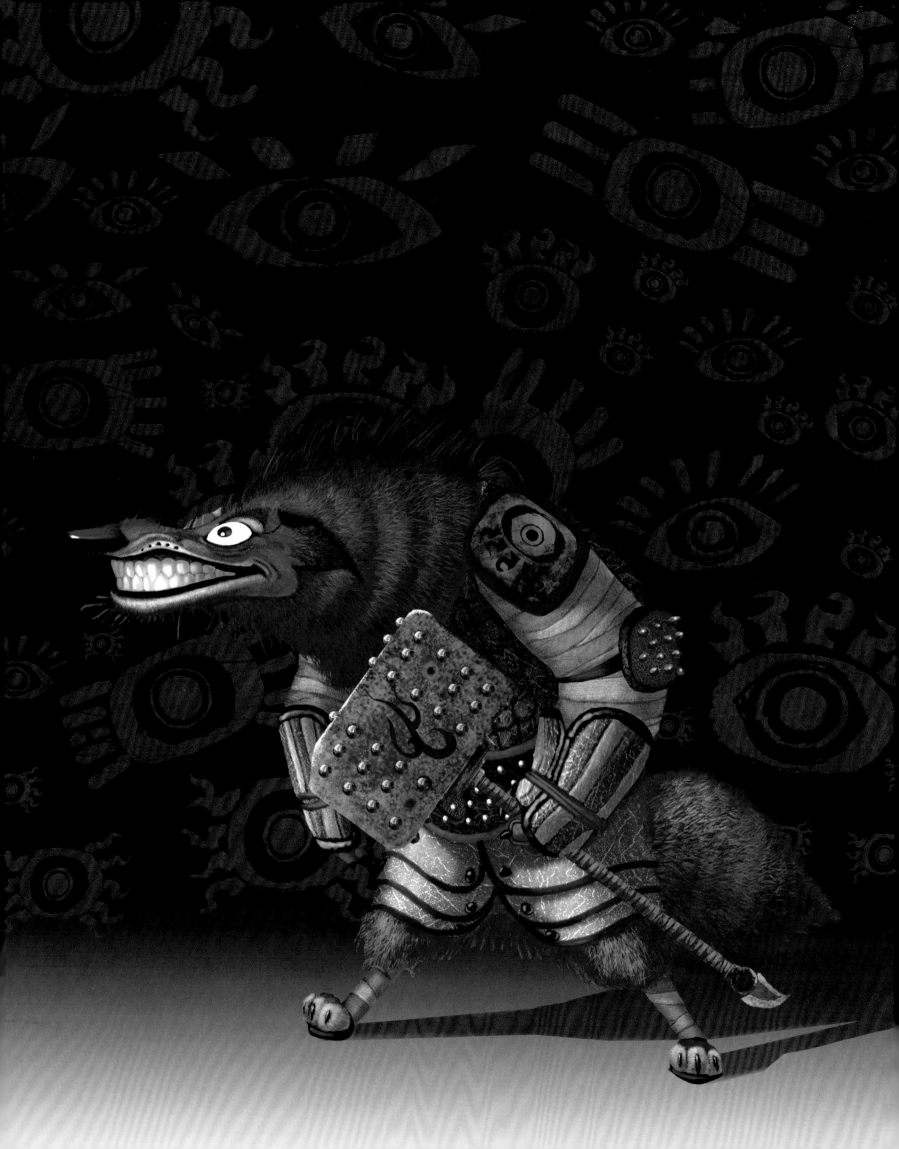

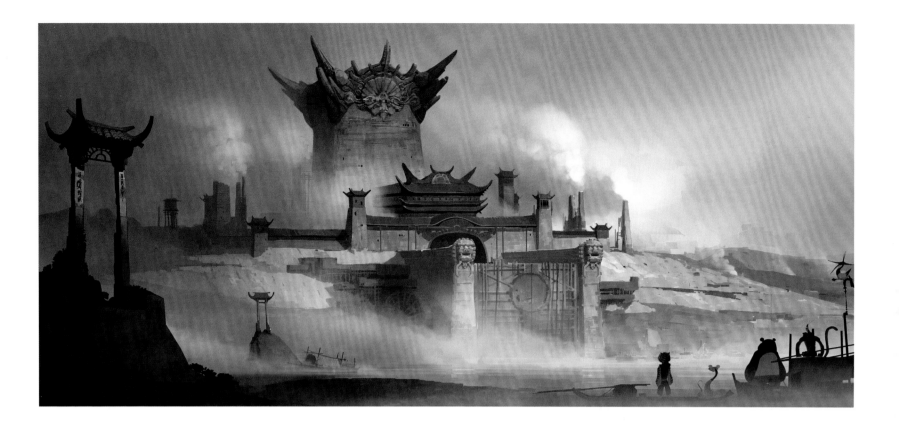

"The movie had a more emotional side to it too. Po was trying to figure out who he was and where he was coming from, so it was interesting for us to take this lighthearted character to such an emotional place. It didn't feel like we were telling the same story and allowed audiences to connect with Po on a deeper level."

Raymond Zibach, Production Designer

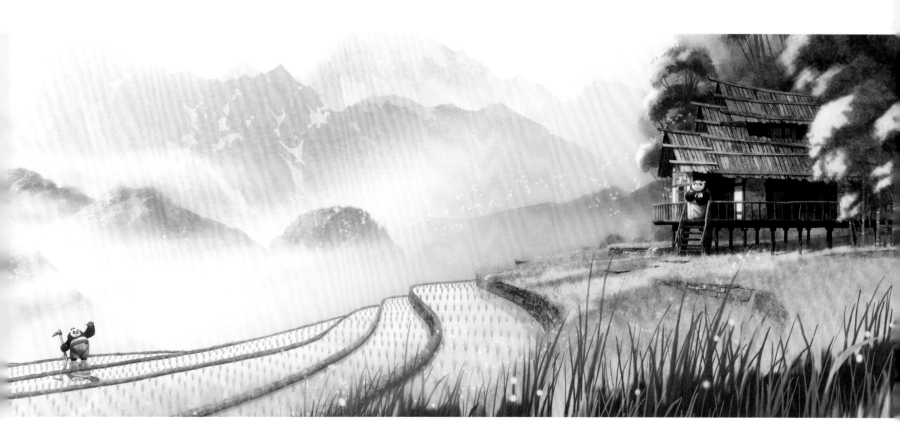

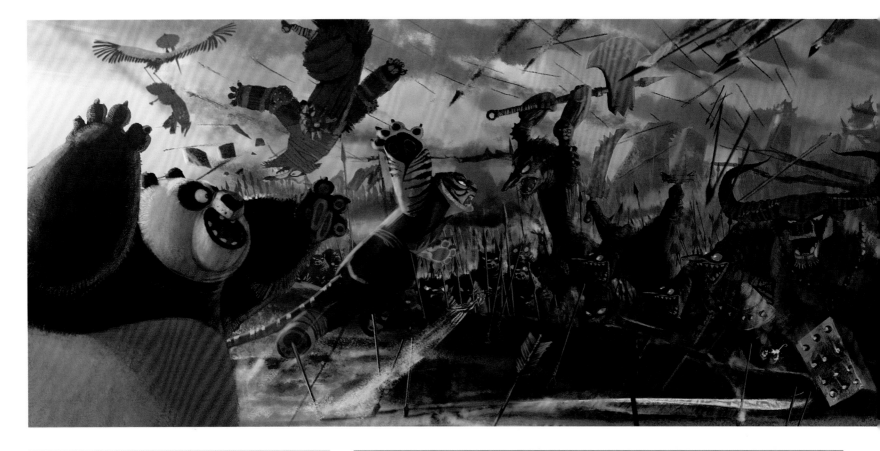

"As technology changes and improves with each movie, it helps improve the look of each movie and we are able to deliver better-looking, bigger worlds with each sequel. So, for *Kung Fu Panda 2,* we could take advantage of the new technologies to create a bigger city and offer nonstop action sequences in this world. This allowed the production design to be more ambitious and bigger than the first movie, and it was all very exciting to me."

Raymond Zibach, Production Designer

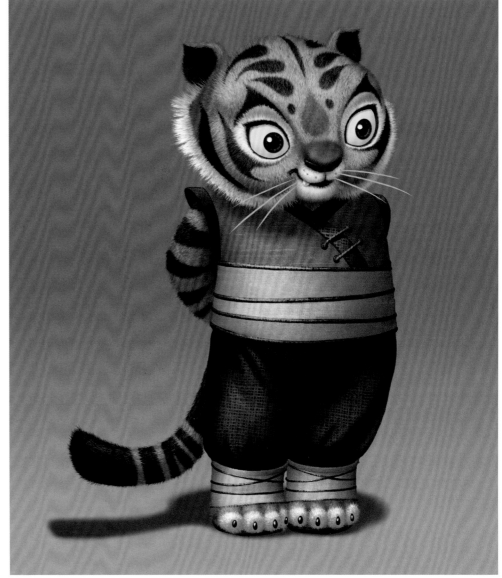

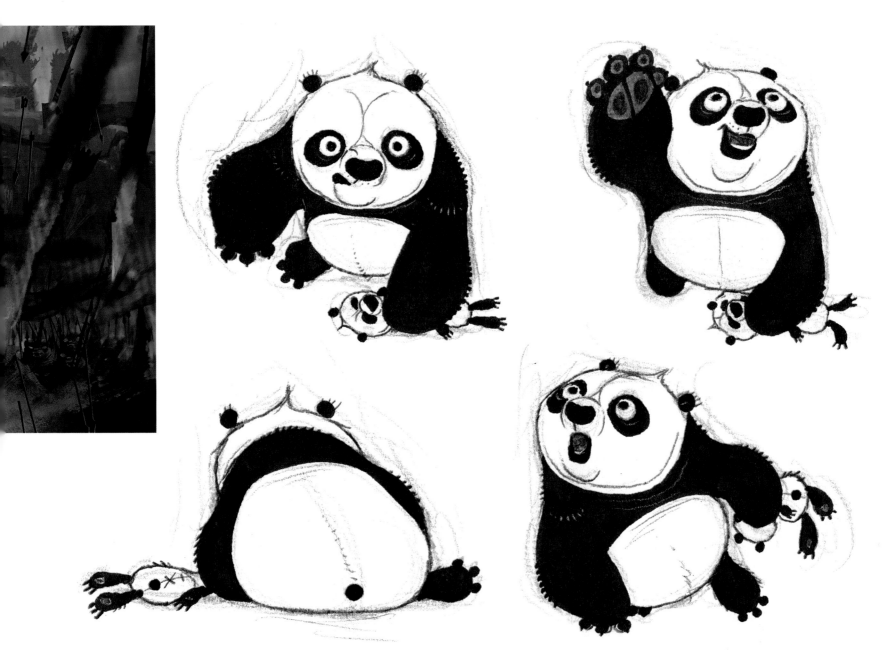

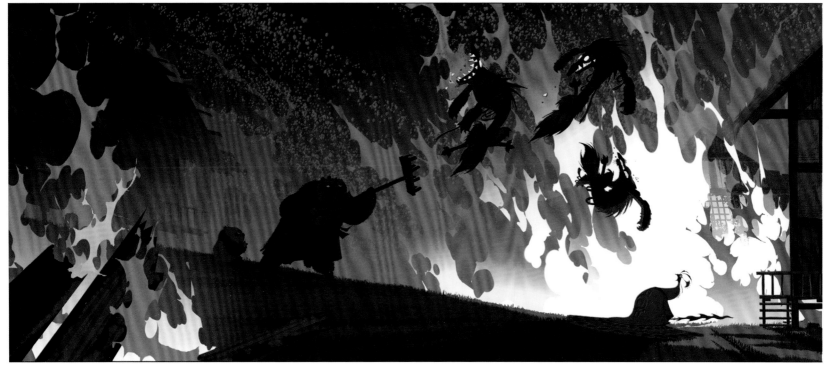

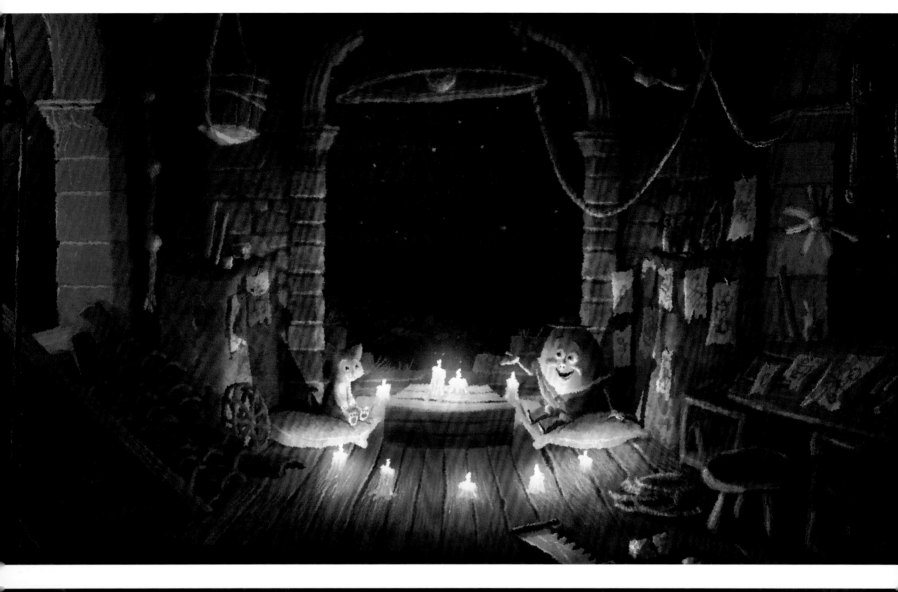

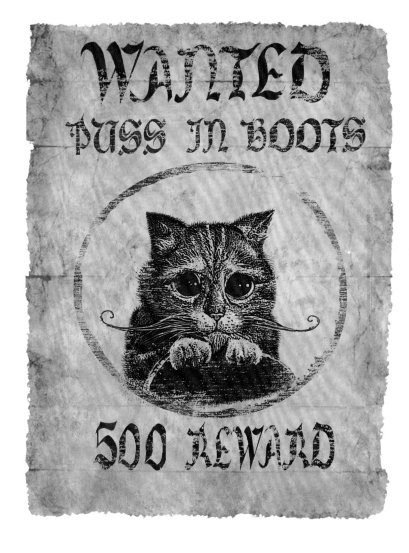

"One of our main challenges was to create a story that would resonate on a deep, emotional level. We were lucky to end up with this classic redemption story that focuses on this brave, nomadic lover. Of course, as the drama becomes more serious, the joke becomes funnier as well because we have a tiny cat at the center of this powerful material."

Chris Miller, Director

Director	**Chris Miller**
Producers	**Joe M. Aguilar, Latifa Ouaou**
Executive Producers	**Andrew Adamson, Guillermo del Toro, Michelle Raimo Kouyate**
Associate Producer	**Tom Jacomb**
Production Designer	**Guillaume Aretos**
Art Director	**Shannon Jeffries**
Visual Effects Supervisor	**Ken Bielenberg**

"Puss In Boots is a pretty exciting character to bring to the screen, because I think he's pretty special. What excited me about the film was a chance to do something different—we took him into a pushed, stylized world, where we got to play with big, symbolic shadows, in this very colorful world."

Guillaume Aretos, Production Designer

"If you look at the design, the inspiration for it, as a whole, is very simple—it's the character himself. He's a twisted character—I mean that in a literal sense. In terms of shape language, we started twisting the shape of things. If you look at the sets, you can see that all of the houses are kind of tilted. Nothing is really straight. We have asymmetry, with very unbalanced characters—going from small to gigantic. So that all goes to the shape language. The other thing is that Puss is a very colorful character. We gathered inspiration from Latin culture and looked at some Spanish movies. We went for less realistic lighting; we went more free, more crazy. We got to play with big shadows, because Puss is a small character in a very big world. In the *Shrek* movies, Puss was about three feet high, when standing in his boots, to balance always being with Shrek, a seven-foot giant. We realized that, in this world, that size wouldn't work—we're in a human world without giants, so we put him back to a normal cat size . . . if cats wore boots and stood upright."

Guillaume Aretos, Production Designer

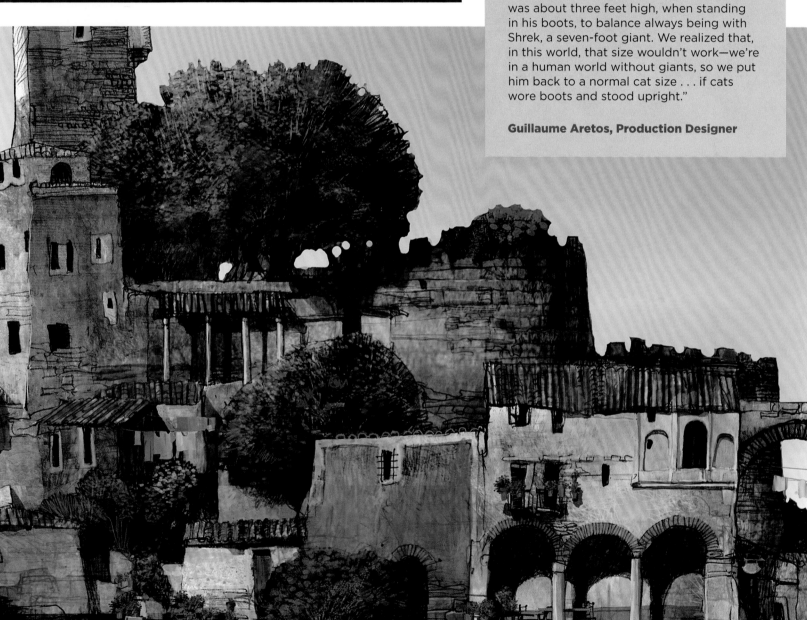

"The character of Puss In Boots made it easy for us to get excited about creating something new. He's bold, romantic, full of color and flavor, and he's got more swagger and style than any other cat in Spain. We could only imagine the world that he came from would have the same attributes. Truth be told, he's such a handsome cat that he would look good in any environment."

Latifa Ouaou, Producer

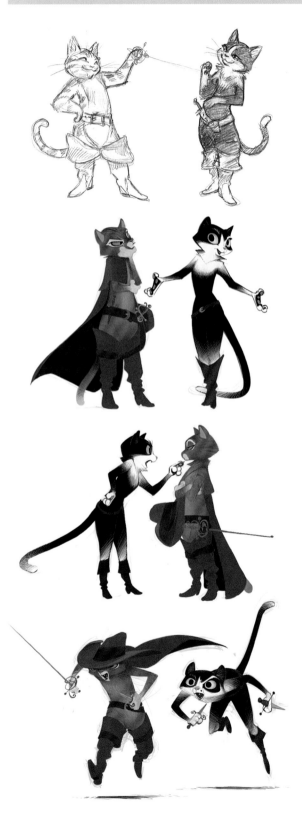

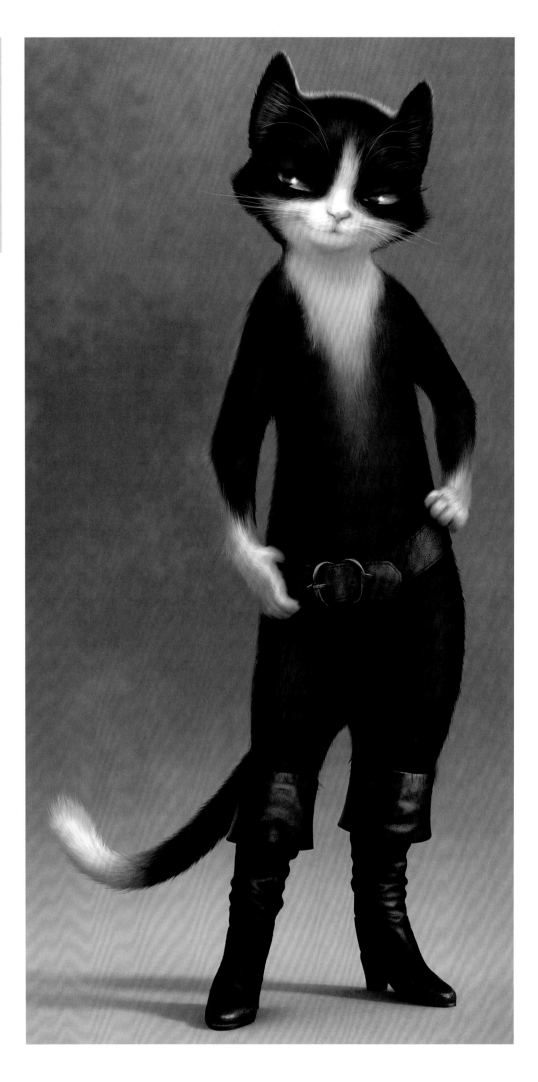

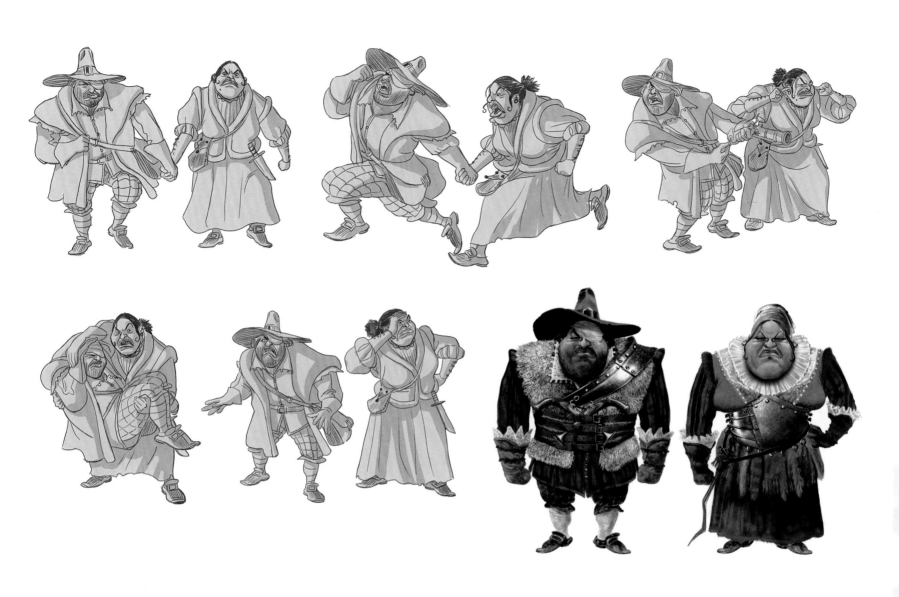

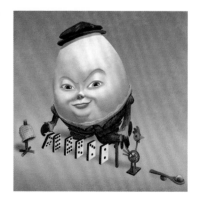

"One of my personal goals was to make sure the movie was quite different from the Shrek movies. We strived to make the story of Puss stand on its own. We kept the pop culture references to a minimum, didn't include any music numbers that would tie in to current music, and avoided side-kicks. It was important for us to stay away from the usual earmarks of spinoffs."

Joe M. Aguilar, Producer

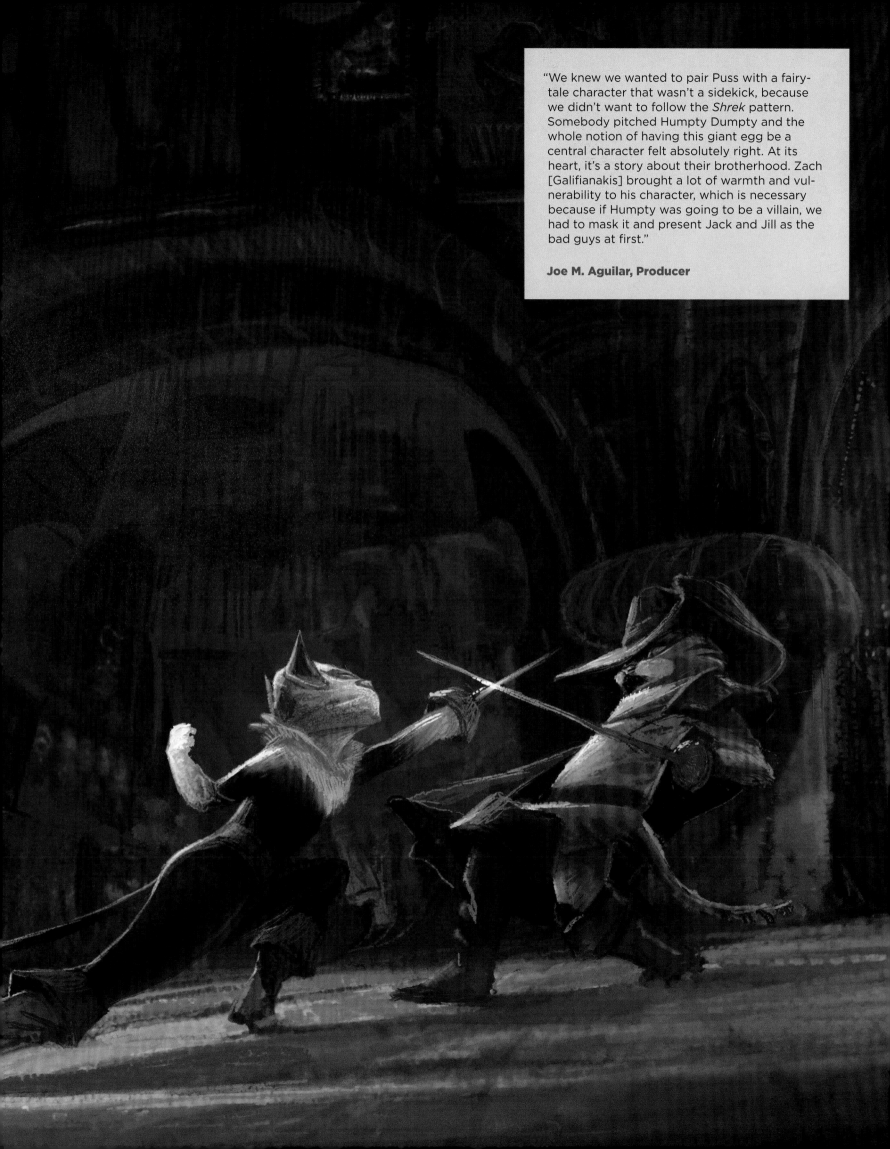

"We knew we wanted to pair Puss with a fairy-tale character that wasn't a sidekick, because we didn't want to follow the *Shrek* pattern. Somebody pitched Humpty Dumpty and the whole notion of having this giant egg be a central character felt absolutely right. At its heart, it's a story about their brotherhood. Zach [Galifianakis] brought a lot of warmth and vulnerability to his character, which is necessary because if Humpty was going to be a villain, we had to mask it and present Jack and Jill as the bad guys at first."

Joe M. Aguilar, Producer

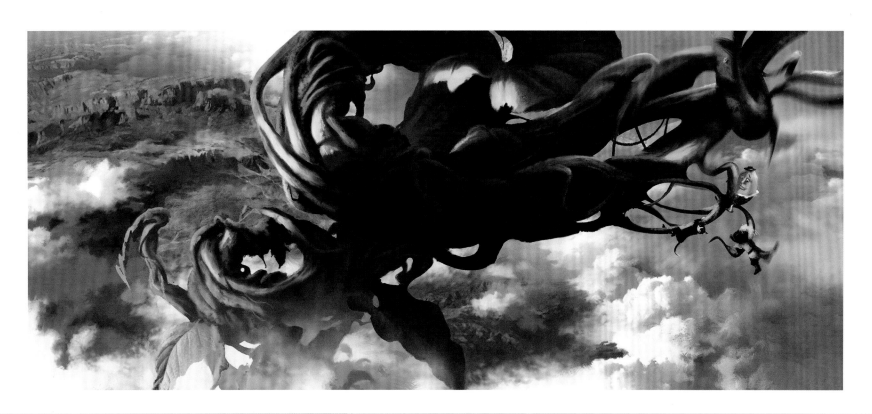

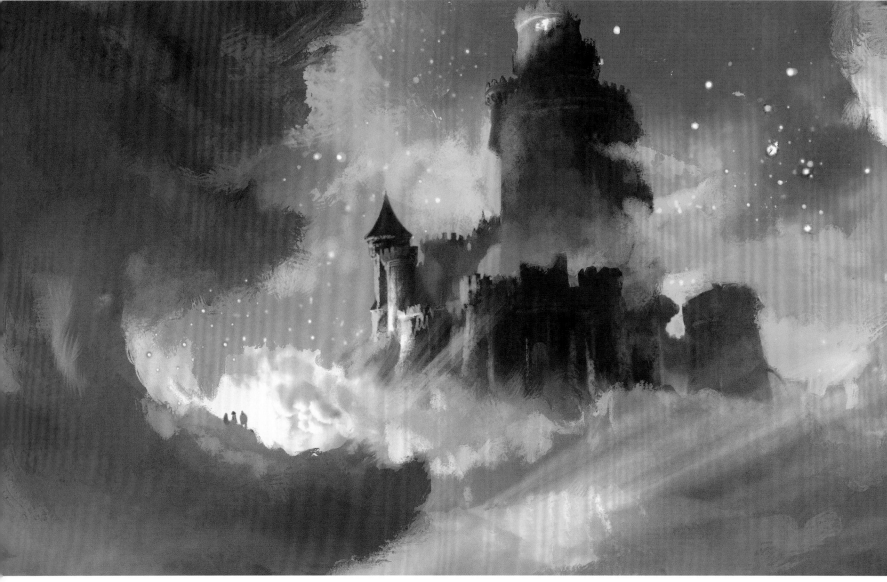

"I think the movie came together beautifully in the end. It looked fantastic in 3D and really offered a very rich theatrical experience. The sequence in which our characters climb the beanstalk and enter the Cloud World is a real standout because of the way we used the 3D format. Our visual effects team did an amazing job of depicting the growing beanstalk and the magical cloud formations. Looking back, I'm very proud of the visual style of the movie, which is warm, bold, dynamic, and liberating—very much like Puss himself."

Chris Miller, Director

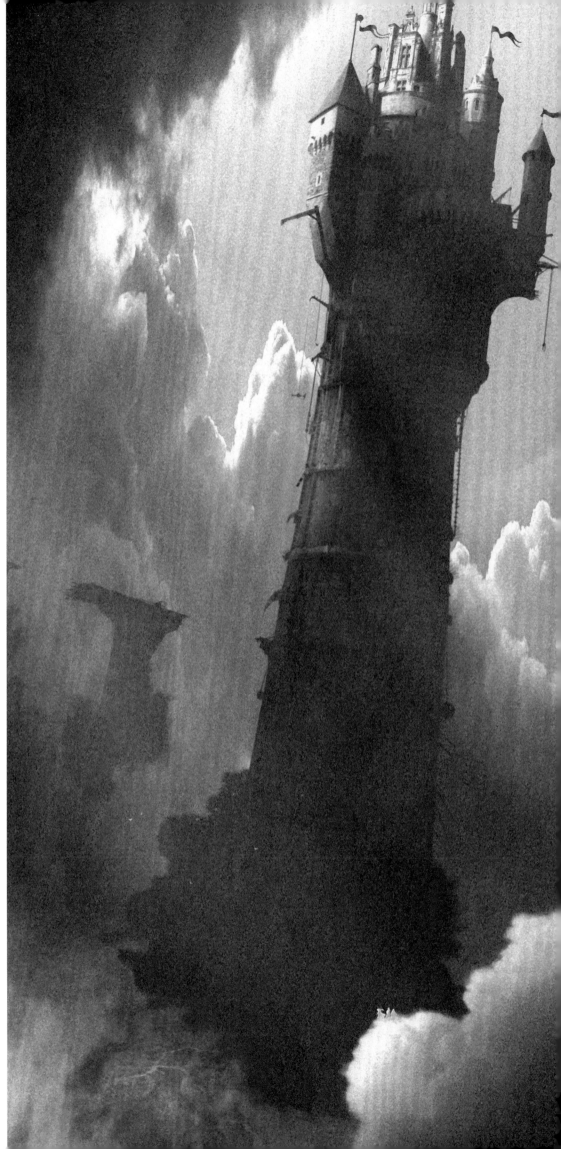

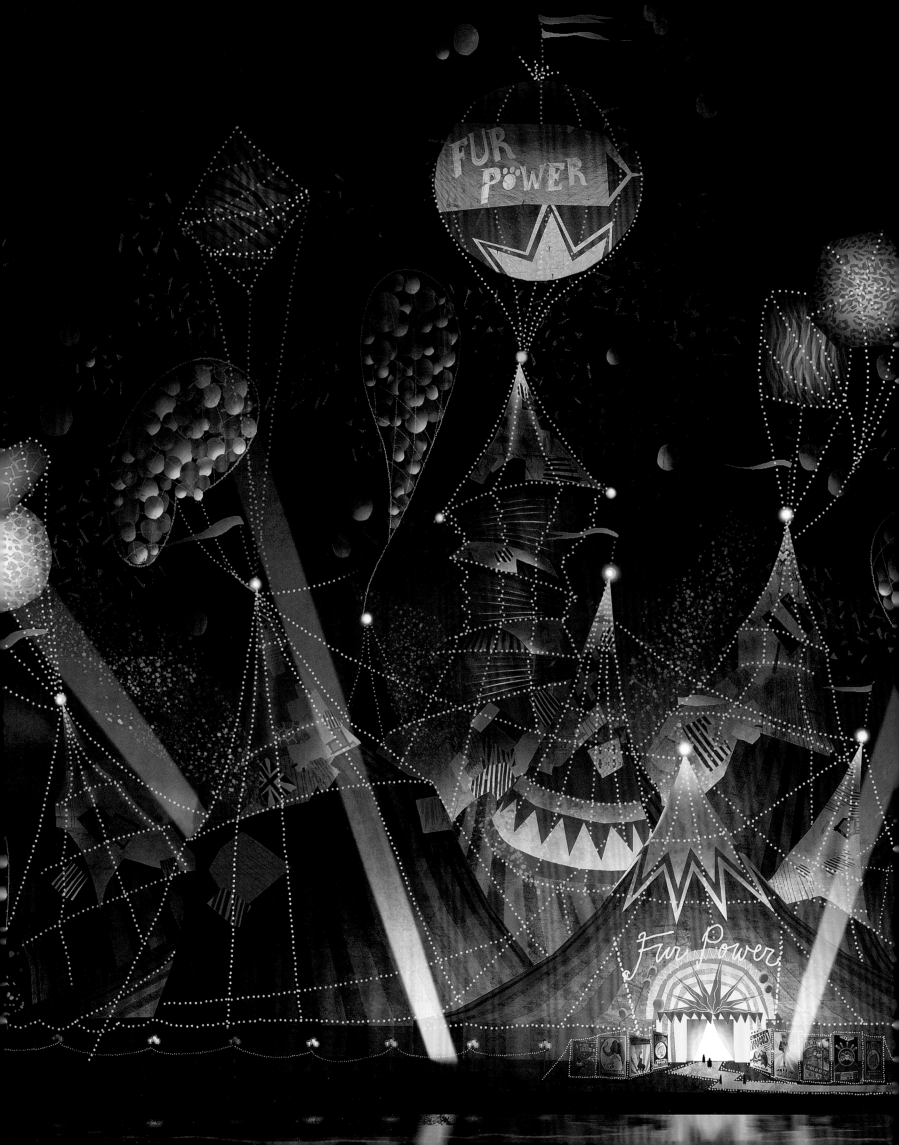

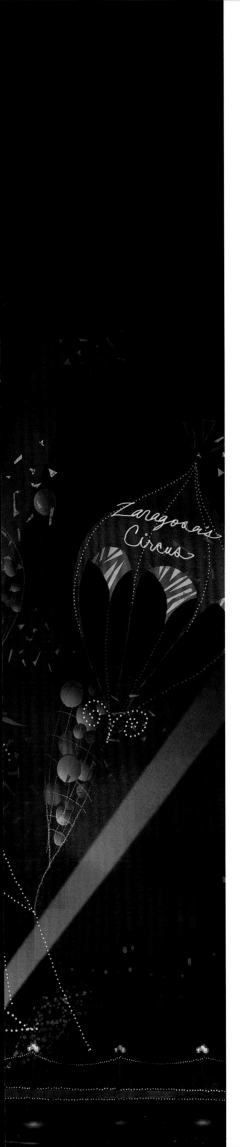

MADAGASCAR 3
EUROPE'S MOST WANTED

2012

Directors	**Eric Darnell, Conrad Vernon, Tom McGrath**
Producers	**Mireille Soria, Mark Swift**
Associate Producer	**Holly Edwards**
Production Designer	**Kendal Cronkhite**
Art Director	**Shannon Jeffries**
Visual Effects Supervisor	**Mahesh Ramasubramanian**

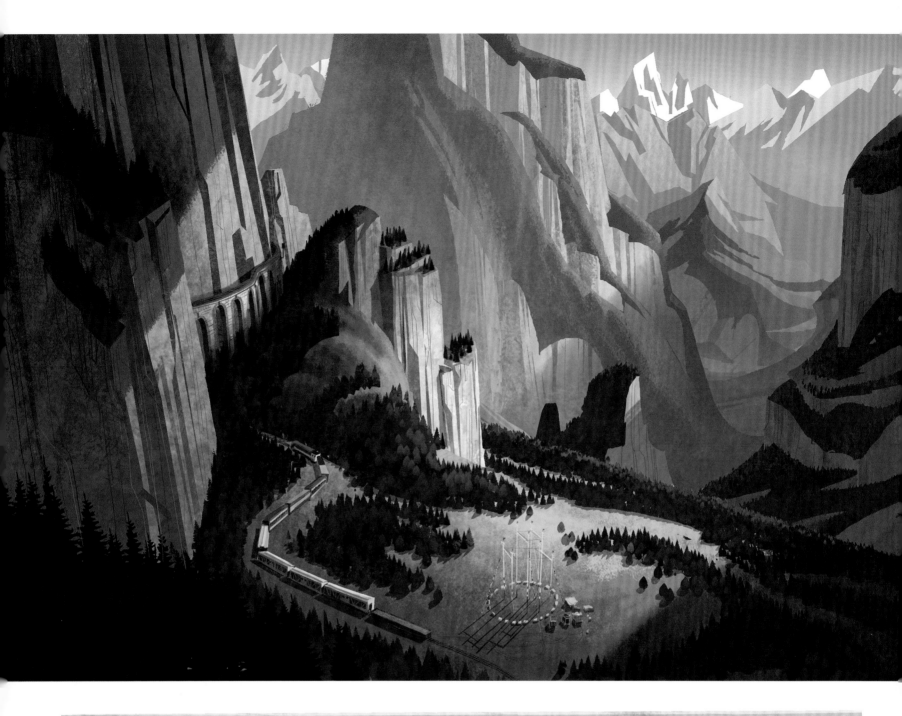

LATHARGIC & SOMEWHAT CLUMSY
WHEN NOT PROPERLY MOTIVATED

WITH PROPER MOTIVATION
"FOOD"
SHE CAN DO ALMOST
ANYTHING WITH UNCANY
GRACE, DARING & PEP

PERHAPS SHE CRAVES PICNIC/CAMPING
FOOD: (POTATOE CHIPS, POWER BARS,
SMORES, MARSHMELLOWS,
BAKED BEANS, HOT DOGS)

"I really love the way the circus was designed, like an old-timey traveling circus—the whole setup with the calliope and Christmas lights in the back. The third movie hit a lot of high points in terms of both story and the overall art and design."

Conrad Vernon, Director

"Because we had license to celebrate the animation we love, we revisited Disney's *Dumbo,* especially the famous "Pink Elephants on Parade" sequence. We were thinking, 'Wow, we haven't seen that kind of otherworldly surreal type of animation on the big screen for a while,' and we had the opportunity to do that with the circus, in CG and in 3D. For me it was just scraping the surface. I would love to see a whole movie that was even more imaginative and really pushed the envelope in a surreal mode."

Tom McGrath, Director

"In the third movie, we brought our characters back into the human world. We essentially built Monte Carlo step-by-step. We actually went to the principality and photographed every street and sidewalk. Then we brought it all back to the studio and used it all as reference to build this massive environment, and every building has as many polygons and vertices as all the environments in *Antz* put together! One of the conceits of the *Madagascar* franchise is that there are no parallel lines, so things are always a little askew. We did that with our character designs but also carried it out in our buildings and streets. You couldn't model all those details by hand, especially within the time that we had to produce the movie. But the smart artists and technicians at DreamWorks were able to come up with a LEGO-like system that would construct these buildings procedurally while keeping all the artistic rules that we'd developed and put in place. So this system would construct these buildings for us automatically, putting in the windows, the balconies, the moldings, etc.—but they all have this off-kilter, unbalanced look, so that every window, every detail is unique."

Eric Darnell, Director

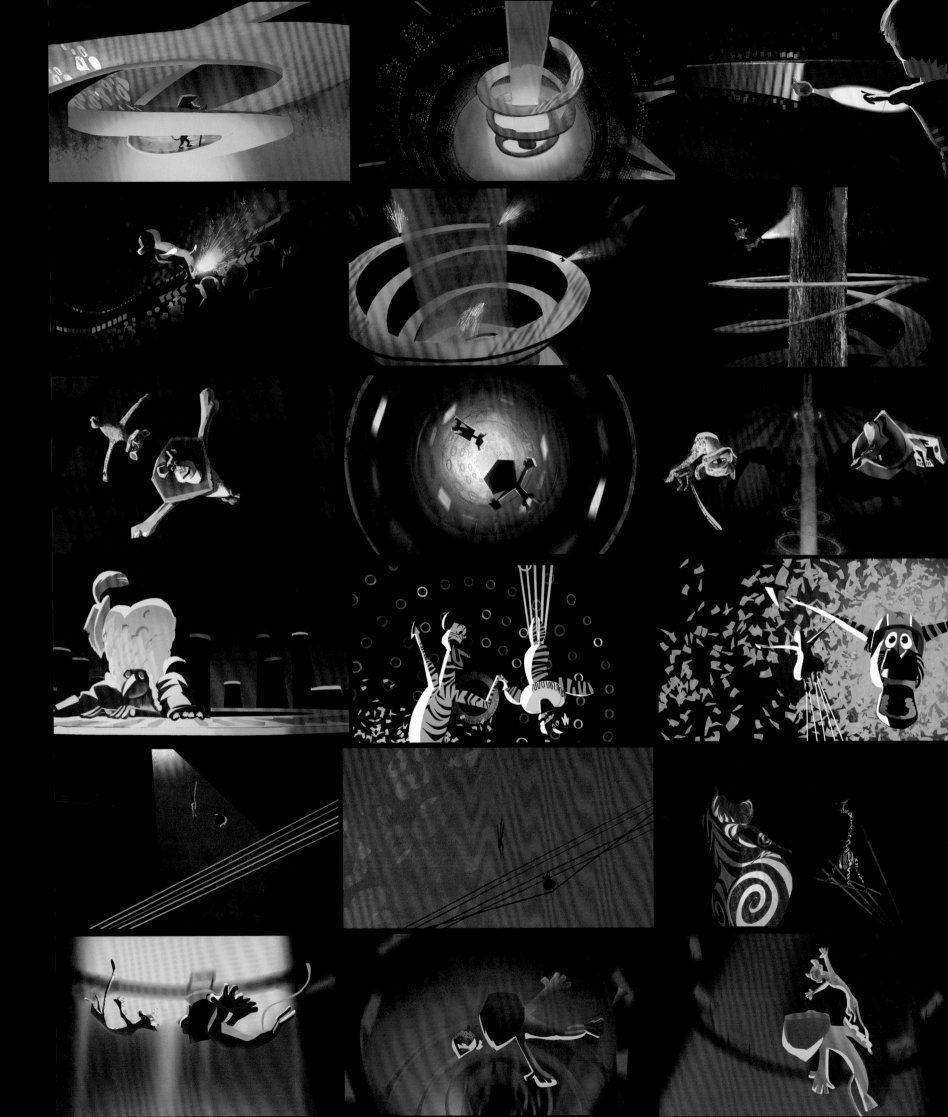

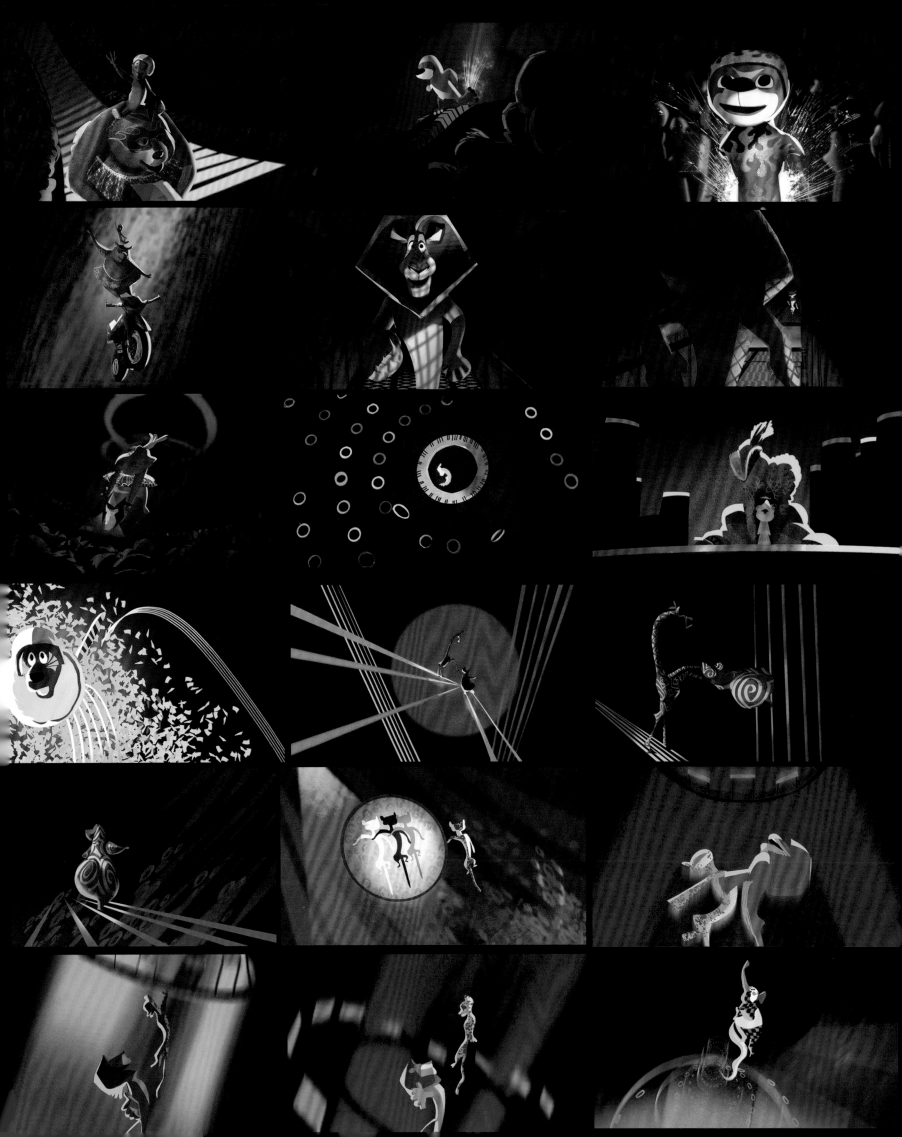

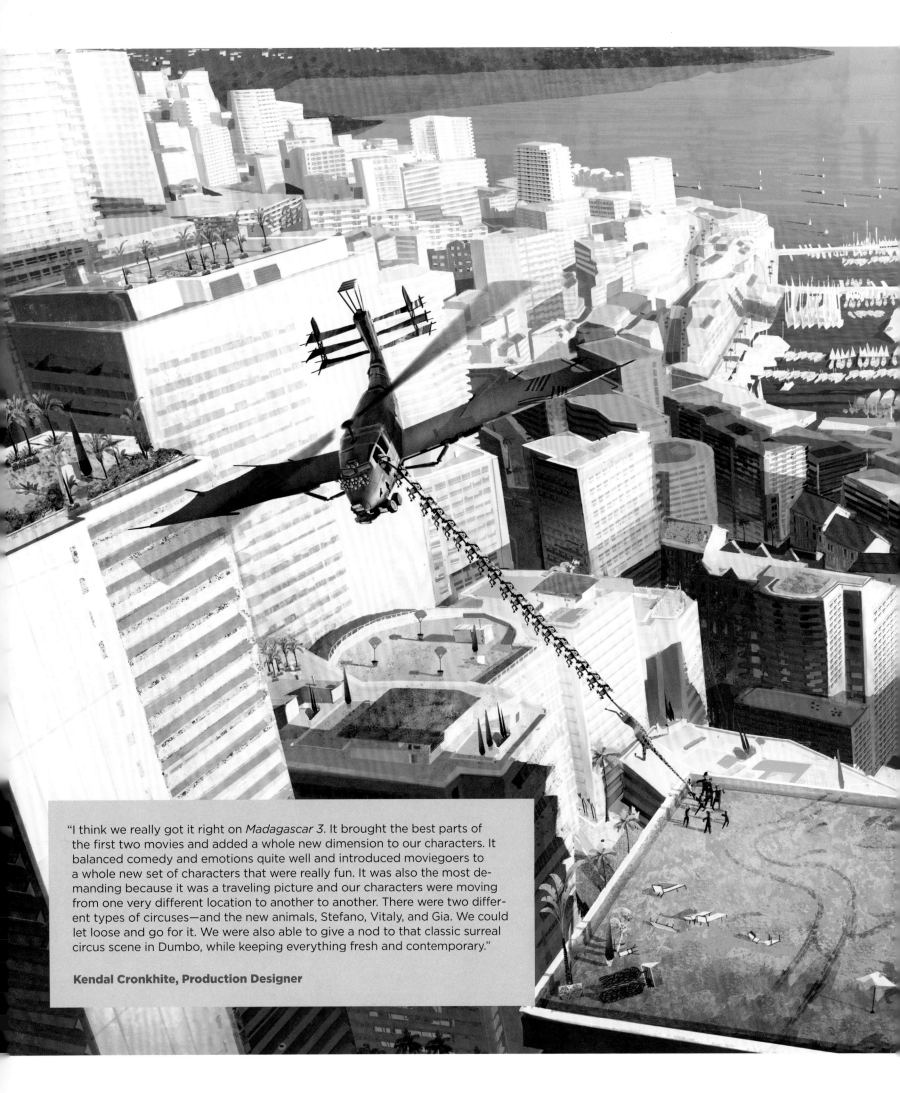

"I think we really got it right on *Madagascar 3*. It brought the best parts of the first two movies and added a whole new dimension to our characters. It balanced comedy and emotions quite well and introduced moviegoers to a whole new set of characters that were really fun. It was also the most demanding because it was a traveling picture and our characters were moving from one very different location to another to another. There were two different types of circuses—and the new animals, Stefano, Vitaly, and Gia. We could let loose and go for it. We were also able to give a nod to that classic surreal circus scene in Dumbo, while keeping everything fresh and contemporary."

Kendal Cronkhite, Production Designer

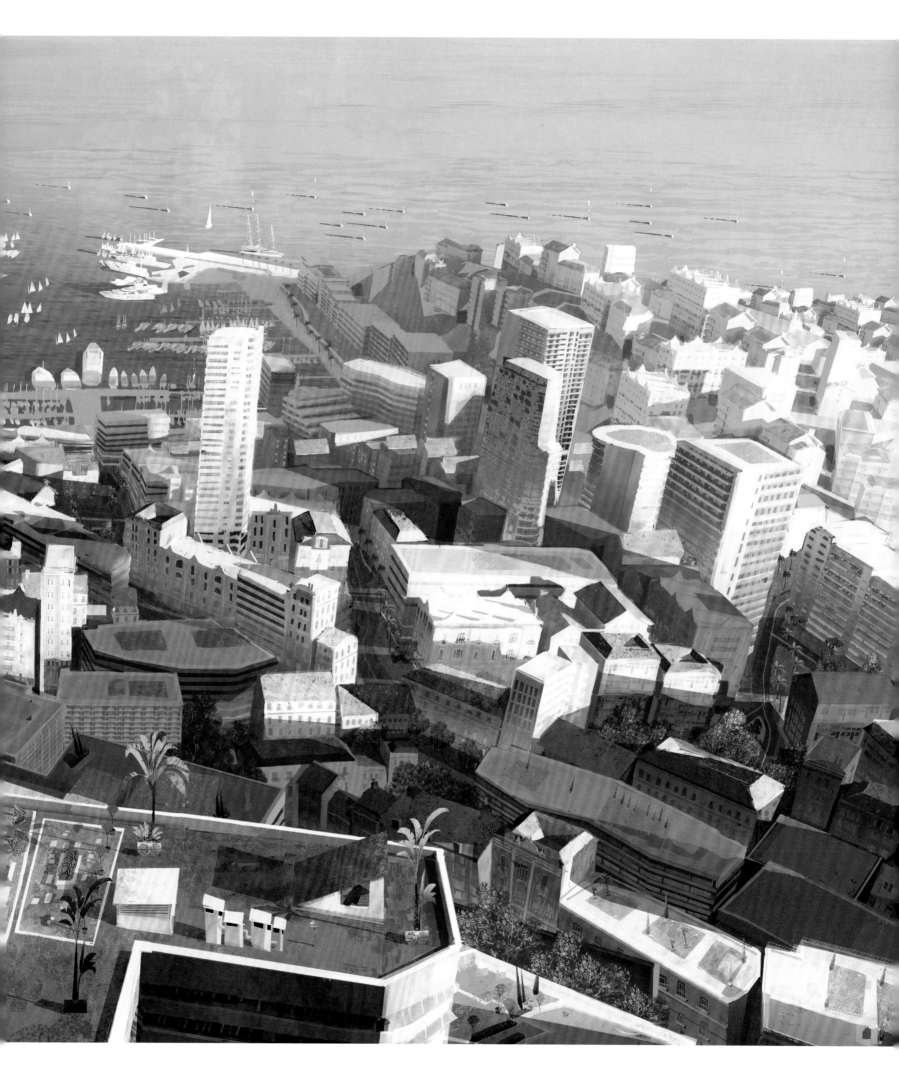

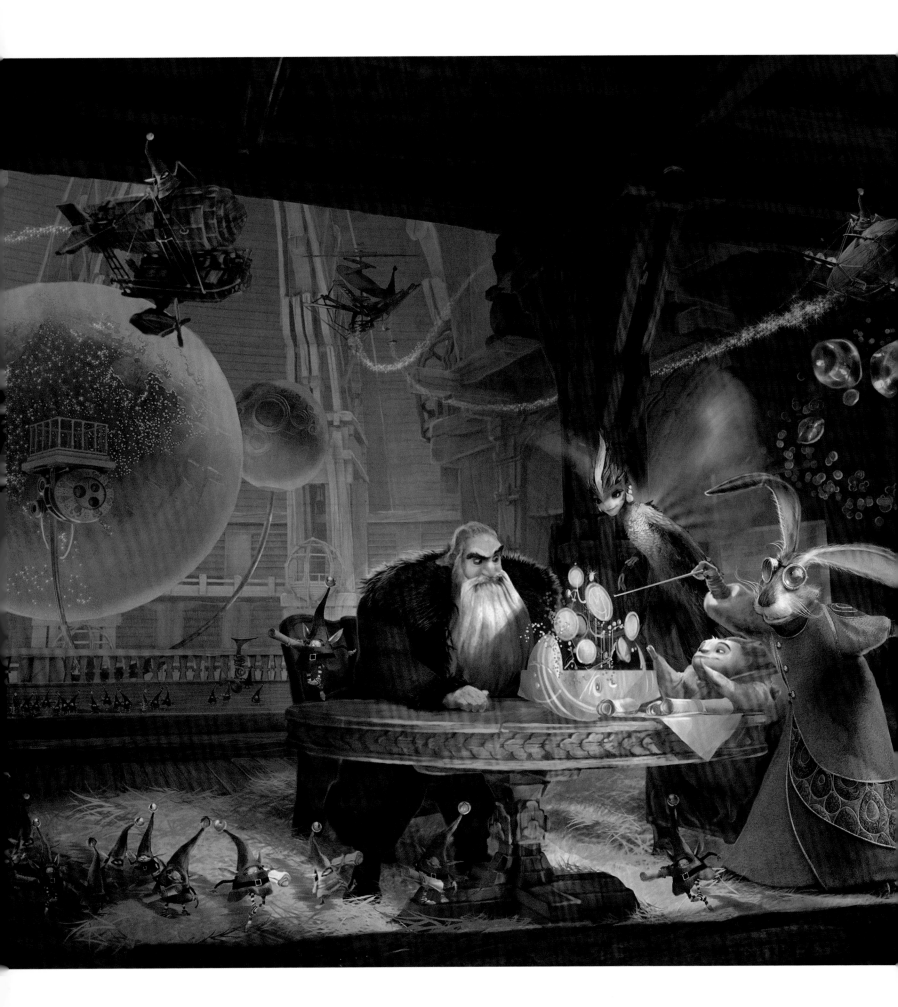

RISE OF THE GUARDIANS

2012

Director	**Peter Ramsey**
Producers	**Christina Steinberg, Nancy Bernstein**
Executive Producers	**William Joyce, Guillermo del Toro, Michael Siegel**
Associate Producers	**Tom Jacomb, Cameron Stevning**
Production Designer	**Patrick Marc Hanenberger**
Art Director	**Max Boas**
Visual Effects Supervisor	**David Prescott**

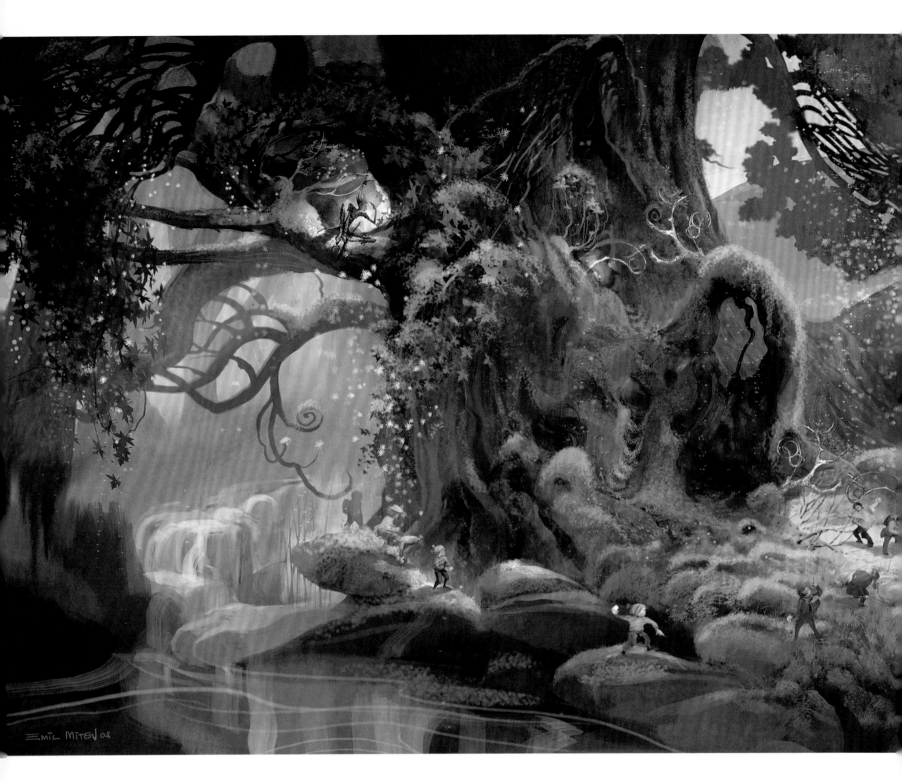

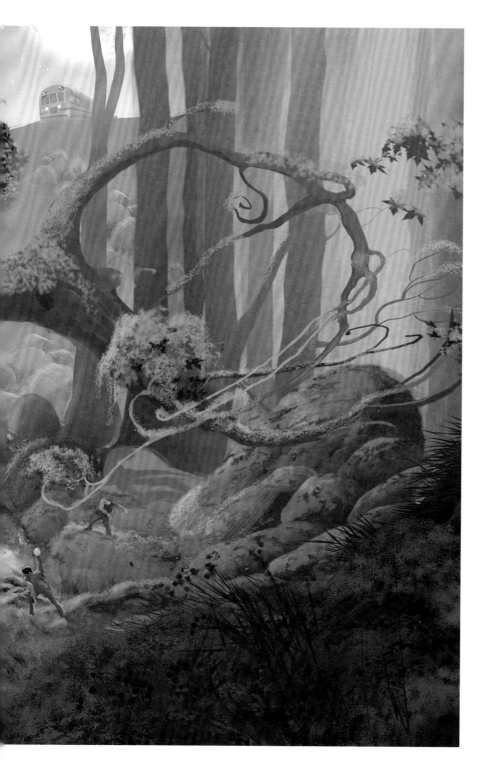

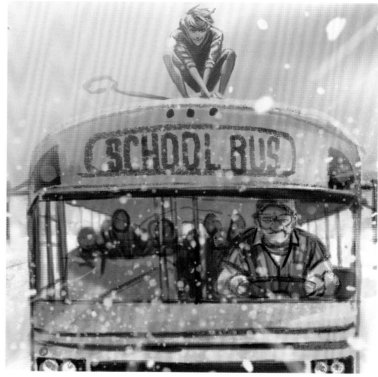

"I felt that *Rise of the Guardians* was the perfect movie for me to do at the time as I had just adopted my baby, who is six years old now. It had a great story and was visually challenging. There were so many characters, both main and secondary, and so many worlds, that they each could be in their own movie, each with a distinct view, storyline, and vision, if we weren't careful. Everyone involved with the movie—director Peter Ramsey, producer Christina Steinberg, production designer Patrick Hanenberger, visual effects supervisor David Prescott, all the department heads, etc.—we all worked together to make sure all the different styles and visuals came together as one distinct movie. It was really important for us to have a cohesive look. I think our big challenge was to create worlds that the audience would believe exist out there, but they had just never seen them before."

Nancy Bernstein, Producer

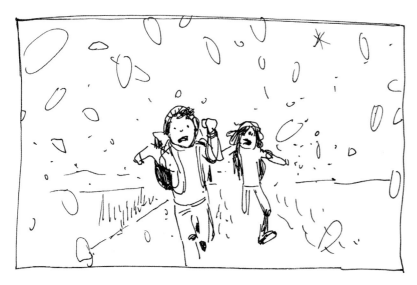

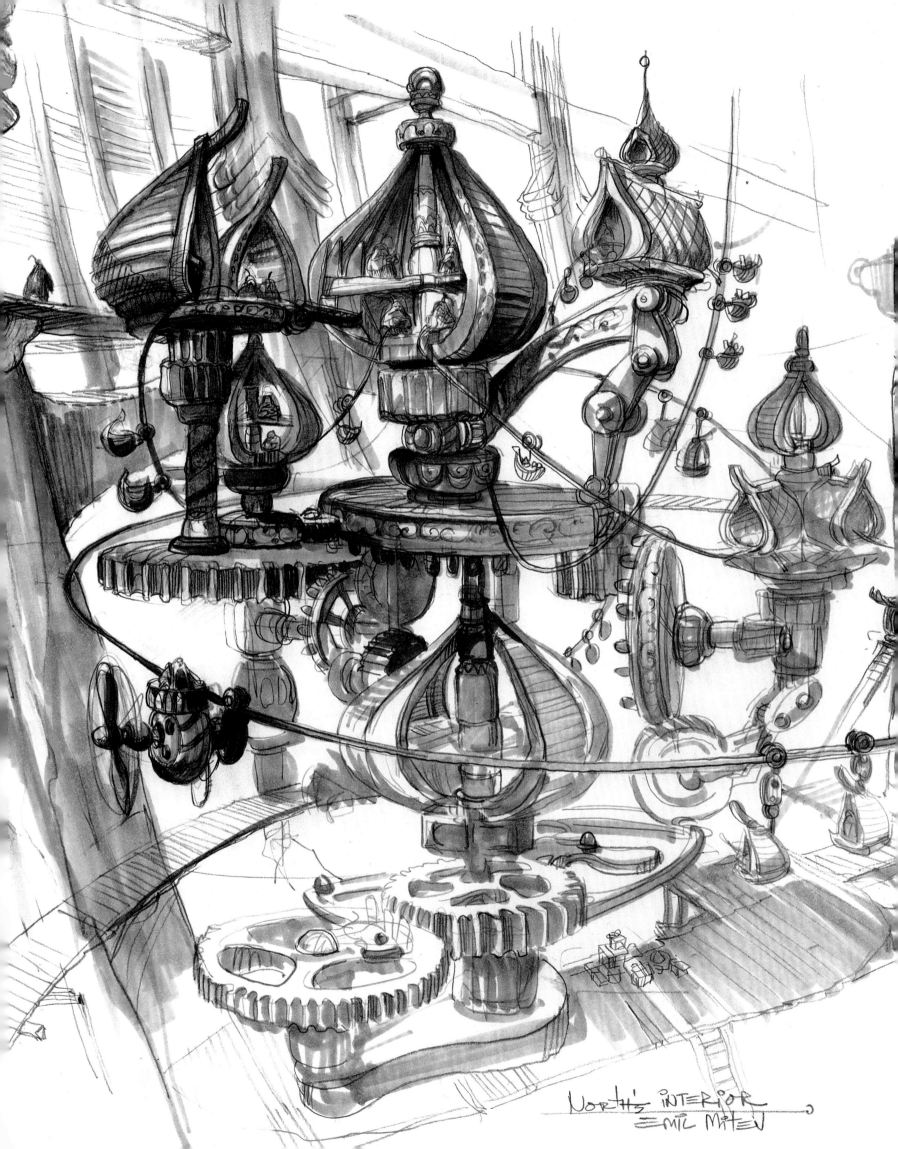

North's Interior
Emil Mitev

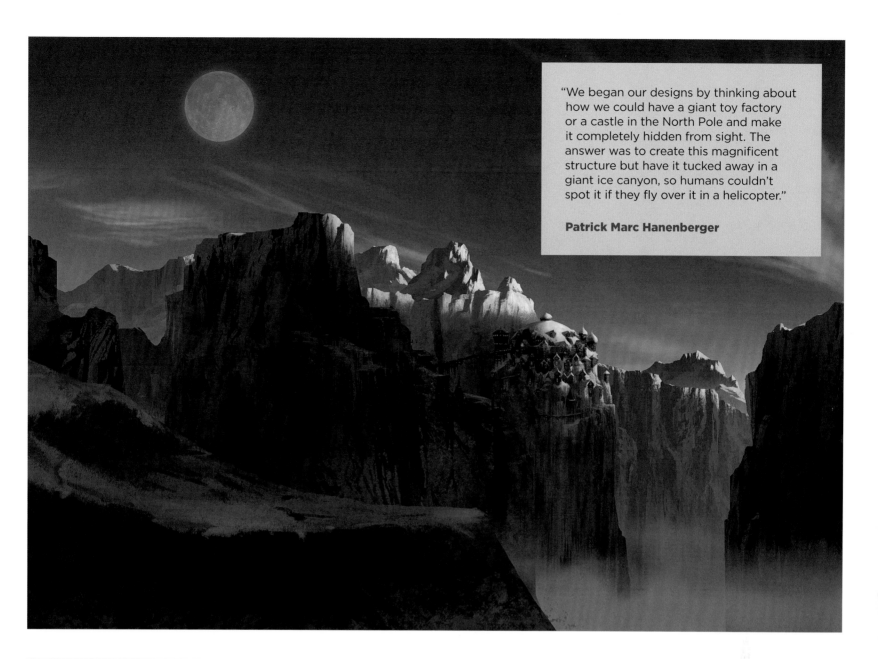

"We began our designs by thinking about how we could have a giant toy factory or a castle in the North Pole and make it completely hidden from sight. The answer was to create this magnificent structure but have it tucked away in a giant ice canyon, so humans couldn't spot it if they fly over it in a helicopter."

Patrick Marc Hanenberger

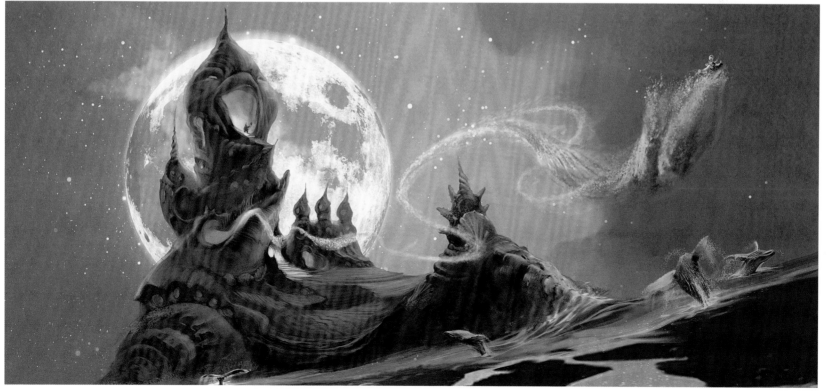

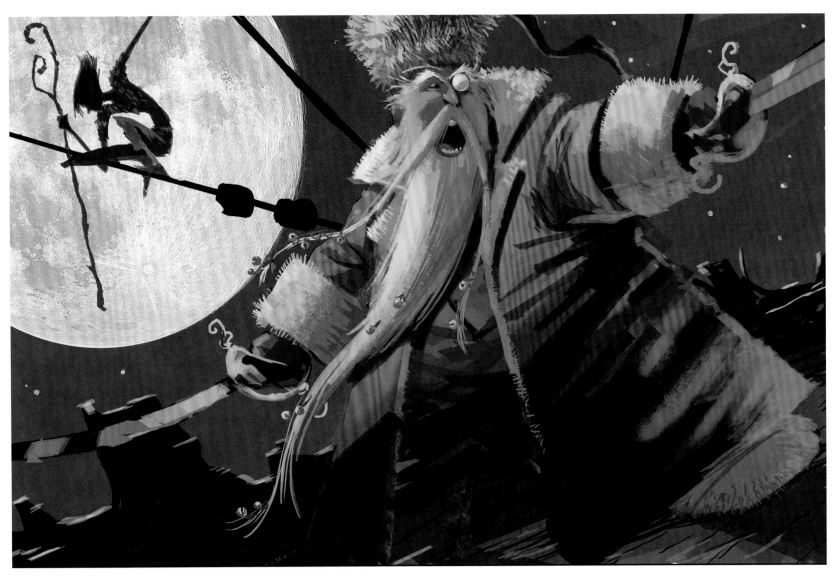

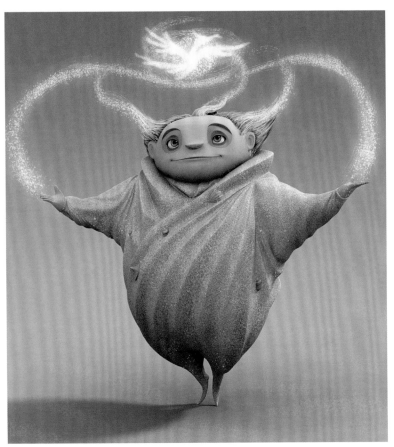

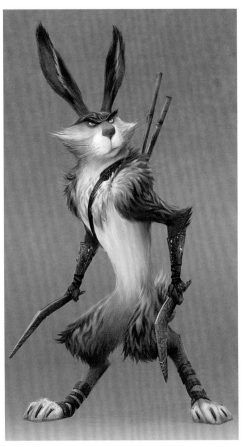

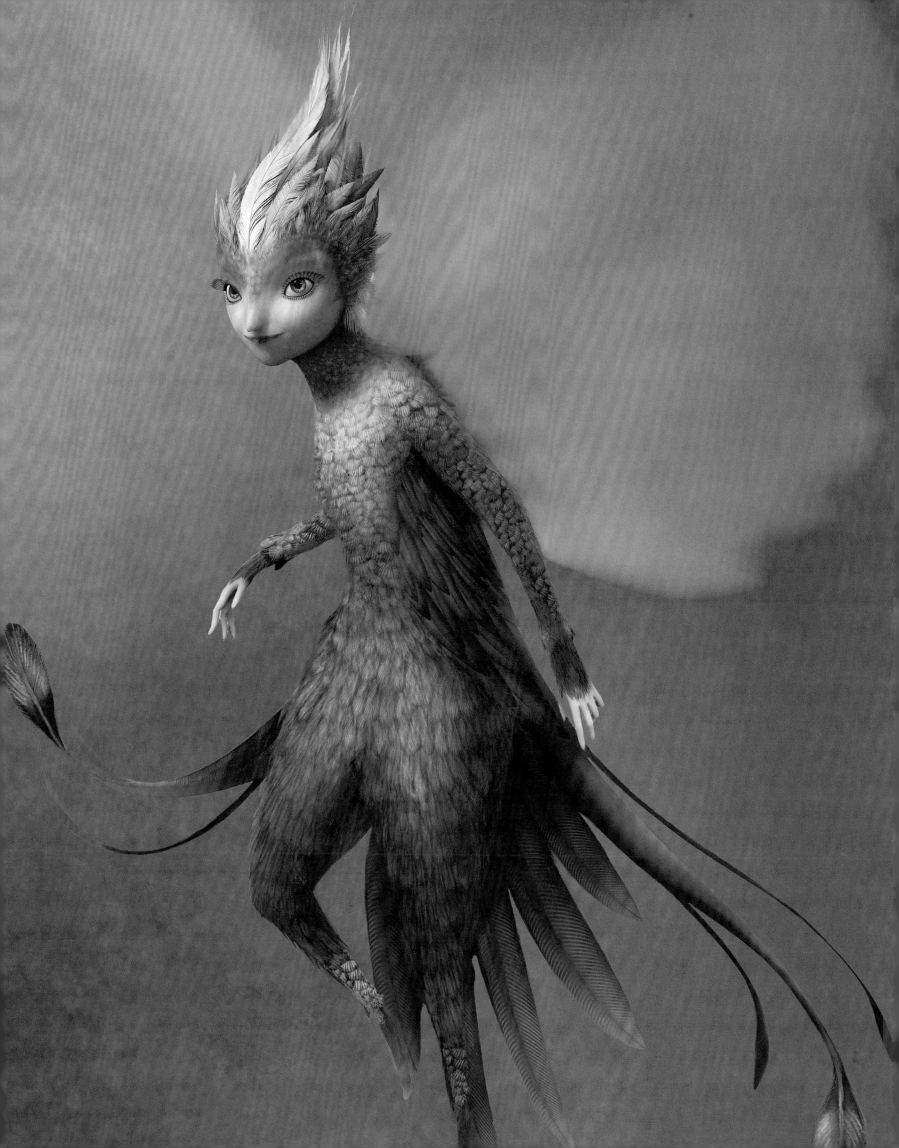

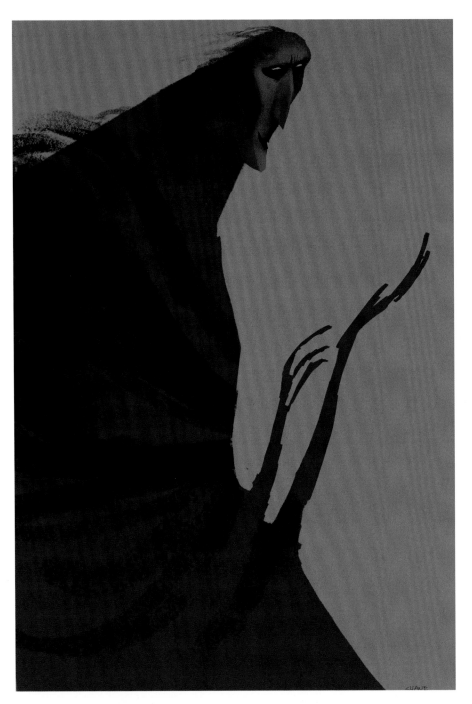

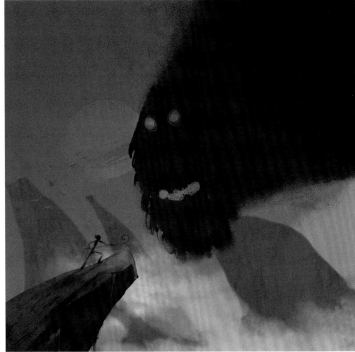

"When I first heard about the project, I began to imagine what we could do with these gigantic, iconic characters: How could we capitalize on the deep emotional connection the audience already had with Santa Claus, the Easter Bunny, and the Tooth Fairy? My thoughts were pretty much in line with those of our writer, David Lindsay-Abaire, and our production designer, Patrick Hanenberger, who also felt strongly about grounding these characters in the real-life connection audiences feel about them. When you're a kid, you believe in them and regard them as real figures, so we wanted to treat them as real personalities, with real weight and real-life attention to detail about their appearances. That was really our starting point."

Peter Ramsey, Director

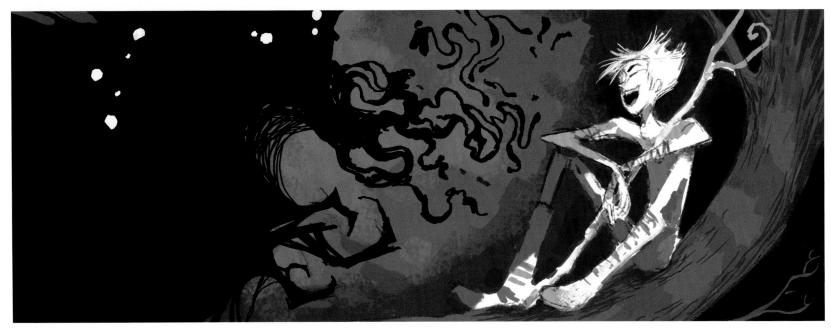

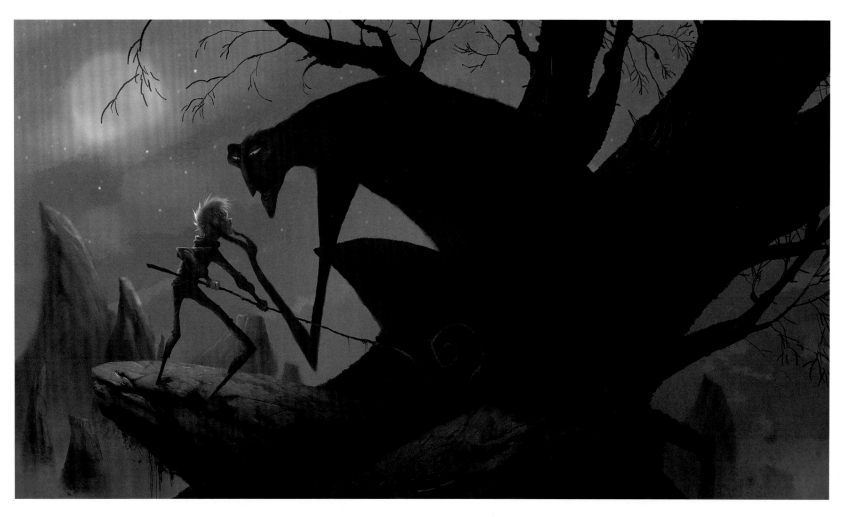

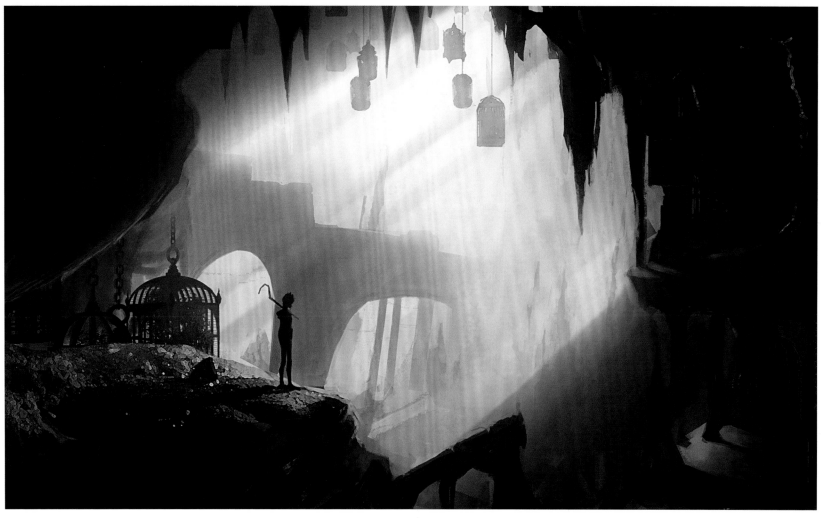

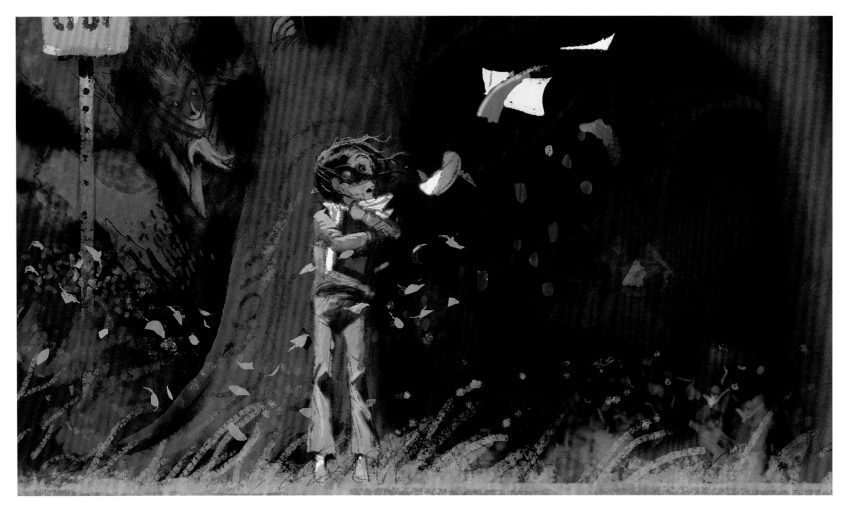

"There were several moments when I knew that the whole project was coming together. I remember the first time I saw Patrick's [Hanenberger] paintings of the North Pole and the Tooth Palace. Then there was the first time I saw the first tests of the Sand Man visual effects or Hamish Grieve's storyboard for the scene in which Jamie sees Jack Frost for the first time. It's always special when we get the first animation tests and feel that we really nailed it, and that the character is coming to life right in front of your eyes. I also think of watching the film's composer, Alexandre Desplat, conducting the London Symphony Orchestra as they performed his score at the Abbey Road Studios in London. Those moments were really amazing for me, but nothing quite topped seeing the finished product with live audiences who were totally engaged with it. To this day, I hear from people who tell us how much they enjoyed seeing the movie with their family. It makes the whole experience really gratifying."

Peter Ramsey, Director

"The Guardians represent hope, joy, wonder, and dreams. If Pitch is able to take them out, they will literally cease to exist. The attributes they represent would be gone from the world and fear would reign."

Christina Steinberg, Producer

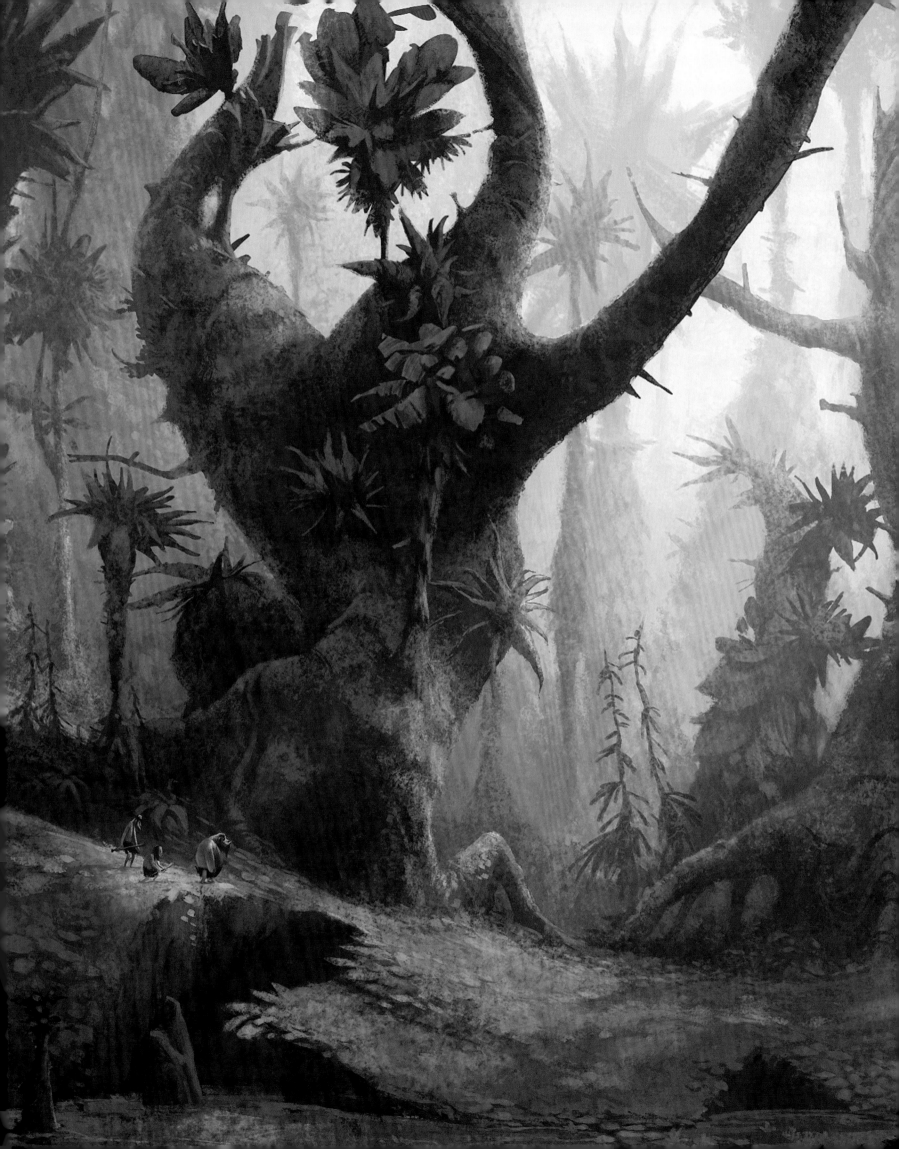

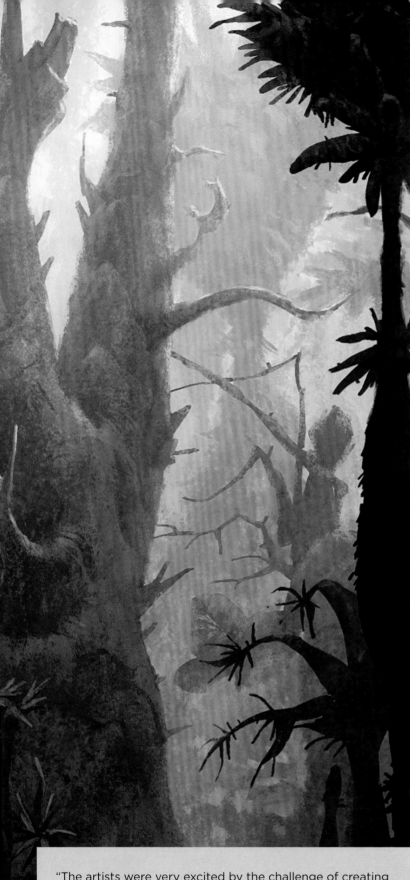

"The artists were very excited by the challenge of creating the world of the Croods, which was a prehistoric world that was created from scratch. In a way, everything was going to come from a place of fantasy, so it was going to fully engage everyone's imagination. So on the one hand it was an exciting prospect, a world without boundaries where we could indulge ourselves. But very quickly we learned the curse of such freedom—no boundaries, no template, so no clear place to begin. We were going to have to write the rule book on this new place."

Chris Sanders, Director

Directors	**Chris Sanders, Kirk DeMicco**
Producers	**Kristine Belson, Jane Hartwell**
Production Designer	**Christophe Lautrette**
Art Directors	**Paul Duncan, Dominique R. Louis**
Visual Effects Supervisor	**Markus Manninen**

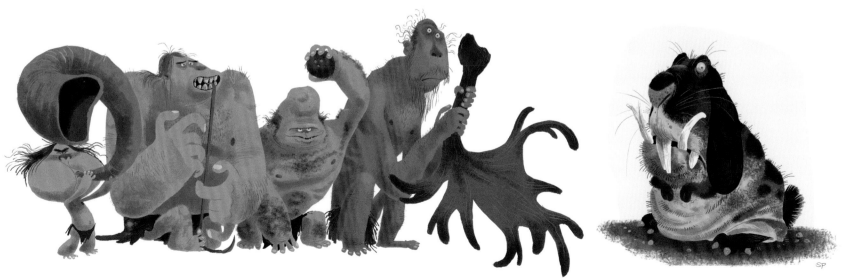

"Had we anchored the movie to a world like 10,000 B.C., where you had straight-up mammoths and saber-toothed tigers, we'd have lost any of the whimsy that you want for an animated feature, especially one that involves people seeing things for the first time. We wanted our audience and the characters to be seeing things for the first time together. In our version, it's like 'Oh, look here are some cute birds, oh man, wait, they're not cute birds.' I think that's what kept the audience involved in it."

Kirk DeMicco, Director

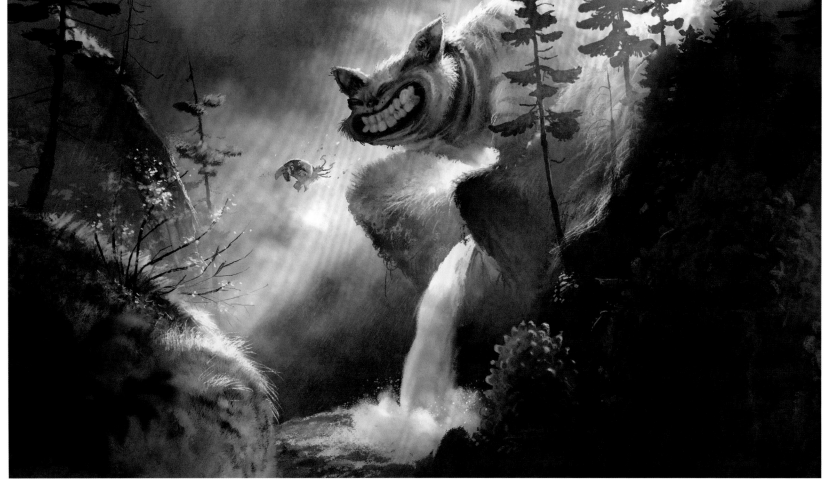

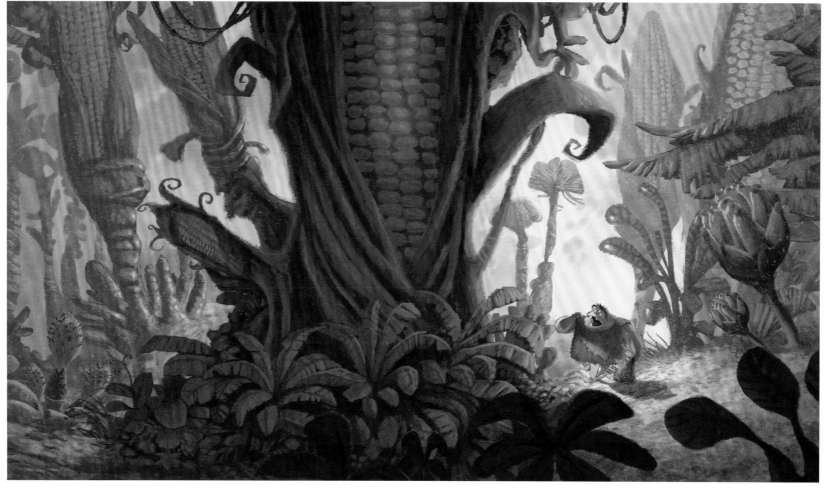

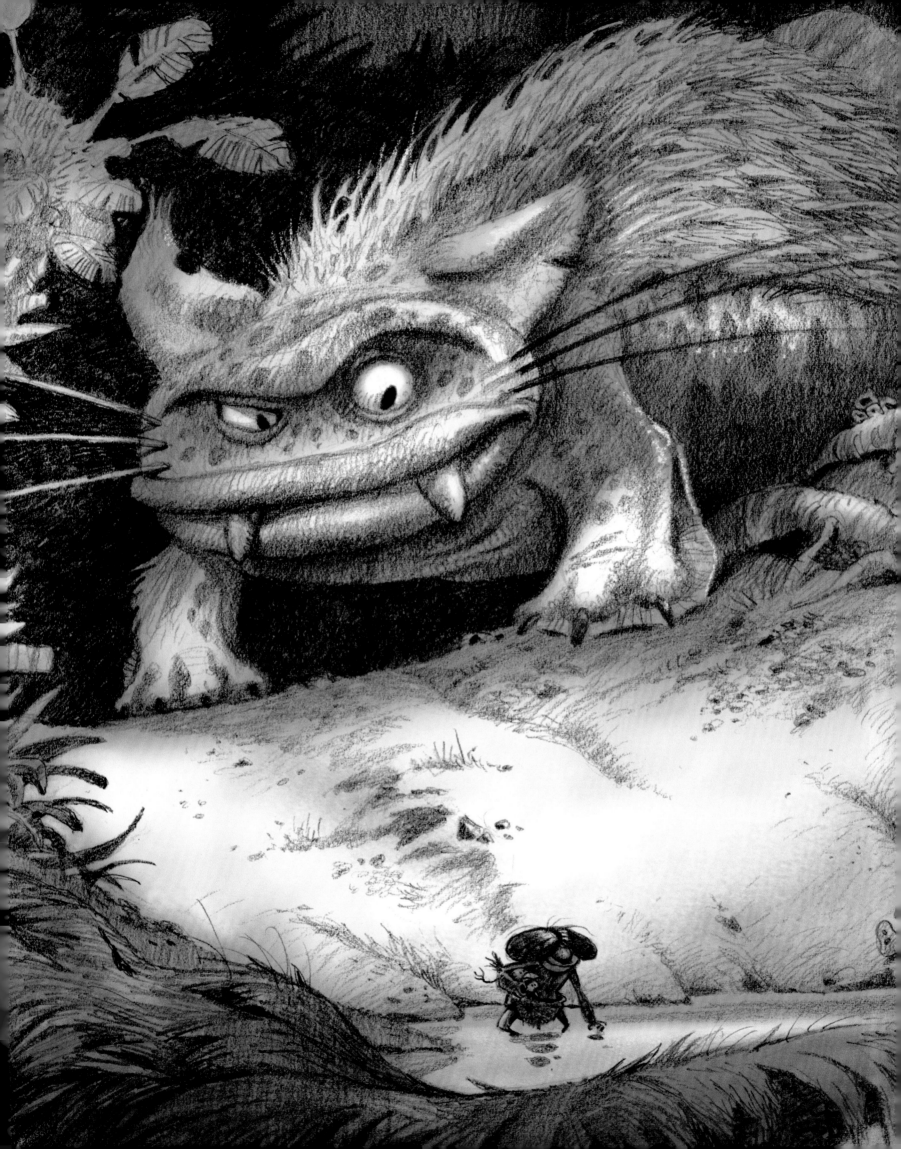

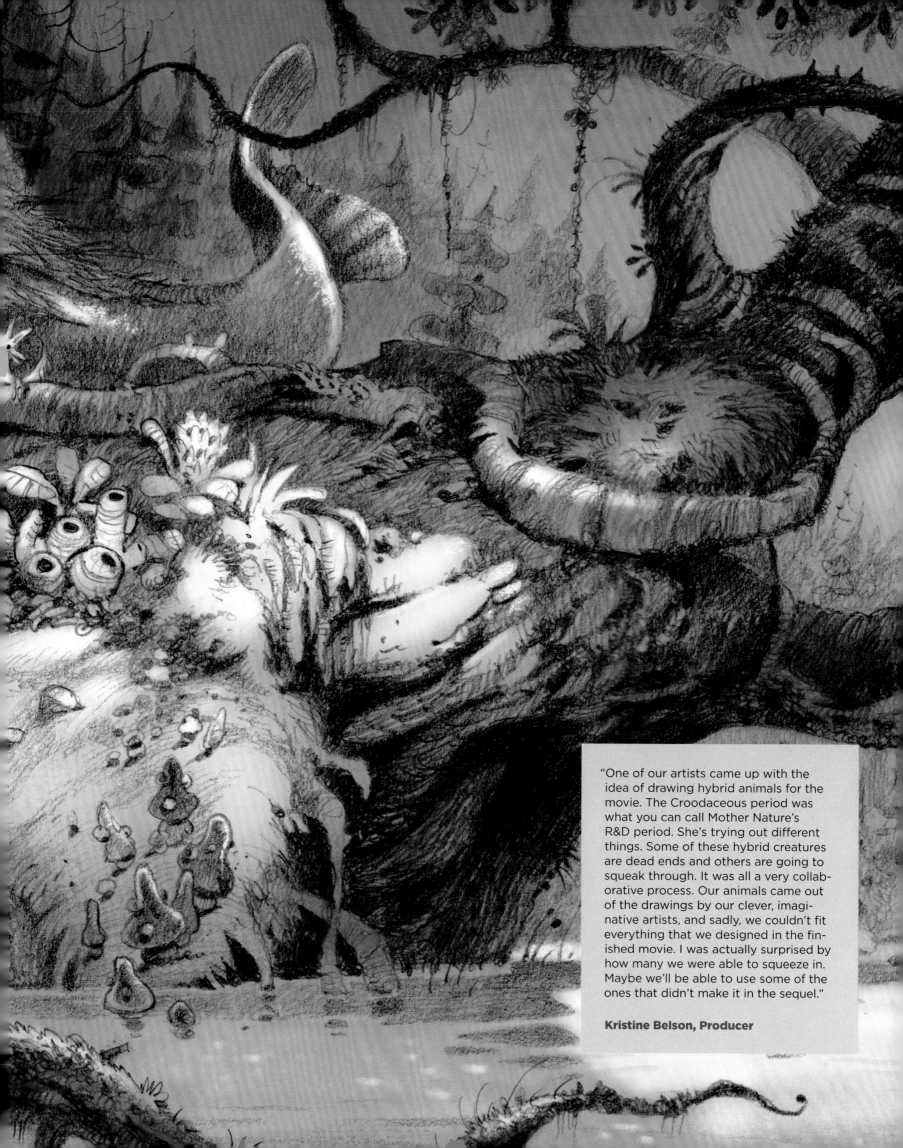

"One of our artists came up with the idea of drawing hybrid animals for the movie. The Croodaceous period was what you can call Mother Nature's R&D period. She's trying out different things. Some of these hybrid creatures are dead ends and others are going to squeak through. It was all a very collaborative process. Our animals came out of the drawings by our clever, imaginative artists, and sadly, we couldn't fit everything that we designed in the finished movie. I was actually surprised by how many we were able to squeeze in. Maybe we'll be able to use some of the ones that didn't make it in the sequel."

Kristine Belson, Producer

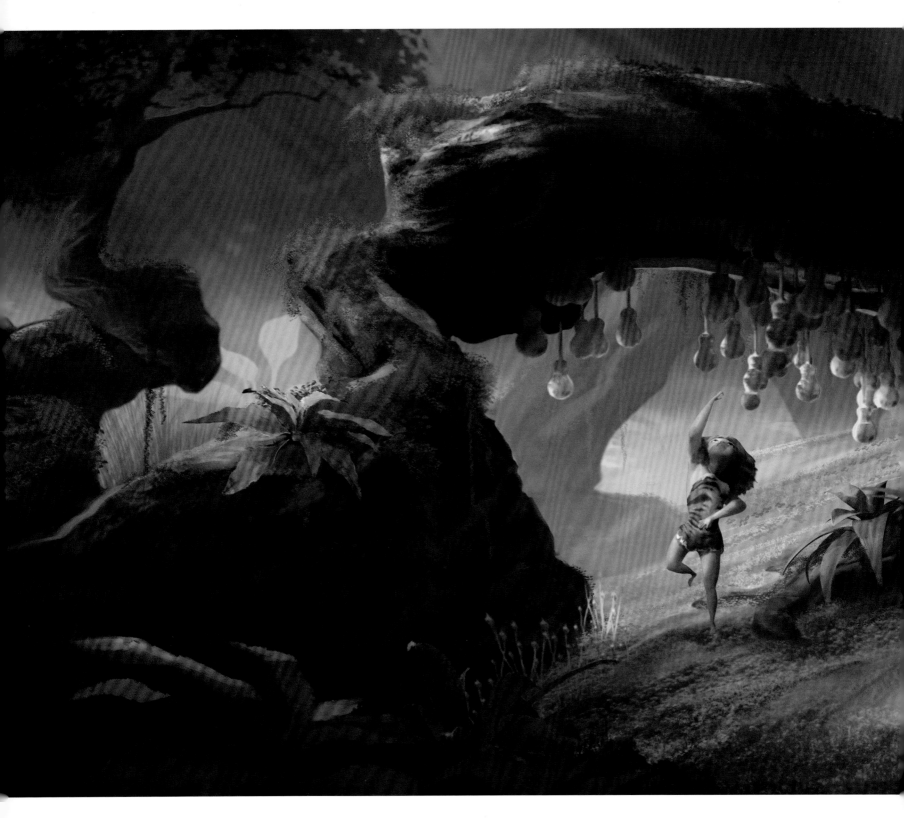

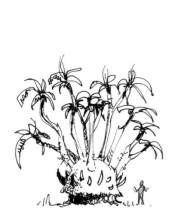
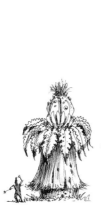
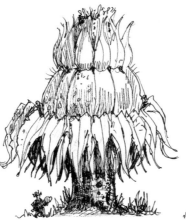
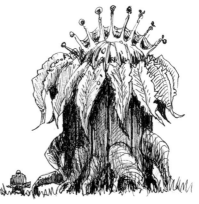

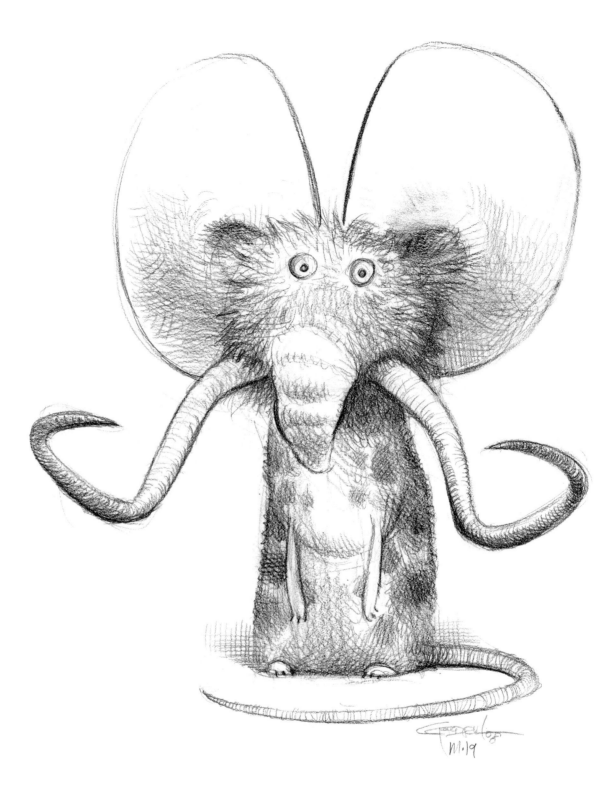

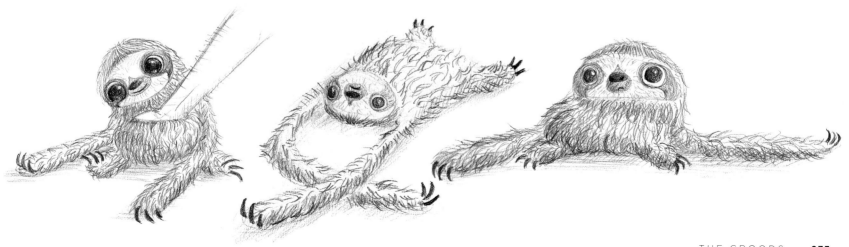

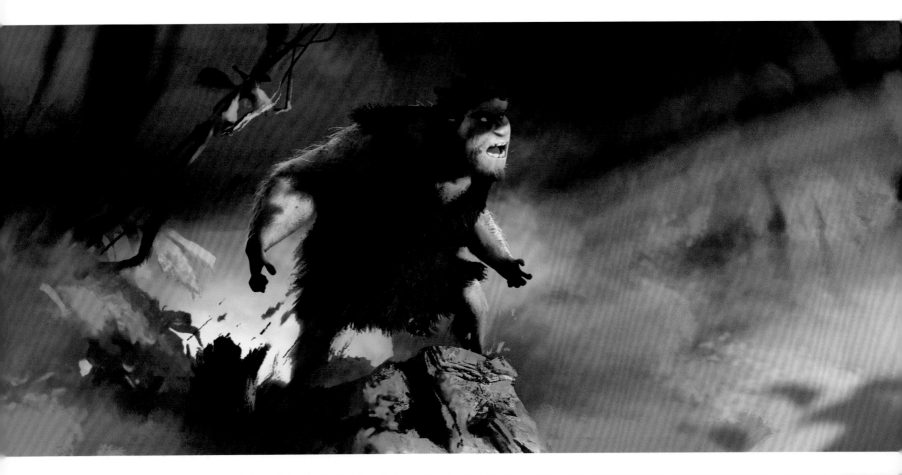

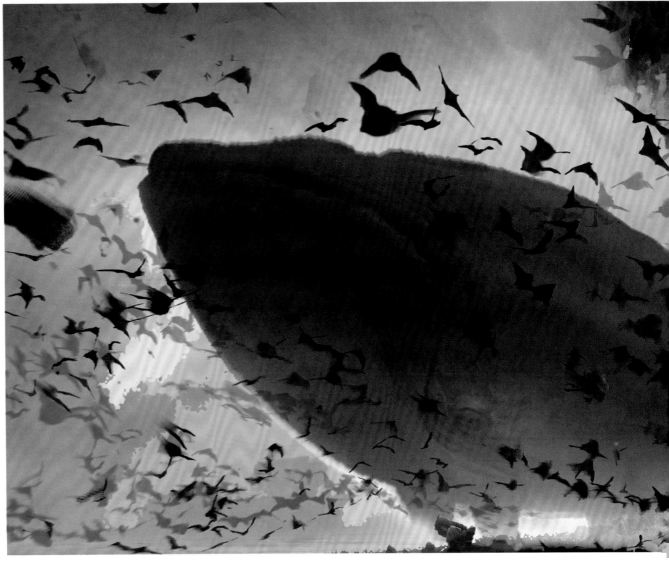

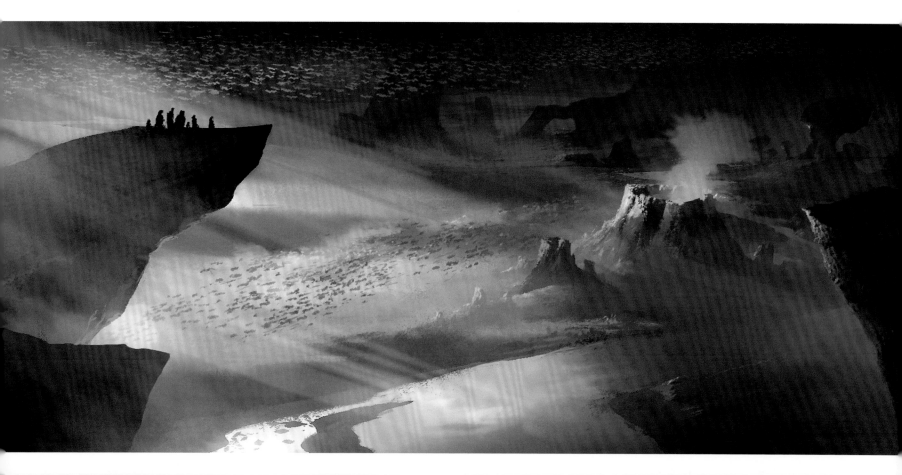

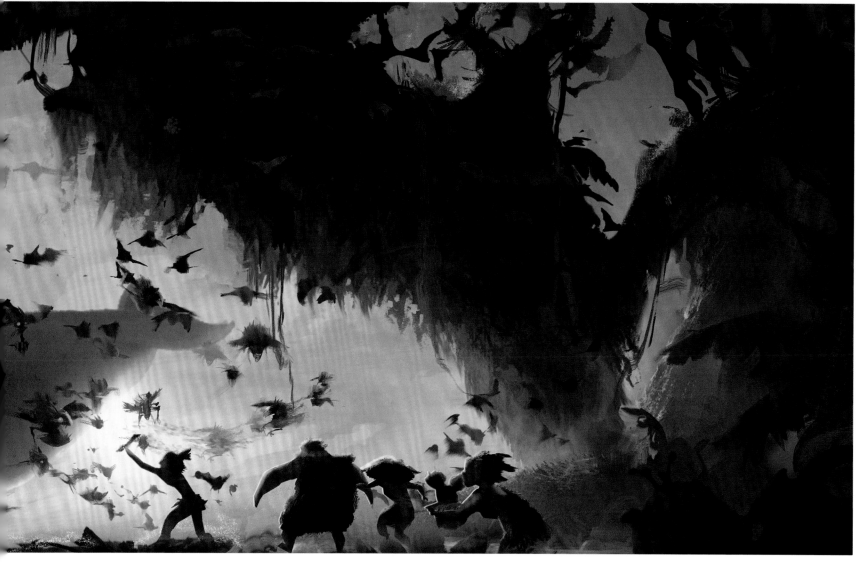

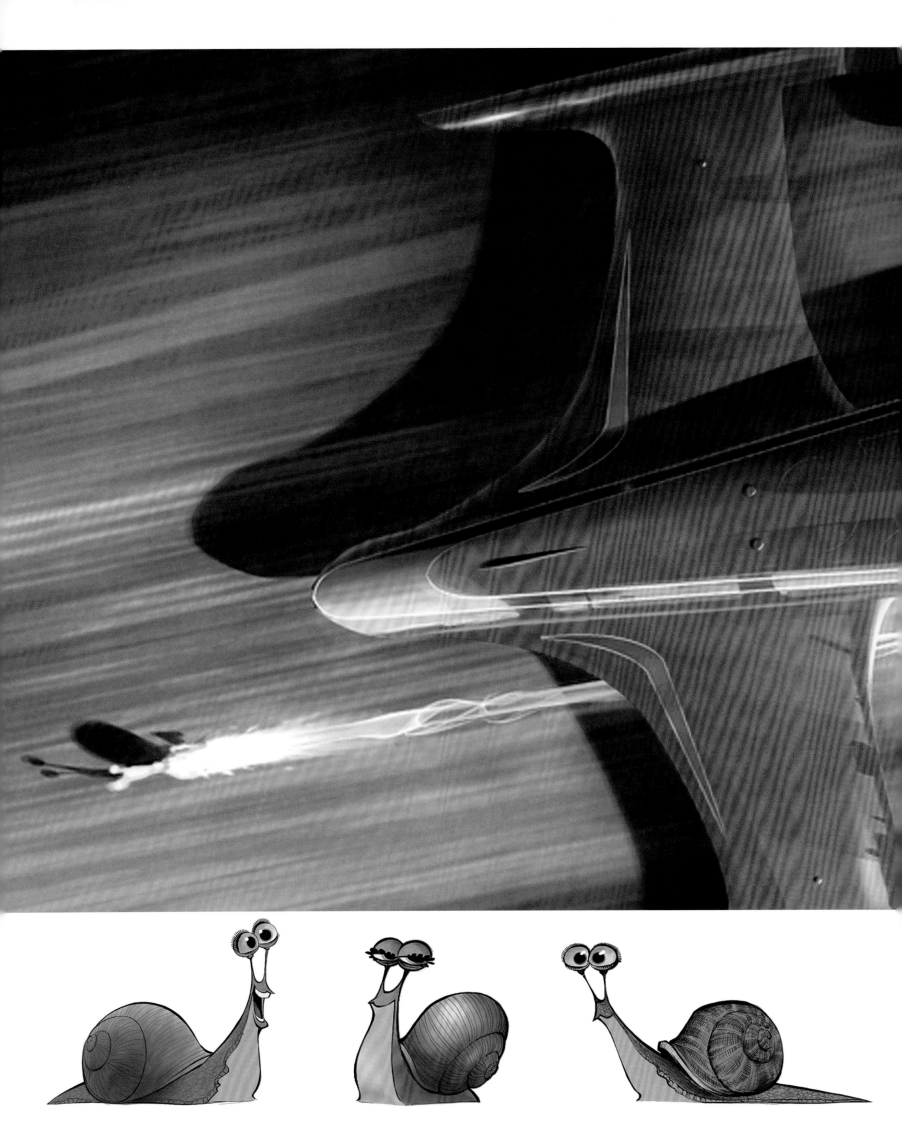

TURBO

"When we were beginning work on the movie, it seemed to me that there were two camps of CG movies—one had realistic backgrounds and characters and the other one had cartoony characters in a cartoony world. I hadn't seen these two approaches married together. I loved the integration of more naturalistic, live-action lighting that was beginning to happen in CG movies but not at the expense of losing the fun, classic, stylized design that had been mastered in the hand-drawn form. It was a gamble. I didn't know it was going to work, but it did. When we saw the first sequence lit, it was hugely gratifying. We had to make sure the shape language of the environments was pushed a bit to blend with the more pushed designs of the character, but for the most part, it was clear the marriage would work."

David Soren, Director

Director	**David Soren**
Producer	**Lisa Stewart**
Co-Producer	**Susan Slagle Rogers**
Production Designer	**Michael Isaak**
Art Director	**Richard Daskas**
Visual Effects Supervisor	**Sean Phillips**

"The anatomy of our snails proved to be challenging. Because they don't have shoulders, hands, eyebrows, or noses—things we normally use to communicate character performance with the audience—we were forced to emphasize other attributes. We had to really micro-shape the eyelids, smush the eyeballs together and bring the eyes closer to their heads, push the mouth higher on the head—we had to really create their faces."

David Burgess, Head of Character Animation

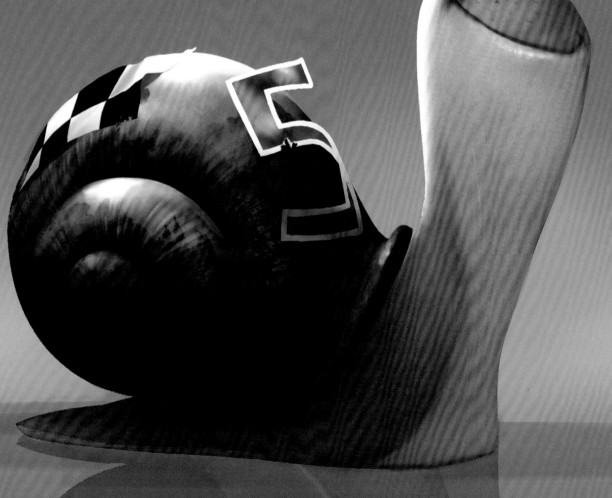

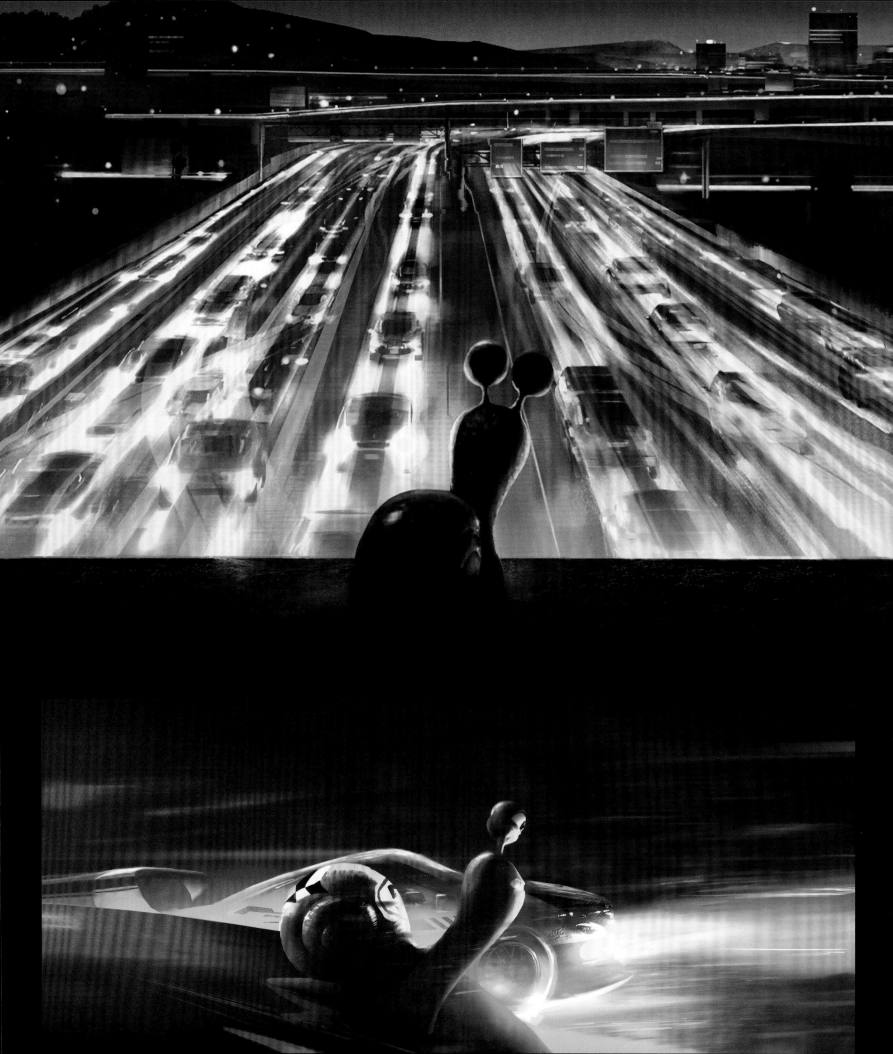

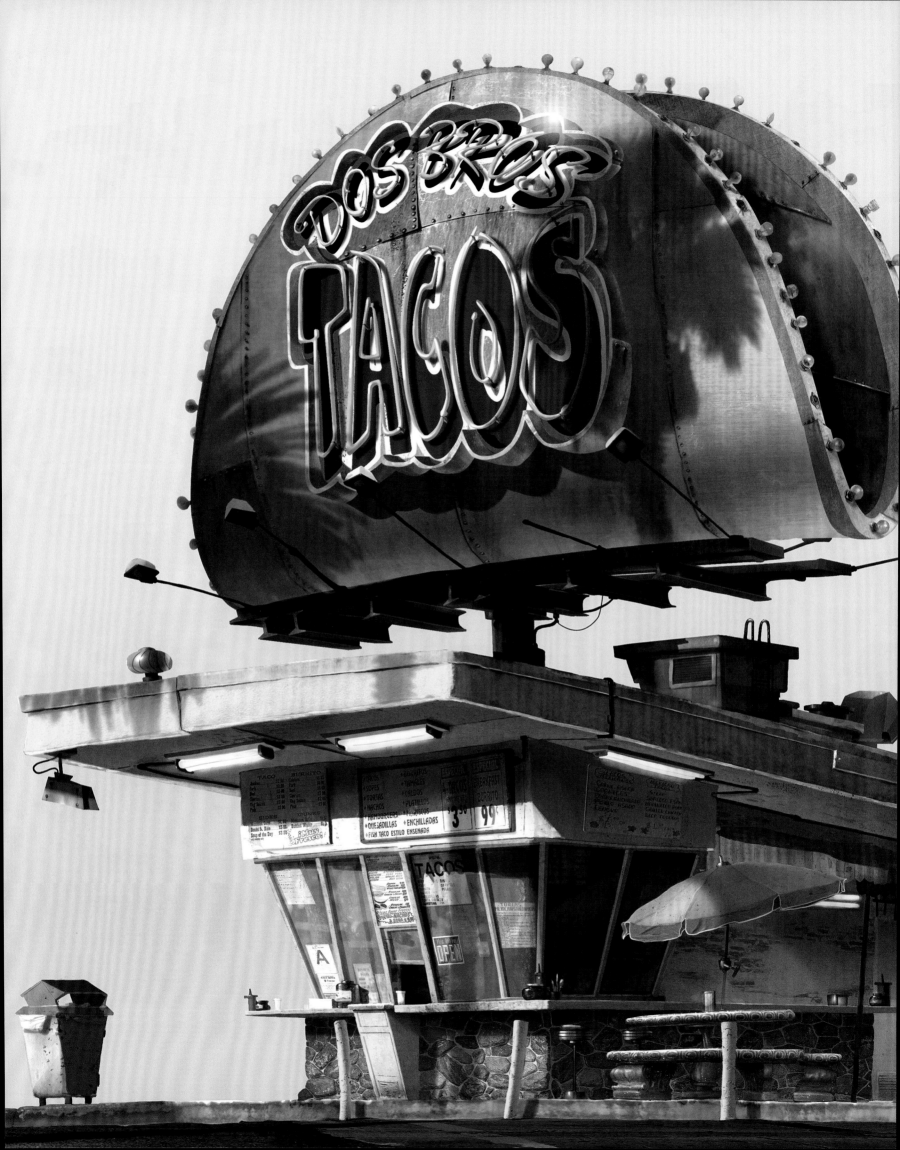

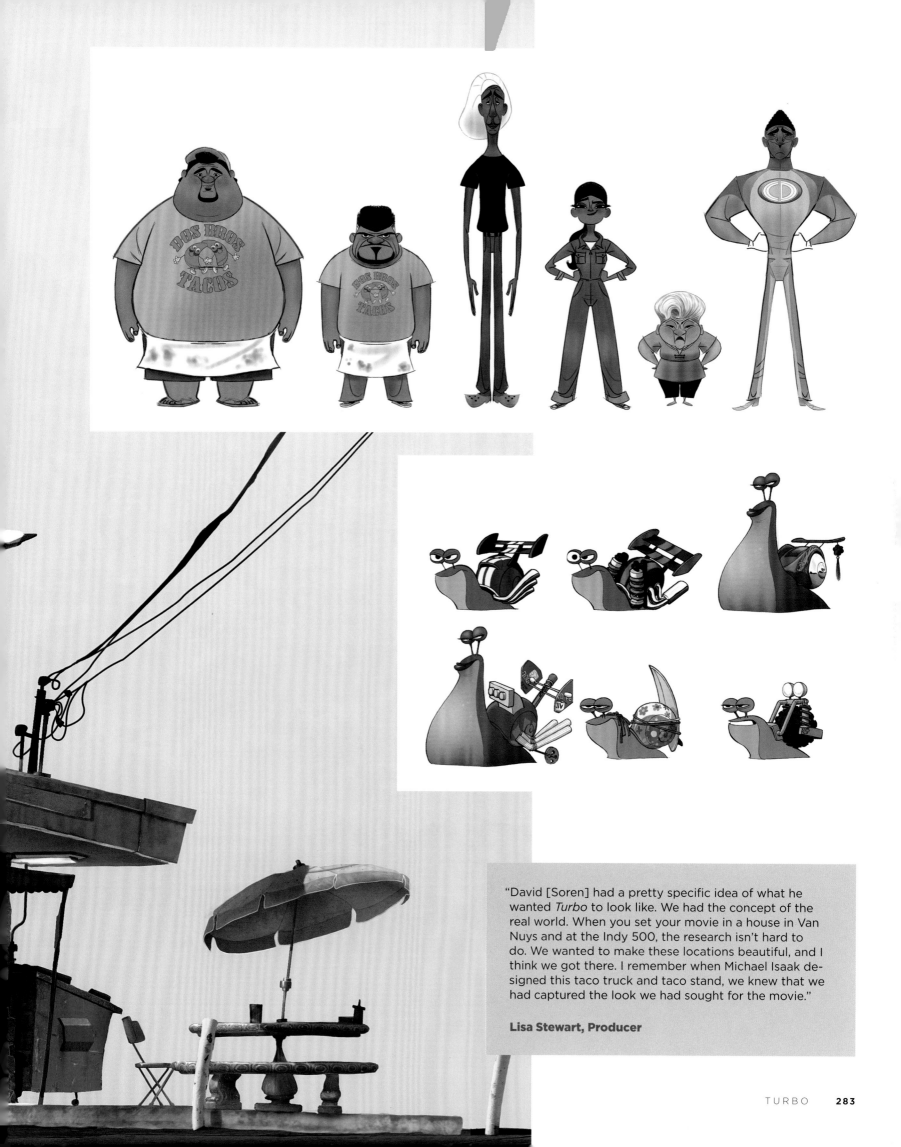

"David [Soren] had a pretty specific idea of what he wanted *Turbo* to look like. We had the concept of the real world. When you set your movie in a house in Van Nuys and at the Indy 500, the research isn't hard to do. We wanted to make these locations beautiful, and I think we got there. I remember when Michael Isaak designed this taco truck and taco stand, we knew that we had captured the look we had sought for the movie."

Lisa Stewart, Producer

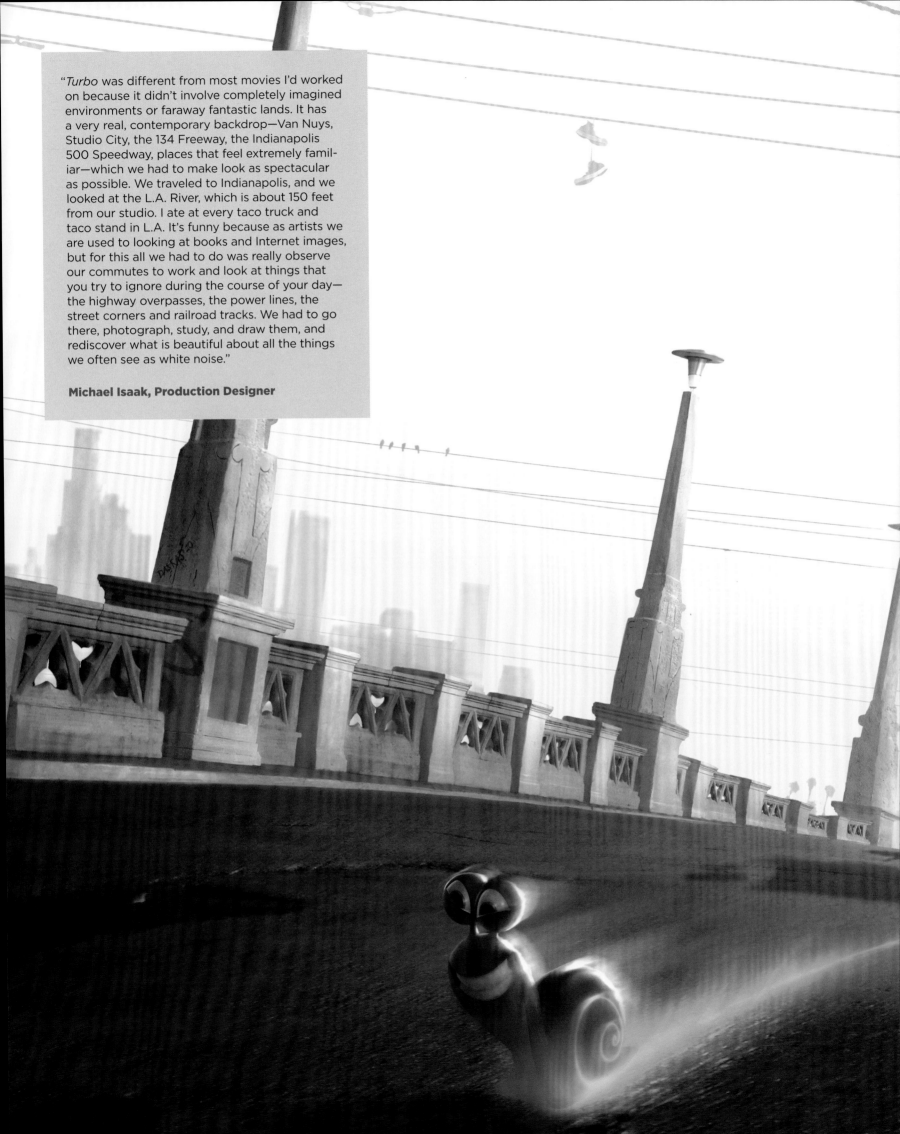

"*Turbo* was different from most movies I'd worked on because it didn't involve completely imagined environments or faraway fantastic lands. It has a very real, contemporary backdrop—Van Nuys, Studio City, the 134 Freeway, the Indianapolis 500 Speedway, places that feel extremely familiar—which we had to make look as spectacular as possible. We traveled to Indianapolis, and we looked at the L.A. River, which is about 150 feet from our studio. I ate at every taco truck and taco stand in L.A. It's funny because as artists we are used to looking at books and Internet images, but for this all we had to do was really observe our commutes to work and look at things that you try to ignore during the course of your day—the highway overpasses, the power lines, the street corners and railroad tracks. We had to go there, photograph, study, and draw them, and rediscover what is beautiful about all the things we often see as white noise."

Michael Isaak, Production Designer

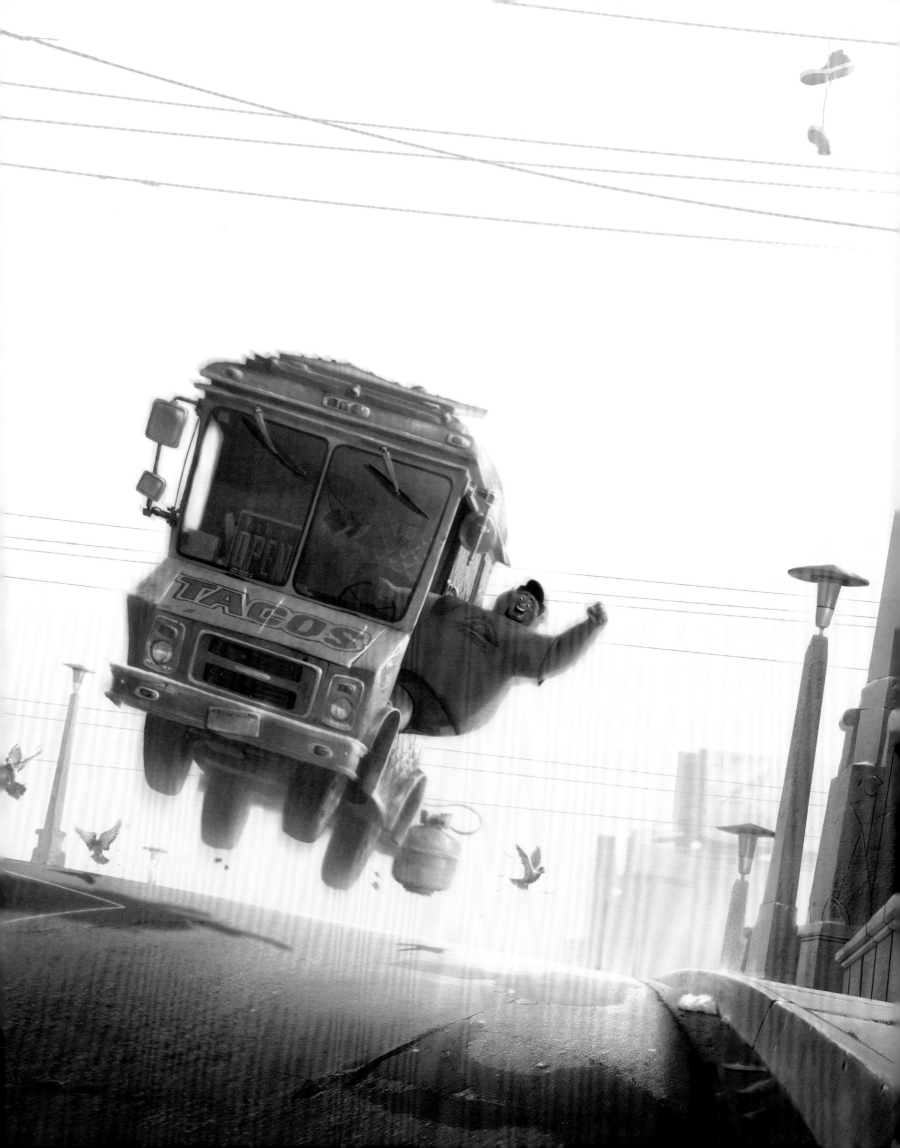

FRONT

"When I was a kid, I used to watch a lot of TV, and I was a huge fan of Rocky & Bullwinkle and Mr. Peabody & Sherman, who were part of that series. I thought the show offered a great flip side of the classic boy and his dog story by focusing on this amazing dog who is a genius. Not only is he a Nobel Prize–winning scientist, he is a world-renowned explorer and an Olympic gold medal winner in the long jump and the decathlon. But his life isn't complete until he decides to adopt a boy named Sherman."

Rob Minkoff, Director

Director	**Rob Minkoff**
Producers	**Alex Schwartz, Denise Nolan Cascino**
Executive Producers	**Tiffany Ward, Eric Ellenbogen, Jason Clark**
Production Designer	**David James**
Art Director	**Tim Lamb**
Visual Effects Supervisor	**Philippe Denis**

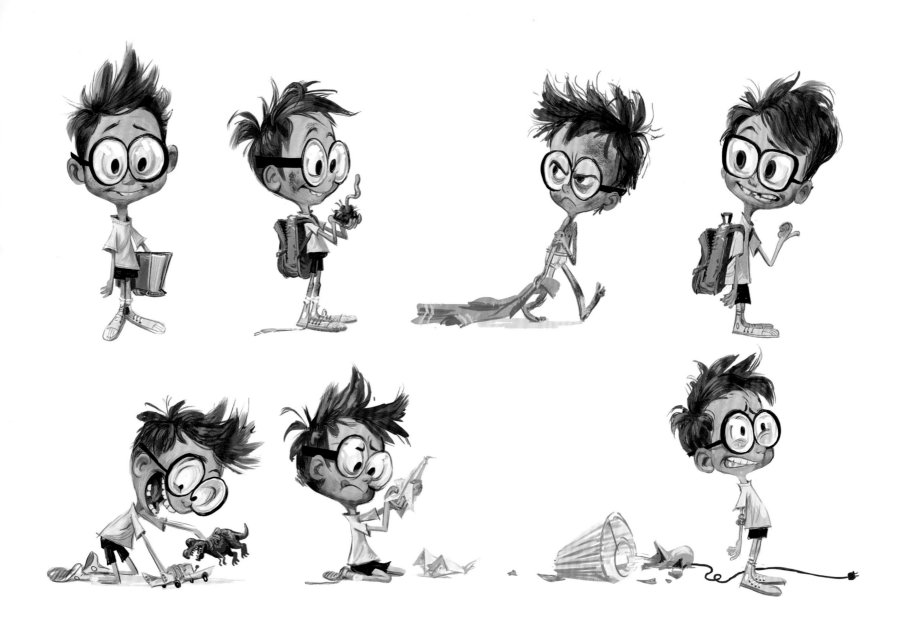

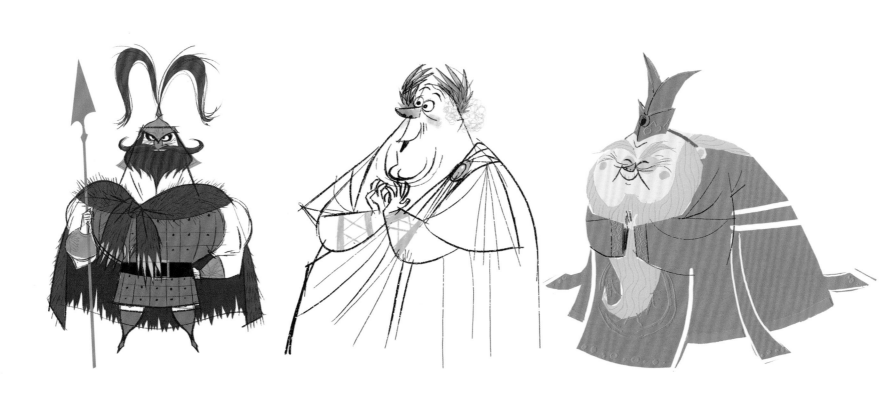

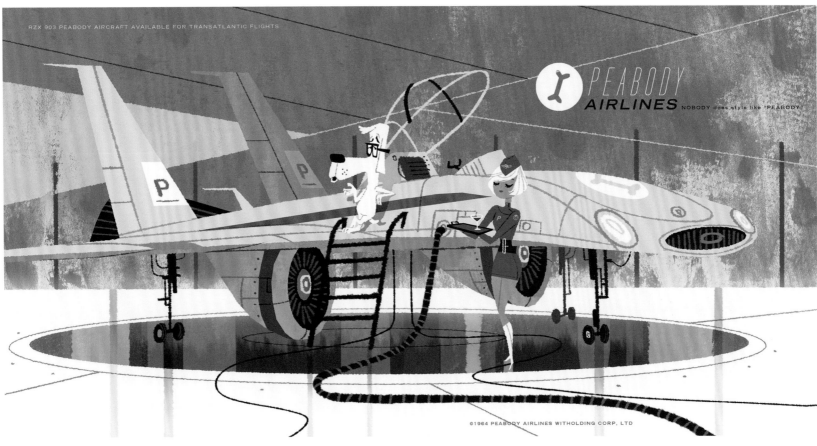

RZX 903 PEABODY AIRCRAFT AVAILABLE FOR TRANSATLANTIC FLIGHTS

PEABODY
AIRLINES NOBODY does style like "PEABODY"

©1964 PEABODY AIRLINES WITHOLDING CORP, LTD

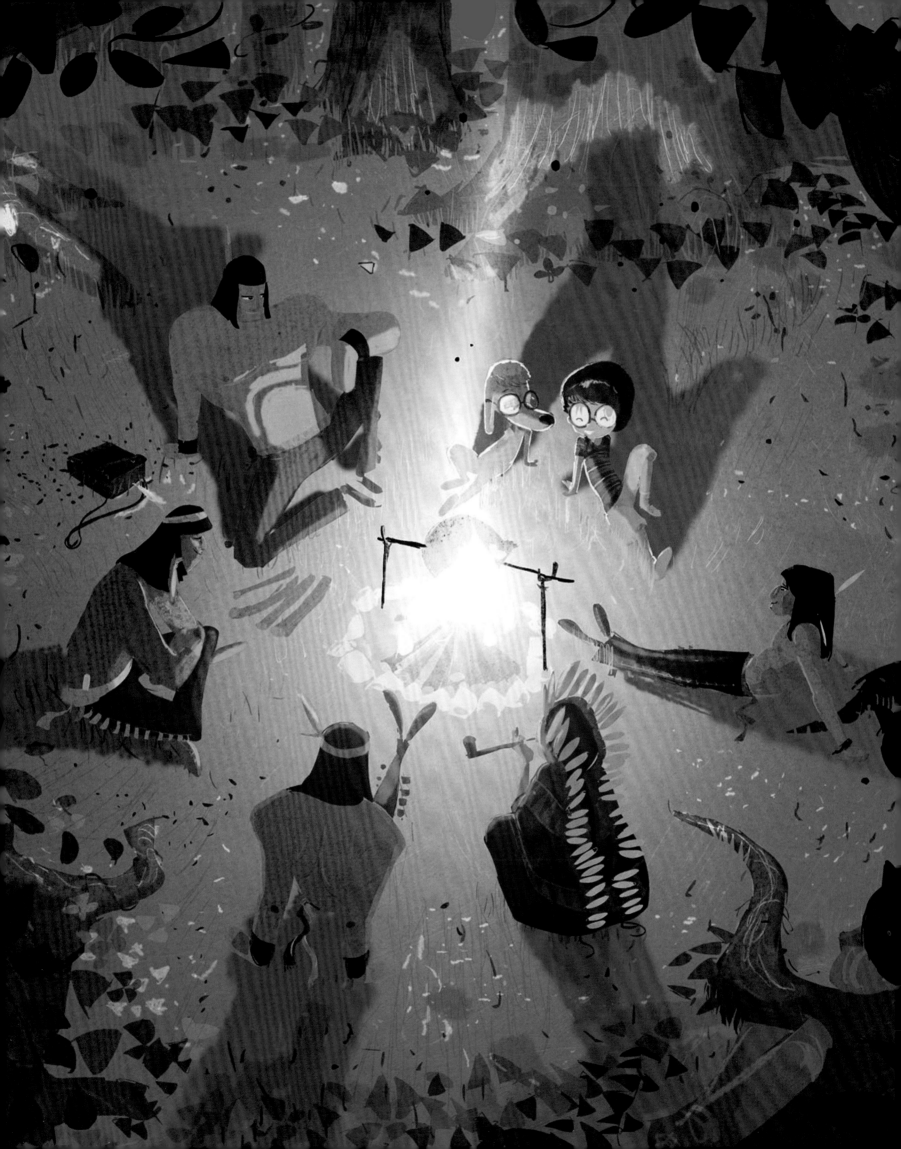

"*Mr. Peabody & Sherman* was the first film I'd done based on preexisting characters, and it posed some very interesting challenges. Jay Ward's original cartoon was made at the peak of midcentury animation and remains a beloved, simple, and charming cartoon. The immediately obvious question was how to translate a minimalist 2D cartoon designed for black-and-white televisions into a feature-length CG film without ruining the source material, and at the same time create the rich cinematic experience that audiences have come to expect. CG tools tend to drag you into a weird hyper-reality, and my biggest fear was that Mr. Peabody would end up looking like a guy in a dog suit or that the world he lived in would be so real that people would unconsciously ask the question, "Why is the dog talking?" The challenge was the opposite of Megamind in many ways; we needed to create a caricatured world fantastic enough that no one would question the existence of a genius talking dog that adopts a boy and builds him a time machine. To achieve the charm and simplicity that the story needed required that we spend a lot of time distilling the images to their simplest constituent elements; even the surfaces themselves are simplified and caricatured. We paid an enormous amount of attention to controlling color stylization as it played out over the narrative. I found myself taking things out of the movie rather than adding them on. The result (I hope) is a deceptively simple yet rich film that has a clear genetic link to the original cartoon."

David James, Production Designer

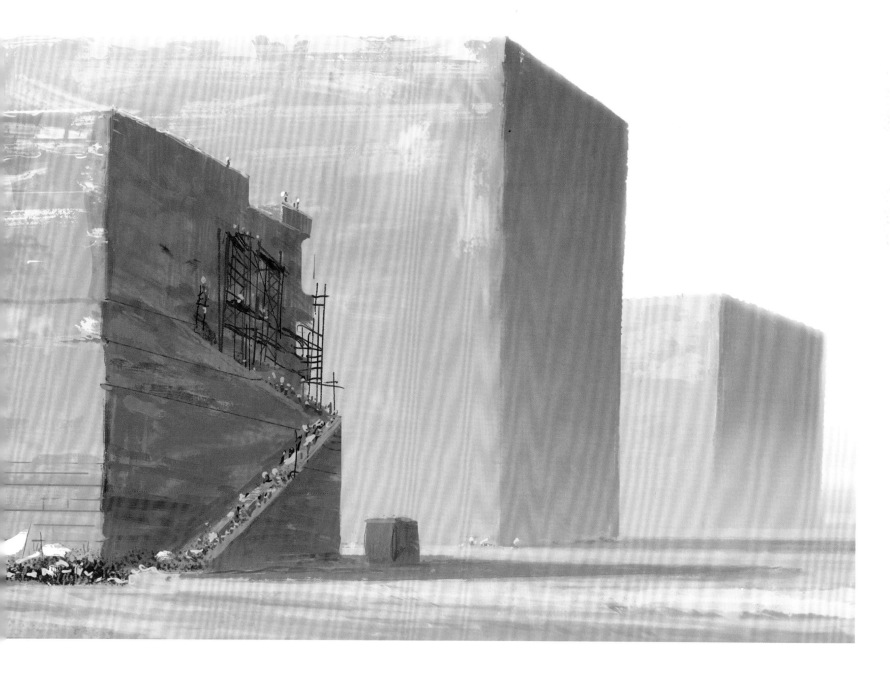

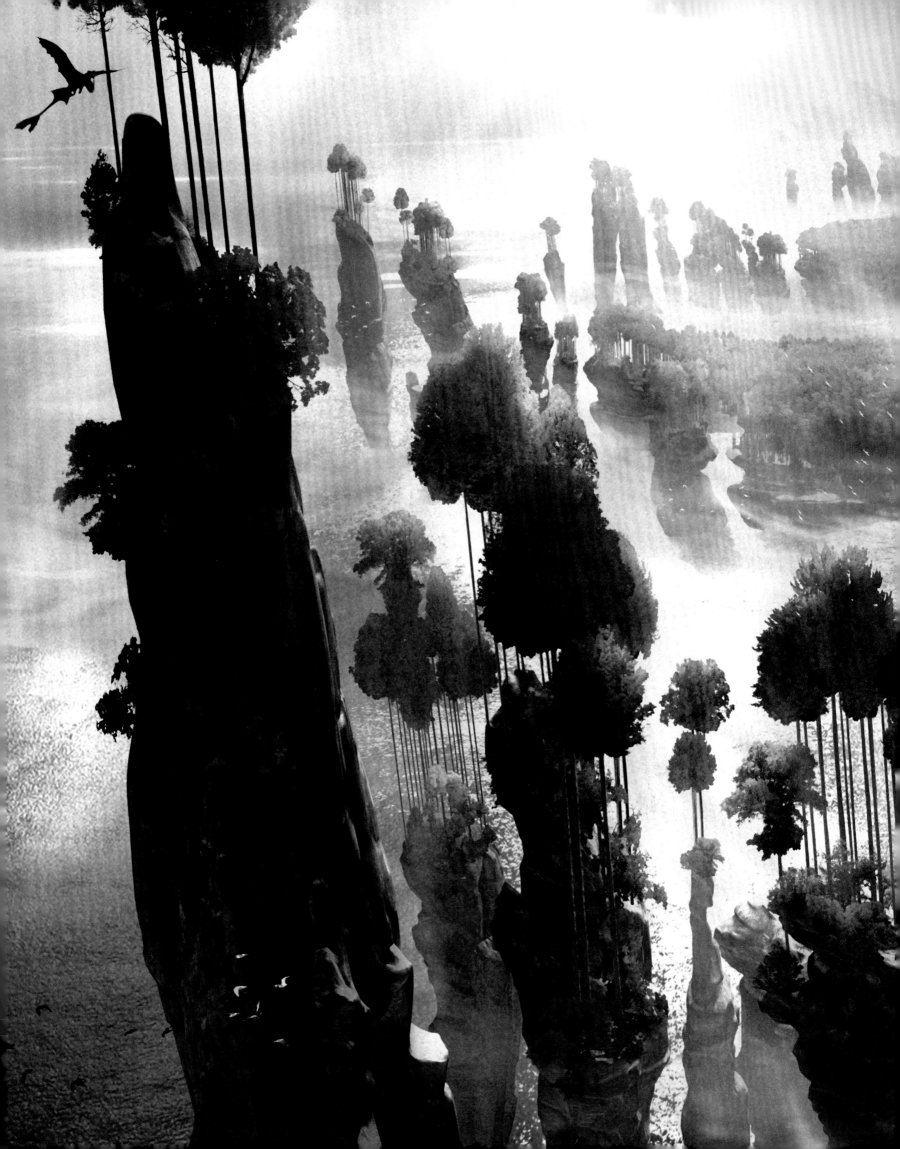

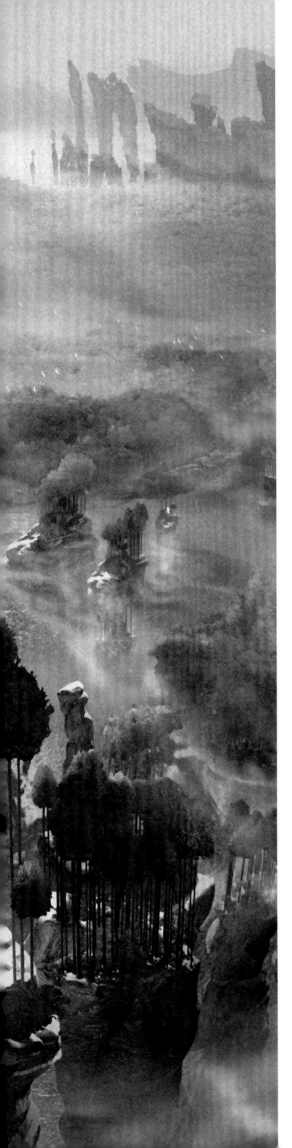

HOW TO TRAIN YOUR DRAGON 2

2014

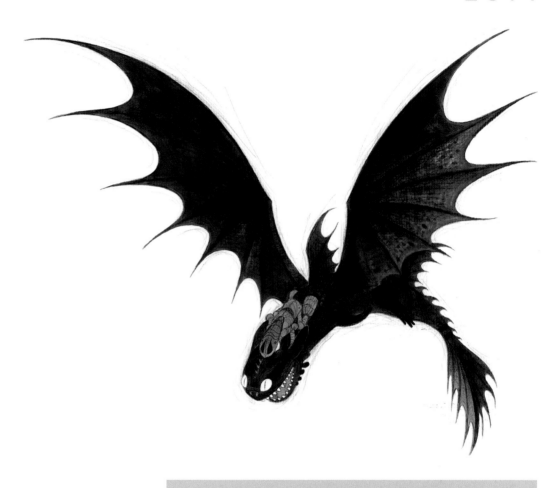

"In our film's environment, stylized shapes are brought into reality by texture and light to create a sense of believability. This is also true in animation, where stylized characters are given naturalistic movements, gestures, and emotions to create that same level of perceived realism."

Simon Otto, Head of Character Animation

Director	**Dean DeBlois**
Producer	**Bonnie Arnold**
Executive Producers	**Dean DeBlois, Chris Sanders**
Co-Producer	**Kendra Haaland**
Associate Producer	**Aaron Dem**
Production Designer	**Pierre-Olivier Vincent**
Art Director	**Zhaoping Wei**
Visual Effects Supervisor	**Dave Walvoord**

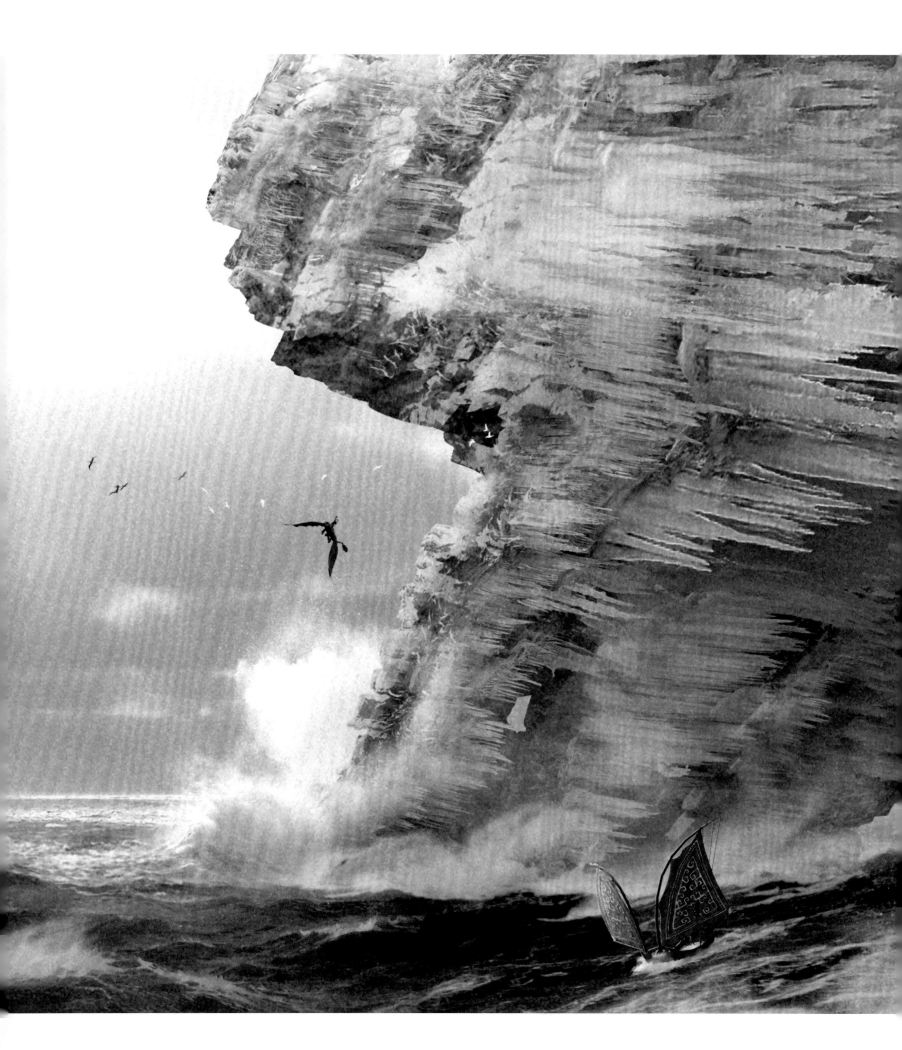

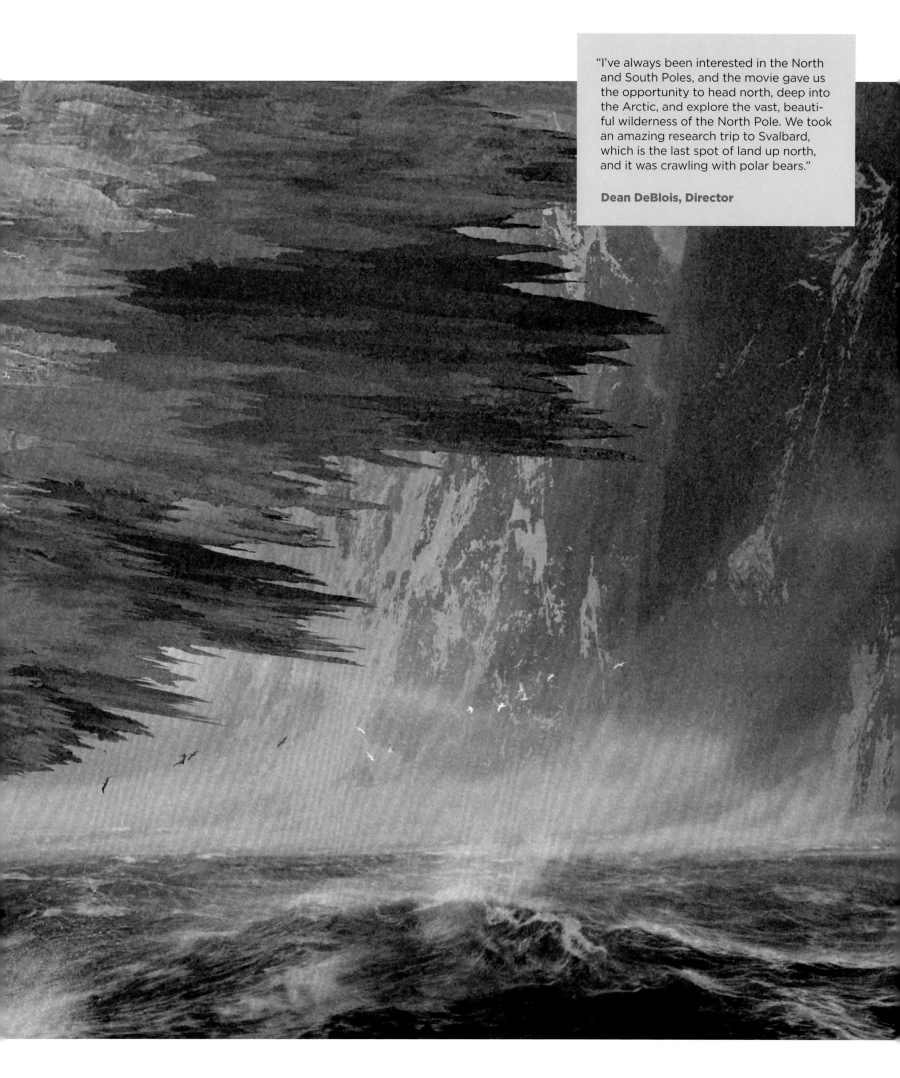

"I've always been interested in the North and South Poles, and the movie gave us the opportunity to head north, deep into the Arctic, and explore the vast, beautiful wilderness of the North Pole. We took an amazing research trip to Svalbard, which is the last spot of land up north, and it was crawling with polar bears."

Dean DeBlois, Director

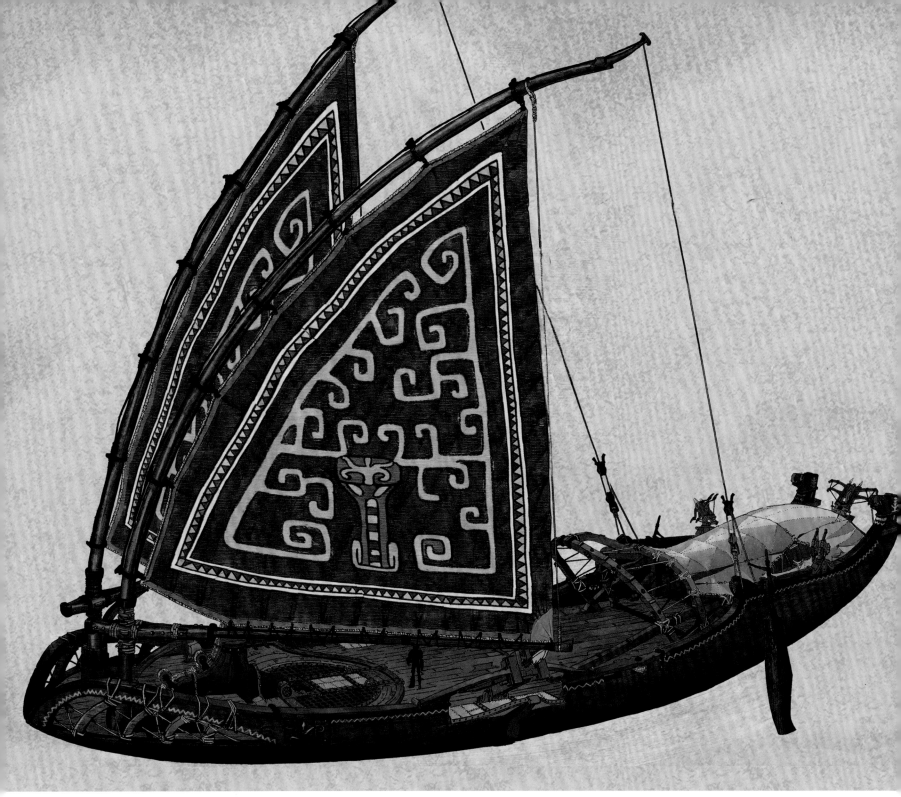

"In the second film, writer-director Dean DeBlois takes Hiccup and Toothless beyond the island of Berk, where they encounter challenges and revelations that they could not have imagined. There's more adventure and more fun with all the heart of the first film. Pierre-Olivier Vincent is the production designer, and you can clearly see the influence of his art on this movie as well. For the original movie, he created this believable world of the Vikings—it's a place that doesn't really exist but you'd love to visit it if you could."

Bonnie Arnold, Producer

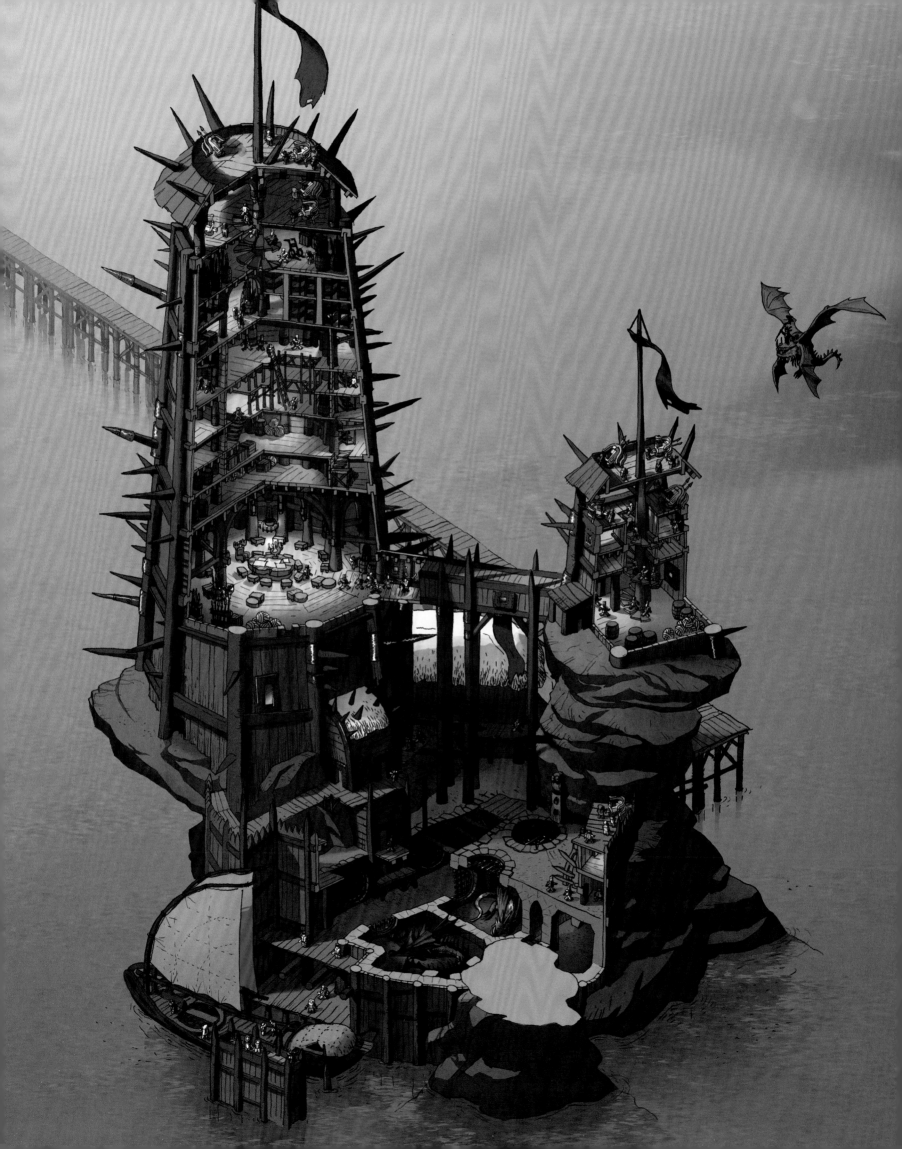

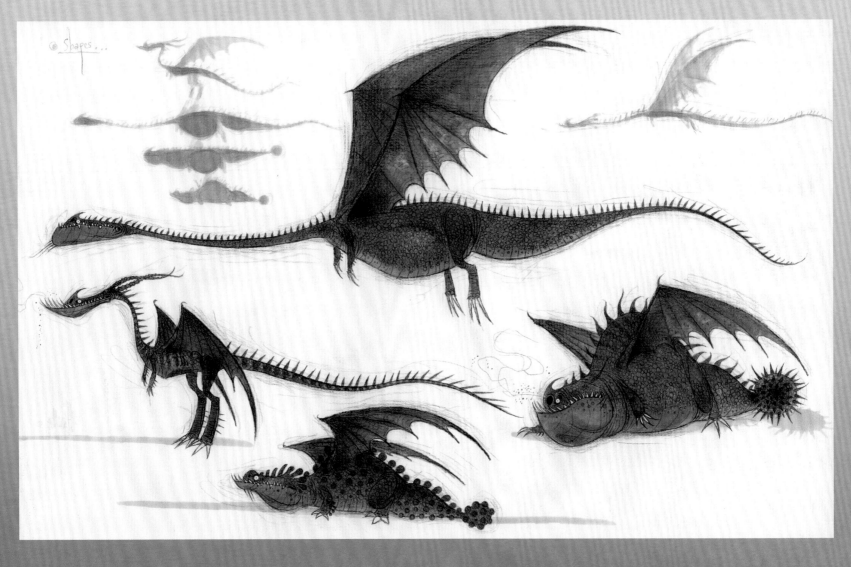

Shapes...

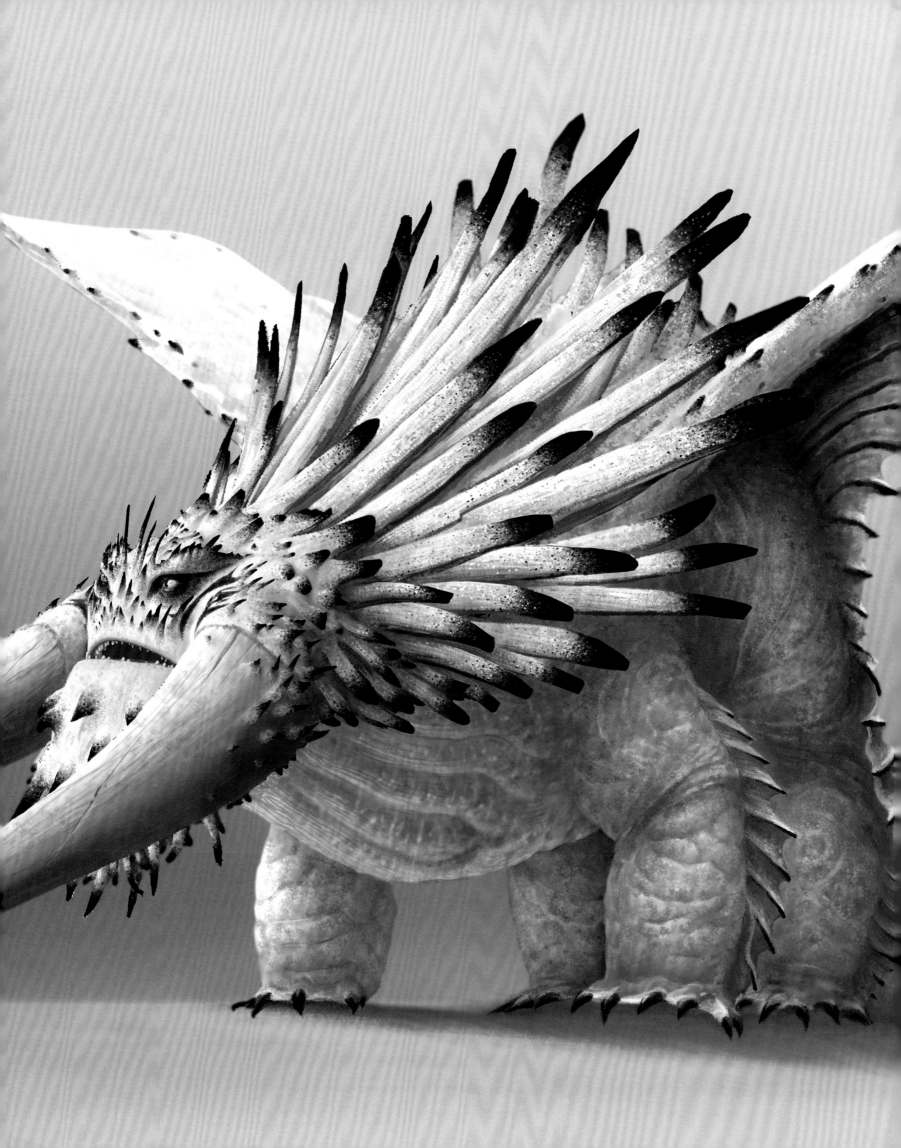

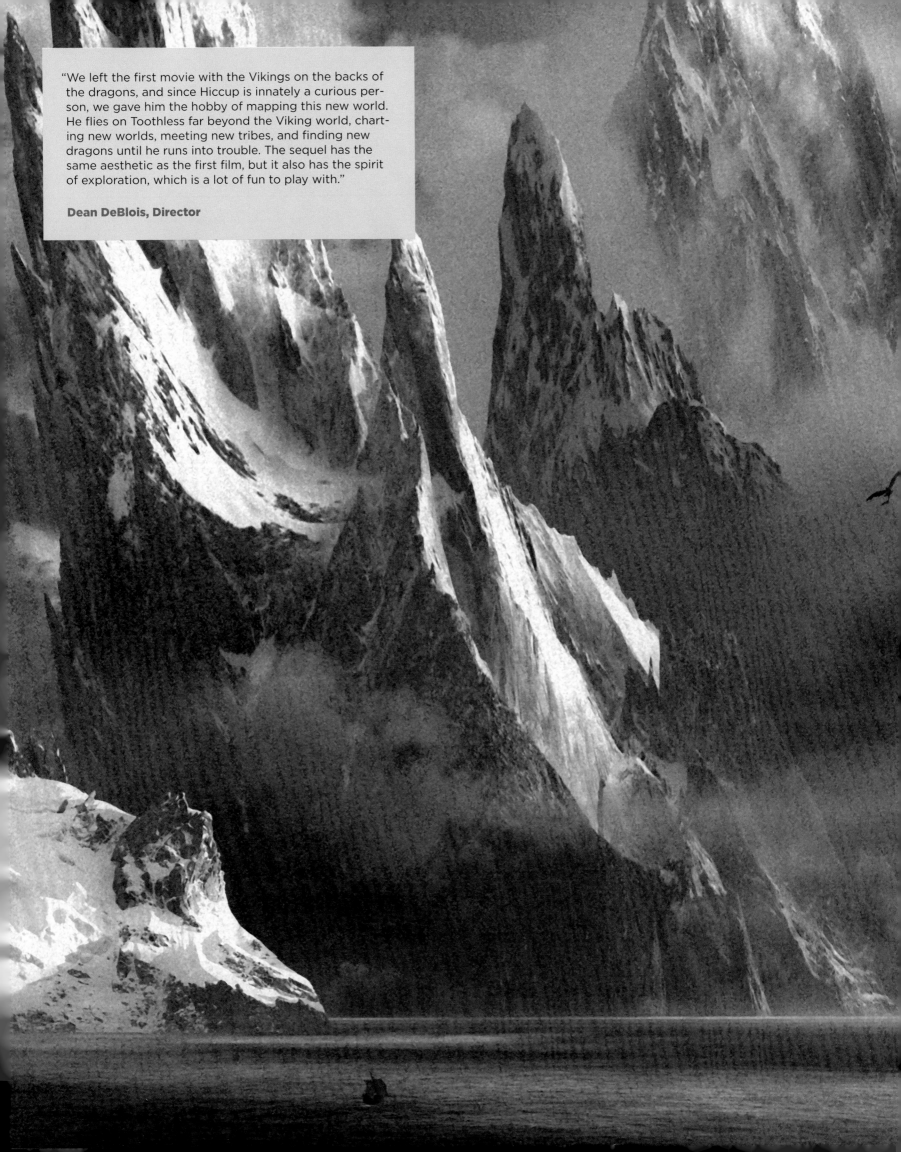

"We left the first movie with the Vikings on the backs of the dragons, and since Hiccup is innately a curious person, we gave him the hobby of mapping this new world. He flies on Toothless far beyond the Viking world, charting new worlds, meeting new tribes, and finding new dragons until he runs into trouble. The sequel has the same aesthetic as the first film, but it also has the spirit of exploration, which is a lot of fun to play with."

Dean DeBlois, Director

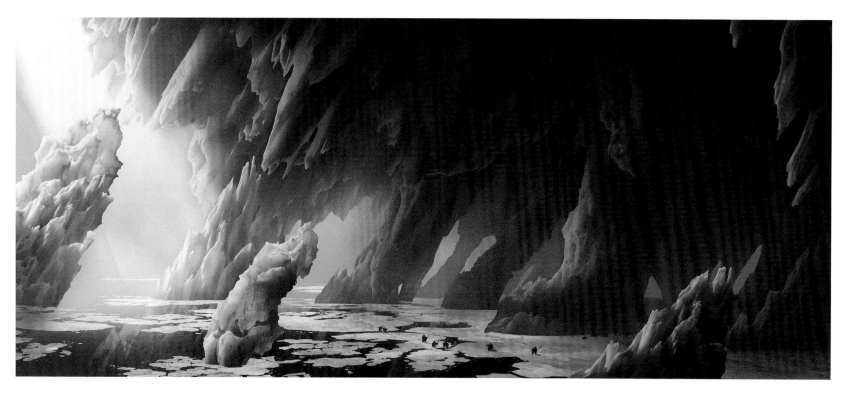

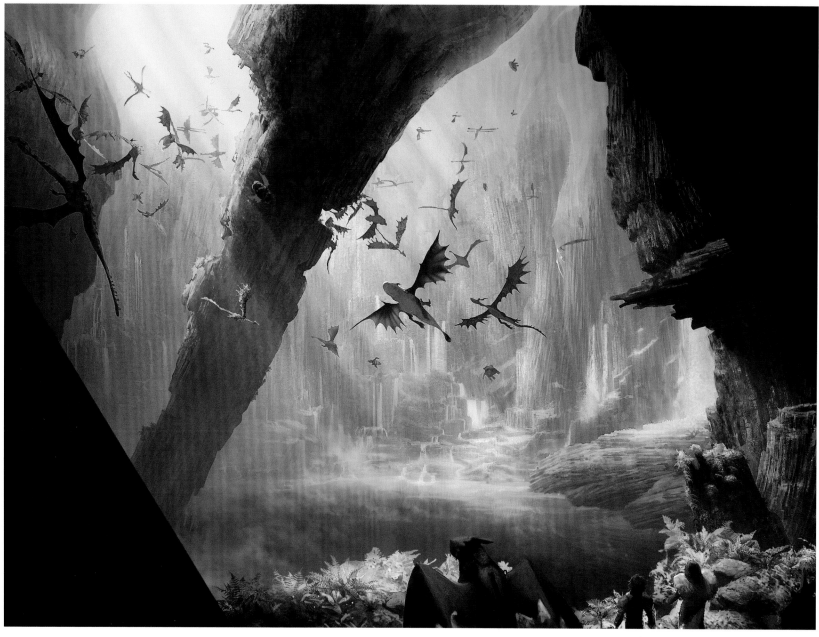

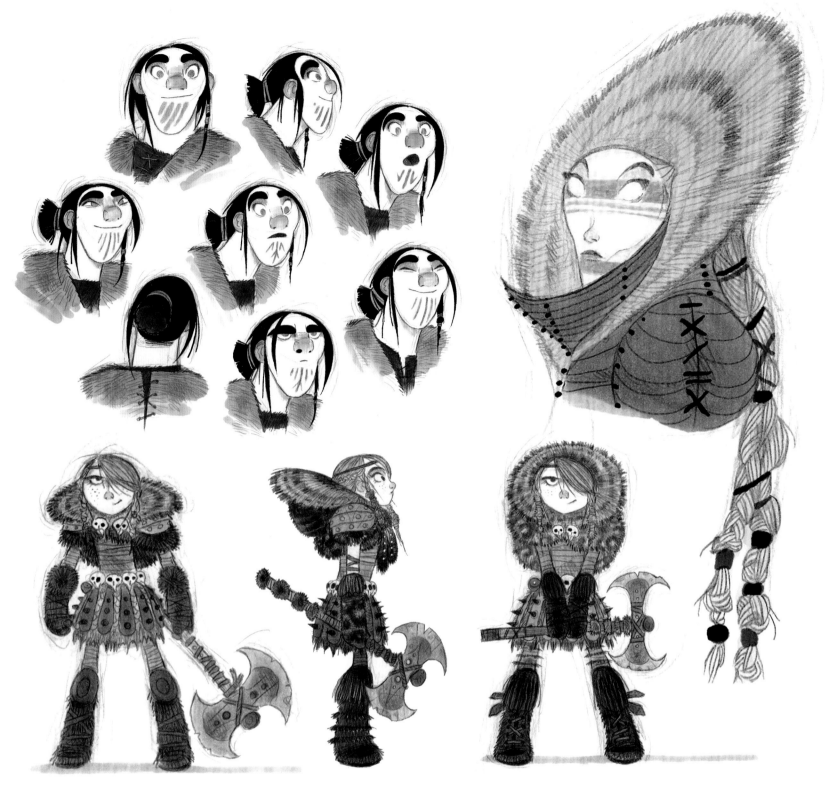

"*The Empire Strikes Back* is a great example of a movie that was able to take something that we love and expand it in every direction: The scope got bigger, the characters got richer—this idea of new worlds, new gadgets, new costumes, new foes. Everything about that movie was such an inspiration to me. In a world where a lot of sequels are pretty disappointing, it's our intent to really overdeliver with *Dragon 2.*"

Dean DeBlois, Director

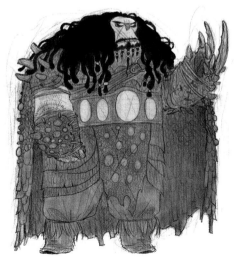
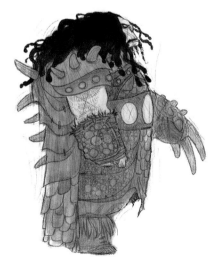

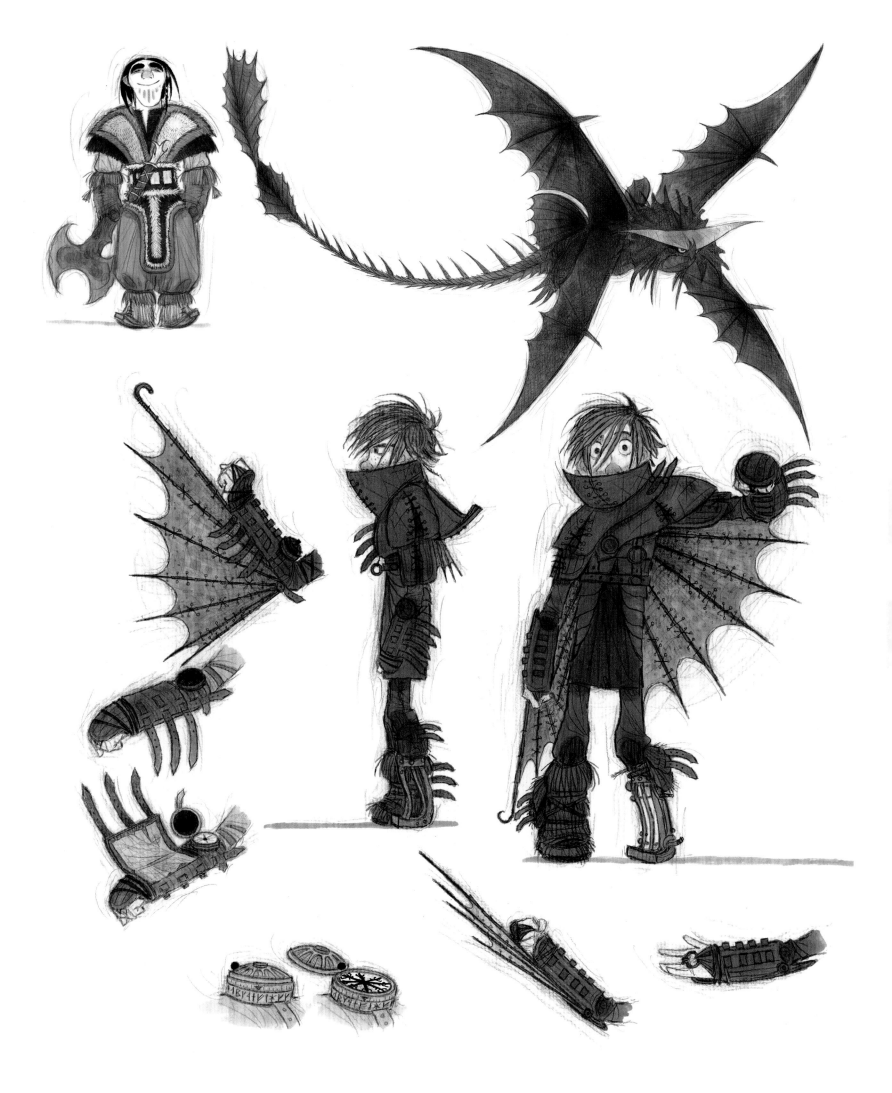

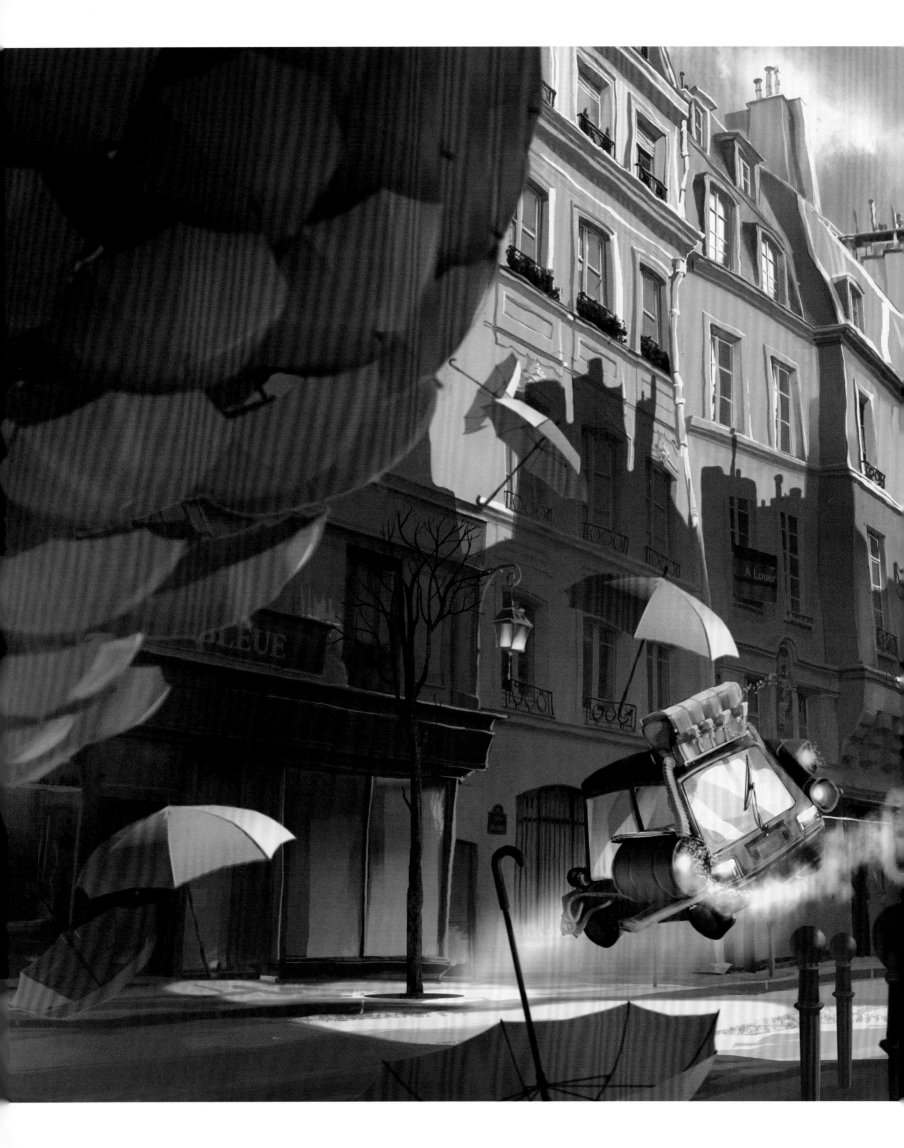

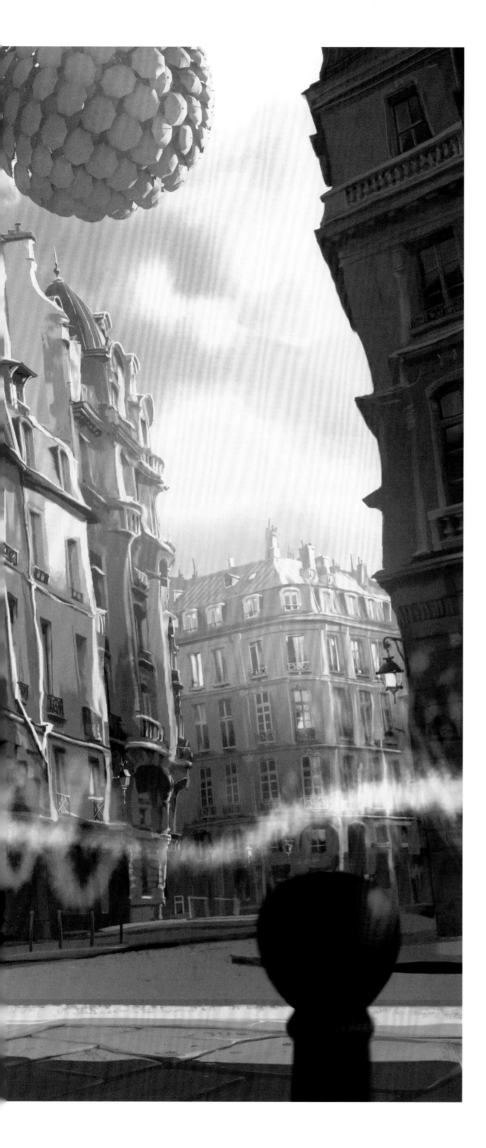

HOME
2014

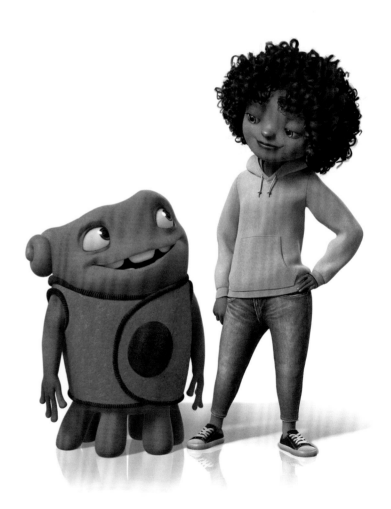

Director	**Tim Johnson**
Producers	**Chris Jenkins, Suzanne Buirgy**
Production Designer	**Kathy Altieri**
Art Director	**Emil Mitev**
Visual Effects Supervisor	**Mahesh Ramasubramanian**

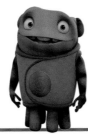

BOOV

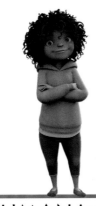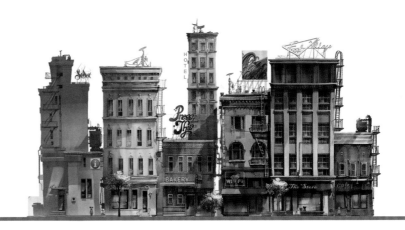

HUMAN WORLD

GORG

"It was very important for Jeffrey Katzenberg to stay away from a general studio house style that you see in many of the other animation studios. At DreamWorks, we try to create a style for each film that not only is appropriate for the story, but also is different from any other movie we've done. Artists thrive on change. They are always looking for new challenges and the ability to explore new styles. To be able to make a huge artistic shift every few years is exciting and satisfying; it feels as if you're working at a new studio with each new film, but in reality you are surrounded by the deep friendships and working relationships you've forged for years."

Kathy Altieri, Production Designer

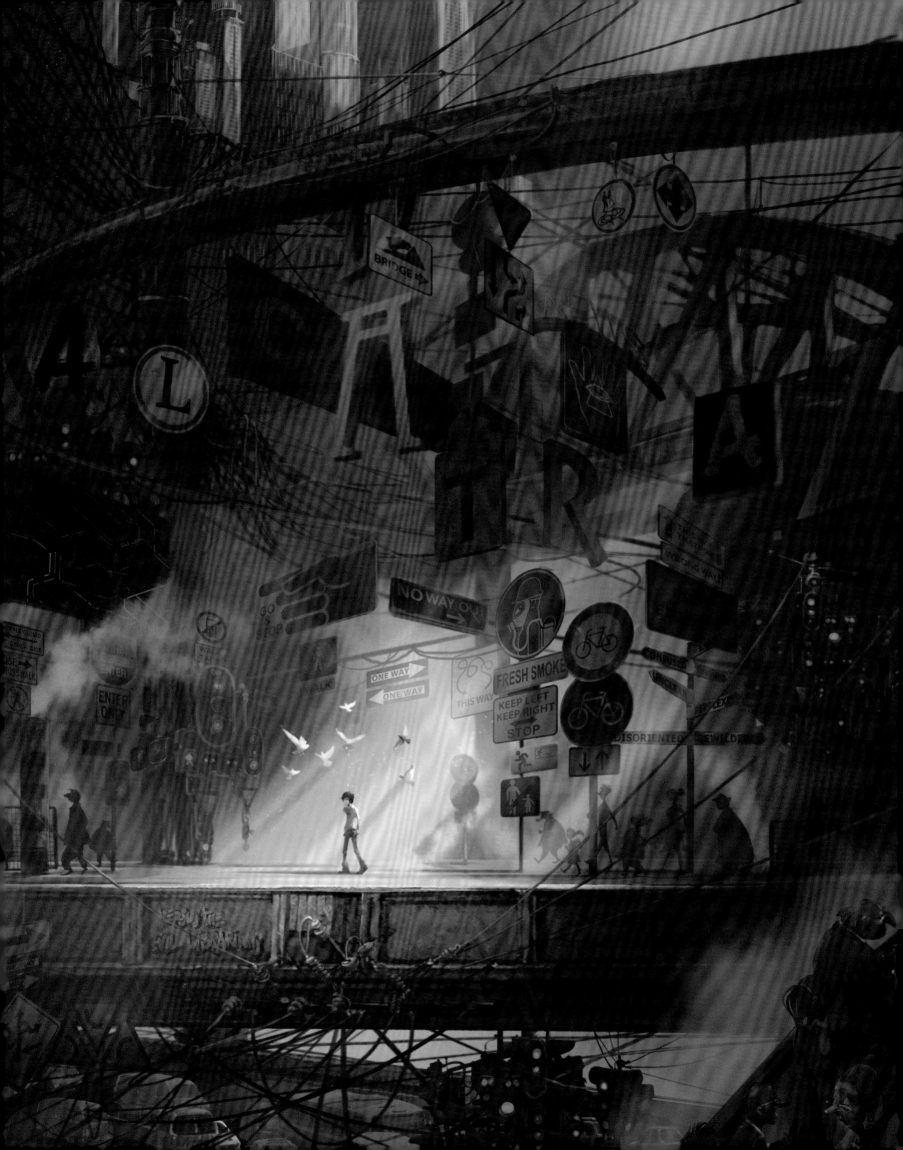

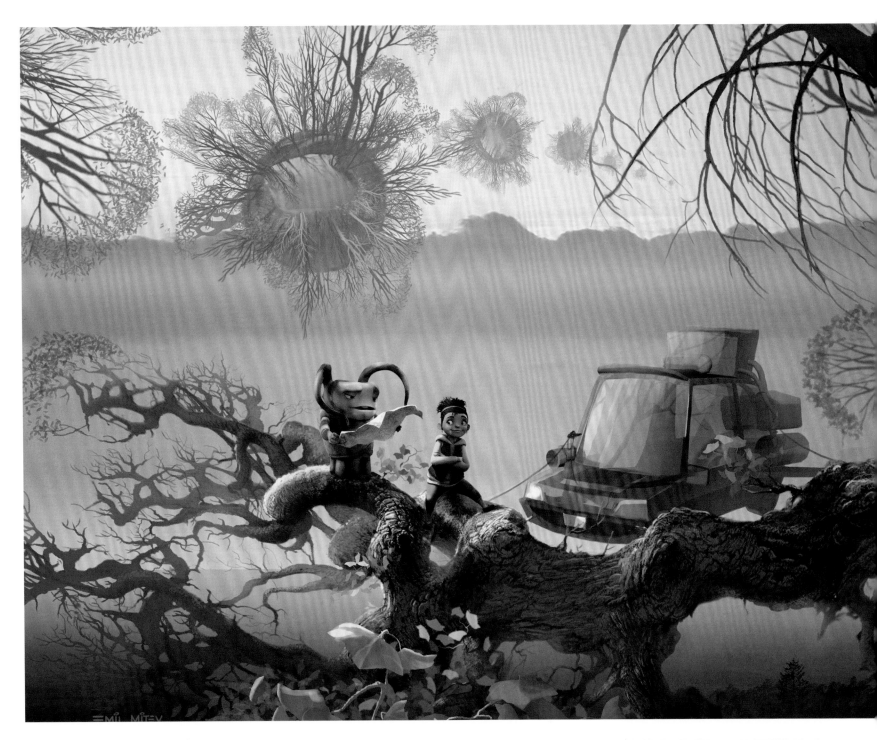

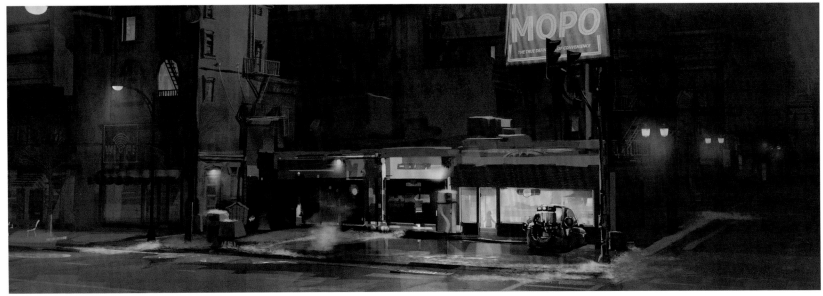

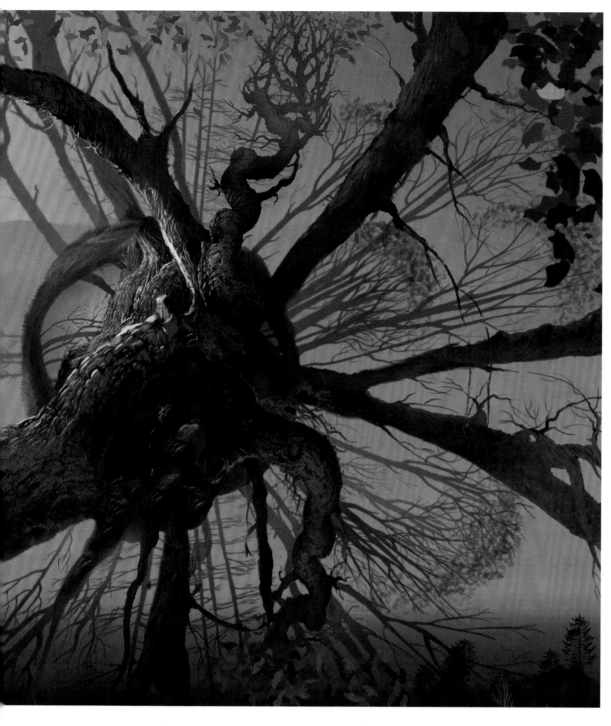

"I read Adam Rex's book in 2007 and thought it had a great message about how, perhaps innocently, we can be so arrogant about our own culture, friends, likes, and dislikes. It also showed how hard we have to work and the beautiful results we can get when we really try to step in someone else's shoes. It tells the story of an alien invasion from the aliens' point of view. The story imagines the aliens as these swaggering, arrogant creatures who think that they're the best things that happened to Earth."

Tim Johnson, Director

"The good news is that with advancements in computer animation, the opportunity for surprise is built into the medium. You can create imaginative worlds to take the audience and make their jaws fall into their laps. We're definitely doing that with *Home* by reinventing what science fiction technology will look like and having a lot of fun with the whimsy and expressiveness of the animation."

Tim Johnson, Director

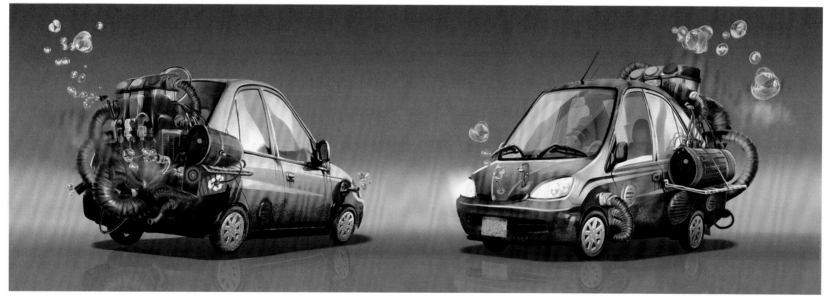

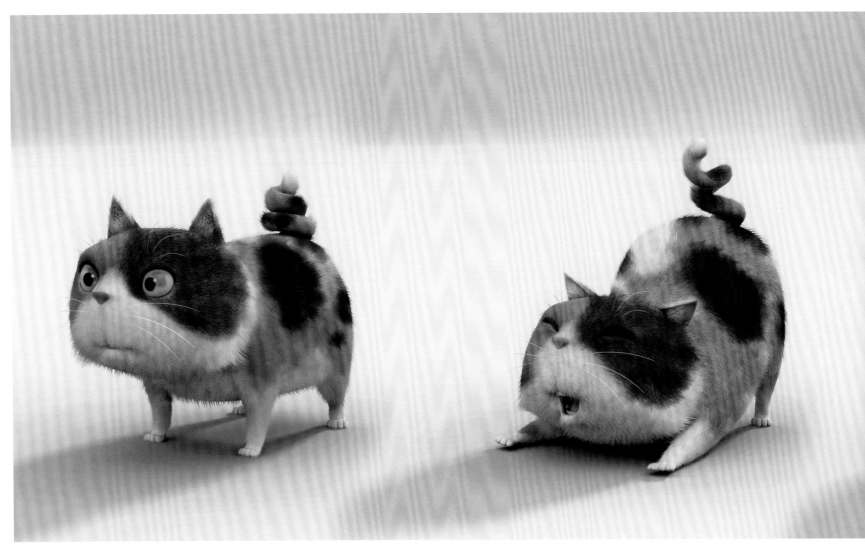

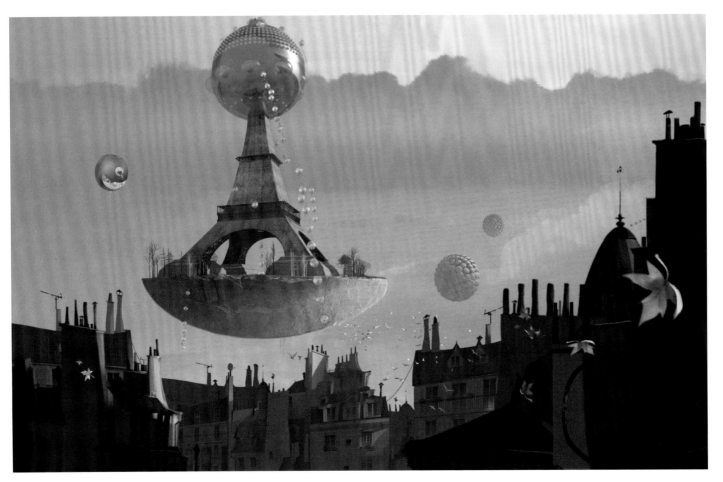

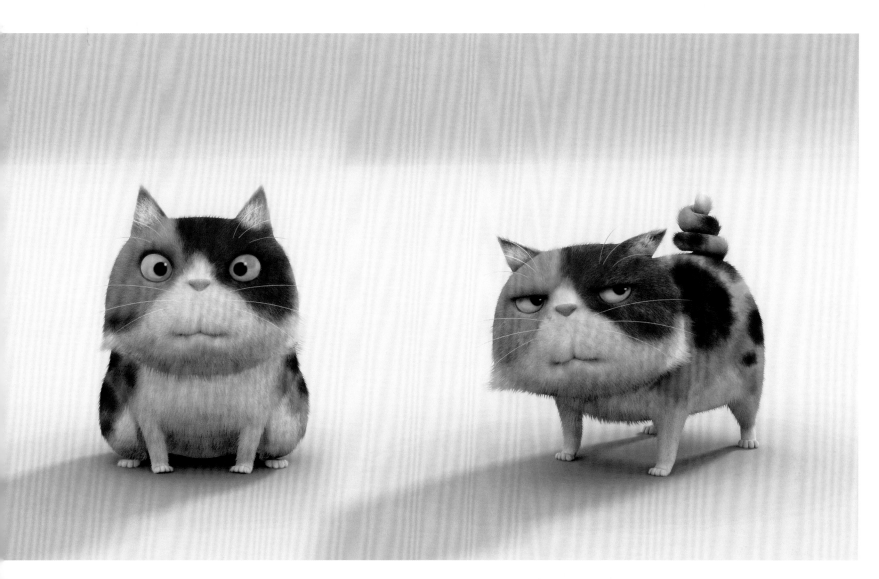

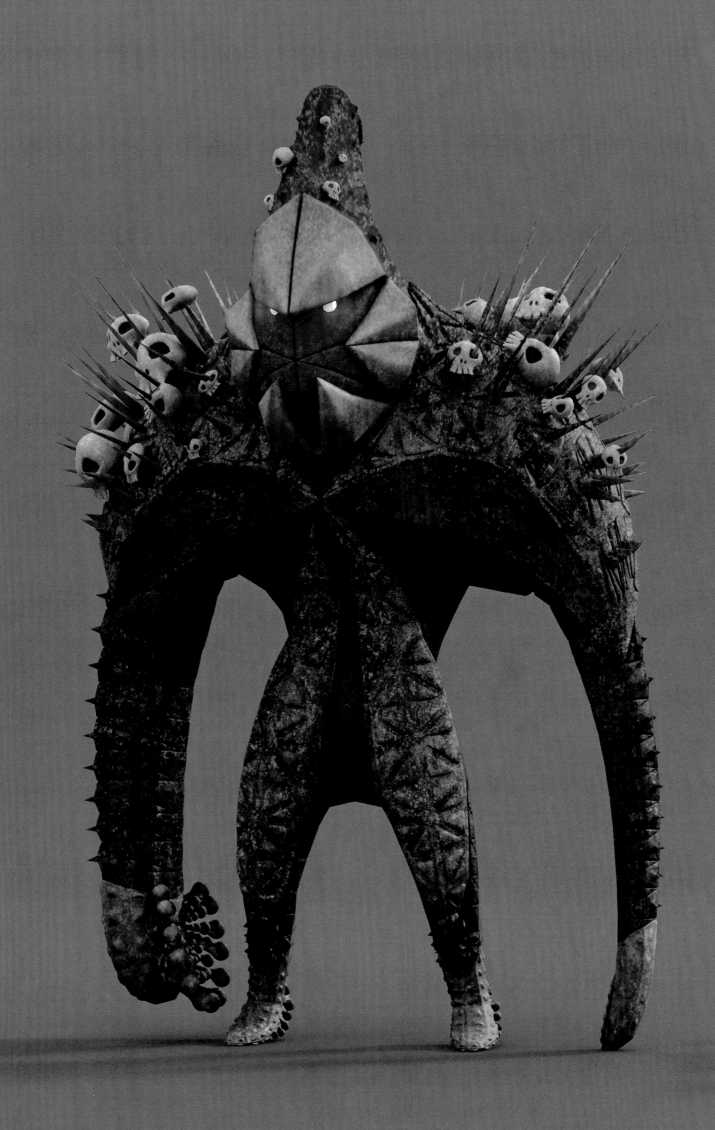

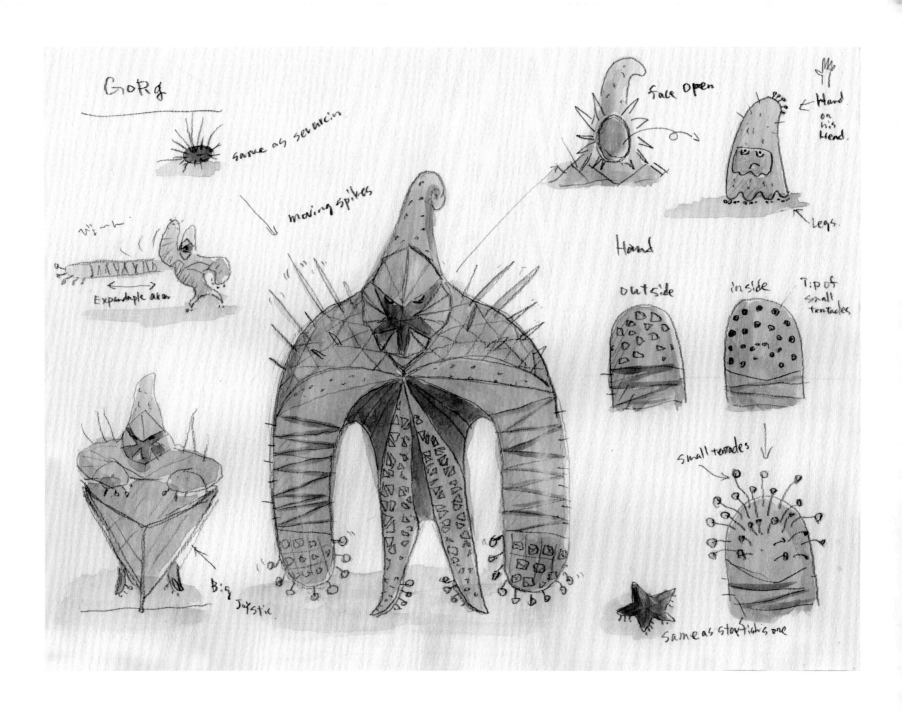

Gorg

same as severin

moving spikes

Expandable area

face open

Hand on his Head.

Legs.

Hand

outside

inside

Tip of small tentacles

small tentacles

same as starfishs one

Big Joystic.

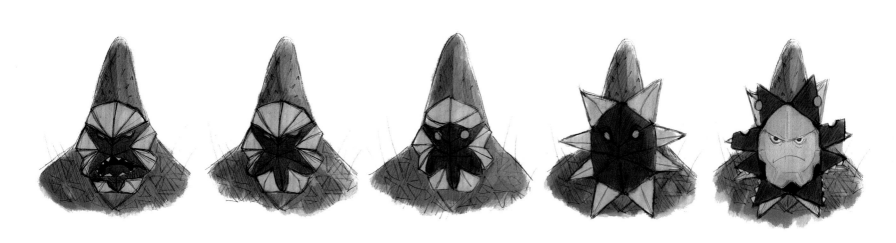

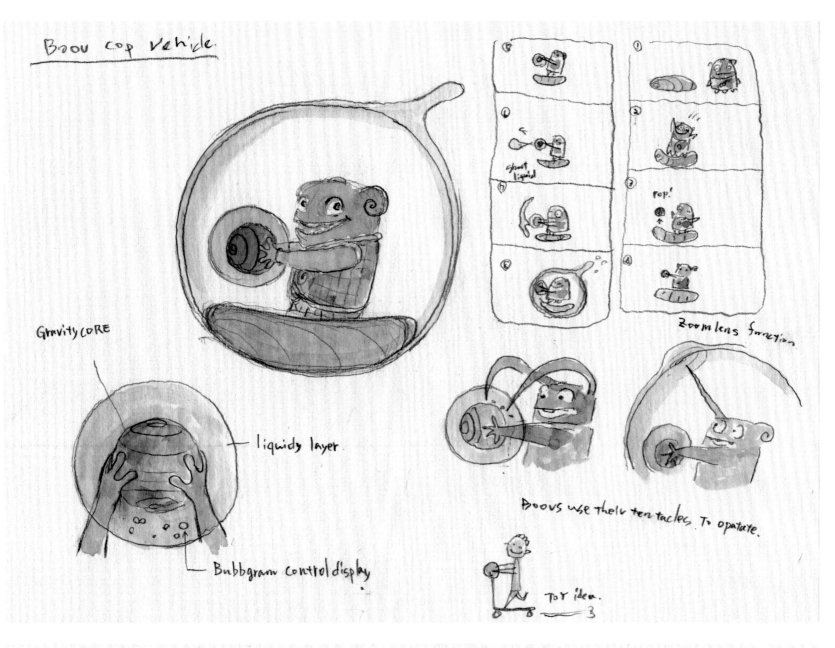

Boov cop vehicle

GravityCORE

liquidy layer

Bubbgram control display

Zoom lens function

Boovs use their tentacles. To operate.

Toy idea.

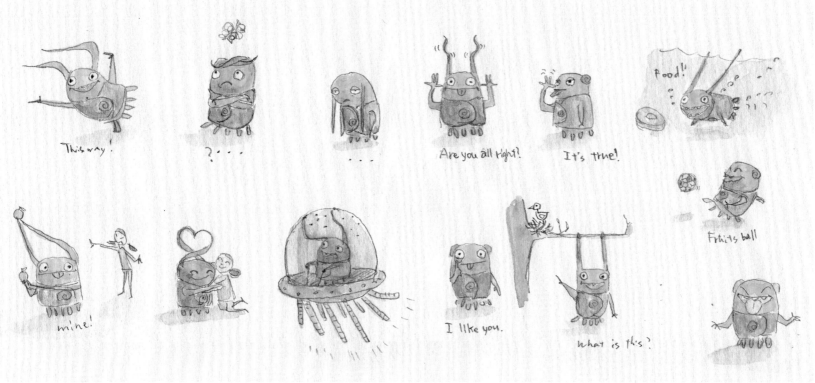

This way.

?....

...

Are you all right!

It's true!

Food!!

mine!

I like you.

what is this?

Fruits ball

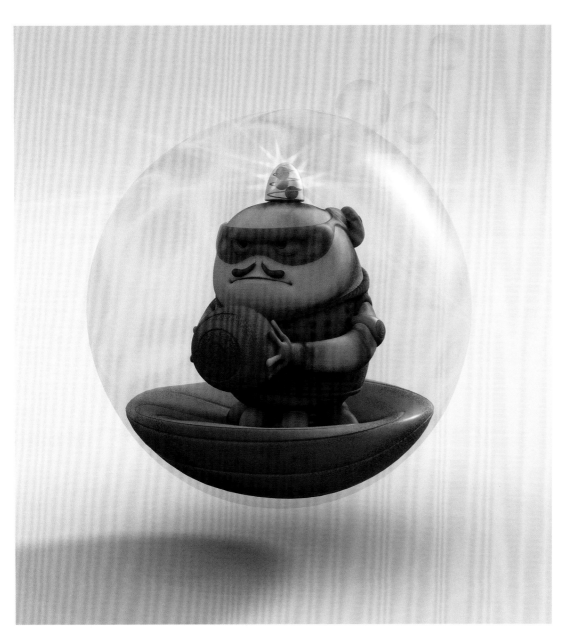

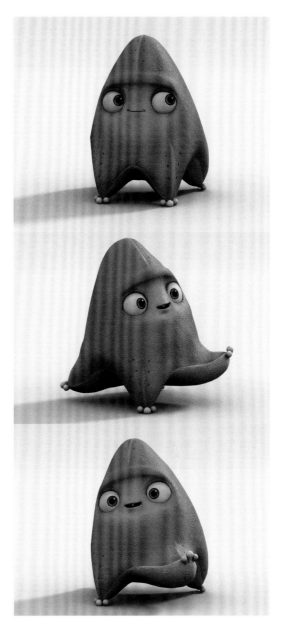

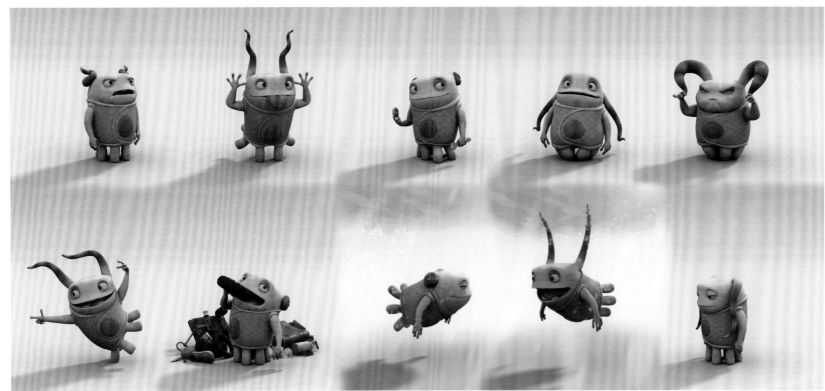

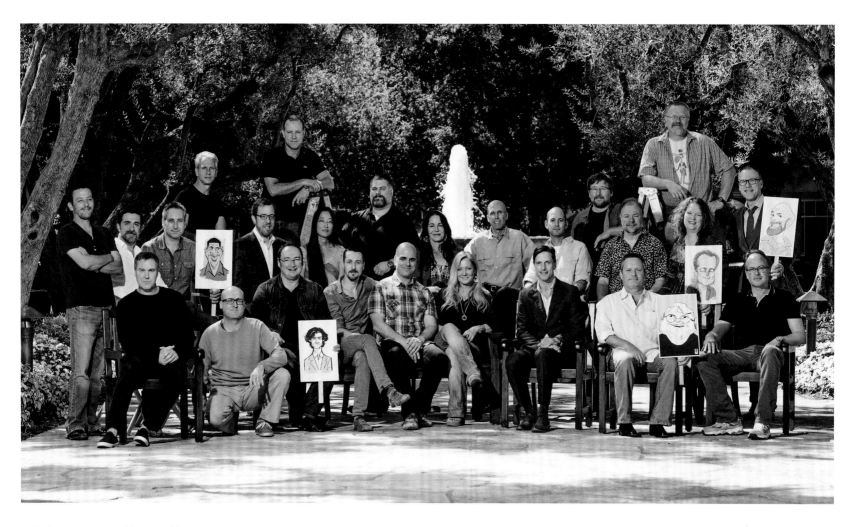

Chief Executive Officer Jeffrey Katzenberg and Chief Creative
Officer Bill Damaschke with all the directors working at the studio in
Spring 2013. Directors not able to attend are represented in sketch
form created by DWA artists.

ANTZ

October 2, 1998

ANNIE AWARD NOMINATIONS

- **Directing in an Animated Feature**
 Eric Darnell
 Tim Johnson

- **Music in an Animated Feature**
 Harry Gregson-Williams
 John Powell

- **Production Design in an Animated Feature**
 John Bell

- **Writing in an Animated Feature**
 Todd Alcott
 Chris Weitz
 Paul Weitz

THE PRINCE OF EGYPT

December 18, 1998

ACADEMY AWARD®

- **Best Original Song**
 Stephen Schwartz, "When You Believe"

ACADEMY AWARD® NOMINATION

- **Best Original Music or Comedy Score**
 Stephen Schwartz (Music, Lyrics)
 Hans Zimmer (Orchestral Score)

ANNIE AWARD NOMINATIONS

- **Animated Theatrical Feature**
 DreamWorks Animation and DreamWorks Pictures

- **Directing in an Animated Feature**
 Brenda Chapman
 Steve Hickner
 Simon Wells

- **Effects Animation**
 Jamie Lloyd

- **Storyboarding in an Animated Feature**
 Lorna Cook

- **Voice Acting**
 Ralph Fiennes (Rameses)

GOLDEN GLOBE NOMINATIONS

- **Best Original Score**
 Stephen Schwartz
 Hans Zimmer

- **Best Original Song**
 Stephen Schwartz, "When You Believe"

THE ROAD TO EL DORADO

March 31, 2000

ANNIE AWARD NOMINATIONS

- **Animated Theatrical Feature**
 DreamWorks SKG

- **Character Animation**
 Rodolphe Guenoden
 Darlie Brewster

- **Effects Animation**
 Doug Ikeler

- **Music in an Animated Feature**
 Hans Zimmer
 John Powell
 Elton John
 Tim Rice

- **Production Design in an Animated Feature**
 Christian Schellewald

- **Storyboarding in an Animated Feature**
 Jeff Snow

- **Voice Acting by a Male Performer in an Animated Feature**
 Armand Assante (Tzekel-Kan)

CHICKEN RUN

June 23, 2000

ANNIE AWARD NOMINATIONS

- **Animated Theatrical Feature**
 DreamWorks, Pathé, Aardman

- **Directing in an Animated Feature**
 Peter Lord
 Nick Park

- **Writing in an Animated Feature**
 Karey Kirkpatrick

GOLDEN GLOBE NOMINATION

- **Best Motion Picture, Comedy/Musical**

SHREK

May 18, 2001

ACADEMY AWARD®

- **Best Animated Feature**
 Aron Warner

- **Best Adapted Screenplay**
 Ted Elliott
 Terry Rossio
 Joe Stillman
 Roger S. H. Schulman

AFI AWARD NOMINATION

- **Movie of the Year**
 Aron Warner
 John H. Williams
 Jeffrey Katzenberg

ANNIE AWARDS

- **Animated Theatrical Feature**
 PDI and DreamWorks SKG

- **Directing in an Animated Feature**
 Andrew Adamson
 Vicky Jenson

- **Effects Animation**
 Arnauld Lamorlette

- **Music in an Animated Feature**
 Harry Gregson-Williams
 John Powell

- **Production Design in an Animated Feature**
 Guillaume Aretos

- **Storyboarding in an Animated Feature**
 Robert Koo

- **Voice Acting by a Male Performer**
 Eddie Murphy (Donkey)

- **Writing in an Animated Feature**
 Ted Elliott
 Terry Rossio
 Joe Stillman
 Roger S. H. Schulman

ANNIE AWARD NOMINATIONS

- **Character Animation**
 Paul Chung
 Raman Hui
 Jason A. Reisig

- **Production Design**
 Douglas Rogers

GOLDEN GLOBE NOMINATION

- **Best Motion Picture, Comedy or Musical**

- **Outstanding Producer of Theatrical Motion Pictures**
Aron Warner
John H. William
Jeffrey Katzenberg

SPIRIT: STALLION OF THE CIMARRON

May 24, 2002

ACADEMY AWARD® NOMINATION

- **Best Animated Feature**
Jeffrey Katzenberg

ANNIE AWARDS

- **Character Design in an Animated Feature**
Carlos Grangel

- **Effects Animation**
Yancy Lindquist

- **Production Design in an Animated Feature**
Luc Desmarchelier

- **Storyboarding in an Animated Feature**
Ronnie Del Carmen

ANNIE AWARD NOMINATIONS

- **Animated Theatrical Feature**
DreamWorks

- **Effects Animation**
James Lloyd

- **Storyboarding in an Animated Feature**
Larry Leker
Simon Wells

GOLDEN GLOBE NOMINATION

- **Best Original Song, Motion Picture**
"Here I Am"
Hans Zimmer (music)
Bryan Adams (lyrics)
Gretchen Peters (lyrics)

VISUAL EFFECTS SOCIETY (VES) AWARD NOMINATION

- **Best Character Animation**
James Baxter

SINBAD: LEGEND OF THE SEVEN SEAS

July 2, 2003

ANNIE AWARD NOMINATIONS

- **Character Design in an Animated Feature**
Carter Goodrich

- **Music in an Animated Feature**
Harry Gregson-Williams

- **Production Design in an Animated Feature**
Seth Engstrom
Raymond Zibach

SHREK 2

May 19, 2004

ACADEMY AWARD® NOMINATIONS

- **Best Animated Feature**
Andrew Adamson

- **Best Original Song**
"Accidentally in Love"
Adam Duritz
David Immerglück
Matthew Malley
David Bryson
Dan Vickrey

ANNIE AWARD NOMINATIONS

- **Animated Effects**
Jonathan Gibbs

- **Best Animated Feature**
DreamWorks Animation

- **Directing in an Animated Feature**
Andrew Adamson
Conrad Vernon
Kelly Asbury

- **Music in an Animated Feature**
Harry Gregson-Williams

- **Storyboarding in an Animated Feature**
Conrad Vernon

- **Voice Acting in an Animated Feature**
Antonio Banderas (Puss In Boots)

- **Writing in an Animated Feature**
Andrew Adamson
Joe Stillman
J. David Stem
David N. Weiss

GOLDEN GLOBE NOMINATION

- **Best Original Song**
"Accidentally in Love"
Adam Duritz
Dan Vickrey
David Immerglück
Matthew Malley
David Bryson

VES AWARD NOMINATION

- **Outstanding Performance by an Animated Character in a Feature**
Antonio Banderas (Puss In Boots)
Raman Hui

SHARK TALE

October 1, 2004

ACADEMY AWARD® NOMINATION

- **Best Animated Feature**
Bill Damaschke

ANNIE AWARD NOMINATIONS

- **Animated Effects**
Scott Cegielski

- **Character Animation**
Ken Stuart Duncan

- **Character Design in an Animated Feature**
Carlos Grangel

- **Production Design in an Animated Feature**
Armand Baltazar
Samuel Michlap
Daniel St. Pierre

- **Writing in an Animated Feature**
Michael J. Wilson
Rob Letterman

VES AWARD NOMINATION

- **Outstanding Performance by an Animated Character in an Animated Feature**
Renée Zellweger (Angie)
Ken Duncan

MADAGASCAR

May 27, 2005

ANNIE AWARD NOMINATIONS

- **Animated Effects**
Matt Baer
Rick Glumac
Martin Usiak

- **Animated Feature**
DreamWorks Animation

- **Character Design in an Animated Feature**
Craig Kellman

- **Music in an Animated Feature**
Hans Zimmer

- **Production Design in an Animated Feature**
Yoriko Ito

- **Storyboarding in an Animated Feature**
Tom McGrath
Catherine Yuh Rader

PGA AWARD NOMINATION

- **Producer of Animated Feature**
Mireille Soria

VES AWARD NOMINATION

- **Performance by an Animated Character in an Animated Feature**
Sacha Baron Cohen (King Julien)
Rex Grignon
Denis Couchon

WALLACE & GROMIT: THE CURSE OF THE WERE-RABBIT

October 7, 2005

ACADEMY AWARD®

- **Best Animated Feature**
Nick Park
Steve Box

ANNIE AWARDS

- **Animated Effects**
Jason Wen

- **Animated Feature**
DreamWorks Animation
Aardman Animations Ltd.

- **Character Animation**
Claire Billett

- **Character Design in an Animated Feature**
Nick Park

- **Directing in an Animated Feature**
Nick Park
Steve Box

- **Music in an Animated Feature**
Julian Nott

- ◆ **Production Design in an Animated Feature**
 Phil Lewis

- ◆ **Storyboarding in an Animated Feature**
 Bob Persichetti

- ◆ **Voice Acting in an Animated Feature**
 Peter Sallis (Wallace)

- ◆ **Writing in an Animated Feature Production**
 Steve Box
 Nick Park
 Mark Burton
 Bob Baker

ANNIE AWARD NOMINATIONS

- ▪ **Character Animation**
 Jay Grace

- ▪ **Character Animation**
 Christopher Sadler

- ▪ **Storyboarding in an Animated Feature**
 Michael Salter

- ▪ **Voice Acting in an Animated Feature**
 Helena Bonham Carter
 (Lady Tottington)
 Ralph Fiennes
 (Victor Quartermaine)
 Nicholas Smith
 (Reverend Hedges)

PGA AWARD

- ◆ **Outstanding Producer of Animated Feature**
 Claire Jennings
 Nick Park

VES AWARD

- ◆ **Outstanding Performance by an Animated Character in a Feature**
 Loyd Price (Gromit)

OVER THE HEDGE

May 19, 2006

ANNIE AWARDS

- ◆ **Character Design in an Animated Feature**
 Nicolas Marlet

- ◆ **Directing in an Animated Feature**
 Tim Johnson
 Karey Kirkpatrick

- ◆ **Storyboarding in an Animated Feature**
 Gary Graham

ANNIE AWARD NOMINATIONS

- ▪ **Animated Feature**
 DreamWorks Animation

- ▪ **Character Animation in a Feature**
 Kristof Serrand

- ▪ **Production Design in an Animated Feature**
 Paul Shardlow

- ▪ **Storyboarding in an Animated Feature**
 Thom Enriquez

- ▪ **Voice Acting in an Animated Feature**
 Wanda Sykes (Stella)

FLUSHED AWAY

November 2, 2006

ANNIE AWARDS

- ◆ **Animated Effects**
 Scott Cegielski

- ◆ **Character Animation in a Feature**
 Gabe Hordos

- ◆ **Production Design in an Animated Feature**
 Pierre-Olivier Vincent

- ◆ **Voice Acting in an Animated Feature**
 Ian McKellen (Toad)

- ◆ **Writing in an Animated Feature Production**
 Dick Clement
 Ian La Frenais
 Chris Lloyd
 Joe Keenan
 Will Davies

ANNIE AWARD NOMINATIONS

- ▪ **Character Animation in a Feature**
 Line Korsgaard Andersen

- ▪ **Directing in an Animated Feature**
 David Bowers
 Sam Fell

- ▪ **Storyboarding in an Animated Feature**
 Simon Wells

PGA AWARD NOMINATION

- ▪ **Outstanding Producer of Animated Feature**
 Cecil Kramer
 Peter Lord

SHREK THE THIRD

May 18, 2007

ANNIE AWARD NOMINATION

- ▪ **Directing in an Animated Feature**
 Chris Miller
 Raman Hui

VES AWARD NOMINATIONS

- ▪ **Outstanding Effects in an Animated Feature**
 Matt Baer
 Greg Hart
 Krzysztof Rost
 Antony Field

- ▪ **Outstanding Performance by an Animated Character in an Animated Feature**
 John Cleese (King Harold)
 Guillaume Aretos
 Tim Cheung
 Sean Mahoney

BEE MOVIE

November 2, 2007

ANNIE AWARD NOMINATIONS

- ▪ **Animated Feature**
 DreamWorks Animation

- ▪ **Animation Production Artist**
 Michael Isaak

- ▪ **Music in an Animated Feature**
 Rupert Gregson-Williams

- ▪ **Storyboarding in an Animated Feature**
 Nassos Vakalis

- ▪ **Voice Acting in an Animated Feature**
 Patrick Warburton

GOLDEN GLOBE NOMINATION

- ▪ **Animated Film**

PGA AWARD NOMINATION

- ▪ **Outstanding Producer of Animated Features**
 Jerry Seinfeld
 Christina Steinberg

KUNG FU PANDA

June 6, 2008

ACADEMY AWARD® NOMINATION

- ▪ **Best Animated Feature**
 John Stevenson
 Mark Osborne

ANNIE AWARDS

- ▪ **Animated Effects**
 Li-ming Lawrence Lee

- ▪ **Animated Feature**
 DreamWorks Animation

- ▪ **Character Animation in a Feature**
 James Baxter

- ▪ **Character Design in an Animated Feature**
 Nico Marlet

- ▪ **Directing in an Animated Feature**
 John Stevenson
 Mark Osborne

- ▪ **Music in an Animated Feature**
 Hans Zimmer
 John Powell

- ▪ **Production Design in an Animated Feature**
 Tang Kheng Heng

- ▪ **Storyboarding in an Animated Feature**
 Jennifer Yuh Nelson

- ▪ **Voice Acting in an Animated Feature**
 Dustin Hoffman (Shifu)

- ▪ **Writing in an Animated Feature**
 Jonathan Aibel
 Glenn Berger

ANNIE AWARD NOMINATIONS

- ▪ **Character Animation in a Feature**
 Philippe Le Brun
 Dan Wagner

- ▪ **Production Design in an Animated Feature**
 Raymond Zibach

- ▪ **Storyboarding in an Animated Feature**
 Alessandro Carloni

- ▪ **Voice Acting in an Animated Feature**
 James Hong (Mr. Ping)
 Ian McShane (Tai Lung)

GOLDEN GLOBE AWARD NOMINATION

- **Best Animated Film**

PGA AWARD NOMINATION

- **Outstanding Producer of Animated Feature**
 Melissa Cobb

VES AWARD NOMINATIONS

- **Outstanding Animated Character in an Animated Feature**
 Jack Black (Po)
 Dan Wagner
 Nico Marlet
 Peter Farson

- **Outstanding Animation in an Animated Feature**
 Markus Manninen
 Alex Parkinson
 Amaury Aubel
 Li-ming Lawrence Lee
 Dan Wagner
 Raymond Zibach

MADAGASCAR: ESCAPE 2 AFRICA

November 7, 2008

ANNIE AWARD NOMINATIONS

- **Best Animated Effects**
 Fangwei Lee

- **Best Writing in an Animated Feature**
 Etan Cohen
 Eric Darnell
 Tom McGrath

VES AWARD NOMINATION

- **Outstanding Animation in an Animated Feature**
 Scott Peterson
 Laurent Kermel
 Andrew Wheeler
 Greg Gladstone

MONSTERS VS. ALIENS

March 27, 2009

ANNIE AWARD

- ◆ **Best Storyboarding in a Feature Production**
 Tom Owens

ANNIE AWARD NOMINATIONS

- **Animated Effects**
 Scott Cegielski

- **Voice Acting in a Feature Production**
 Hugh Laurie (Dr. Cockroach Ph.D.)

VES AWARD NOMINATION

- **Outstanding Effects Animation in an Animated Feature**
 David Allen
 Amaury Aubel
 Scott Cegielski
 Alain De Hoe

HOW TO TRAIN YOUR DRAGON

March 26, 2010

ACADEMY AWARD® NOMINATIONS

- **Best Original Score**
 John Powell

- **Best Animated Feature**
 Chris Sanders
 Dean DeBlois

ANNIE AWARDS

- ◆ **Animated Effects**
 Brett Miller

- ◆ **Animated Feature**
 DreamWorks Animation

- ◆ **Character Animation in a Feature**
 Gabe Hordos

- ◆ **Character Design in an Animated Feature**
 Nicolas Marlet

- ◆ **Production Design in an Animated Feature**
 Pierre-Olivier Vincent "POV"

- ◆ **Storyboarding in an Animated Feature**
 Tom Owens

- ◆ **Writing in an Animated Feature**
 Will Davies
 Dean DeBlois
 Chris Sanders

- ◆ **Directing in a Feature**
 Chris Sanders
 Dean DeBlois

- ◆ **Music in an Animated Feature**
 John Powell

- ◆ **Voice Acting in an Animated Feature**
 Jay Baruchel (Hiccup)

ANNIE AWARD NOMINATIONS

- **Animated Effects**
 Jason Mayer

- **Best Character Animation in a Feature**
 Jakob Hjort Jensen

- **Best Character Animation in a Feature**
 David Torres

- **Best Storyboarding in an Animated Feature**
 Alessandro Carloni

- **Voice Acting in an Animated Feature**
 Gerard Butler (Stoick)

GOLDEN GLOBE NOMINATION

- **Best Animated Film**

PGA AWARD NOMINATION

- **Outstanding Producer of Animated Feature**
 Bonnie Arnold

VES AWARDS

- ◆ **Outstanding Animated Character in an Animated Feature**
 (Toothless)
 Gabe Hordos
 Cassidy Curtis
 Mariette Marinus
 Brent Watkins

- ◆ **Outstanding Animation in an Animated Feature**
 Bonnie Arnold
 Craig Ring
 Simon Otto

- ◆ **Outstanding Effects Animation in an Animated Feature**
 Andy Hayes
 Laurent Kermel
 Jason Mayer
 Brett Miller

SHREK FOREVER AFTER

May 21, 2010

ANNIE AWARD NOMINATIONS

- **Animated Effects**
 Andrew Young Kim

- **Production Design in an Animated Feature**
 Peter Zaslav

- **Storyboarding in an Animated Feature**
 Paul Fisher

- **Music in an Animated Feature**
 Harry Gregson-Williams

- **Voice Acting in an Animated Feature**
 Cameron Diaz (Fiona)

VES AWARD NOMINATIONS

- **Outstanding Animation in an Animated Feature**
 Teresa Cheng
 Jason Reisig
 Gina Shay
 Doug Cooper

- **Outstanding Effects Animation in an Animated Feature**
 Can Yuksel
 Yancy Lindquist
 Jeff Budsberg
 Andrew Young Kim

MEGAMIND

November 5, 2010

ANNIE AWARD NOMINATIONS

- **Animated Effects**
 Krzysztof Rost

- **Character Animation in a Feature**
 Mark Donald
 Anthony Hodgson

- **Character Design in an Animated Feature**
 Timothy J. Lamb

- **Storyboarding in an Animated Feature**
 Catherine Yuh Rader

- **Writing in an Animated Feature**
 Alan Schoolcraft
 Brent Simons

VES AWARD NOMINATION

- **Outstanding Animated Character in an Animated Feature**
 David Cross (Minion)
 Rani Naamani
 Dick Walsh
 Adrian Tsang

KUNG FU PANDA 2

May 26, 2011

ACADEMY AWARD® NOMINATION

- **Best Animated Feature**
 Jennifer Yuh Nelson
 First woman to be nominated for an Oscar for directing an animated feature

ANNIE AWARDS

- ◆ **Directing in a Feature**
 Jennifer Yuh Nelson

- ◆ **Production Design in a Feature**
 Raymond Zibach

ANNIE AWARD NOMINATIONS

- **Animated Effects**
 Dave Tidgwell
 Jason Mayer

- **Best Animated Feature**
 DreamWorks Animation

- **Character Animation in a Feature**
 Dan Wagner
 Pierre Perifel

- **Editing in a Feature**
 Clare Knight

- **Storyboarding in a Feature**
 Gary L. Graham
 Philip Craven

- **Voice Acting in a Feature**
 Gary Oldman (Shen)
 James Hong (Mr. Ping)

PGA AWARD NOMINATION

- **Outstanding Producer of Animated Feature**
 Melissa Cobb

VES AWARD NOMINATION

- **Outstanding Visual Effects in an Animated Feature**
 Melissa Cobb
 Alex Parkinson
 Jennifer Yuh Nelson
 Raymond Zibach

PUSS IN BOOTS

October 28, 2011

ACADEMY AWARD® NOMINATION

- **Best Animated Feature**
 Chris Miller

ANNIE AWARD NOMINATIONS

- **Animated Effects in an Animated Production**
 Can Yuksel

- **Animated Feature**
 DreamWorks Animation

- **Character Animation in a Feature**
 Olivier Staphylas

- **Character Design in a Feature**
 Patrick Maté

- **Directing in a Feature**
 Chris Miller

- **Editing in a Feature**
 Eric Dapkewicz

- **Music in an Animated Feature**
 Henry Jackman

- **Storyboarding in a Feature**
 Bob Logan

- **Voice Acting in a Feature**
 Zach Galifianakis (Humpty Alexander Dumpty)

GOLDEN GLOBE NOMINATION

- **Best Animated Feature**

PGA AWARD NOMINATION

- **Outstanding Producer of Animated Feature**
 Joe M. Aguilar
 Latifa Ouaou

VES AWARD NOMINATIONS

- **Outstanding Animated Character in an Animated Feature**
 Antonio Banderas (Puss In Boots)
 Laurent Caneiro
 Olivier Staphylas
 Ludovic Bouancheau

- **Outstanding Created Environment in an Animated Feature**
 (The Cloud World)
 Greg Lev
 Brett Miller
 Guillaume Aretos
 Peter Zaslav

- **Outstanding Visual Effects in an Animated Feature**
 Chris Miller
 Ken Bielenberg
 Guillaume Aretos
 Joe M. Aguilar

MADAGASCAR 3: EUROPE'S MOST WANTED

June 8, 2012

ANNIE AWARD NOMINATIONS

- **Animated Effects in an Animated Production**
 JiHyun Yoon

- **Character Design in an Animated Feature**
 Craig Kellman

- **Production Design in an Animated Feature**
 Kendal Cronkhite
 Shannon Jeffries
 Kenard W. Pak
 Lindsey Olivares

- **Storyboarding in an Animated Feature**
 Rob Koo

RISE OF THE GUARDIANS

November 21, 2012

ANNIE AWARDS

- ◆ **Animated Effects in an Animated Production**
 Andy Hayes
 David Lipton
 Carl Hooper

- ◆ **Storyboarding in an Animated Feature**
 Johane Matte

ANNIE AWARD NOMINATIONS

- **Animated Feature**
 DreamWorks Animation

- **Character Animation in a Feature**
 David Pate
 Philippe Le Brun
 Pierre Perifel

- **Editorial in an Animated Feature**
 Joyce Arrastia

- **Music in an Animated Feature**
 Alexandre Desplat

- **Production Design in an Animated Feature**
 Perry Dixon Maple
 Woonyoung Jung
 Patrick Marc Hanenberger
 Max Boas
 Peter Maynez
 Felix Yoon

Stan Seo
Jayee Borcar

- **Voice Acting in an Animated Feature**
 Jude Law (Pitch)

GOLDEN GLOBE NOMINATION

- **Best Animated Feature**

PGA AWARD NOMINATION

- **Outstanding Producer of Animated Feature**
 Christina Steinberg
 Nancy Bernstein

VES AWARD NOMINATIONS

- **Outstanding Animation in an Animated Feature**
 David Prescott
 Peter Ramsey
 Christina Steinberg
 Nancy Bernstein

- **Outstanding Created Environment in an Animated Feature**
 (The North Pole)
 Peter Maynez
 Andy Harbeck
 Eric Bouffard
 Sonja Burchard

- **Outstanding FX and Simulation Animation in an Animated Feature**
 (The Last Stand)
 Andrew Wheeler
 Carl Hooper
 Stephen Wood
 Andy Hayes

Project Manager **Eric Klopfer**
Production Manager **True Sims**
Art Director **Christophe Lautrette**
Cover Design **Rhion Magee & Jeremiah Schaeffer**

Library of Congress Control Number: 2013945518

ISBN: 978-1-4197-1166-4

Printed and bound in China
10 9 8 7 6

Abrams books are available at special discounts when purchased in quantity for premiums and promotions as well as fundraising or educational use. Special editions can also be created to specification. For details, contact specialsales@abramsbooks.com or the address below.

ABRAMS The Art of Books
115 West 18th Street, New York, NY 10011
abramsbooks.com